MANNERS & MORALS

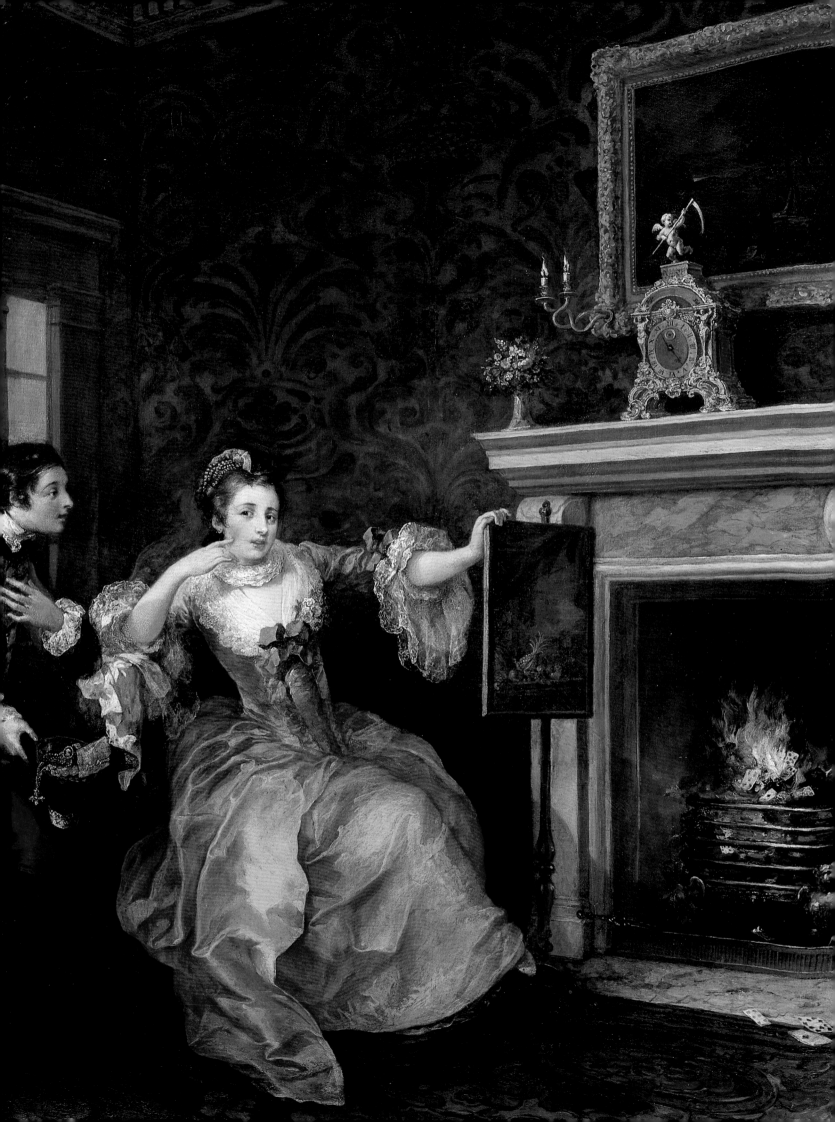

Manners & Morals

HOGARTH AND BRITISH PAINTING 1700-1760

THE TATE GALLERY

This exhibition is sponsored by

·PEARSON·

front cover
William Hogarth
Canvassing for Votes 1754–5 (detail)
(cat. no. 197)

back cover
William Hogarth
A Performance of 'The Conquest of Mexico' 1732–5
(detail) (cat. no. 68)

frontispiece
William Hogarth
The Lady's Last Stake 1758–9
(cat. no. 210)

ISBN 0 946590 84 2 (paper)
ISBN 0 946590 85 0 (cloth)
Published by order of the Trustees 1987
for the exhibition of 15 October–3 January 1988
Copyright © 1987 The Tate Gallery. All rights reserved
Designed and published by Tate Gallery Publications,
Millbank, London SW1P 4RG
Printed in Great Britain by Balding + Mansell UK Limited

Contents

7 Foreword

9 Acknowledgements

11 Introduction *Elizabeth Einberg*

19 The Artist's Training and Techniques *Rica Jones*

30 Catalogue *Elizabeth Einberg*

212 Biographical Index of Artists

249 Lenders

250 Select Bibliography

Foreword

The Tate Gallery's last general survey of an entire period of the British School was *Landscape in Britain c.1750–1850* in 1973, and we are delighted that it has now been possible to present one centred on the first of the great native British painters on whom the Tate's historic collection pivots – William Hogarth.

Such displays, which depend entirely on the generosity and public-spirited attitude of private and public lenders, are a great privilege to mount. Her Majesty the Queen has graciously lent from the Royal Collection, and we are particularly grateful for the very generous loans from the Yale Center for British Art, New Haven, the National Portrait Gallery, and Sir John Soane's Museum. Above all, I would like to single out the unprecedented co-operation which we have received from the Thomas Coram Foundation for Children, the former Foundling Hospital, which has agreed to allow us to remove the cream of its collection and reassemble it at the centre of this exhibition. This is one of the most poignant documents of artistic life in Britain at this crucial period of its growth and we hope that our display will mark an auspicious beginning to the Foundation's celebrations of its 250th anniversary in 1989.

The exhibition has been selected and catalogued by Elizabeth Einberg, Assistant Keeper in the Historic British Collection at the Tate Gallery; her own acknowledgements to all those who have helped her follow.

It is a pleasure to thank Pearson for their very generous sponsorship of the exhibition. It was with Pearson that the Tate Gallery first began the adventure of exhibition sponsorship in 1981, and we are delighted to be working with them again.

Alan Bowness *Director*

Acknowledgements

Since Sir Lawrence Gowing's comprehensive survey of Hogarth's career at the Tate in 1971 there have been many exhibitions that have looked at this period in depth, either from specific angles or in terms of a single painter. It is hoped that quite a few of them will be still fresh in people's minds, particularly *Rococo Art and Design in Hogarth's England*, organised by Michael Snodin at the Victoria and Albert Museum in 1984, Tessa Murdoch's *The Quiet Conquest*, on the Huguenots in England, at the Museum of London in 1985 and Jacob Simon's *Handel* at the National Portrait Gallery in 1986, all of which gave panoramic surveys of most or part of the same period.

Many will also be familiar with the long series of annual scholarly exhibitions at the Iveagh Bequest, Kenwood, and its subsidiary, Marble Hill House, Twickenham, which over the last twenty years or so have covered many aspects of eighteenth-century British art. The most recent and relevant to this period were Anne French's survey of classical landscape painting in England in her *Gaspard Dughet* exhibition of 1980, Ellen Miles's *Thomas Hudson* in 1979, Arline Meyer's *John Wootton* in 1984 and Brian Allen's *Francis Hayman* this year, from which a few paintings are being transferred directly to this exhibition. Stephen Sartin's *Arthur Devis* at Preston and the National Portrait Gallery in 1983 was another highly relevant monographic exhibition, and there is a certain amount of overlap with John Hayes's *Thomas Gainsborough* (Tate Gallery 1980), David Solkin's *Richard Wilson* (Tate Gallery 1982) and Nicholas Penny's *Sir Joshua Reynolds* (R.A. 1986). This summer's exhibition at the British Museum of *Drawing in England from Hilliard to Hogarth* by Lindsay Stainton and Christopher White makes one hope that space might be found in the not too distant future for an exhibition of works on paper covering specifically the first half of the eighteenth century.

Among some very interesting exhibitions that throw more light on the time in question which were mounted at the Yale Center for British Art in New Haven, and which did not, unfortunately, travel to London were: Ellen D'Oench's *The Conversation Piece: Arthur Devis and his Contemporaries* (1980), T.J. Edelstein's (with Brian Allen) *Vauxhall Gardens* (1983) and Kimerly Rorschach's *The Early Georgian Landscape Garden* (1983). I can do no more than refer the interested visitor to their excellent catalogues. To all these (as well as the many pioneering exhibitions that preceded them) and their authors I am greatly indebted, and this exhibition should be seen as a kind of supplement to them.

Special thanks are also extended to the many owners who gave freely of their time and information. I am particularly indebted to Sir Oliver Millar and Sir Brinsley Ford for invaluable advice and practical help. I would also like to record my special thanks to Brian Allen, Malcolm Baker, Mary Beal, Hugh Belsey, Alec Cobbe, Linda Cabe, David Coke, Belinda Cousens, Margaret Cousland, Stephen Deuchar, Marie Draper, Christopher Gowing, Christopher Foley, John Hayes, Amelia Jackson, Vivian Knight, Elizabeth Lambert, Colin Masters, James Miller, Rosalind Marshall, Boris Mollo, Gavin Musgrave, Evelyn Newby, David Posnett, Aileen Ribeiro, Duncan Robinson, Malcolm Rogers, Phillis Rogers, Jacob Simon, Peter Thornton, Julian Treuherz, Lavinia Wellicome and Richard Wood.

I would also like to extend my thanks to my colleagues in the Historic British Collection for reading all or parts of the catalogue and making invaluable suggestions, in the department of Exhibitions and Technical Services for dealing so admirably with the horrendous logistics of the organisational side of the exhibition, in the Conservation department for their unfailingly generous and patient help with the physical examination of the loans, in the Information department for dealing meticulously with the publicity material, and last but not least to those in the Publications department for nursing the catalogue through the press with unruffled skill and tact. Working with all of them singly or in teams has been one of the unalloyed pleasures of the past year.

Since the period surveyed is replete with well-indexed monographs and general literature, references have been kept to a minimum. As a rule only the last exhibition of a painting is given, although in some cases exhibitions of specific importance to the history of the painting or its subject are also referred to. The same applies to literature, which is restricted to the most recent publication from which the interested student can retrace the full documentation of a work, to not easily traceable publications, and, especially in the case of Hogarth, to publications that give the fullest detailed descriptions of his complex subject matter and that are easily available to the general public.

Elizabeth Einberg

The exhibition to which this catalogue refers is the third that Pearson has sponsored at the Tate Gallery. It will, I am sure, be as well received by the public as was *Landseer* in 1982 and *The Pre-Raphaelites* in 1984. As neighbours on Millbank, the Tate is our local art gallery and it is always a pleasure and privilege to be associated with its activities. Though I hope that Pearson will be sponsoring future exhibitions at the Gallery, this one is the last with which its Director, Alan Bowness, and its Head of Information Services, Corinne Bellow, will be involved. Both retire next year and we wish them well and thank them for easing us so efficiently and helpfully into the role of sponsor.

Michael Blakenham
Chairman, Pearson plc
October 1987

Introduction

ELIZABETH EINBERG

It is usual to begin eighteenth-century British art history somewhere around 1730, with the early paintings of Hogarth, and certainly never before 1714, the death of Queen Anne, the last of the Stuarts. This is convenient if one wants to describe recognisable periods of taste and style, now labelled Baroque, Rococo and so forth, or think in terms of reigns, such as Georgian or Victorian, which often coincide with certain periods of style. It is easy to forget that that is not how things looked to contemporaries. Anyone who lived through the period 1700–1760 witnessed remarkable changes in taste, outlook, economics, politics, literature and art. The period covers an enormous transition from the mentality of the seventeenth century, which we know chiefly through the aristocratic, court-centred taste that prevailed among a tiny minority and which is psychologically very remote from us, to the so-called Age of Enlightenment, the rise of modern scientific thought, and a much more broadly based bourgeois culture which involved increasingly greater sections of the population, put growing emphasis on individual character and the value of human life as such, and in some measure raised the quality of life for a larger number of people than ever before. This exhibition tries to explore some of these aspects as they are reflected in contemporary British painting. It is also the period which shaped and provided the stage for the work of England's first great native painter, William Hogarth (1697–1764).

When the young Duke of Gloucester, the only surviving son of the future Queen Anne, died in 1700, it became likely that the Protestant Hanoverian descendants of James I would inherit the throne of England in the foreseeable future. This was initially a far from foregone conclusion, since there was in the country still a substantial following for the exiled Catholic King James II. When he died in 1701, Louis XIV of France proclaimed his son James Edward Stuart (the Old Pretender) James III of England. His and his son's attempt to invade England via Scotland in 1715 and 1745 left a deep mark on the national consciousness, however doomed the attempts may look with hindsight now. His followers, the Jacobites, had considerable support among the Tory traditionalists, Catholics and Scots, while the Protestant Hanoverians were supported by the Whigs.

Hogarth was born in the reign of William III, into the family of a school-teacher of Greek and Latin who had come to London from the north of England in the hope of making his fortune. They came from deeply Protestant, non-conformist stock, and William was probably named after his sovereign. For anyone with even the remotest ambition, London was the only place to go. With around 600,000 inhabitants at the turn of the century, it was the largest city in Europe, bigger even than Paris, in a country whose total population was less than about two-thirds of that of London today. Norwich with some 30,000 inhabitants was the next largest city in the country, and fewer than half a dozen other towns reached even a third of that. London was the country's main port, its financial centre, the seat of government and the court, the main consumer of goods and dispenser of patronage. Although by our standards main roads, where they existed, were mere dirt tracks, impassable in bad weather (a fast journey from London to Edinburgh took about a fortnight), it was the ambition of people even in the remotest districts to see London at least once in their life. On the other hand, for the wealthy and well-born life in England was never as court- or town-centred as in, say, France. It was a matter for comment among foreigners how much the English enjoyed life on their estates and in their country houses.

In an age of rampant inequalities, English society was divided not so much by blood and caste, but according to wealth. Ownership of land brought power, and primogeniture (the rule that only the eldest son could inherit the estate and titles) saw to it that estates were not broken up among many offspring, weakening the centre of family influence. It also made for finer gradations between the titled and the merely rich and, as the century progressed, also between them and the professions, as careers in the church, the army, in law or in commerce became respectable alternatives for the younger sons of the aristocracy. This applied of course only to a minute upper level of inherited and created wealth; the bulk of the population often knew want and poverty, lack of opportunity and callous injustice. Nevertheless, compared with the rest of Europe, England was relatively well off, its trade expanding, its agriculture was one of the most productive, and by the eighteenth century Englishmen were no longer subjected to famine after poor harvests. Although authoritarian by our standards, English society supported a free, unmuzzled press that was the envy of foreigners and a proportionally smaller standing army than any other European country. While most of the wealth was amassed by a small section of landowners and merchants, in a relatively open society such as England had, it could not but help filtering down to an increasingly greater number of the less privileged. The English prided themselves on being pragmatic and straightforward, commercial-minded

and practical, a society in short that regarded art with suspicion, as a vehicle for Popish ideas or the dangerous glorification of monarchs and the court. For a long time, and particularly so in the eighteenth century, it was axiomatic that the English were only interested in portraits of themselves, their houses and estates, their horses and their families, probably in that order. 'Great' art (by which was meant History Painting, that is to say painting that dealt with religious, epic, or other elevated themes) came from abroad, and was anyway the concern of only those who could afford to make a Grand Tour of Europe. Hogarth was one of those people who never tired of trying to change this outlook, to broaden the scope of British art, to prove that native painters could be equal to foreign Old Masters. In this he largely failed (not without reason), but at the same time he created a brilliant new art form that stands unrivalled in eighteenth-century painting – the 'modern moral subjects' or Comic History Painting, 'comic' being used here in the older meaning of Ben Jonson's

> Persons, such as comedy would choose,
> When she would shew an image of the times,
> And sport with human follies, not with crimes.

It answered the spirit of the age in that it made everyday events and 'ordinary' people a legitimate subject for art, but it was also highly individual in that its roots can be found in Hogarth's own background.

London's day-to-day social life was conducted in coffee-houses and taverns which were the meeting places of friends, business associates, clubs, societies, circles of specialist interest, places to read newspapers, write letters and to receive them; they were places from where one could run a business and which offered entertainment and conviviality for much of the better-off (male) population from breakfast until late at night. London had some 2,000 coffee-houses, and Hogarth's father tried to capitalise on this by opening a Latin-speaking one in 1703, the first full year of Queen Anne's reign. It failed, and by 1707 he was confined to the Fleet, the debtors' prison, although within a year he was able to buy himself out of prison and live within its Rules. This meant that he was able to enjoy a certain amount of liberty that enabled debtors to live with their families and earn a modest income. From this he was released by an Act of general amnesty in 1712 that applied to debtors who owed less than £50. During this formative period of his life William Hogarth gained familiarity with the classics and the underbelly of urban society, a consuming need to excel, a literary turn of mind that placed great emphasis on words, puns and double meanings, and above all a searing hatred of want, deprivation, corruption, injustice and human cruelty and callousness at all levels.

In some ways his family was typical of the period which saw the rise of the middle classes in England. It began the century in a state of neediness, with his mother selling patent medicines to keep the family together, but it had enough drive and the luck to have a gifted and ambitious son who helped with its support until his sisters could set up a respectable draper's shop, while William went on to gain independence and eminence in his profession. Born as he was in St Bartholomew's Close near Smithfield Market, it must have been with a gratifying sense of achievement that he was able in 1736 to present to the newly built St Bartholomew's Hospital nearby, as a gift, the grandiose biblical scenes of healing (83) that still decorate its grand staircase.

His beginnings did not look promising. In 1713 Hogarth was apprenticed for seven years to Ellis Gamble, a silver engraver, not a greatly revered profession, and in 1720 he opened business as an independent engraver in his mother's house in Long Lane. From October that year he also subscribed to Chéron's and Vanderbank's new academy in St Martin's Lane, showing that it was his intention to become a full member of the artistic community of London, and to better himself by becoming a painter.

In painting, this was still the age of Kneller. It is difficult for us to imagine now how pervasive his influence would have been in Hogarth's youth. For nearly forty years the German-born Sir Godfrey (1646–1723) – who like the early Hanoverian kings never lost his thick German accent – had been the leading portrait painter in England, and since in England that was the main business of painting, his pre-eminence was unchallenged. He had achieved every honour that Van Dyck had, and more: sole Principal Painter to the King from 1691, knighted in 1692, painter of numerous crowned heads in Europe at royal behest, created Knight of the Holy Roman Empire in 1700, owner of a splendid country house at Whitton, Middlesex, designed by Wren and decorated by Louis Laguerre, this visual spokesman of the late seventeenth century lived on to be granted a baronetcy by George I in 1715, and to paint not only the last poet of the Restoration, Dryden, who died in 1700, but also, in 1721, the quintessential voice of eighteenth-century Augustan poetry, Alexander Pope. As late as 1753 Reynolds was criticised by John Ellys, Kneller's last surviving follower, for not painting like Kneller. When asked to explain, he could only answer 'Shakespeare in poetry, and Kneller in painting, damme!'. This was probably how Kneller saw himself, unchallenged and supreme, and superb organiser of the nation's largest workshop practice, which could well cope with the huge demands for portraits and replicas of them (and which was, incidentally, responsible for much of the shoddiness that passes under the name of Kneller). As a result, we have to look at the period between the Glorious Revolution of 1688, when the Catholic James II was deposed in favour of his daughter Mary and her husband William of Orange, and the greater part of the reign of George I through the eyes of Kneller, just as we have to look at the British

establishment of the late eighteenth century through the eyes of Reynolds. Kneller's legendary vanity was fuelled by lack of competition and the flattery of the wits of the day, including Pope, with whom he was on friendly terms (21, 22). We have Pope's description of the dying Kneller contemplating the design for his monument in Westminster Abbey, regretting having to leave his country house behind, and dreaming of the special reception committee, headed by St Luke, that awaited his arrival in heaven. Nothing could be further from the humanitarian concerns of Hogarth, through whose eyes we tend to see the succeeding period of the first half of the eighteenth century.

Kneller's great merit was to pass on sound training methods through the first academy in London which he founded in 1711, after which London was never again without a training establishment for budding artists, and encouraging, at his best, a free bravura brushwork that influenced later painters. He and Thornhill, the only British-born painter to equal his success, though in the sphere of decorative painting rather than portraiture, were the last painters working in the eighteenth century who could naturally use the language of Baroque allegory in works that can still be looked at without embarrassment today, painting on a large scale that went increasingly out of fashion as the century progressed.

Yet the dawning sense of intimacy and individuality typical of the new century begins to show itself in works like Kneller's Kit-cat series (23–27) which *in toto* has something of the air of a vast conversation piece, a feeling reinforced by Kneller's last painting for the series in 1721, in which he presents two powerful peers, the Earl of Lincoln and the Duke of Newcastle, in relaxed, convivial conversation, even while wearing their Garter sashes. Large sets of portraits (of places as well as of people) became a feature of eighteenth-century painting, and a later equivalent of the Kit-cat series can be seen in the masquerade portraits of the Dilettanti Society of the 1740s (121–124).

Painting in general was still largely confined to aristocratic circles, large in scale, aiming to record dynastic grandeur, splendid possessions or epic achievement. As there was no native school as such, the best painters came from abroad. Kneller's nearest rival was the Swedish painter Michael Dahl (18) who was patronised by Queen Anne's Tory court (in so far as painting was politically polarised at all, Kneller was the favourite painter of the opposition Whigs) and who worked in a gentler version of Kneller's style. Dahl survived long enough to be included with his fellow Swede and pupil Hans Hysing (72) in one of the earliest records of a group of British artists to take the form of a conversation piece, Gawen Hamilton's group portrait of *c.*1735 of clubbable 'virtuosis' (nowadays we would say art-lovers) who gathered at the King's Arms Tavern in Bond Street (65). The fact that most of them are known to have been Catholics or Tories may explain the absence of the fiercely Hanoverian Hogarth from this group, even though he was an eminent painter by this time. Among native painters, Jervas (19), though important for the range of eminent sitters his Irish charm, good connections and urbane connoisseurship secured, was never a serious rival to Kneller in artistic terms. The real bridge between the surviving representatives of the seventeenth and the new artists of the eighteenth centuries was Jonathan Richardson (36, 71), the master of Thomas Hudson, and also an important writer on artistic theory.

In the early eighteenth century the mansions of the great still had their ceilings and walls decorated with vast schemes of virtuous or heroic content, an art which, in the absence of any native talent, was supplied by an army of foreign painters, the most notable among whom were the Italian Antonio Verrio (1637–1707) and the Parisian Louis Laguerre (10). The latter is particularly important in that Sir James Thornhill is said to have learnt his art from him. The most gifted were the Venetians Amiconi, Pellegrini and Sebastiano and Marco Ricci, uncle and nephew (9, 11), whose rich use of paint and Venetian facility with colour must have set a standard for Hogarth's own developing response to the medium. Sebastiano Ricci's two large mythologies still on the staircase of Burlington House, with their theatrical *contrapposto* caryatids, and the designs for Bulstrode (11) with their grisaille surrounds, find echoes in Hogarth's later work such as the presentation of 'The Beggar's Opera' (Gallery 3) and in the grisaille surrounds and cartouches of the decorations at St Bartholomew's Hospital. In spite of Hogarth's efforts to keep the tradition of large-scale decorative painting going in his lifetime, it became increasingly divorced from its serious origins and found its patrons not in the great nobles or civic institutions, but in theatre managers and in owners of pleasure gardens like Vauxhall (146), becoming lighter in content and more purely decorative in nature.

What Kneller was to portraiture, Thornhill was to history and decorative painting. As his contemporaries noted, he had also reached 'the top of the mountain' in his profession, with the added advantage of being British at a time when Britons were becoming increasingly patriotic – the concept of a Greater Britain was another eighteenth-century innovation, brought about by the Union of Scotland and England in 1707. In 1720 he became Serjeant Painter to the King; he was knighted and bought back the old family mansion in Dorset (he came from an old county family that had fallen on hard times); he became Member of Parliament for Weymouth in 1722. Unique among British painters, he did practically no portrait painting except as a side-line, if the commission seemed interesting enough: thus he painted Sir Isaac Newton in 1710 (12) for the Master of Trinity College, Cambridge, and finished the grand portrait of Sir Christopher Wren that had been left uncompleted by Verrio and Kneller (it hangs in the Sheldonian Theatre, Oxford). He was a model that any

ambitious British painter could follow, and clearly he was an inspiration to Hogarth. In 1715 Thornhill had gained the commission to paint the newly completed dome of St Paul's, one of the most desirable artistic projects of the time which had attracted many hopeful painters from abroad; he had managed to elbow aside all foreign competition not so much by superior talent as by pulling the strings of patriotism in high places. Together with the Painted Hall at Greenwich on which he worked from 1708 to 1727, it was to become his most enduring monument. This was heady stuff, and Hogarth recalled later that 'the Painting of St Pauls and greenwich hospital were . . . running in my head' constantly throughout his apprenticeship. He used the facilities of Thornhill's Academy, collaborated with him in a number of cases, and in 1729 married his daughter Jane – much to Thornhill's initial displeasure. It is from about this time that Hogarth's career as a painter can be said to begin. For the rest of his life Thornhill's achievement was to be his spur, and if he failed in some kinds of worldly success, it was because he did not possess his father-in-law's ability to engage the support of the powerful.

In some ways the first half of the eighteenth century is also the age of George Vertue (30, 71), the modest and industrious antiquarian and engraver who from about 1713 until his death in 1756 saw it as his mission to collect every available scrap of information about contemporary art in Britain. He collected them into some forty notebooks (most of which survive in the British Museum) with the intention of writing the first history of British art. This he never did, but Horace Walpole (54) bought Vertue's notebooks from his widow and distilled their information into his *Anecdotes of Painting in England*, the first published systematic account of art in Britain. The notebooks, chaotic and oddly spelt as they are, remain an inexhaustible source of information about the period, as well as a most reliable one, for, as Walpole put it, 'the integrity of Mr. Vertue . . . exceeded his industry, which is saying much'. His utter devotion to detail and accuracy, and his English suspicion of myth and exaggeration, if not his organising abilities or syntax, set a standard for the obsession with accuracy shared by all scholars. To quote Walpole again, 'so little was he the slave of his own imagination, he was cautious of trusting to that of others' – a truly Newtonian way of observing fact. He also knew the value of quoting the source of his information and despaired, as art historians do now, of ever making it into lively and entertaining reading material for the general public. One of his most endearing qualities is his ability to sweep from grand global observations to seemingly random human detail, such as when he wrote in 1732: 'Art flourishes more in London now than probably it has done for 50 or 60 years before – in Number of artists & works done which in a great manner is owing to the peacefull times and travailling thro Europe, Italy or Rome & c. but one little remark. I observe that the most elevated Men in Art here now are the lowest in

stature', and adds that Hogarth, Zincke the miniature painter, Philips, Scott, Scheemaker the sculptor and his brother, Hamilton and Worsdale are all 'five foot men or less'.

And indeed, Vertue was recording a period when art was flourishing in Britain as never before. Whereas in 1723 he had been able to compile a list of only twenty-three 'painters of Note in London', most of them foreign, by 1748 *The Universal Magazine* could print a list of eminent painters working in London numbering no fewer than fifty-six names, most of them English, even though quite a few remain just names to us.

When the country was shaken by the South Sea Bubble crisis in 1720 (the result of nation-wide gambling in the uncontrolled money-market of a wealthy country) the Whig statesman Sir Robert Walpole adroitly used the situation to stabilise the political scene in his favour, gaining a grip on Government power which he maintained for the next twenty-two years. With it Britain entered one of the most stable periods in her history. It was also round about this time that a new element began to make its appearance in British painting – the happy, informal style we call the Rococo.

Immigrant Dutch and Flemish artists like Angellis, Horemans, Nollekens, the Van Akens and the French-trained Mercier brought with them small-scale pastoral and genre scenes, derived from Watteau and Dutch 'merry company' subjects, which to begin with were just mood-setting or entertaining cabinet pictures, but which were soon adapted to fit in with the overwhelming English requirement for portraiture. Their intimate scale and concern with home comforts, polite company and less formal relationships between individuals suited the tenor of the age and developed in Britain into the eighteenth century's most attractive contribution to painting, the informal conversation piece. It is here that Hogarth first made his mark as a painter, along with a host of lesser British talents like Philips, Bardwell, Dandridge and Highmore, and works like the splendid 'Conquest of Mexico' of 1732 (68) show how quickly and how far he outstripped them all. The scope which this new type of painting gave for setting a scene made it an ideal vehicle for the new genre of the theatre piece, which Hogarth began to develop with 'The Beggar's Opera' in 1728 (see a later version in Gallery 3), and this led naturally to his 'moral tales'. Because these lent themselves to a mass circulation in the form of prints, they brought Hogarth fame, notoriety and a good income.

Taste was undergoing a profound change. Even among the great, 'thinking small' and a simple, bluff directness became fashionable. Walpole, who as the most powerful statesman of the day amassed enormous wealth by the nefarious methods sanctioned by the age and spent it in princely style at his seat at Houghton in Norfolk, liked to play the down-to-earth country squire, munching Norfolk

apples in Parliament, and preferred to have himself painted not as a grandee, but as a sportsman in a hunting outfit, on a small scale, by the sporting painter Wootton, with only the Garter star discreetly proclaiming his status (one of the four versions of this painting was shown at the recent Wootton exhibition at Kenwood, 1984, no.16; typical of the collaborative practices of the age, the face is said to be by Jonathan Richardson).

As the houses of lesser people improved and the picture-buying public increased, those who had no country estates came to enjoy a neat prospect of their town or city, or of any other place of local interest, such as markets, fairs, pleasure gardens or promenades. Through them, almost as a by-product of city views such as the Covent Garden scenes of Van Aken, Griffier (43, 181) and others, the motley crowd of the common people became increasingly an acceptable subject for painters. At the same time a literature was developing that catered for a wider reading public. It began in the form of the periodical essays initiated by the *Tatler* of Addison and Steele in 1709 and ultimately raised to a high art by Dr Johnson in his *Rambler* and *Idler* in the 1750s. It was readable, entertaining, came in small doses, used ordinary language and focused on limited, precise topics, often of a moral nature. Like the conversation piece, it was a small-scale art form that answered the need of the day, and it was only a matter of time before this new kind of writing found expression also in the popular novel, which first hit the public with Samuel Richardson's runaway success *Pamela, or Virtue Rewarded*, published in 1740. Painting and literature soon met within these literary parameters, as in the 'Hob' scenes by the younger Laguerre (49–52), Vanderbank's 'Don Quixote' series (55–58) and finally in that ultimate manifestation of the English Rococo style, Highmore's 'Pamela' series (134–145).

After Hogarth, Highmore was probably the best of the English painters of the period, with a range that stretched from Kneller-inspired portraits of the 1720s to the marvellously direct large conversation piece of 'Mr Oldham and his Friends' (Gallery 3). The difference between him and Hogarth was that he lacked Hogarth's fire and any impulse to moralise. Hogarth, who painted scenes from Milton (84), Shakespeare (82) and Gay's 'Beggar's Opera', had, however, different ambitions: his series and sets were not to be illustrations to literature, but independent works of art in themselves, on a par with the great works of literature. Hence his sets and 'Progresses' took the form of secular sermons in paint and were meant to be com-mentaries on the human condition, not through the accepted mythological heroes of the past, but through men and women of the contemporary world. Combined with his increasing mastery of paint, this produced works of genuine original genius, like the immensely popular 'The Harlot's Progress' set of 1732 (destroyed in the fire at Fonthill in Hogarth's lifetime), followed by 'The Rake's Progress'

(74–81), and culminating in the astonishing four scenes of 'An Election', completed in 1755 (196–199), as well as in single tableaux like 'O The Roast Beef of Old England' (Gallery 2), 'The March to Finchley' (173), and 'The Lady's Last Stake' (210) of 1759, after which to all intents and purposes he ceased to paint. All these entered, largely through the medium of prints, deeply into British national consciousness, where they still remain to this day.

In portraiture, the arrival of Vanloo in 1737 had brought a certain cosmopolitan elegance to the straightforward images of Richardson, Highmore and above all Hudson, while greater talents like Ramsay derived real benefits from study abroad. Hogarth was also a leading portrait painter, especially throughout the 1740s, although he never became a painter to the establishment like Hudson or Ramsay: his temperament was too mercurial and his personality too prickly for a successful society portraitist, for although he craved success, he was obstinately prepared to pursue it only on his own – often not altogether reasonable – terms. It is not surprising therefore that his masterpieces in portraiture were to be of a philanthropic commoner, Captain Coram (157), and the children of a successful apothecary (120).

One of the great changes in outlook that took place during this period was in the attitude to children, at least among the more leisured classes. As the awareness of the complexity of individual human beings grew, childhood came to be seen as a valid and important stage in life, rather than as an inconvenient and uncertain investment in the family succession. Infant mortality was enormous both among high and low. It was not unusual to have, like Queen Anne, at least fifteen children, none of whom survived infancy, and in the 1740s there were still London parishes where three out of four children died before the age of six. Treated as awkward miniature adults by the wealthy at the beginning of the century (infants were often expected to stand in silence in the presence of parents) and as desperately burdensome encumbrances by the poor (Defoe wrote in 1724 that in some country districts there was not a child of five that could not earn its own bread), by the time Hogarth was painting in the 1730s, childish play had come to be recognized as a valid activity, and nursing and child training became legitimate interests of well-bred mothers. The relationship of parents to children became less authoritarian, the toy market increased, books and readers were produced especially for children. Childhood was allowed to last longer, and more parents had their children painted. Reynolds's career began chiefly as a painter of the children of the rich and the powerful, before the latter came to him to be painted themselves. By contrast, Dahl's outraged refusal in 1723 to paint the two-year-old son of George I before being given a chance to paint the royal parents, cost him the appointment of Serjeant Painter in succession to Kneller. It is interesting to compare the large children's groups of Kneller, Dandridge, Ramsay, Hogarth,

Knapton and Reynolds to see how the greater freedom from the formal constraints that were the requisite of adult portraiture encouraged painters to experiment with movement and novel compositions and gave scope for a more inventive and fresh approach to group portraiture.

In the 1730s and 40s there was hardly a squire who did not go in for the improvement of his house or estates, and landscape painters, insofar as they were not copying classical painters of the past century for overdoors or supplying feeble pastiches of them for chimney pieces, were still chiefly suppliers of house and estate portraits, although, especially in the case of Lambert, ones of increasing sophistication (85, 86). The country-house view and the conversation piece combined happily in sets like Haytley's views of Beachborough (127, 128), while it was left to the much more French-inspired Dandridge (108), Hayman (147) and Gainsborough (189) to begin to use landscape settings for portraits in a genuinely evocative and poetic way. Pure landscape painting as such begins to enter the British domain with studies like Lambert's timid 'Moorland Landscape' of 1751 (182) and Gainsborough's wonderfully accomplished 'Extensive River Landscape' of c. 1750 (180).

Early paintings by Wilson and Nickolls show that London had a respectable tradition of view-painting even before the arrival of Canaletto in 1746, but it was Canaletto who taught British view-painters how to hinge a composition on a striking detail, such as an aesthetically pleasing skyline (155) or a dramatic feature like an arch (176).

The growing numbers of artists and an increasingly wider patronage, established places of study and international contacts gave the artistic community of London a desire for greater self-assertion and ambitions to be seen as a corporate body. The single artist in his studio as in Tillemans's, self portrait of 1716 (29), had given way to organised academies for students run by boards of directors like Kneller's and friendly self-help groups like Hamilton's of 1735 (65), and by the mid-century there were increasingly loud calls for an established academy under royal patronage on the French model. Hayman was one of those in favour, and his allegorical sketch (193) on the subject hints at what was envisaged. This was distasteful to Hogarth, who wanted training on democratic lines, with as little hierarchy as possible. His own initiative had taken the form of getting involved in the decoration of the Foundling Hospital, the leading charitable establishment of the 1740s, which he astutely saw as a good venue to display contemporary works of art before the public. At least half-a-dozen hospitals were founded (or re-founded) in London by the mid-century; all had grand administrative blocks where the great and good held their meetings and to which 'people of fashion' were freely admitted to admire the rich furnishings. His proposal in 1746 that artists should supply the Foundling Hospital with free examples of their work

was taken up by virtually all the leading painters of the day, and the resulting remarkable collection, which is still in the care of the Hospital (157–173), can be regarded as an embryonic National Gallery of British Art. But by now artists felt the need for a more flexible venue, serving their needs only, and nothing short of an incorporated academy would provide this. Hogarth's views were by now behind the times, if not to say downright eccentric.

From the mid-century new and powerful forces were moving in the artistic world. Even as Devis was carrying the charmingly stilted style of the conversation piece, like the echo of a bygone age, into the second half of the eighteenth century, the talents of Gainsborough and Reynolds were gathering strength and Ramsay's were reaching a new peak. Informality was giving way to a new insight into character and there was a new concern for a Grand Style that befitted an increasingly powerful and wealthy nation. Hogarth's angry humanitarian concerns had never made him more than moderately well-off, or truly respected in the highest circles of society, and he felt the need to capture an intellectual platform in art by writing a treatise on aesthetics, *The Analysis of Beauty*, published in 1753. Ever since Newton's analysis of the nature of light had stunned public consciousness with the publication of *Opticks* in 1704 (part of its impact was due to the fact that it was written in English and not Latin) and even more through Algarotti's popularisation of the book in 1737, it was thought that an analytical, objective, categorising approach to all phenomena was capable of yielding final and incontrovertible results and conclusions. Hogarth's attempt to apply this method to beauty and so raise it by this means to the dignity of pure science, inevitably failed, earning him the criticism, not for the first time, of having over-reached himself. The same year Reynolds returned from Italy with a vast repertoire of classical forms and a shrewd understanding of how to apply them effectively to changing tastes in portraiture, so as to invest it with a new grandiloquent dignity that the age seemed to call for.

In 1757, as the last of the medieval houses on London Bridge were being pulled down, Ramsay returned from Italy equipped with a new style to challenge Reynolds, and Hogarth at last inherited the family appointment of Serjeant Painter to the King from his brother-in-law John Thornhill (who never seriously painted). It brought no royal commissions and Hogarth, tried by the difficulties of engraving 'An Election', announced that he would no longer paint any Comic Histories, but only portraits. The following year his young admirer James Caulfeild, 1st Earl of Charlemont, persuaded him to paint one more conversation piece, the result being 'The Lady's Last Stake' (210). This led to another commission which Hogarth decided to cast in the tragic mode, 'Sigismonda Mourning Over the Heart of Guiscardo' (Gallery 2). It failed to please his client who refused to accept it in 1759,

causing Hogarth, whose peculiar delusion it was to see in it his absolute masterpiece, untold heartache, and virtually to cease painting for good. When the first public exhibition organised by the Society of Artists opened in London in May 1760, Hogarth was not among the exhibitors.

The year 1760 also saw the death of Mercier, who originally brought the informal conversation piece to England over forty years before, and the arrival from Germany of Zoffany, who was to take the genre to new heights of palpable verisimilitude during the last decades of the century, combining it, as did Hogarth, with theatre painting. It was also the year when various Acts were passed to widen and improve the City streets, and all the old City gates, with the exception of Newgate, were demolished. Southwark Fair, established in 1462 and memorably painted by Hogarth in 1733, was finally closed down because of rowdiness. When in October 1760 the twenty-two-year-old George III succeeded his grandfather to the throne, he inherited a country on the brink of unparalleled industrial and mercantile development, and one that was changing from a maritime power into an imperial one. It is its Grand Style of painting as represented by the mature Reynolds and Gainsborough, Romney and Wilson, Stubbs and Wright of Derby that one tends to associate with the Golden Age of eighteenth-century British painting; the age of Hogarth was well and truly past.

Illness and strife dogged Hogarth's last years, and although he recovered sufficiently to send in six paintings to the Society of Artists' exhibition of 1761, none of them was new, and he did not exhibit again. He continued to live at Chiswick and his house in Leicester Square, tinkering with prints and his projected autobiography, until his death, after a hearty dinner of beef-steak, in the night of 25–26 October 1764.

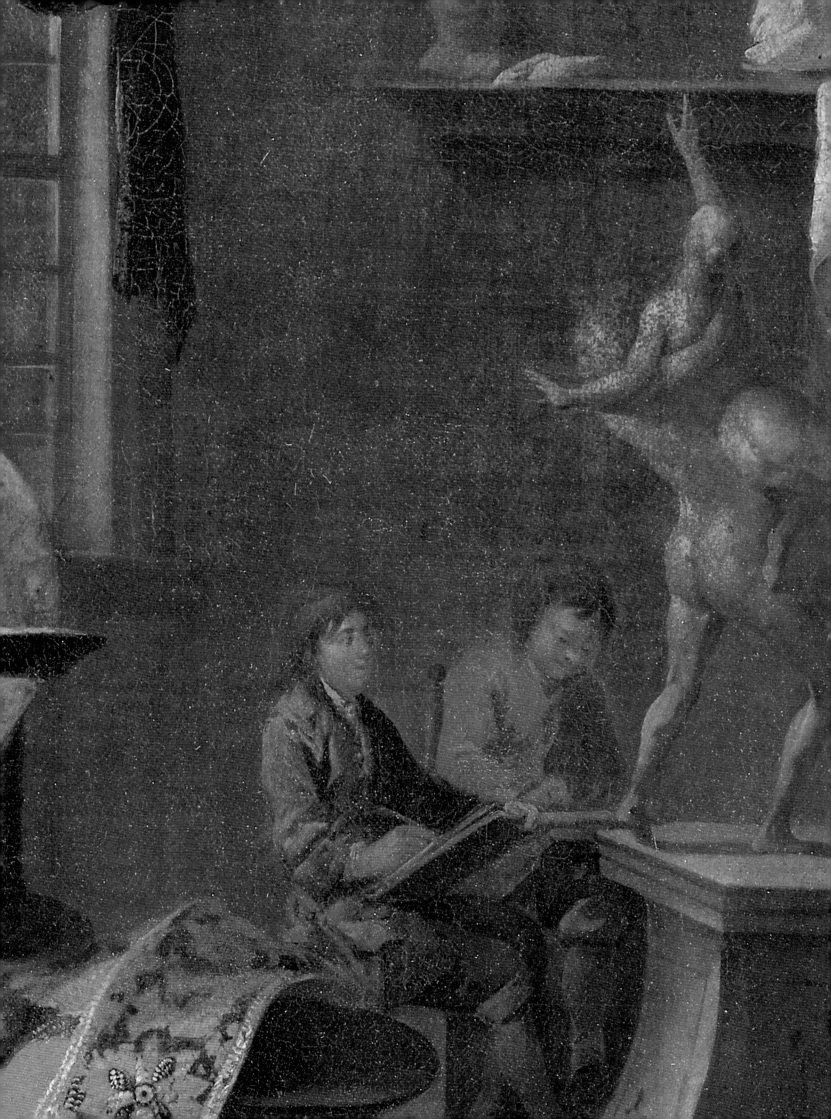

The Artist's Training and Techniques

RICA JONES

I The Early Academies of Art in England

The first academy of art in England was founded on St Luke's Day, 11 October 1711, when over sixty people, 'most of them eminent artists and lovers of art in this Nation'[1], met in an uninhabited house in Great Queen Street to elect a governor and twelve directors. It was a late development in the history of academies, which had originated in Italy during the Renaissance and spread to France, Germany and Holland during the seventeenth century. Academies taught drawing not painting. First the students copied drawings and prints; next they drew from casts; finally from the living, nude model. Drawing (disegno) was considered to be the intellectual content of painting. Through it the artist demonstrated his knowledge of proportion, perspective, human anatomy and the antique. These were the essential factors in the elevation of painting from a craft to a noble pursuit. This purpose was common to all academies, though the style of achieving it varied from country to country. In France the *Académie Royale de Peinture et de Sculpture* was, from the 1680s, tightly controlled by the state. Its powers were awesome: no painter who had not been a member could apply for royal or court patronage; no other institution, studio or workshop could practise life drawing; and a rigid hierarchy was imposed on the subject-matter of art, history painting being considered the noblest. In Holland, on the other hand, academies had developed within the context of the artist's studio, with groups of artists meeting in the evenings to draw from life and the antique.[2] Soon the academic system of teaching drawing was adopted in the workshops. Pupils doing the traditional, long training in the art and craft of painting learned to draw in the way they might if they were at the academy at Paris, Bologna or Rome.[3]

In England during the seventeenth century it is probable that this informal type of academy existed in the studios of the leading artists, most of whom were Netherlandish in origin or training.[4] During the period covered by the exhibition, Tillemans certainly had most of the accoutrements of a studio academy, as can be seen in 'The Artist's Studio' of 1716 (29). Casts, drawings, books, old master paintings and pupils at work, one being instructed by the master, are all represented. Only the life model is missing.

Pupils drawing a piece of classical sculpture. Detail from 'The Artist's Studio' by Tillemans (29)

How painters without access to large studios managed for life drawing is not clear; their recognition of its value is proved in a request made to the Company of Painter-Stainers in 1657. The 'picture-makers' belonging to the Company asked their ruling body if they could use the lower parlour of the Painter-Stainers Hall 'for an attendance to make use of drawing from the life'. The court replied that 'there should be no meeting of the company or appertaining to the Guildhall whereby to keep an academy in any part thereof for drawing to the life'.[5] The vehemence of the refusal is not explained. Might it be that 'they were . . . suspected of being held for immoral purposes', as an eighteenth-century writer says of the early academies in his day?[6]

Kneller's Academy

As a result of the meeting in Great Queen Street, Kneller was unanimously elected governor of the new academy. He was almost certainly the originator of the idea but whether alone or with others is not known. Three connoisseurs of art, who were elected directors, 'undertook to promote and get subscriptions from many painters and other artists in London'.[7] Subscription was the only source of income and the fee was one guinea per head. The other directors were Dorigny, an engraver; Gouge, Gibson and Richardson, portrait painters; Thornhill, Laguerre and Pellegrini, history painters; Luttrell, an artist in crayons; and Bird, a sculptor. Amongst the painters who subscribed over the next three years were Wootton, Chéron, Tillemans, Casteels, Dahl, Hysing, Vanderbank, Laroon, Dandridge and Highmore.[8]

Kneller and his directors collaborated to form the rules of the academy. They were 'writ and framed'[9] but have not survived to tell us how the place was run. Our only contemporary sources are the fragmentary jottings of Vertue, who was a founder member, and Hogarth, who was apprenticed to a silver engraver during these years and is not known to have been a member. Throughout his writings, Vertue refers to this school as the 'Academy of Painting' and it is important not to misconstrue the title. It is clear from his references to artists at work there that the medium of teaching was drawing. Pellegrini, to give one instance, 'drew very often. He had an extraordinary readiness in setting the model well'.[10] No one is described as painting. The title is the clue that for the first time London's artistic community had absorbed the academic

tradition. The concept of 'disegno' is summed up in John Gwyn's *Essay on Design* of 1749. In his preface he explains:

> I have made use of the word *design* in this essay, to express the supreme inventive art of the painter, sculptor or architect abstractly considered. . . . The great organ or instrument of this art is *draught* or *drawing*. . . . Without this neither the genius nor learning of the designer, painter or sculptor can be displayed to advantage. It is the *sine qua non*, after all other accomplishments are obtained.[11]

Vertue accepted the idea wholeheartedly:

> it's certain every scholar or pupil who learns truly, correctly and freely to draw . . . on paper etc . . . may, with suitable genius, be allowed to be capable to turn either to engraving, sculpture or painting.[12]

From his notes life drawing emerges as the principal activity but there is also one reference to Peter Berchett, a history painter from France, where he had trained at the *Académie*. When in London, 'he drew in the academy very well . . . and made many drawings for the other artists to work after'.[13] So it seems that learning by copying was practised too. Nobody mentions whether there were casts from life or the antique.

Hogarth, writing many years after, claims that Kneller's academy 'imitated the form of the French plan, but with less fuss and solemnity'.[14] Given his hatred of the academic style and the French, this should be treated with caution. The twelve formal directors might have been enough to provoke the statement, especially at a time when his own academy was under threat. We get no indication from Vertue that there were formal classes or lectures on theoretical subjects. In this context, however, Vertue's own plans for an academy, which occur in his notes in 1720 and later, must be considered.[15] They are based roughly on the French system but, on balance, seem independent of his experience at Kneller's school. 'All to draw by daylight'[16] is one of Vertue's rules; yet at the end of the first year at Great Queen Street, Peter Berchett had to resign because the fumes from the lamp made him feel sick.[17] In any case, when nine of the directors and most of the subscribers were practising artists, it is hard to imagine how they could have met before evening.

On the information available, it seems that the academy followed Dutch lines rather than French, though English artists were probably aware of the possible gains from a system as powerful as that in Paris. French artists enjoyed royal and court patronage and in France there was a national Grand Style. In England it was largely foreign artists who did well and Thornhill was the sole exponent of the Grand Style. The academy as a means of enhancing English art must have appealed to many of the members, and their different ideas on how to achieve it might account for the internal dissent that punctuated and finally halted

this academy's progress. In the face of long standing opposition from Thornhill and Chéron, a French history painter who had studied at the academy in Rome, Kneller took account of his advancing years and resigned in 1716.[18] Thornhill was elected to his place and continued for several years until 'parties rose against him'.[19] He then started a new academy at his own house in Covent Garden, while the opposing faction, led by Chéron and Vanderbank, moved to St Martin's Lane and set up a rival school in an old Presbyterian meeting house.[20]

'Jealousies arose',[21] says Hogarth about the split in Kneller's academy. Promoting a national school must have appealed equally to Kneller and Thornhill. Kneller, who once dreamed that St Luke gave him a special place in Heaven[22], had no small opinion of his place in the history of art. Thornhill several times intrigued deeply to secure for himself rather than a foreigner the decoration of important national monuments, such as Hampton Court Palace and the dome of St Paul's.[23] During the years before the split he had made several, vain attempts to interest his patron, the Lord Treasurer Halifax, in funding a state-run academy headed by himself. It was to be situated 'at the upper end of the Mews . . . consisting of many appartments convenient for such a purpose'.[24] He costed it at £3139.

Thornhill's Academy

His own academy, 'in [a] place he built at the back of his own house in the piazza'[25] and fitted up with 'a proper table for the model to stand on, a large lamp, iron stove and benches in a circular form',[26] sounds less elaborate but no less a proof of his commitment. What sort of studies, if any, he offered beyond life drawing is not known. In his house he had a collection of antique casts and old master paintings. He had also made two sets of copies of the Raphael Cartoons, one of which, quarter size, he intended to publish for the benefit of students, though never did.[27] So it is possible that the members had a range of things to draw from, which makes it the more surprising that the academy did not prosper, or at least did not fulfil Thornhill's hopes for it. In November 1724, in despair at how few subscribers there were, he reopened it 'for anyone to draw, every evening, gratis',[28] but with no greater success. Was he, in his anxiety to influence English art, too zealous and overbearing a teacher? Hogarth thought too much 'regulation'[29] was the reason. Or, to refer to Hogarth again, was it really the presence of a female model over at St Martin's Lane that drew the crowds?[30] We do not know.

The First St Martin's Lane Academy

Chéron and Vanderbank set up their academy in 1720.[31] In 1722 they advertised it as 'The Academy for the Improvement of Painters and Sculptors by drawing from the Naked'.[32] Classes were held during the winter every

evening except Mondays and Saturdays. A man and a woman modelled, the latter receiving five guineas from the Prince of Wales when he visited the school with Sir Andrew Fountaine, a noted connoisseur, in 1722.[33] Some of the artists who subscribed in the first year were Knapton, Hysing, Laguerre, Highmore, Dandridge and Hogarth,[34] making his first appearance as a member of an academy. Despite its apparent popularity, which the visit of the Prince must have helped, the academy lasted only a few years. It came to grief when the treasurer embezzled the subscription money. 'The lamp, stove etc. were seized for rent and the whole affair put a stop to'.[35]

The Second St Martin's Lane Academy

When Thornhill died in 1734, his son-in-law, Hogarth, inherited the fittings of his life room. With these, plus subscriptions from those interested, he embarked in 1735 on a new academy and looked for a room 'big enough for a naked figure to be drawn after by thirty or forty people'.[36] He hired one in St Martin's Lane; from the sound of his account, not the one used by Vanderbank. The manner of arranging the classes was as follows:

The subscribers in their turn, set the model; that is, place the man or woman in such attitude, in the middle of the room, as suits their fancy; he who sets the figure chooses what seat he likes; and all the rest take their places according to the list, and then proceed to drawing, every man according to his prospect of the figure.[37]

Though we are not told how the list was arranged, we can be sure that Hogarth believed it to be egalitarian. He became 'an equal subscriber with the rest'.[38] Paid directors and 'imitation of the foolish parade of the French academy'[40] were not allowed. In Hogarth's eyes the French academic ideal was wrong because it approached nature through the medium of other people's art, with the result that the art it produced became stifled. In his own view art should be approached principally through nature:

Compare the stony features of a painted or a sculptured Venus . . . to . . . the blooming young girl of fifteen, or the artificial Cupid to lovely children. Compare the workmanship of one with the other and scarcely the painted sun and moon fall shorter of their originals.[41]

Copying, therefore, had no place in his academy, nor the application to the figure of geometric canons of proportion, so popular abroad. John Elsum, in *The Art of Painting after the Italian Manner*, published in 1704, summarises this kind of theory in recommending that the face be divided as follows:

Forehead to chin = three noses
Length of mouth = one nose
Hollow of eyes = one nose
Space between eye and ear = one nose.[42]

Hogarth, in his print 'The Five Orders of Periwigs', published in 1761, scorns the arbitrariness of the whole idea in the scale he gives for the periwigs:

One nodule
3 Nasos
each Naso 34 Minutes.

Again we get no direct reference to the presence of casts, though if there had been any in Thornhill's academy, they would probably have ended up here, since Hogarth does not appear to have been totally opposed to their study.[43] Tradition has it that when the fittings of the St Martin's Lane Academy were incorporated into the Royal Academy Schools in 1771, casts were among the property.[44]

Although there were no formal, paid directors, Hogarth was not alone in the running of the school. One note of Vertue's indicates that he shared its management with other senior members, possibly on a yearly basis.[45] They were John Ellis, a former pupil of Thornhill and Vanderbank; Hayman; Gravelot; the Rev. James Wills, a painter; Isaac Ware, architect, and G.M. Moser, a Swiss artist, who for several years had run an academy of life drawing at Salisbury Court, or Arundel Street according to some sources. One account of this school claims that its members, mostly foreign, had been subscribers at Thornhill's academy till his death. The school merged with Hogarth's in the late seventeen-thirties or early forties.[46]

Hogarth's academy was successful. Most of the exhibitors at the exhibition of 1761, organised by the Society of Artists, had been subscribers at some time.[47] Using Hogarth's views on art as a basis, one might speculate that the academy, in providing a life model, suitable equipment, instruction based on observation rather than precept and a free and easy atmosphere, gave artists what they wanted. It seems to have run smoothly for over ten years but by the 1750s Hogarth's views on academies were seriously out of step with contemporary thinking.

Pamphlets urging the foundation of a state-run academy had existed since the 1730s[48] and the feeling became widespread over the next two decades. The elevation of the English artist was seen as the principal function of the academy. 'What!' said John Gwyn in the *Essay on Design*, 'Shall we ever be obliged to foreign workmen for all that is beautiful and masterly in our churches and palaces?'[49] Hogarth felt equally indignant about this but he was alone in rejecting aristocratic patronage and the continental grand style as the means of bringing honour to the English painter. The prevailing view was the opposite:

That this country might produce as good painters as any on earth if they were equally encouraged is what no man in his wits will deny. Were the lovers of painting among our nobility to contribute to the erecting and maintaining [of] Academies of Painting, as is done in other nations, we should in a few years boast of as eminent

hands as any in Italy. For this would not only be a nursery for painters, but improve the national taste and judgment in our art: our nobility would then be able to judge of a piece by the rules of art, and value it according to its own intrinsic excellence, without consulting the name or depending on the judgment of Italian picture-mongers.[50]

Though the school in St Martin's Lane was disparaged by all the exponents of a state academy, the artists took a few years to come to the same view as an organised body. In the meantime the Dilettanti Society, composed of wealthy amateurs of art, backed a plan for a public academy, drawn up in 1749 by one of its members. Unfortunately no proper funding could be found.[51]

In 1753 a circular letter was sent out to artists from the St Martin's Lane Academy. Signed by the Secretary, Francis Milner Newton, it invited them to a meeting at the Turk's Head Tavern to elect twenty-four artists who would thereafter advise on the foundation of a public academy and become its professors.[52] Hogarth was outraged, not only that they had used academy funds to print the letter, but because it so contradicted all he believed in. His involve-ment at St Martin's Lane waned from this point.[53] Though the meeting led to nothing, the feeling persisted. In 1755 a group of twenty-five artists, of whom at least fourteen were St Martin's Lane Academy members, published another plan for a public academy.[54] Knowing George II's scant interest in art, they proposed public subscription as the means of funding until a royal charter might be granted. The Dilettanti Society offered financial backing but the project failed for two reasons: the artists and the dilettanti quarrelled over the sharing of government and further funds could not be found.

So the Academy at St Martin's Lane went on largely as it was, led by Hayman, Moser and possibly Reynolds, who joined in 1755. In 1767 Moser moved the school to Pall Mall. It closed in 1771 when he became the Keeper of the Royal Academy Schools and took the fittings with him.[55]

The failure of all these attempts was due largely to King George II's apathy towards painting. When the Royal Academy of Arts was founded in 1768, it was granted its charter by a new monarch, George III. It followed the continental style of teaching and was unusual in being founded by artists rather than patrons, politicians or connoisseurs.

Notes

1 Vertue, George, Notebook I, *Walpole Society*, XVIII, 1930, p.2.
2 Pevsner, Nikolaus, *Academies of Art, Past and Present*, Cambridge 1940, pp.25–93.
3 Martin, Dr W., 'The Life of a Dutch Artist in the Seventeenth Century', *Burlington Magazine*, VII, 1905, pp.125–8. Also Part 2, *Burl. Mag.*, VII, 1905, pp.416–27; Part 3, *Burl. Mag.*, VIII, 1905–6, pp.13–24 and Part 4, *Burl. Mag.*, XI, 1907, pp.357–69.
4 Talley, M.K., *Portrait Painting in England: Studies in Technical Literature before 1700*, Mellon Centre for Studies in British Art 1981. For artists' references to academies: pp.308, 314, 315.
5 Englefield, W.A.D., *The History of The Painter-Stainers Company of London*, 1923, reprinted 1950, p.115.
6 Edwards, E., *Anecdotes of Painters*, 1808, p.xx.
7 Vertue, Notebook III, *Walpole Soc.*, XXII, 1934, p.7.
8 Vertue, Notebook VI, *Walpole Soc.*, XXX, 1951–2, pp.168–9.
9 Vertue, III, p.92.
10 Vertue, Notebook II, *Walpole Soc.*, XX, 1932, p.39.
11 Gwyn, John, *An Essay on Design*, 1749.
12 Vertue, III, p.55.
13 Vertue, I, p.87.
14 Kitson, M. (ed.), 'Hogarth's "Apology for Painters"', *Walpole Society*, XLI, 1966–68, p.93.
15 Vertue, II, pp.126–8 and pp.150–55.
16 *Ibid*. p.152.
17 Vertue, VI, p.169.
18 Whitley, W.M., *Artists and their Friends in England*, 1928, vol.1, p.13.
19 Vertue, VI, p.170.
20 Kitson, *op. cit.*, p.93.
21 *Ibid*. p.93.
22 Whitley, *op. cit.*, pp.19–20.
23 Waterhouse, E., *Painting in Britain 1530–1570*, 1969, p.87.
24 Vertue, III, p.74. and Walpole, H., *Anecdotes of Painting in England*, 1872 reprint of 1788 edition, p.328.
25 Kitson, *op. cit.*, p.93.
26 *Ibid*. p.93. This is the list that Hogarth, 'having become of [Thornhill's] neglected apparatus', says he donated to his own academy.
27 Walpole, *op. cit.*, p.329.
28 Kitson, *op. cit.*, p.95.
29 *Ibid*. p.94.
30 *Ibid*. p.93.
31 Vertue, III, p.126.
32 Whitley, *op. cit.*, p.18.
33 Vertue, III, p.11.
34 Vertue, VI, p.170.
35 Kitson, *op. cit.*, p.93.
36 *Ibid*. p.94.
37 Campbell, R., *The London Tradesman*, 1747, p.99.
38 Kitson, *op. cit.*, p.94.
40 *Ibid*. p.94.
41 *Ibid*. p.86.
42 Elsum, John, *The Art of Painting after the Italian Manner*, 1704, p.26.
43 Kitson, *op. cit.*, p.86.
44 Stephens, F.G., in *Art Journal*, 1882, p.261. Quoted in the Papers of W.T. Whitley, Courtesy of the Trustees of the British Museum.
45 Vertue, VI, p.170 and III, p.123.
46 Edwards, *op. cit.*, p.xxi; Vertue III, p.76; Whitley, *op. cit.*, 1, p.27 and Paulson, R., *Hogarth, His Life, Art and Times*, 1971, vol.2, p.140.
47 Kitson, *op. cit.*, Introduction, p.72.
48 Pye, John, *Patronage of British Art*, 1845, p.74 n. 33.
49 Gwyn, *op. cit.*, p.47. Gwyn's book of 1749 is one of the most eloquent arguments for the foundation of a royal academy. He was an architect and a member of the second St Martin's Lane Academy, as was Samuel Wale, who designed two of the book's illustrations.
50 Campbell, *op. cit.*, pp.96–7.
51 Sandby, W., *History of the Royal Academy of Arts*, 1862, p.24. Whitley says 1748: vol.1., p.157.
52 Pye, *op. cit.*, pp.75–6.
53 Kitson, *op. cit.*, Introduction, p.56.
54 Pye, *op. cit.*, p.77. For a list of academy members in the early 1750s, see J. Kirby, *Dr Brook Taylor's Method of Perspective Made Easy*, Ipswich 1754, vol.1.
55 Whitley, *op. cit.*, 1, pp.234–5.

II Changes in Techniques of Painting, 1700–1760

This brief study is an examination, through portraiture, of the techniques of painting developed by the native British School. It is not intended as a survey of the many styles and influences that were current in painting during the first half of the eighteenth century; nor is it comprehensive in its treatment of British painters. Instead the work of three major and two lesser portrait painters is examined in relation to the techniques of the seventeenth century and to Kneller, whose work exerted such a great influence over painters in the first half of the period. It is first of all necessary to examine the organisation of the painter's studio and the materials of painting.

Successful portrait painters in this period organised their studios so that assistants did the drapery and backgrounds, while they themselves concentrated on the face and hands. In the final stages of the painting, they might add a few touches here and there to unify the composition. The two notable exceptions were Hogarth and Gainsborough.

Sometimes the drapery man was not part of the studio but had an independent career as a 'painter-tailor',[1] as Hogarth called him. The Van Aken brothers were the most successful. Their reputation was such that at least one painter from outside London, Winstanley of Liverpool, sent his unfinished portraits up to town by coach to be dressed by them.[2]

The artist's studio was still the principal place for training in the art and craft of painting. Perhaps two-thirds of the artists featured in this exhibition gained some of their training in the studio of an established painter. During this period there were no hard and fast rules for the length of training; from a few months to six years are recorded. It would seem that any young painter of independent means or an independent mind could study where he chose.

We have no details of how trainees learned to paint or what their studio duties may have involved. The traditional activities of preparing materials might have to be undertaken if the master so wished; otherwise the colourman existed to supply paint, varnishes and supports ready prepared. References to ready-made paint for artists occur from 1710 and by the end of the period several reputable shops existed.[3]

The Palette

> For a clear and beautiful complexion, lay on your palette these following colours: white flakes [white lead], yellow ochre, vermilion, red lead . . . light red, Indian red, lake, smalt, blue-black, terreverte, brown-pink, umber and bone black.[4]

This list of the principal pigments used in face painting in the seventeenth century is given by Marshall Smith in his book *The Art of Painting* of 1692. He could also have mentioned carmine for the cheeks, ultramarine for the shadows of the flesh, and asphaltum, a bituminous pigment, used by some in the darkest shadows. For draperies and backgrounds he adds indigo and verdigris. Orpiment, massicot, manufactured vegetable yellows, and other manufactured blues and greens were also available.

Thomas Bardwell's list of the principal pigments in *The Practice of Painting and Perspective Made Easy*, published in 1756,[5] is practically the same. Only two new pigments came into use during the period. Prussian blue, invented around 1705 and in use in England during the forties, largely replaced indigo and the manufactured copper blues. Mixed with yellow it was a more reliable way of making green than using verdigris and other copper greens, or mixtures with indigo. Naples yellow, although known in Europe during the seventeenth century, became popular in England during the period and began to replace massicot and the pale vegetable yellows, because unlike them it did not fade.[6]

Binding Media

The three oils traditionally used for painting are linseed, walnut and poppy. Linseed dries faster than the other two, so has always been the favourite for general use. Walnut and poppy, on the other hand, do not yellow as much as linseed, so were recommended for mixing with white and blues. The few analytical studies that have been done on paint from the early eighteenth century reveal that the artists in question, Hogarth and Bardwell, continued this practice.[7]

In addition to pure oil there were 'drying-oils', which were any of the three types boiled up with lead or another siccative to accelerate the drying of some colours. Like their seventeenth-century predecessors, writers of manuals on painting in the period describe the oil suitable for each pigment and recommend the best way of preparing the different coloured paints.

Supports

With very few exceptions eighteenth-century portraits were painted on canvas, wooden panels being rare since the early seventeenth century. This canvas support was always coated with a priming or ground, which stopped the paint from sinking into the cloth and also provided a unifying undertone for the picture. In the seventeenth century grounds on canvas had been mainly coloured brown, red, beige, cream or a gritty grey made warm by a layer of red beneath it. In the eighteenth century the tone becomes cooler and paler. A few beige, buff and tan grounds occur but the predominant colour is grey, which varies in tone from silvery white to pewter.

Bardwell ascribes the introduction of the grey ground to

Kneller,[8] whose practice in this, as in other things, became a model for succeeding generations. His grey grounds have a cold, greenish cast and are of a complex construction.[9] They were probably prepared in his own studio or possibly by the colourman he is reputed to have brought with him from the continent.[10] The grey grounds used by most of the English painters, however, are remarkably standard in construction. They consist of white lead, chalk and varying amounts of black or umber pigment bound together in oil and applied to the canvas in two or more coats. Sometimes there is a layer of glue size between the coats of priming and there is nearly always a coat of size directly on the canvas to isolate it from the oil in the ground.[11]

Most artists probably bought their canvas ready primed from the colourman. 'Primed cloths' could be bought in regular sizes: half length, Kit-cat (slightly bigger), three-quarter length and full length. The texture of the ground is also pretty standard. Predominantly smooth, they have a faint striation in one direction left by the brush or spatula with which they were applied. Some contain fine white lumps which could be sugar of lead (lead acetate), added to speed up the drying-time.

Although seventeenth-century painters often put a coloured layer (*imprimatura*) on top of the ground before starting to paint, eighteenth-century artists appear on the whole to have left it as it was.

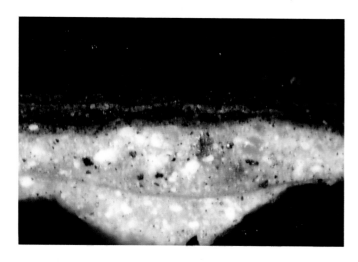

Microscopic cross-section from the bottom edge of 'Hannah Ranby' by Hogarth (191), showing two layers of grey ground separated by a layer of size, and several layers of paint on top.
Photograph by courtesy of Amelia Jackson.

TECHNIQUES OF FACE PAINTING

The Seventeenth Century

The manner of painting a face in the seventeenth century, as described by the manuals of painting, was as follows. After the head had been drawn onto the canvas, the artist began the first painting or dead colouring. The purpose of dead colouring was 'to mark everything in its proper place and to sweeten it well to prevent the trouble of correction and amendment'.[12] It also provided a solid foundation for those colours which would look dull or thin on their own, for example lake (a transparent purple-red), or which were too expensive to use lavishly, such as ultramarine blue. The idea goes back to Van Eyck and the Flemish Primitives, who laid their colours in layers to bring out the best in each pigment and to ensure their durability.

The flesh tints for the dead colouring were mixed up and laid out on the palette before painting was begun. Having mixed a basic flesh pink from lead white, light red (an earth pigment) and perhaps a little vermilion (a brighter red), the artist subdivided it. By adding some of the same reds and perhaps some lake and yellow ochre, he made up a range of tones for the modulations of the light parts of the face.

Then with a similar mixture of white and light red, he added more red, terreverte (a sage-coloured green), yellow ochre and black to form a similar range of greenish half-shadows. Admixtures of ultramarine and lake provided blue half-shadows.

Dark shadows were mixed from a base of yellow ochre and light red with brown-red ochres, terreverte and black. The darkest shadows were made of brown-pink (a transparent yellow-brown), lake and bone black.

Marshall Smith recommended that the tints be laid on the canvas from light to dark; others said the opposite. All agreed that at this stage the colours should be laid on in patches, with no attempt made to soften the gradations. This latter process, known as sweetening, came after the dead colouring was complete but still wet. To sweeten his work, the artist took a clean brush and very lightly hatched across the joins to soften them.

At this point the hair was sketched on in dark and light tones. The books advised that the dead colouring be allowed to dry thoroughly, at which point it might be oiled out. This meant rubbing neat oil into the painted areas and then wiping it off. The microscopically thin film of oil left on the paint helped prevent the oil in further layers from sinking. In the second and subsequent paintings, the artist heightened the colouring, increased the light and shade and added touches of local colour, highlights and reflections. The mixtures of paint were similar to the dead colouring but incorporated brighter pigments in the lights, for instance more vermilion, lake, carmine; and translucent ones in the darks, such as asphaltum and brown-pink.

Although the range of colours and number of tints varied

from artist to artist and experienced painters could mix up many on the canvas as they worked, this manner of painting was pretty standard and accounts for the solidity we associate with seventeenth-century portraiture. A few of the pigments were not entirely stable, for example lake, vegetable yellows, asphaltum and carmine, but they appear to have been used with discretion. Most of the pigments were sound, as was the choice of binding-media.

Kneller

In 1691 Kneller was observed painting a portrait of Mr Montague.[13] With only five colours, white, red ochre, yellow ochre, lake and bice (a manufactured copper blue or green) he mixed up a range of flesh tints and half shadows. He did not mix up any dark shadow tones but used pure colours which he worked up with flesh tones on the canvas.

Kneller used a limited palette because he believed 'the ancients did use in flesh but three or four colours'. His dead colouring, after an hour and a half's work, looked 'cold and hard'. He then sweetened the work, not with a dry brush but one 'charged with much linseed oil'. He laid this oil 'on the hard edgings of his colours and it melted it finely and softened it and where the colours [were] stiff and not easy to work, he would mix a little oil with it and make it work free'.

He then put in yellowish shadows to warm the face. In the second painting he made it warmer still and improved on the likeness. In a later note the same author, who is possibly the painter William Gandy, recorded that in his effort to get a good likeness, Kneller sometimes ran to ten or twelve sittings. 'To get in the likeness takes up all his time, which is the thing that carries away the base, so he makes little or nothing of painting but likeness is all'. This almost certainly means that in revising the likeness he sometimes removed the dead colouring. Technically this was unsound, as was the working in of excess oil, but he was too preoccupied with likeness and speed to care.

Many of Kneller's faces are painted more or less in one layer. An example in the exhibition is 'Sir Samuel Garth' (23). When the brushwork is viewed at high magnification, the ground is visible in the furrows of each stroke. Two layers are present only in the highlights and these are done wet-in-wet.

Other things recorded by the same observer may be seen in the portrait of Garth. The brown-red shadow along the three-quarter profile is a single, unmodified colour. As it turns under the chin, it is softened with a basic flesh tone, which was worked in as he painted. Compared with a portrait by Lely, for example, there are very few flesh tones. Each plane of the face is described more or less in one tone and the sharper planes are separated by a thin grey boundary. This is the ground deliberately left visible to help establish the contours of the face. It is particularly

noticeable in the area around the nose, cheek and upper lip. Possibly the reason why he sweetened with an oily brush is that it would soften the edge of the paint without dragging it across the boundary.

These grey boundaries provide a reason for his choice of cold grey grounds. Another is that the whites of the eyes needed painting only at the inner corners. The middle tone of the wig is provided by the ground. Although here and there it bears microscopic traces of a thin dark paint, it is clear that large areas of it were never painted.

The portrait of 'The 2nd Earl of Godolphin' (25) illustrates Kneller's alternative style, which is not described by the observer. The palette is warmer, the range of colours wider, the shadows pink and red instead of brown and slightly less use is made of the ground; the whites of the eyes, for example, are described entirely in paint. Although in this work dead colouring is visible at the far edge of the forehead, others are painted in one layer only e.g. the 'Portrait of Sir Isaac Newton' in the National Portrait Gallery.

Kneller's Influence

Kneller was in every respect a difficult pattern to follow; and yet all English painters would fain imitate him, would fain adopt his manner. He painted with an amazing quickness, without any appearance of study, and often times at the first stroke. This set them all upon painting quick, tho' they were far from being obliged to it by the multiplicity of their occupations. Several were so affected as not to cover the whole canvas, that is in those parts where its tint and its colour might answer the purpose, because Sir Godfrey Kneller had done so. They carried their enthusiasm so far as to attempt to distinguish very wretched pieces by the ridiculous merit of having been done at the first stroke.[14]

Not quite all English painters imitated Kneller in the manner here described by Rouquet in 1755. Those who did sometimes worked with a remarkable degree of economy.

Mr. Highmore paints much, and the faces often, at one sitting; as much finished as possible – never touches them more.[15]

In Highmore's 'Portrait of a Gentleman in a Brown Velvet Coat' in the Tate Gallery (Gallery 3), there is no evidence of dead colouring. The grey ground is left unpainted to form the cool shadows around the eyebrows and the mouth, while the shadow down the side of the face is painted as thinly as possible to allow the ground to affect its colour.

Vanderbank's 'Portrait of William Lee Antonie, M.P.', also in the Tate Gallery (Gallery 2), is a similar case. All the shadows in the middle of the face appear to be unpainted ground and it is uncertain that they were ever glazed over.

Hogarth

Hogarth was self-taught as a painter. With his enormous visual memory he was receptive to a variety of styles, which he filtered into a technique that was essentially traditional. Face painters who came back from study abroad and took the fancy of the public with 'some new stratagem of painting the face all red or all blue or all purple at the first sitting'[16] got nowhere with Hogarth.

He began his career as a portrait painter with a technique based firmly on seventeenth-century practice and ended it with one that was more personal, particularly in its use of colour. He never cut down on underpainting, probably because it suited his practice of working the picture out on the canvas as he painted. Alterations are common in his work.

The portraits of Hannah and George Ranby[17] (191 & 192) illustrate the range of his technique. The structure of Hannah's face looks like a textbook example of seventeenth-century practice. Hogarth admired Van Dyck and one wonders also how many manuals of painting he might have read during his youth, when he was apprenticed to a silver engraver but dreaming of pictures. The grounds of both portraits are mid-grey. It is possible that George's has a thin brownish-grey imprimatura on top. The dead colouring in Hannah's portrait is composed of lead white and muted ochres, applied in the recommended lean state so that the oilier layers on top had a firm base. When the dead colouring was dry, he applied the thick lights on the forehead, nose, upper lip and chin. With a mixture of white lead, red and yellow ochres and lake he heightened the colour of the cheeks, ending in a sharp semi-circle beneath the eye-socket.

Although underpainting is discernible through X-radiography in the portrait of George, the face we see is done more or less in one layer. The different tones are applied wet-in-wet. The range of colours is wider and brighter than Hannah's. Although white and ochres still form the matrix of the flesh tones, the amount of vermilion in them was increased. The half shadows were made by admixtures of bright blue, green or ochres to a little basic flesh tone on the palette. They were worked quickly into the wet face so that the effect of local colour might be retained, for example the shadow between the boy's right eye and his nose. The method of using the recessive colours of the underpainting for the receding areas of Hannah's face, which is one of the principles of the seventeenth-century manner, is replaced in this wet-in-wet technique by a direct use of local colour to describe the form.

Ramsay

In 1738 Ramsay came back from study in Italy. Soon afterwards Vertue observed:

> Ramsay . . . accustoms himself to draw the faces in red lines, shades etc., finishing the likeness in one red colour or mask before he puts on the flesh colour; which he proposes as a method to make the flesh colour clear and transparent – and such a manner was used in Italy. . . . However, when the faces are painted . . . over, little or nothing of that first red can be seen.[18]

Close examination of many portraits by Ramsay reveals a solid red layer beneath the flesh tones of the face. The rest of his picture was done on top of the grey ground that he normally used. The colour of the red mask is based mainly on the pigment, vermilion; it is just visible at the corners of the eyes and around the nose in the 'Portrait of Lord John Murray' (215). In the portrait of his wife (216), the underpainting is a soft pinky beige. Bright red seems to have been used in portraits of both sexes until the late seventeen-forties and for men until the sixties – but exceptions occur.

The pink flesh tones on top of the red underlayer are composed of lead white, red and yellow ochres and terreverte to keep them cool. Black and warm brown ochres are added to the basic mixture on the palette for the half-shadows. In the seventeen-thirties he seems to have put a transparent, dark glaze over this opaque brown for the deep shadows; later on, when his style became softer, he omitted the glaze and hatched into the shadows with fine red lines. This is visible in the shadow below Lady John Murray's chin. Pink cheeks were made by hatching a mixture of lead white, red ochre and lake into the basic flesh tone with a fine brush while it was wet; as Vertue says, in a manner 'rather licked than pencilled'.[19]

This technique was quite new to England, if not to Italy, but the artist respected tradition in his use of stable pigments and, as far as one can tell, a judicious choice of binding media.

Reynolds

It has been noted by Ellis Waterhouse[20] that Reynolds, during his years in Italy, studied the antique and old masters but, unlike Ramsay, never worked with contemporary painters. Reynolds believed that the technical methods of the old masters had not been passed to their successors in the eighteenth century. He returned to London full of the Grand Style and with a determination to introduce it, via the portrait, into English art. Knowing little about Italian techniques and failing to recognise that time has an effect on paint as well as on varnish, he set out to emulate the effect of the old master paintings with a choice of materials and procedure that overturned centuries of sound technical practice. His pupil and biographer,

Northcote, lists the colours set out on his palette for the first sitting of a portrait around 1755:

1. Carmine and white : various tints.
2. Orpiment and white : various tints.
3. Blue-black and white : various tints.
4. A mixture on the palette as near the sitter's complexion as possible.[21]

Carmine is transparent and fugitive. All the manuals of painting gave due warning that orpiment, a vivid yellow, would ruin any mixture that contained copper or lead. As one seventeenth-century source put it: 'Orpiment will lie fair in [or on?] any colour, except verdigris, but no colour will lie fair on him; he kills them all'.[22]

For the next layer the following colours were added to the palette: black (i.e. lamp or ivory), lake, yellow ochre and ultramarine. Although the colours would have been ground in oil before being placed on the palette, varnish was the medium recorded in this case for use during painting.

Another observer recorded that he began the head by laying a coat of white, into which he worked his first colours till he had got a cold likeness. Then with the brighter colours, particularly yellows, he scumbled and glazed the face until it looked warmer. The head was frequently finished in one sitting.

His adventurous approach to painting meant that there were many variations on this theme. Asphaltum was a great favourite of his for imparting rich, dark glazes. Fugitive yellow lakes also feature in his notes. Until his later years, however, when his palette changed to include vermilion and more ochres, he relied largely on this range of colours. In addition to oils, he is recorded to have used copal varnish, mastic varnish, megilp (a mixture of mastic varnish and drying-oil), beeswax, Venice turpentine (a thick, resinous liquid) and egg white as binding-media or intermediate varnishes.

His paintings cracked and faded within his own lifetime. Even before people returned their pictures to him for restoration, he would have known from his years with Hudson that his materials were not stable. Like Kneller with his short cuts, he was pursuing a goal that was more important to him than durability.

Conclusion

In the period covered by the exhibition the techniques of portraiture current in the seventeenth century underwent great change. Although binding media and pigments remained largely the same, at least until Reynolds returned from Italy, the manner of constructing a painting was either simplified or replaced by techniques developed personally by individual artists.

The process of simplification lay principally in reducing the number of layers in the painting and allowing the

ground to work as cold half-shadows in the flesh tones. The use of the transparent glaze in shadows became less common.

The source of this development was Kneller, for whom it was an expedient in his desire for rapid execution. His bravura, knighthood and house in the country must have been reason enough for many a young painter to adopt his techniques. He enjoyed people watching him work. Other conditions encouraged the process, not least the exigencies of making a living out of oil painting in a northerly climate amidst fierce competition and fickle public taste. Although demand for portraits increased, the number of painters increased to meet it.

The principal influence on the development of individual techniques was lack of system and structure in the training of painters. Many people had no training at all. For those who were part of a portrait manufactory, training must have been a humdrum experience. It is significant that the major artists either turned their backs on training at home and went abroad or developed their own techniques in isolation.

This loosening of strict technical rules was one of the most important factors in the development of British art. By the end of the period most of the leading painters, Reynolds, Gainsborough, Hayman, Ramsay, Devis, had each developed a technique that was exclusive to their own style of painting. Later in the century, with the foundation of the Royal Academy Schools, which eschewed formal teaching of technique, the traditions of studio training largely disappeared. As a result many painters outdid Reynolds in technical disasters but the freedom from tight technical restraints helped produce Turner, Constable and the Pre-Raphaelites, and has become one of the tenets of Modern art.

Notes

1 Kitson, M. (ed.), 'Hogarth's "Apology for Painters"', *Walpole Society*, XLI, 1966–68, p.98.
2 Vertue, George, Notebook III, *Walpole Society*, XXII, 1934, p.91.
3 Whitley, W.T., *Artists and their Friends in England*, 1928, vol.I, p.331.
4 Smith, Marshall, *The Art and Practice of Painting According to the Theory and Practice of the Best Italian, French and German Masters*, 1692, p.77.
5 Bardwell, Thomas, *The Practice of Painting and Perspective Made Easy*, 1756.
6 Harley, R.D., *Artists' Pigments c.1600–1835*, 1970.
7 Roy, Ashok, 'Hogarth's "Marriage à la Mode" and Contemporary Painting Practice', *National Gallery Technical Bulletin*, vol.6, 1982, pp.59–67. Talley, M.K. and Groen, K., 'Thomas Bardwell and his Practice of Painting', and White, R., 'An Examination of Thomas Bardwell's Portraits – The Media', *Studies in Conservation*, vol. 20, 1975, pp.44–113.
8 Bardwell, *op. cit.*, p.6.
9 Unpublished material kindly made available by Aviva Burnstock of the National Gallery Scientific Department.
10 Whitley, *op. cit.*, vol.I., p.330.
11 Unpublished material gathered from a survey done at the Tate Gallery in 1986 by A. Southall and R. Jones.
12 Elsum, John, *The Art of Painting after the Italian Manner*, 1704, p.38.
13 The description of Kneller at work is from the Ozias Humphrey's Pocket Book, BM. AdMS 22950. Part of it is transcribed in the Papers of W.T. Whitley in the British Museum Print Room. A long account of it with extracts is to be found in M.K. Talley's *Portrait Painting in England: Studies in Technical Literature before 1700*, Paul Mellon Centre for Studies in British Art, 1981, pp.344–57.
14 Rouquet, André, *The Present State of the Arts in England*, [1755], Cornmarket Press Facsimile, 1970.
15 Vertue, III, p.54.
16 Kitson, *op. cit.*, p.98.
17 Much information on these two portraits was kindly provided by Amelia Jackson.
18 Vertue, III, p.96.
19 Ibid.
20 Waterhouse, Ellis, *Painting in Britain 1530–1790*, 1953, p.165.
21 Specific information on Reynolds's technique comes from 'All Good Pictures Crack' by M.K. Talley in *Reynolds*, the catalogue of the Royal Academy exhibition of 1986, pp.55–69.
22 De Mayerne, Theodore Turquet, *Pictoria, Sculptoria & quae subalternarum artium. 1620*, ed. M. Faidutti and C. Versini, Lyons c. 1970, p.149.

Catalogue

Figures in brackets refer to catalogue numbers.
References in brackets to Galleries 2, 3 & 4 are to
paintings displayed in the Tate permanent collection.
Dimensions are given in inches followed by centimetres
in brackets; height precedes width.

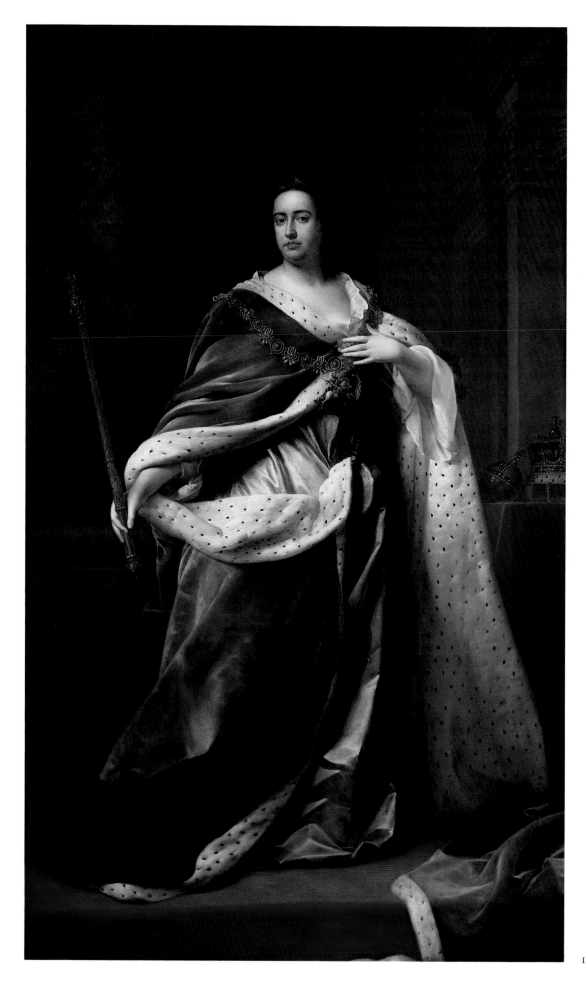

I

EDMUND LILLY active 1702, died 1716

1 **Queen Anne** 1703
Inscribed 'E.Lilly.Fecit.1703' on base of column lower left
Canvas 94 × 56½ (239 × 143.5)
Prov: Presumably always at Blenheim
Lit: G. Scharf, *Catalogue . . . of the Pictures at Blenheim Palace*, 1862, I, p.18; C.H. Collins Baker, *Lely and the Stuart Portrait Painters*, 1912, II, p.206
By Kind Permission of His Grace The Duke of Marlborough

Queen Anne (1665–1714), daughter of James II and the last of the Stuarts, is shown here in the year after her accession. She wears the collar of the Garter and holds the sceptre; her crown, resting on a Bible, and the orb are on the table beside her. The architectural background is reminiscent of Blenheim.

Lilly, about whom little is known but who may have been of Norfolk origin, seems to have absorbed the style of the leading domiciled portrait painters of the day – the German Kneller, the Swedish Dahl, and something of the more sweeping designs of the Paris-trained Prussian Closterman – to produce this fine regal image, executed with considerable confidence in beautiful silvery tones and, for a formal parade portrait of the time, unusually full of movement. Its smooth finish, and the somewhat veiled and distant dignity of the 'Augustan mask' remained a staple ingredient of much of early eighteenth-century portraiture, particularly in the hands of painters like Thomas Hudson. Lilly is also said to have painted still-life and history pieces, but no examples of these are known.

SIR GODFREY KNELLER 1646–1723

2 **Richard Boyle, 3rd Earl of Burlington, as a Boy, with his Sisters Elizabeth, Juliana and Jane**
*c.*1700
Inscribed 'Earl of Burlington/(Nat.25th April/ 1694/ Obt at Cheswick 13th Decr 1753) / and his Sisters' lower right in later hand
Canvas 76¼ × 70¼ (193.7 × 178.5)
Prov: Painted presumably for Charles, 2nd Earl of Burlington, and thence by descent.
Exh: *The Royal House of Guelph*, New Gallery Regent Street 1891 (23)
Lit: Stewart 1983, pp.96 no.117, 161 no.9, pls.57a, 85d, 86a
The Trustees of the Chatsworth Settlement

The painting shows Richard Boyle (1694–1753), Lord Clifford, who succeeded his father as 3rd Earl of Burlington in 1704, and three of his six sisters, probably (left to right) Elizabeth (d.1751), who married Sir Henry Bedingfield, Juliana (d.1739), who married Thomas, 3rd Earl of Ailesbury, and Jane (d.1780).

After two tours of Italy in his early twenties, the Earl became a leading arbiter of the neo-classical Palladian taste which gradually superseded the Baroque of Wren and Gibson. Its adherents saw England as the true heir of the glories of classical Rome (as indeed did many politicians of the day) and tried to reawaken the sense of a new 'Augustan age' through the arts, a trend that was to be a source of great frustration to native talents like Hogarth (although it did not stop him from buying a country cottage practically next door to Burlington's villa at Chiswick).

Burlington's passionate interest in music, garden design and above all architecture, as well as his immense wealth, made him one of the most generous patrons of the time, in Vertue's words, a veritable 'noble Maecenas of the Arts', with the means to implement his theories in the gardens and buildings of his villa at Chiswick and at Burlington House in Piccadilly. He was a friend and neighbour of Alexander Pope, and the chief patron of William Kent and Colen Campbell, of Handel and of Italian opera.

Although the habit of painting youngsters in 'Roman' or Arcadian costume was well-established in the seventeenth century and lasted well into the eighteenth (see Vanderbank's 'William Lee' of 1738 in Gallery 2), it is particularly apposite in this case. The young heir's Roman sandals, classical drape and imperious gesture set him apart from his admiring and much more naturalistically painted sisters, although even here Kneller hardly permits any real sense of childhood to intrude.

2

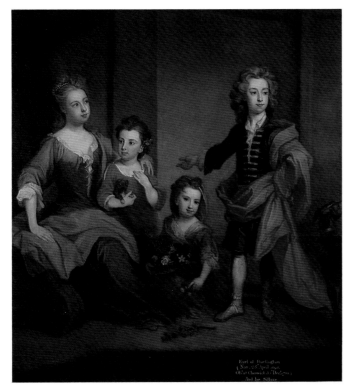

Earl of Burlington
(Nat. 25 April 1694
Ob at Cheswick 13 Decr 1753)
And his Sisters

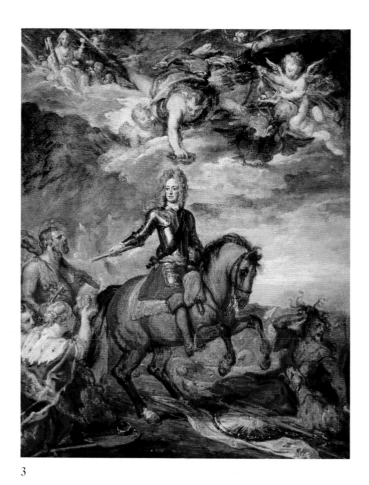

3

SIR GODFREY KNELLER 1646–1723

3 **The Triumph of Marlborough** *c*.1706
Inscribed 'His Grace the Duke of Marlborough./
Painted by S^r Godfrey Kneller/soon after the
Battle of Ramilies 17 [. . .]/when Flanders & Brabant
surrender'd' on the back of the relining canvas,
probably copied from original
Canvas 36½ × 29 (91.2 × 72.5)
Prov: Possibly by family descent from the sitter to his
eldest daughter, Henrietta, Duchess of Marlborough,
thence to her son-in-law Thomas Pelham, Duke of
Newcastle, and to Thomas Pelham, later 1st Earl of
Chichester; . . .; Earl of Chichester by 1891, bt by the
National Portrait Gallery 1892
Exh: *Sir Godfrey Kneller*, National Portrait Gallery
1971 (86, repr. in col.)
Lit: Stewart 1983, pp.62, 117, no.467, pl.59
National Portrait Gallery

The sketch shows John Churchill, 1st Duke of Marlborough
(1650–1722) on a rearing charger, surrounded by allegorical
figures commemorating, according to the inscription on the
back, his victory at Ramillies in May 1706. The tableau is
presided over by Justice and trumpeting Fame, as Mercury
crowns the Duke with laurels. Hercules stands beside him,
holding the civic keys, and an ermine-clad figure presents
him with the conquered citadel, a rudder and a broken
manacle at her feet. The Duke's charger tramples the
emblems of France, the figure of Discord, and the hounds of
war.

A *modello* for a large work that was never carried out, this
attractive sketch shows real fire and an awareness of Rubens
that invariably evaporated when such works were enlarged.
It also marshals with natural ease the full-blown rhetoric of
Baroque allegory, a device that came to be used with less and
less congruity as the century progressed (53, 67)

SIR GODFREY KNELLER 1646–1723

4 **Queen Anne Presenting the Plans of Blenheim to
Military Merit** 1708
Inscribed 'G.Kneller f' on plinth lower right
Canvas 50 × 40 (127 × 101.5)
Prov: First recorded by Vertue in the possession of Dr
Richard Mead in 1724, apparently presented by him to
the Duke of Marlborough before March 1752, when it
appeared in the sale of Mr Hollingsworth & Mitchett,
Jeweller, where Vertue unsuccessfully bid for it, bt
Ellys; . . .; Dr Mead's sale, Langford's 21 March 1754
(15); . . .; in the collection of the Duke of Marlborough
by 1800, thence by descent
Lit: Stewart 1983, pp.61–2, 92 no.51, pl.58
*By Kind Permission of His Grace The Duke of
Marlborough*

4

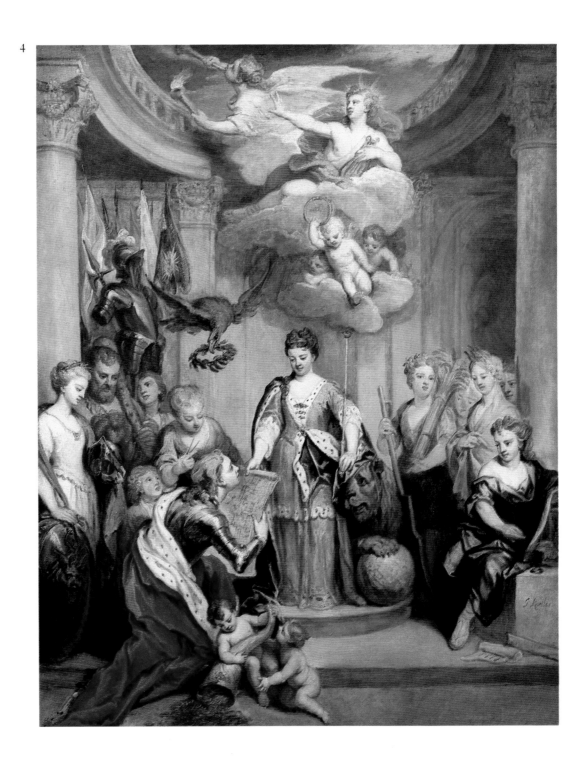

The *modello* for a large painting commissioned by Queen Anne with the intention of presenting it to her favourite, to be hung in the upper end of the Long Gallery at Blenheim, but never carried out because of the rupture between the Queen and the Marlboroughs. In his own description of the painting Kneller writes that 'The Duke of Marlborough desired that no person should be represented by the life except the Queen's Majesty. But that the whole picture should be Allegoricall.' The Queen is shown presenting to a 'warlike Vigorous Figure representing Military Merit a Model of Blenheim drawn on paper', while above 'Apollo inlighteneth the whole and appears with his Harp and Rays commanding Fame with his lighted Torch to proclaim and

Signifie the same to the Whole Universe. Under Apollo his love of Truth is Signified by three boys holding a Serpent in a Circle, the Emblem of Eternity.' Minerva and Hercules attend the kneeling Duke, and the Duchess bends forward to inspect the plans. Beside the British lion are figures of Plenty and the Arts and Sciences, while History prepares to record the scene in her scroll. On the left are the captured trophies of Louis XIV, the Sun King, now exposed as a sham by his supposed patron, the Sun God himself.

The picture was highly esteemed by Kneller himself, and was originally in the collection of his physician, Dr Mead (159), who was a personal friend, and a pall-bearer at Kneller's funeral.

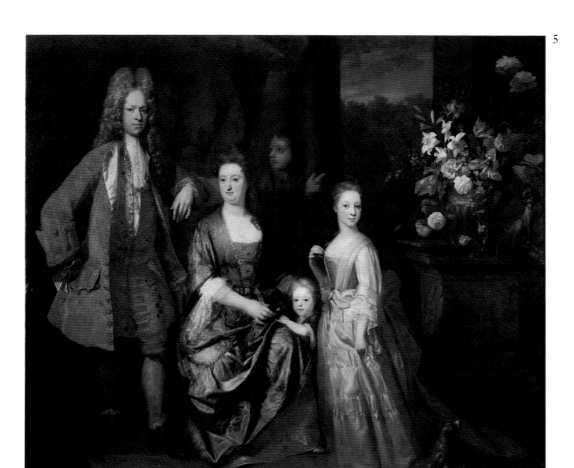

ENOCH SEEMAN *c*.1690–1745

5 **Colonel Andrew Bissett and His Family** 1708
Inscribed 'Enoch Seeman. pinx. AE. 18½. 1708.' on
pedestal right, and 'COLL·BISSET·III·' on collar of
dog
Canvas 90½ × 102 (130 × 159)
Prov: Painted for the sitter, and bequeathed to his
niece Marjorie Winram, who left it to her daughter
Catherine, who married James, Lord Forbes; thence
by descent

The Master of Forbes

The man standing on the left is Colonel Andrew Bissett
(1660–1742), who was commissioned in the Coldstream
Guards in 1688, became Colonel of the 30th Foot in 1717,
and Lt-General in 1735. He is buried in Westminster Abbey.
Next to him is his wife Constance, and their little daughter,
also Constance (baptised 1705). As the couple had no other
living children, it can be assumed that the girl in yellow is the
Colonel's niece and ward Marjorie Winram (?1698–1765),
the daughter of his deceased sister Catherine and her
husband George Winram, who served under Bissett and had
been taken prisoner at Almanza in 1707, where Bissett had
commanded the Coldstream Guards. She married Andrew

Innes, and Colonel Bissett, whose children predeceased him,
left this painting to her in his will.

The strangely shadowy figure of the boy behind the group,
involved, but not quite part of it, is probably a representation
of Bissett's son Andrew, who died young in 1702. His other-
worldliness is expressed in that, unlike the others, he does not
look at the spectator, but at his father, and points to the finely
painted flowers (symbol of transience) on the pedestal on the
right. The sunset landscape and the fact that compositionally
the pedestal occupies a place where the son and heir could
have stood, could be intended as a sad comment on the failure
of Bissett's line. Pedestals such as this were also sometimes
the place where to display the family coat of arms; instead, it
is decorated with satyrs' masks. The dog with Bissett's name
on the collar – perhaps an exotic pet brought back from Spain
– and the monkey holding cherries teasing it, could be just
family pets, but they could equally well stand for faith (the
dog) being mocked by vain hopes, especially as children were
often painted holding cherries (120), the 'Fruit of Paradise'.

The inscription is the best indication so far of the painter's
date of birth. The painting is clearly the product of more than
one hand, and is probably something of a family enterprise:
Enoch's father, who trained him, was still alive in 1723, and
he also had two brothers who painted.

THOMAS HILL 1661–1734

6 Garton Orme at the Spinet *c.*1705–8
Canvas 48 × 38 (122 × 96.5)
Prov: By descent to Sir Orme Sargent, by whom
bequeathed to the lender 1962
Lit: P.Bishop & B.Roscoe, *Holburne of Menstrie
Museum . . . A Guide to the Collections*, 1986, pp.10–11,
repr.
The Trustees of the Holburne Museum, Bath

Garton Orme (1696–1758) of Lavington, Sussex, did not as
an adult live up to the charm of this portrait: he is reputed to
have murdered his first wife and ran up debts that required
the sale of half his property. None of this is anticipated in
this portrait by Hill who, trained by Faithorne and the
Dutchman Dirk Freres, stood somewhat apart from the
Kneller tradition and could express, as Waterhouse put it, 'a
gentleness and refinement hardly to be found in any other
portrait painter of the time'.

This painting well illustrates the appealing freshness of
this slightly naive and not very prolific painter who,
unusually for the time, succeeds in conveying something of a
genuine feeling of childhood in his sitter, even though he is
dressed, as convention demanded, like a miniature adult.

The spinet is of a late seventeenth-century type, its range
increased by dividing the last two accidental keys into two
parts, each tuned to a different note.

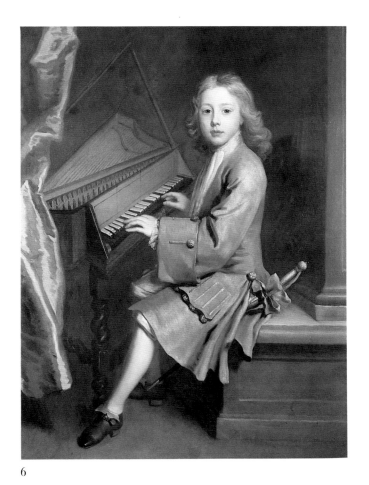

6

TRAJAN HUGHES active 1709–1712

7 A Foxglove in a Wooded Landscape 1712
Inscribed 'T Hughes 1712' bottom left
Canvas 40 × 35½ (101.6 × 90.0)
Prov: . . .; Col. M.H. Grant by 1947, by descent to a
relative, from whom bt by the lender
Lit: Col. M.H. Grant, *The Old English Landscape
Painters*, II, 1958, p.104, fig.96
Avvocato Franco Antico

One of only two known works by an artist of some distinc-
tion, but about whom nothing is known. Waterhouse (1981)
thought that his work suggests some knowledge of the animal
painter Francis Barlow (died 1704).

As in the case of no.48, it seems to be an example of the
kind of subject matter for which there was little call in
England, and which remained the province of the occasional
painter or gifted amateur until the late eighteenth century.

7

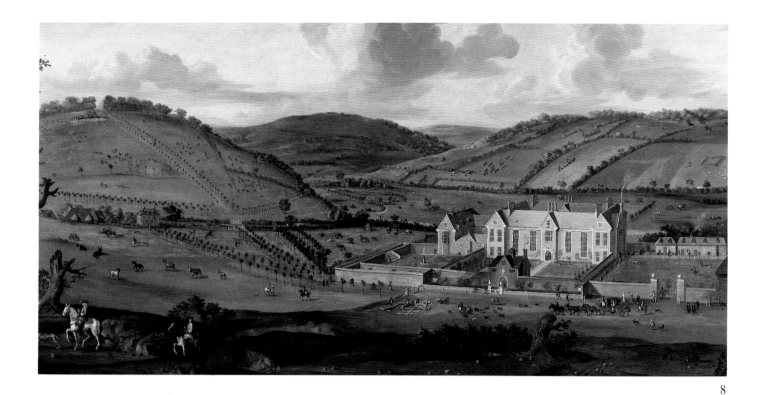

8

BRITISH SCHOOL, EARLY EIGHTEENTH CENTURY

8 **Prospect of Littlecote House, Wiltshire** *c*.1705–10
Panel 45 × 91 (114 × 227)
Prov: Probably painted for Alexander Popham
(d.1705) of Littlecote House or his son Francis, sold
Littlecote Sale, Sotheby's 20–22 November 1985 (807,
repr. in col.) bt Colnaghi, from whom bt by lenders
and placed on loan to Littlecote House
Lit: Harris 1979, pp.97–8, 144–5, 270, pl.156
The Trustees of the Royal Armouries

The view looks down on the south front of Littlecote House
in Wiltshire, with the river Kennet behind. The chief
purpose of the painting seems to be to record the newly laid
out avenues and plantations to the left of the old pink brick
Elizabethan mansion, which still stands. It is a lay-out that
would have matured well into the eighteenth century. The
painting is also one of the most comprehensive visual records
of manorial life in Queen Anne's England and is, as John
Harris wrote, 'raised to the level of great documentary art by
the astonishing account of the multifarious activities in
garden and park'.

In the foreground two horsemen, possibly Sir Alexander
Popham (d.1705) and his son Francis, ride off to the left,
swords raised in salute, to be followed by a coach-and-six
being driven out of the stable yard, carrying the lady of the
manor and her black servant. They leave behind a hive of
activity; the landscape teems with people going about their
appointed tasks. Joiners and carpenters assemble roof-
timbers in front of the somewhat dilapidated gatehouse, a

gardener leans on the wall with his scythe, men set off with
nets for the fishponds, a milk-boy carries his pails towards
the manor farm on the left, horses are being trained and
exercised in the fields – the list seems endless. No fewer than
three hunts are in full cry in the countryside beyond; the
horizontal line of hedges at the bottom of the hill just above
the house follows the old bridle road (roughly the present A4)
along which horsemen, coaches, pack-horses and carts move
westwards.

Somewhat old-fashioned in that it is painted on panel
rather than canvas, it encapsulates two trends in British
painting that were to remain dear to patrons deep into the
eighteenth century, even though techniques of expressing
them changed beyond recognition. One was the love of the
seemingly plain, objective view that made Canaletto the
darling of the British collecting classes; the second was a
delight in the minutiae of human existence, requiring a
painting to be 'read' like a book, that Hogarth was to use for
his own ends.

attributed to
MARCO RICCI 1676–1730

9 **A View of the Mall from St James's Park** c.1710
Canvas 45 × 76⅞ (114.1 × 195.2)
Prov: ...; ?Astley-Corbett sale, Christie's 8 July 1927
(66) bt Knoedler; ...; Ailsa Mellon Bruce, presented
to the lender 1970
National Gallery of Art, Washington D.C. (Ailsa Mellon Bruce Collection)

The urban prospect, especially one that was more interested in human activity than topography, took a longer time to develop in England than the country house or estate view. It took a visiting Venetian like Marco Ricci, with a Venetian's interest in public and social spectacle, first to observe the courtiers, townsfolk and visiting foreigners promenading along the Mall in St James's Park, their nearest equivalent to *rus in urbe* (the country within the city). This was one of the Latin mottoes which adorned Buckingham House (which did not become a palace and a royal residence until the nineteenth century), built in about 1707 by the Duke of Buckingham at one end of the Mall. The Park had three avenues for pedestrians and two straight ornamental pieces of water, the so-called Canal and Rosamond's Pond, which had been laid out in the seventeenth century. Only a few years before this was painted, it had been improved by Queen Anne's gardener Henry Wise (1653–1738), who deepened the Canal to stop the meadows from flooding, and planted 350 limes to shade the walks. It was freely accessible to everybody, and was the most fashionable walk in London for the *beau monde*, who came to take the air here from midday onwards, to be seen and to learn the news of the day, until it was time to change for the court or for dinner. It was a place for social intrigue by observing who bowed to whom, for picking up 'ladies of the town', or watching members of the royal family promenading with an escort of half-a-dozen Yeomen of the Guard. It changed little (see 114) until about 1770, when Lancelot 'Capability' Brown altered the formal lay-out to conform with the then modern notions of curvilinear landscape design and changed the Canal into what we now know as the Serpentine.

This painting is probably a contemporary copy of the prime version at Castle Howard.

9

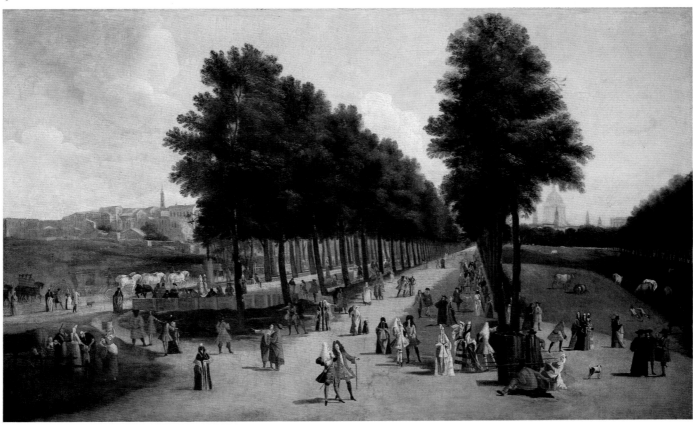

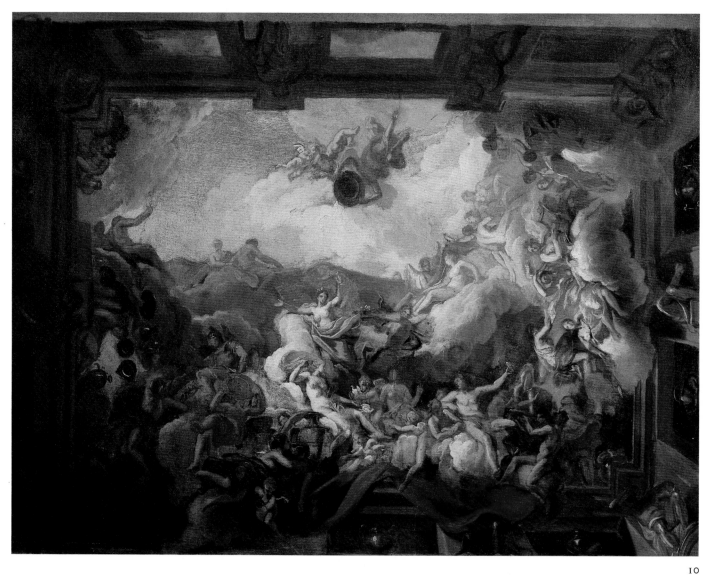

10

LOUIS LAGUERRE 1663–1721

10 **Ceiling Design Showing a Feast of the Gods with Venus and Bacchus** *c.*1720
Canvas, 36 × 48 (91.5 × 122)
Prov: ...; Appleby Bros by 1957 (advertised as by Thornhill); Hazlitt Gallery by 1961 (exhibited as French School), bt by the lender
Exh: English Baroque Sketches, Marble Hill House, Twickenham, 1974 (12)
Private Collection

Born in France and trained under Charles Le Brun, Laguerre settled in England in 1683 and became Thornhill's chief rival in history and decorative painting. He was one of the twelve directors of the Academy set up by Kneller in 1711 (as was Thornhill), and was important as the teacher of the first generation of native-born painters. His work at Chatsworth, Blenheim, Marlborough House and elsewhere was highly influential.

According to Vertue, he was at first chosen to paint the dome of St Paul's in 1715, but was supplanted by Thornhill (14 and 15). Nevertheless Thornhill held him in great esteem, and his sale in 1735 included at least eighteen sketches by Laguerre.

A pendant of this painting with a scene of Cupid and Psyche before Jupiter is in a private collection. It has not been possible to connect the designs with any particular commission, but on stylistic grounds they appear to date from the end of Laguerre's career.

SEBASTIANO RICCI 1659–1734

11 **The Baptism of Christ: Design for the Chapel at
Bulstrode House** *c.*1713–14
Inscribed 'HIC EST FILLIVS/MEVS
DILECTV[S]/LVC[VS] CA[PVT]III' on cartouche on
top of arch
Canvas 26 × 40 (66 × 101.6)
Prov: ...; acquired by the lender 1981
Lit: Croft-Murray 1970, pp.15, 266, pls.13–14;
P. de Montebello, *Notable Acquisitions 1981–1982,*
The Metropolitan Museum of Art, New York, 1982,
p.42, rep. in col.
*Metropolitan Museum of Art, New York. Purchase,
Rogers and Gwynne Andrews Funds, and Gift of Mrs
Jane L. Melville, by exchange, 1981*

Sebastiano Ricci left Venice to join his nephew Marco in
England in 1712, attracted by the possibility of participating
in the decoration of the dome of St Paul's, which was then the
most important project of its kind in Europe. In this he was
frustrated by Thornhill, and when he lost, also to Thornhill,
the commission to paint the Prince of Wales's Bedchamber at
Hampton Court in 1716, he returned to Italy. During his
short stay, however, he executed several highly influential
schemes, including the one still in place on the staircase of
Burlington House.

In 1713–14 he painted the chapel at Bulstrode for Henry
Bentinck, 1st Duke of Portland, which included two walls
with the Last Supper and the Baptism of Christ. The chapel
was destroyed in the nineteenth century, but Vertue's
description of it in 1733 makes it clear that this sketch, and its
pendant (of which there are three versions in American and
Italian private collections), were for Bulstrode. Vertue was
particularly struck by the 'great force of lights & shade, with
variety & freedom in the composition'.

The rich paint and theatrical presentation of this sketch
has a strength and vitality that would not have been lost on
Hogarth, and it is tempting to see it as one of the triggers for
his own fascination with theatre painting, strong light and
shade contrasts, and vigorous action, as well as for his
ambitious scheme for the staircase of St Bartholomew's
Hospital (83).

11

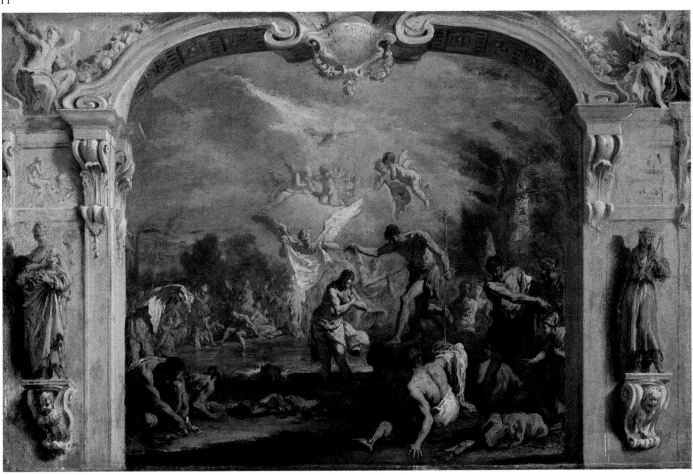

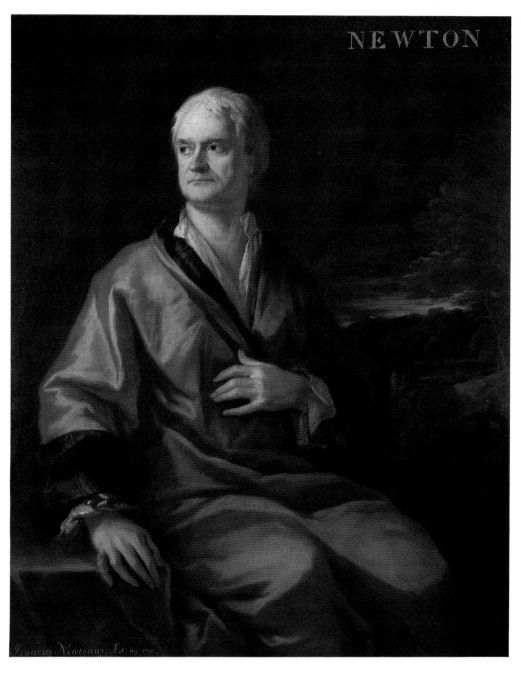

SIR JAMES THORNHILL 1675–1734

12 Sir Isaac Newton 1710
Inscribed 'NEWTON' top right and 'Isaacus Newtonus
Aet 69.1710/Donavit Bentleius Coll. Mag.' lower left
in older hand
Canvas 48 × 40 (122 × 101.5)
Prov: Painted for Richard Bentley, by whom left to
the lenders
Exh: National Portrait Exhibition, South Kensington,
1867 (35)
Lit: C.H. Collins Baker, 'Antonio Verrio and
Thornhill's Early Portraiture', *Connoisseur*, CXXXI,
1953, p.11, pl.IV
The Master and Fellows of Trinity College, Cambridge

Painted for Richard Bentley (1661–1742), leading classical
scholar and critic, Master of Trinity College, Cambridge,
and friend of Sir Christopher Wren, John Locke and
Newton, in about 1710, together with portraits of himself
and Ezekiel Spanheim. Although a classicist himself, Bentley
promoted science, and organised a competitive system of
awarding scholarships and fellowships at the university.

Thornhill considered himself primarily a decorative
history painter in the grand Baroque manner and had little
interest in portraiture, although he was evidently not averse
to painting the great intellects of his day. After Verrio's death
in 1707, he and Kneller completed his unfinished full-length
of Sir Christopher Wren at the Sheldonian Theatre, Oxford
(which was to serve as the model for Hogarth's 'Captain

Coram', in 1740 – no.157), but Newton, then at the height of his international fame, must have been his most distinguished sitter. Appropriately, he eschews here the academic gown and fashionable dress and wig of the others, opting for, as Collins Baker aptly put it, a 'larger style . . . a noble Roman presentment of the aged white-haired seer'. Roubiliac's bust and his statue of Newton at Trinity seem to be modelled on this portrait.

As Thornhill's son-in-law, Hogarth must have felt that he had indeed succeeded in following in the older man's footsteps when he obtained the important commission to paint 'The Indian Emperor or Conquest of Mexico' (68) for Newton's immediate heirs, as well as portraits of two of Newton's most distinguished surviving collaborators, the Earl of Macclesfield and William Jones (118), all works on which he evidently lavished particular care and sympathy.

SIR JAMES THORNHILL 1675–1734

13

13 Decorative Staircase (?) Design with the Story of Aeneas and Dido *c.*1719–24
Canvas 23 × 16½ (58.4 × 41.8)
Prov: . . .; Colnaghi by 1959, sold to Edward Croft-Murray, thence by descent
Exh: English Baroque Sketches, Marble Hill House, Twickenham, 1974 (46)
Lit: Croft-Murray 1962, p.266, pl.134
Private Collection

Decorative wall-design with a scene depicting the meeting of Dido and Aeneas in front of a statue of Juno. The architectural surround has a central cartouche with military trophies, topped with a ducal coronet. It is thought to be a project for Canons, near Edgware, a mansion of legendary splendour built between 1713 and 1725 to designs by James Gibbs for James Brydges (1674–1744), 1st Duke of Chandos, after he had amassed a fortune as Paymaster-General of the forces abroad. It was decorated by many leading artists of the day, including Thornhill, Kent, Bellucci, Laguerre and Grisoni. The Duke's lavish lifestyle – which included a private orchestra for which he employed Handel as *Kapellmeister* – eventually outstripped his wealth; his possessions had to be sold soon after his death, and by 1750 the house had been dismantled for building material, leaving little record of its appearance. Contemporary accounts state that Thornhill painted the staircase and saloon, and a surviving preparatory pencil sketch by him for this subject (collection of the late Edward Croft-Murray) is inscribed 'D.Chandᵉ. at Canons'. Brydges received his dukedom in 1719, and as Thornhill was paid for his work at Canons in August 1724, the scheme must date from this period.

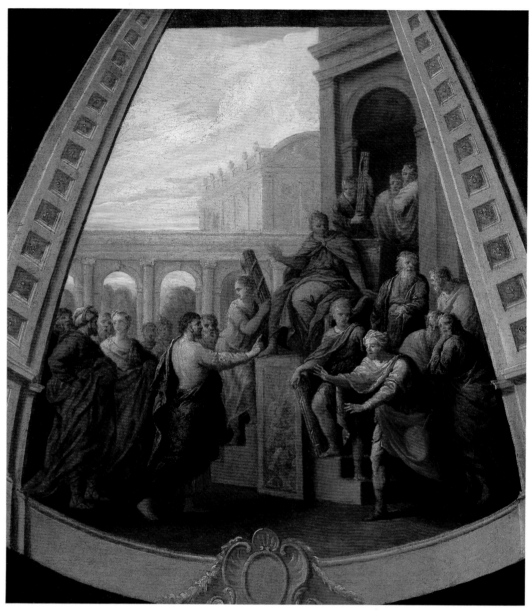

SIR JAMES THORNHILL 1675–1734

**14–15 Two Sketches for the Dome of St Paul's
Cathedral** *c.*1710
Canvas, each 32¼ × 29 (82 × 73.7)
Prov: ...; National Art-Collections Fund 1953,
presented to St Paul's Cathedral
Exh: (14 only) *Early Baroque Sketches*, Marble Hill
House, Twickenham, 1974 (35)
Lit: Croft-Murray 1962, pp.72, 271, pl.127 (for 14);
G. Beard, *The Work of Christopher Wren*, 1982,
p.34–5
The Dean and Chapter of St Paul's Cathedral

14 Paul and Barnabas before Sergius Paulus

15 St Paul Preaching at Athens

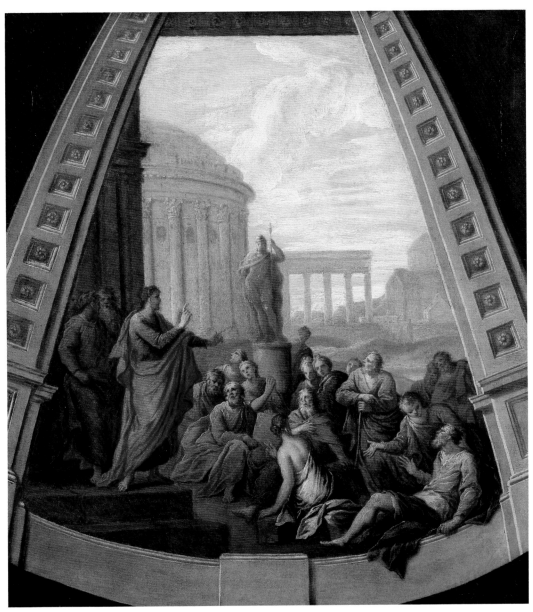

15

In 1710, after thirty-five years of building, the last stone of the lantern above the dome of St Paul's Cathedral was laid in the presence of its architect, Sir Christopher Wren, then seventy-eight years old. The previous year, the Cathedral's Commissioners of the Fabric had asked for painters interested in decorating the interior of the dome with 'Scripturall History' to submit their designs, and had examined submissions by Thornhill, Pellegrini, Catenaro, Berchet and Cheron, and, according to Vertue, Laguerre. Wren preferred Pellegrini, but in the end Thornhill was given the commission, largely because he and his supporters contended that it should not go to a foreigner. Between 1714 and 1717 Thornhill painted the dome with eight grisaille scenes from the life of St Paul, for which he was paid £4,000, and he worked on other sections of the cupola until 1721.

These are two of three known coloured oil sketches (the third is in the Yale Center for British Art, New Haven) showing Thornhill's design in its early stages. As they are in colours, and not in grisaille as eventually executed, they may have formed part of an earlier design done by Thornhill in 1710, when the Commissioners instructed him and Pellegrini to submit specific designs.

It was to be Thornhill's most important commission apart from his masterpiece, the Painted Hall at Greenwich Hospital, on which he worked for nearly twenty years from 1707 onwards. He was the first native-born painter to succeed, in the teeth of fierce and some would say more deserving foreign competition, in making a career for himself without having to resort to portrait painting. It is as well to remember that he was first a teacher and later the father-in-law of William Hogarth.

SIR GODFREY KNELLER 1646–1723

16 John Erskine, 6th Earl of Mar, with his son Thomas, Lord Erskine *c*.1715
Inscribed 'GKneller Barone . . .' bottom left corner, and with the sitters' identity in a later script
Canvas 91⅝ × 55⅜ (232.7 × 140.7)
Prov: Painted for the sitter, but not collected; Kneller's studio sale, 20 April 1726 (338, 'The Earl of Mar, and his Son, a Capital Picture by Sir Godfrey K' and lot 339 'His Lady, Ditto'), bt Lady Wortley Montagu, and presented to her sister, the Countess of Mar; thence by descent
Lit: Lord Killanin, *Kneller and His Times*, 1948, pl.83; Stewart 1983, p.116, no.485
The Earl of Mar and Kellie, on loan to the Scottish National Portrait Gallery

John Erskine, Earl of Mar (1675–1732) is shown with his son Thomas, Lord Erskine (*c*.1705–1766), wearing the robes and jewel of the Order of the Thistle. The paintings were presumably ordered in about 1714, following his second marriage to Frances Pierrepont (17), but were never collected because of the Earl's involvement in the Jacobite uprising of 1715 and his subsequent exile to France.

This and the following are among the finest of Kneller's late works, and still carry in them the solemn dignity that came naturally to the 17th century: it is inconceivable that Lord Erskine would have had himself painted with his family in the manner in which the Duke of Somerset and his family were painted by Philips less than twenty years on (60).

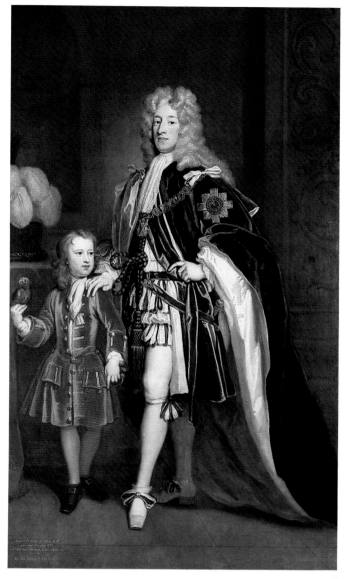

16

SIR GODFREY KNELLER 1646–1723

17 Frances Pierrepont, Countess of Mar, and Page *c*.1715
Inscribed with the sitter's identity in a later script
Canvas 93 × 57¾ (240 × 146.6)
Prov: As 16
Exh: *Sir Godfrey Kneller*, National Portrait Gallery, 1971 (99, repr.)
Lit: Lord Killanin, *Kneller and his Times*, 1948, repr. in col. as frontispiece; Stewart 1983, pp.69, 116 no.458, pls.67a, 71a–c
The Earl of Mar and Kellie, on loan to the Scottish National Portrait Gallery

Frances Pierrepont (1690–1761) was the eldest daughter of the 1st Duke of Kingston, and married John Erskine, Earl of Mar, as his second wife in 1714. She was the sister of Lady Mary Wortley Montagu (36), who went to considerable trouble to obtain her sister's portrait at Kneller's sale in 1726, and then presented it to her. Lady Mar lived in Paris with her exiled husband, and suffered from increasing melancholy which deepened into insanity in 1728, when she was sent home to England.

As Lord Mar's second wife, and not the mother of his heir, Lady Mar is painted not as a strict pendant to her husband, in the robes of a peeress, but as a remarkably independent figure in a magnificent pink and silver riding outfit. In compositional terms this gives the painting a monumental stability that is well able to balance her husband's full heraldic regalia, while the horse and groom adds the extra interest needed to counterbalance the Earl's son in the companion picture.

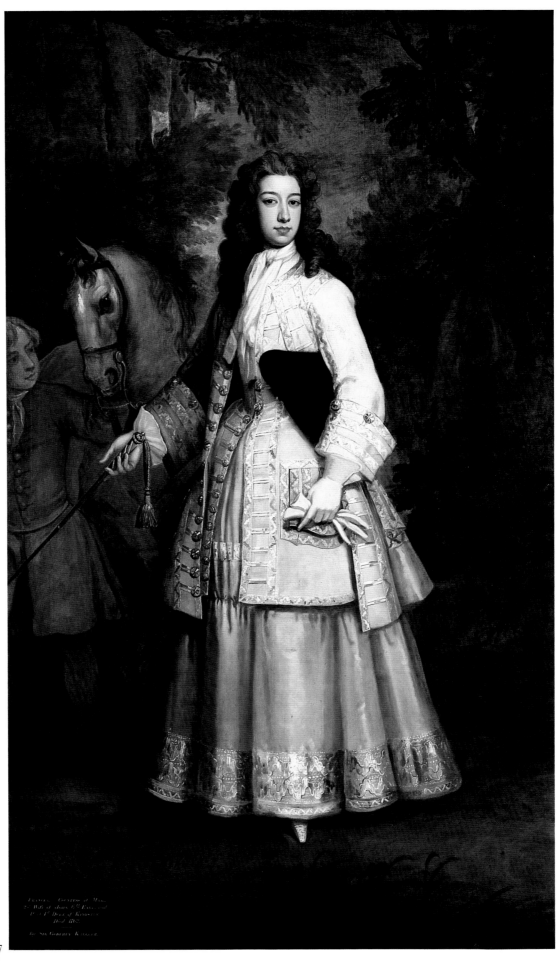

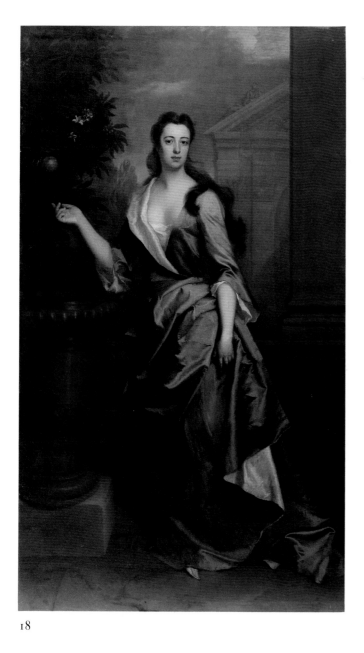

18

MICHAEL DAHL ?1659–1743

18 **Henrietta, Countess Ashburnham** 1717
Inscribed 'MDahl:pinx:1717' (initials in monogram)
lower left
Canvas 91 × 53 (231 × 135)
Prov: ...; Earl of Ashburnham, sold Sotheby's 15 July
1953 (108) bt Agnew; presented by Maj. Philip R.
England OBE to the lender
Exh: Painting and Sculpture in England 1700–1750,
Walker Art Gallery, Liverpool, 1958 (6)
*The Trustees of the National Museums and Galleries on
Merseyside; Walker Art Gallery, Liverpool*

The sitter is Lady Henrietta Stanley, daughter of William,
9th Earl of Derby, and widow of John, 4th Earl of Anglesey.
She married John, 1st Earl of Ashburnham in 1714, and died
a year after this portrait was painted, aged thirty-one.

To Vertue, writing in 1731, Dahl was, along with
Richardson and Jervas, one of the 'three foremost Old
Masters' then still representing a bygone age. Dahl con-
tinued to paint until about 1740, and when he died at the then
remarkable age of 87, Vertue described him as a 'man of great
Modesty and few words', who had been second only to
Kneller in popularity among the great nobles. His portraits
are a gentler version of Kneller's style, often with a surer
feeling for drapery and colour.

This kind of grand full-length, draped in loose robes
rather than wearing fashionable dress, had been one of
Kneller's most successful formulas but was now going out
of fashion, not to be revived until the resurgence of a new
Grand Style under Reynolds.

CHARLES JERVAS *c.*1675–1739

19 **Martha and Theresa Blount** 1716
Canvas 48¾ × 39 (124 × 99.5)
Prov: From the sitters by descent
Lit: R. Williams, *Mapledurham House*, 1977,
pp.11–12; A. Crookshank and the Knight of Glin, *The
Painters of Ireland c.1660–1920*, 1978, pp.34–6, pl.19
J.J. Eyston

Martha (1690–1763) and Theresa (1688–1759) were the
daughters of Lyster Blount of Mapledurham and were both
courted by Alexander Pope. In a letter to Dr Parnell, written
in February 1716, Jervas describes his work on this painting,
which is considered to be one of his best:

'I have just set the last hand to a Couplet, for so I may call
two Nymphs in One Piece. They are Pope's Favourites &
therefore you will guess must have cost me more pains than

19

any Nymph can be worth. He has been so unreasonable to expect that I should have made them as beautiful upon canvas as he has done upon paper'.

Painting in England always tended to struggle in the wake of literature, and it is instructive to compare Jervas's backward-looking treatment of the 'Nymphs' with Pope's affectionate verse portrayal of Theresa at her daily activities in the country at about the same time, a description much closer in feeling to the coming vogue for the intimate conversation piece:

> She went, to plain-work, and to purling brooks,
> Old fashion'd halls, dull aunts, and croaking rooks . . .
> To pass her time 'twixt reading and Bohea,
> To muse, and spill her solitary Tea,
> Or o'er cold coffee trifle with the spoon,
> Count the slow clock, and dine exact at noon;
> Divert her eyes with pictures in the fire,
> Hum half a tune, tell stories to the squire . . .

Jervas was a pupil of Kneller, but in spite of a trip to Italy and much assiduous copying of Van Dyck, he never really managed to produce much beyond a watered-down and softened version of his master's style. Nevertheless his association with Pope, Swift and other literary men and the dearth of native talent in the early decades of the century gave him great prominence and popularity, and he succeeded Kneller as Principal Painter to the King in 1723.

attributed to
JONATHAN RICHARDSON Senior
c.1665–1745

20 **Alexander Pope and his Dog Bounce** *c*.1718
Inscribed 'A. POPE.' on the collar of the dog
Canvas 49⅜ × 39¼ (125.4 × 99.7)
Prov: Probably painted for the 1st Baron Lyttelton; first recorded at Hagley (as by Richardson) in 1766, thence by descent
Exh: *Alexander Pope*, National Portrait Gallery, 1961, not numbered
Lit: W.K. Wimsatt, *The Portraits of Alexander Pope*, New Haven 1965, pp.85–8, repr.9.1
The Viscount Cobham

An important early image of the poet Alexander Pope (1688–1744), who was painted by almost every leading artist of the time, and whose iconography is even more complex than that of Newton, the other great hero of the age.

This is a splendid example of a brooding literary portrait in the old-fashioned vein, using the conventional seventeenth-century background of rocky outcrop and summary evening landscape, and commenting on the poet's solitary pursuits with an elaborate state of undress and the presence of one of his 'great faithful Danish dogs', of whom he had several in succession, all called Bounce.

Yet as a 'thinker's' portrait in the modern sense it leaves much to be desired, for it is evident that the convention of the period sought to capture likeness rather than fleeting character, and the face remains essentially a mask.

A slightly better (or perhaps better-preserved) version, without the dog, belongs to the Beinecke Library, Yale University.

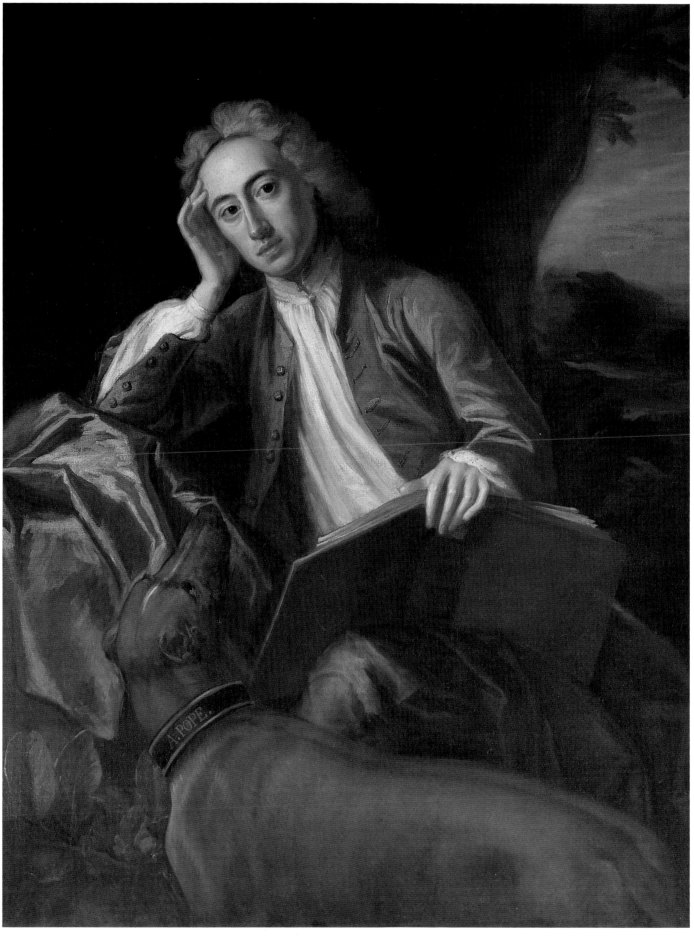

20

21

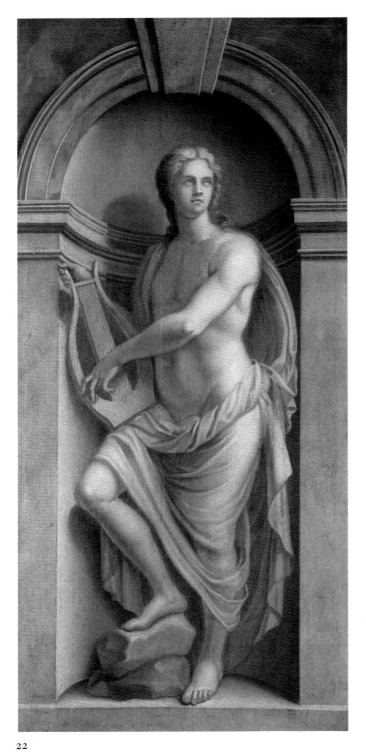

22

SIR GODFREY KNELLER 1646–1723

21–22 Two Grisailles of Classical Statues *c*.1719
Canvas, each 86 × 42½ (218.5 × 108)
Prov: Given to Alexander Pope by the artist *c*.1719, and willed by him to the 1st Lord Bathurst 1744; thence by descent
Lit: Stewart 1983, pp.7, 89, nos.9–11, pls.83c, d, e
Earl Bathurst, on loan to English Heritage, Chiswick House

21 Venus de' Medici

22 Giustiniani Apollo

Two of a set of three life-size grisailles (the third is of the Farnese Hercules, inscribed 'G.Kneller, Amicitiae Gratia') of classical statues presented by Kneller to Pope when the latter moved from London to his villa at Twickenham *c*.1719. Pope thanked the artist with a flattering epigram 'To Sir Godfrey Kneller, on painting for me the Statues of Apollo, Venus and Hercules':

> What God, what Genius did the Pencil move
> When Kneller painted These?
> Twas Friendship – warm as Phoebus, kind as Love,
> And strong as Hercules.

The paintings were no doubt based on studies Kneller made during his stay in Italy 1672–5, when he is known to have made a special study of antique statues.

SIR GODFREY KNELLER 1646–1723

23–27 Five Portraits from the Kit-cat Club Series *c*.1705–21
Canvas, average size 36 × 28 (91.5 × 71), except 27
Prov: Commissioned by the sitters for Jacob Tonson, the Club's secretary; by family descent until 1945, when bt by the lender
Exh: *Sir Godfrey Kneller*, National Portrait Gallery 1971 (Appendix)
Lit: D. Piper, *Seventeenth-Century Portraits in the National Portrait Gallery*, 1963, pp.398–403; Stewart 1983, pp.67–8
National Portrait Gallery

The Kit-cat Club began in the late seventeenth century as a convivial gathering of gentlemen of the Whig persuasion for dinner and toasting sessions. Its name is said to have come from the owner of a tavern where it met for a time, one Christopher Cat, who was famous for his mutton pies known as 'Kit-cats'. In its turn, the club gave its name to the kind of

baluster-stemmed glass seen in no.27, on which the members engraved their toasts, and to a standard size of half-length portrait – 36 × 28 inches – both of which are still known as Kit-cats.

Among the innumerable drinking and dining clubs of the day, this was the most distinguished and influential, 'the best Club, that ever met', as Vanbrugh was to recall nostalgically. Its roisterings were formalised by an elaborate ritual of toasting the ladies, be they wives, daughters, or reigning society beauties, who were sometimes allowed to be present at the feast. Lady Mary Wortley Montagu (36) remembered it as the most ecstatically happy day of her life when, at the age of eight, she was presented, dressed in her best clothes, to the Club by her father, the Duke of Kingston, had her health drunk by everyone present, her name engraved upon a drinking glass, and was then passed from lap to lap and petted by some of the most famous and influential men of the age.

The Duke of Somerset is said to have initiated, sometime soon after the turn of the century, the custom of presenting a portrait to the Club's secretary, the publisher Jacob Tonson (?1656–1736). Over a period of nearly twenty years more than forty portraits were painted by the Club's resident painter Sir Godfrey Kneller, and hung by Tonson in a specially built room in his house at Barn-Elms. They remained with his descendants until their acquisition by the National Portrait Gallery in 1945.

Although collections of single portraits were not unknown, either of literary men for libraries, or friendship portraits, or glamorous sets like Lely's 'Windsor Beauties', the scale, consistency of format and importance of sitters made this the most famous. The format was something quite new in English portraiture in that it introduced a size between the more limited bust portrait of 30 × 25 inches and the more formal three-quarter length of 50 × 40 inches. Since it allowed the inclusion of one or both hands on the scale of life, it made for greater variety of pose and gave a more intimate, stronger sense of the sitter's presence. These portraits eschewed what Joseph Addison called the 'smiles and a certain smirking Air' and fluttering draperies of their French equivalents, and with their grave simplicity came to represent the gentlemanly ideal of the early eighteenth century. The set was very influential on later painters like Highmore and particularly Hogarth, who is known to have owned a complete set of engravings after it.

23 Sir Samuel Garth *c*.1705
Inscribed 'G.Kneller f;' above hand

Garth (1661–1719) was Physician in Ordinary to George I and a witty amateur versifier on current topics and personalities. His practice brought him great wealth and a knighthood.

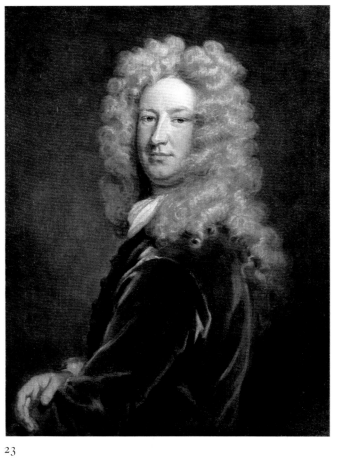

23

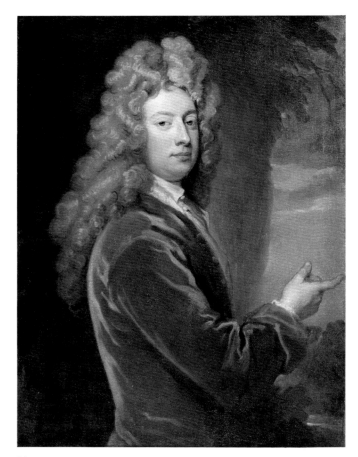

24

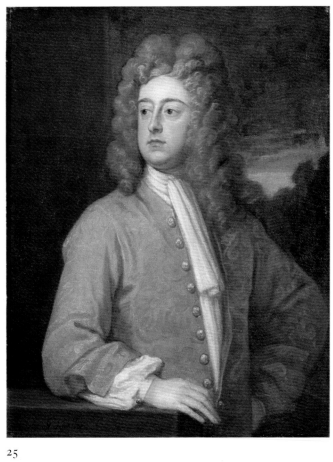

25

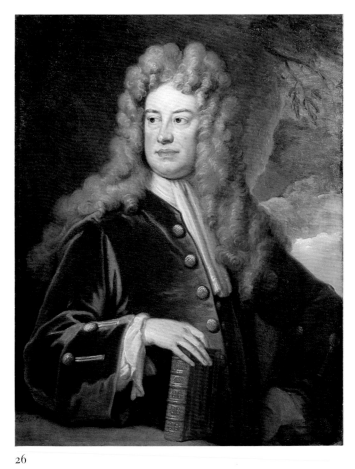

26

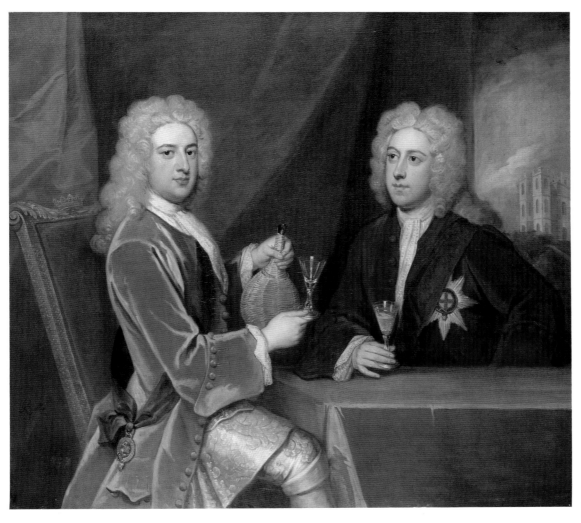

27

24 William Congreve 1709

Inscribed 'GKneller/1709' (initials in monogram)
lower left

Congreve (1670–1729) was the most successful playwright of
the late seventeenth century, having written his most
popular works like 'Love for Love' and 'The Way of the
World' before he was thirty. He also composed some of the
Club's wittiest toasts. A preparatory chalk drawing for the
face is in the Witt Collection.

25 Francis Godolphin, 2nd Earl of Godolphin *c*.1712
Inscribed 'G.Kneller f;' on ledge lower left

Godolphin (1678–1766) became Lord High Treasurer like
his father, and married a daughter of the Duke of Marl-
borough. He rose rapidly under George I, and was appointed
three times Lord Justice to act for the King on his absence in
Hanover. Became Lord Privy Seal in 1735.

26 John Somers, Baron Somers *c*.1715–6

Inscribed 'GKneller' (initials in monogram) lower
right and 'Spensers / Fairy / Queen / Vol.1' on spine of
book

Lord Somers (1651–1716), lawyer and politician, holds
the first volume of an octavo edition of Spenser's 'Fairie
Queene', published in 1715 and dedicated to him.

**27 Thomas Pelham Holles, Duke of Newcastle, and
Henry Clinton, 7th Earl of Lincoln** *c*.1721
Inscribed 'GKneller / f' (initials in monogram) lower
left
Canvas 50 × 58¾ (127 × 149.2)

Henry Clinton (1684–1728), on the right, was a Whig
magnate who opposed the Tory Ministry under Queen
Anne, and became a Privy Councillor and Paymaster-
General under George I. He was noted for his integrity. On
the left is his brother-in-law Thomas Pelham (1693–1768),
created Duke of Newcastle in 1715. The Earl of Lincoln
wears the star of the Garter which he received in 1721. In the
background is a landscape that includes a folly at the Duke of
Newcastle's seat Claremont, Surrey, designed by Vanbrugh,
another member of the Kit-cat Club.

SIR GODFREY KNELLER 1646–1723

28 Mehemet, Groom of the King's Chamber and Keeper of the Closet 1715
Inscribed 'GKneller / 1715' (initials in monogram) lower right. Concealed by the re-lining is an inscription in Kneller's hand, giving the name of the sitter and the date, 1715
Canvas 36 × 28 (91.5 × 71)
Prov: ...: said to have been in a private collection in Athens; purchased by H.M. The Queen for the Royal Collection 1975

By Gracious Permission of Her Majesty The Queen

Mehemet (d.1726) was the more important of George I's two Turkish body servants (the other was Mustafa). He had been captured as a child at Koron, where his father had been Provincial Governor, and given to George I by a Swedish officer. He became an utterly trusted personal servant and was in charge of the King's private accounts from 1699 until his death. This portrait was probably painted on the occasion of his ennoblement in 1715, when he chose the name Königstreu, which translates literally as 'true to the King'. His official title was Keeper of the King's Closet, and his portrait is included among those of the various members of the royal household in William Kent's decorations of the grand staircase at Kensington Palace, painted between 1722 and 1725.

This excellent late portrait shows Kneller's delight in exotic subjects, and gives substance to Walpole's claim that the painter considered his full-length of 'The Chinese Convert' at Kensington Palace as his best work.

PETER TILLEMANS 1684–1734

29 The Artist's Studio *c.*1716
Inscribed 'P.Tillemans.Ft' bottom left
Canvas 26$\frac{7}{8}$ × 33 (68.3 × 84)
Prov: Painted for Dr Cox Macro and first recorded at
Little Haugh Hall *c.*1734; thence by descent to the
Patteson family, and on permanent loan to the
Norwich Castle Museum since 1984
Lit: Raines 1980, p.59, no.80, pl.9b

Norfolk Museums Service (Norwich Castle Museum)

In a list of his paintings made soon after Tillemans's death in
1734, Dr Cox Macro describes this one, hanging in 'the Little
Parlour', as 'P.Tillemans in his painting room Instructing
a Disciple; Mr. Macro standing by him'. The dating is
suggested by the fact that Macro's portrait here looks very
like Zincke's miniature of him of 1716, and that he did not
receive his D.D. until 1717.

The picture gives a good impression of the life of a
successful middle-rank painter of the period, of his relation-
ship with a sympathetic patron, his activities as teacher,
restorer (note the torn painting in the right foreground),
copyist and connoisseur, as well as of the varied styles of
painting he was expected to tackle. Notable is the absence of
any English landscapes and sporting pictures, most of which
Tillemans painted after 1720.

Tillemans came to England from Antwerp with his
brother-in-law Peter Casteels (46) in 1708. By 1715 he had
gained the patronage, indeed friendship, of the Rev. Dr Cox
Macro (1683–1767) of Little Haugh Hall, Suffolk, collector
and connoisseur, and later Chaplain to George II. It was
while staying at Little Haugh that Tillemans, a lifelong
sufferer from asthma, died suddenly in November 1734.

29

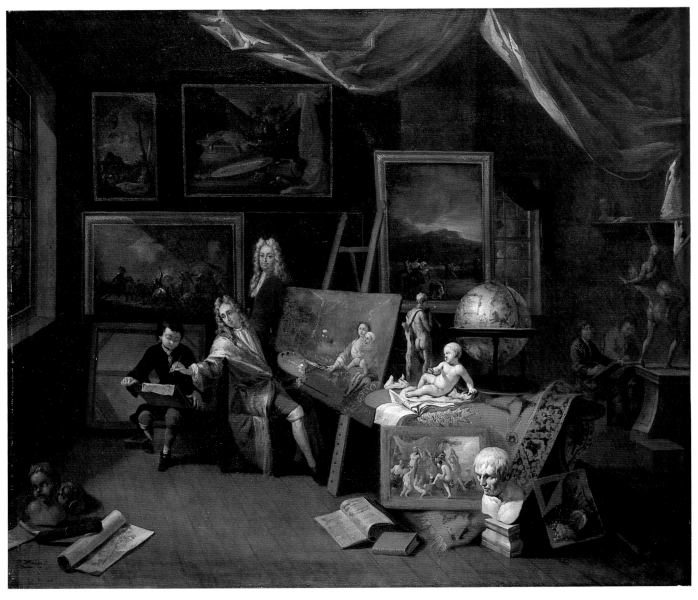

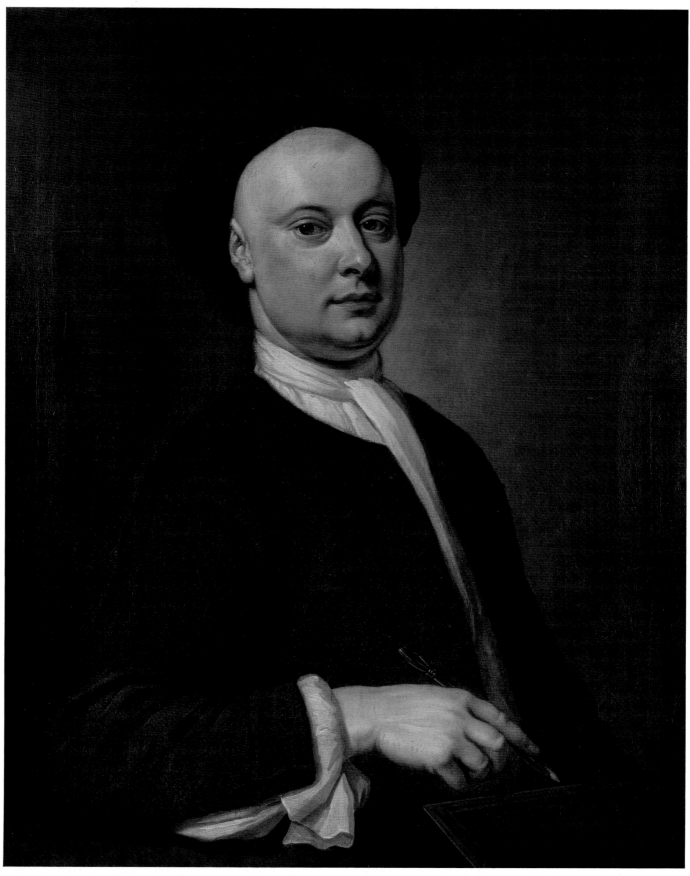

30

THOMAS GIBSON 1680–1751

30 George Vertue 1723
Inscribed 'George Vertue, painted by Thomas Gibson 1723' on back of canvas
Canvas 29 × 24 (73.5 × 50.8)
Prov : First mentioned by Vertue in 1733, but it is not clear when it came into his possession; given by his widow to the Society of Antiquaries 1773
Exh : National Portrait Exhibition, South Kensington, 1867 (175)
Lit : G. Scharf, *Catalogue of the Pictures Belonging to the Society of Antiquaries*, 1865, pp.44–5, LVII; Vertue III, p.45; Kerslake 1977, pp.285–7, fig. 818; Vertue I, repr. frontispiece

Society of Antiquaries of London

George Vertue (1683–1756), engraver and antiquary, was one of the most respected members of the art establishment of his day. A compulsive gatherer of facts concerning art and artists in England, his notebooks were acquired after his death by Horace Walpole, and formed the basis of his *Anecdotes of Painting in England* (published in four volumes between 1762 and 1780), the first serious survey of British art. Vertue's notes, now in the British Museum, are still a well-nigh inexhaustible source of information about paintings and artists before 1756.

Vertue, who was Draughtsman and Sub-Director of the Society of Antiquaries and engraved more than 500 portraits during his lifetime, is shown here in informal dress, his burin poised over a copperplate, thought to be of a portrait of Queen Elizabeth.

This portrait is a pleasing exercise in the tradition of Kneller's Kit-cat portraits, as indeed one would expect from a successful Director of Kneller's Academy like Gibson. Vertue, who was a close friend, speaks of Gibson as a man 'universaly belovd for his affability & good nature' and praises him for his 'correct & firm manner of drawing', which is evident here. During a bout of illness in about 1730 Gibson apparently disposed of his pictures among his friends, and this portrait may have entered Vertue's collection then.

SIR JAMES THORNHILL 1675–1734

31–35 Decorations for the Ceiling of the Aldermen's Court Room, Guildhall 1725–7
Canvas, each (except 31) 32 × 56 (81.5 × 142.3)
Prov : Presented by the artist 1727
Exh : (no.31 only) *High Art At Guildhall : Thornhill, Rigaud and the City Corporation*, Guildhall Library, 1984, not numbered, repr.; *The City's Pictures*, Barbican Art Gallery 1984 (3, repr. in col.)
Lit : V. Knight, *The Works of Art of the Corporation of London*, 1986, pp.8–10, 283–4, repr.

Guildhall Art Gallery, Corporation of London

31

32

33

34

35

In July 1725 Thornhill offered to supply painted decorations for the ceiling of the New Council Chamber (later called the Aldermen's Court Room) of the Guildhall. Unlike the craftsmen involved in the scheme, he gave his services free, and was rewarded in June 1727 by an expensive gift in the form of a gold cup costing £225.7s, especially made for the purpose.

The Chamber was demolished in 1908, but engravings record the appearance of the heavily Baroque scheme, with the oval medallion of the personification of the City of London in the centre, and one of the smaller canvases of the Civic Virtues in each corner. Thornhill also supplied a grisaille overmantel showing Justice embracing Mercy with Liberty, Piety and Truth, which was destroyed in the blitz in 1941. He presented at the same time three further large monochrome allegories, but it is not known if these were meant for the Court Room; in any case, they were destroyed as beyond repair in 1952.

Thornhill's gift to the Corporation may have been an attempt to give new impetus to his career which had gone into decline as the Baroque style which he represented went out of fashion and his former patrons either died or turned to rising stars like Kent. It was to bring him no new commissions, but probably set the pattern for the repeated bids for large-scale civic patronage and high-minded public art made by his son-in-law Hogarth throughout his life (83).

A preparatory chalk sketch for the oval also belongs to the Corporation.

31 **Allegory of London: London, Pallas Athene, Peace and Plenty**
Canvas 72 × 113 (18.3 × 28.7), oval

32 **The Four Cardinal Virtues: Prudence (Putto holding a mirror)**

33 **The Four Cardinal Virtues: Justice (Putto holding a sword)**

34 **The Four Cardinal Virtues: Temperance (Putto holding a bowl and jug of water)**

35 **The Four Cardinal Virtues: Fortitude (Putto leaning against the base of a column)**

LADY MARY WORTLEY MONTAGU.
d. of D. of Kingston.
b. an.d. 1722.

36

attributed to
JONATHAN RICHARDSON Senior
c.1665–1745

36 Lady Mary Wortley Montagu c.1725
Canvas 94 × 57 (239 × 144.8)
Prov: By family descent
Lit: Kerslake 1977, pp.188–91, pl.556; Ribeiro 1985,
pp.218, 266–9, fig.31
The Earl of Harrowby

Mary Pierrepont (1689–1762) was the eldest child of the Earl of Kingston, and sister of Frances (17). In 1712 she married against her father's wishes the Whig M.P. Edward Wortley Montagu (1678–1761) and accompanied him to Turkey when he was appointed Ambassador there in 1716–18. A formidable linguist, writer and advocate of education for women, she maintained a vast correspondence that affords an illuminating insight into early eighteenth-century aristocratic life in England, travel, and not least into her own unusual character. In 1736, after her marriage had become a mere formality, she met in London and fell in love with the young Italian poet and writer Francesco Algarotti (1712–64), best known in this country for his elegant adaptation of Newton's *Opticks* for popular consumption, translated into English in 1739 as *Newton's Philosophy explain'd For the Use of Ladies.* In 1739 she pursued him to Italy and, although the romance ended for her in disappointment, she decided to reside abroad, mostly in Italy, for practically the rest of her life, returning only in the year of her death from breast cancer.

Her vivid descriptions of Turkish life and costume created something of a fashion for 'Turqueries' as masquerade dress in England, seen here adapted slightly to conform with the English fashion for c.1720–5.

37

JOHN WOOTTON 1682–1764

37 Equestrian Portrait of Lionel Sackville, 1st Duke of Dorset 1727
Inscribed 'J. Wootton Fecit /1727' as though incised in stone lower right
Canvas 46¼ × 41¾ (117.5 × 106)
Prov: Probably painted for the sitter, and by descent to the lender
Exh: *John Wootton,* Iveagh Bequest, Kenwood, 1984 (17, repr.)
Lord Sackville

The formal equestrian portrait is perhaps the grandest form that portraiture can take, but it too underwent the same reduction in scale in eighteenth-century England as many other forms of painting. This portrait of Lionel Sackville, 1st Duke of Dorset (1688–1765), certainly aspires to the grandeur of a full-scale parade portrait not only in its full-dress presentation of the sitter, who is wearing the riband and star of the Garter, but also in the formal arrangement and the use of a triumphal arch in the background, its keystone discreetly sculpted with the ducal arms. As the painting dates from the year of George II's coronation at which the Duke acted as Lord High Steward of England, it may have been occasioned by some of the ceremonial activities of that year. It could also be an offshoot of the vast canvas which Wootton painted for the Duke in the same year to commemorate his long service as Constable of Dover Castle and Lord Warden of the Cinque Ports, where he is shown in the procession in a pose similar to the one here.

In her catalogue of the Wootton exhibition Arline Meyer suggests that the head is not by Wootton, but possibly by Thomas Gibson, who is known to have collaborated with Wootton on similar occasions.

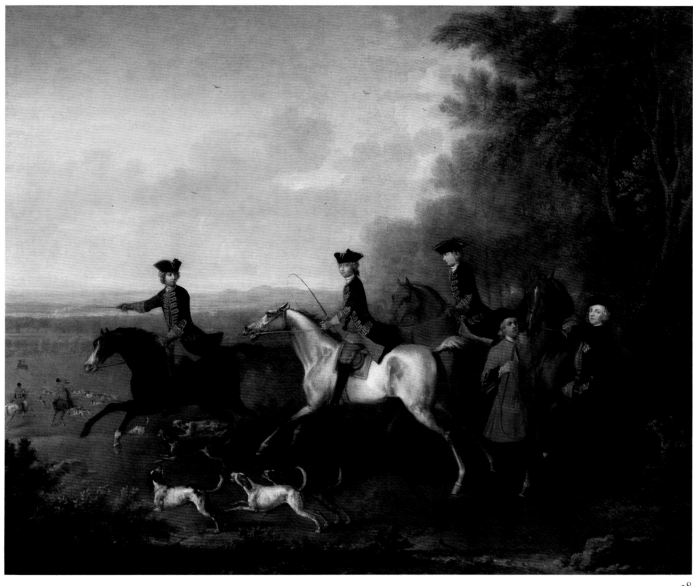

38

JOHN WOOTTON 1682–1764

38 **Frederick, Prince of Wales, out Stag
 Hunting** 1729
 Inscribed 'JWootton/Pinxit/1729' bottom right corner
 Canvas 48 × 61¼ (122 × 155.5)
 Prov: ...; Brig. W.G. Carr by 1954; ...; Christie's
 16 April 1982 (6, repr. in col.)
 Exh: European Masters of the Eighteenth Century,
 R.A. 1954–5 (411)
 Lit: W.H. Wilkins, *Caroline the Illustrious,* 1904,
 p.422; Millar 1963, p.183, no.555
 Private Collection

The horseman in the centre is Prince Frederick (1707–1751),
painted soon after he had at long last been summoned from
Hanover to England by his disaffected father, George II, late
in 1728, and created Prince of Wales. The Prince's relations
with his parents were still quite good at the time, especially

with Queen Caroline, who was Regent from March till
September 1729 during the King's absence in Hanover. The
royal family spent much time together and, with the
exception of the Queen, pursued their favourite sport of
stag hunting almost continuously while at Windsor. Peter
Wentworth, a royal page, wrote to his brother Lord Strafford
on 14 August 1729 that Princess Anne had presented him
with 'a hunting suit of clothes, which is blue, trimmed with
gold, and faced and lined with red. The Prince of Wales,
Princess Anne, the Duke of Cumberland, Princess Mary,
and Princess Louisa wear the same, and looked charming
pretty in them. Thursday se'nnight, Windsor Forest will be
blessed with their presence again, and since the forest *was* a
forest it never had such a fine set of hunters, for a world of
gentlemen have had the ambition to follow his Royal
Highness's fashion.' The Prince is shown here wearing the
trend-setting outfit, but his companions have not been
identified except for the man standing on the right, who is

thought to be his Master of the Horse, George, 2nd Earl of Cholmondeley.

The heads are not by Wootton, who never claimed to be a portrait painter, but possibly by Hogarth, who certainly painted Lord Cholmondeley's son (67) in 1732, and was called in by Wootton to paint the heads of Lord Cholmondeley and the Prince's party in another hunting piece, still in the Royal Collection, in 1734, at five guineas a head.

BARTHOLOMEW DANDRIDGE
1691–c.1755

39 **Equestrian Portrait of Captain Richard Gifford** *c.*1725
Inscribed 'B.Dandridge' lower left
Canvas 48 × 38 (122 × 96.5)
Prov: Presumably painted for the sitter, and by descent to Mrs C.M. Vivian Neal of Poundisford Park, sold Sotheby's 17 July 1985 (43, repr. in col.) bt Heim Gallery, from whom bt by lender .
Exh: *Art Treasures of the West Country*, Bristol Art Gallery 1937 (200)
Lit: R. Edwards, 'Portraits by Bartholomew Dandridge at Poundisford Park', *Country Life*, 22 December 1934, pp.674–5, pl.1; C.C.P. Lawson, *A History of the Uniforms of the British Army*, 1940–1, II, pp.111–2, 151–2
National Army Museum, with the aid of the National Art-Collections Fund

The sitter was a Captain in the Horse Guards, which he joined in 1710. He was the son of Joseph Gifford of Salisbury, Wilts., and lived in Poland Street, Soho. He married Jane, daughter of William Carr of Newcastle-upon-Tyne, in 1716, and died in the winter of 1738–9. His account book with the Horse Guards is in the Scottish National Museum in Edinburgh.

He is shown against the background of a stone column, wearing the crimson velvet undress usual for an officer of the time. The deeply fringed pistol housings in front of his saddle are embroidered with silver. Of particular interest are the regimental kettle drummer and negro trumpeter in the background, as they are apparently the earliest evidence for the traditional popularity of oriental dress among military percussion and brass players (their instruments being thought typical of 'Turkish music').

Its formal balance and restrained, dignified colour, makes this a fine example of the small-scale equestrian portrait, which Dandridge was able to infuse with rather more vitality than Wootton.

39

40

PHILIP MERCIER ?1689–1760

40 A Conversation in a Park *c.*1720–5
Inscribed 'Ph.M.' on pedestal of statue on left
Canvas 13½ × 11½ (34.3 × 29.2)
Prov: ...; first recorded at Syon 1847; thence by
descent
Exh: Philip Mercier, York City Art Gallery and
Iveagh Bequest, Kenwood, 1969 (13, repr.)
Lit: J. Ingamells & R. Raines, 'A Catalogue of the
Paintings, Drawings and Etchings of Philip Mercier',
Walpole Society, XLVI, 1978, p.51, no.218
The Duke of Northumberland

Mercier arrived in England in about 1716 via Paris, having
trained with Antoine Pesne in Berlin. He brought with him a
delicate, small-scale style based on Watteau, with light,
sophisticated colours and an elegance altogether new to
England. While he continued to produce lucrative pastiches
made up from figures taken from well-known compositions
by Watteau, he also adapted the genre to more immediate
English needs in the form of small-scale informal group
portraits which greatly influenced English contemporaries
like Hayman, Dandridge, Hogarth and ultimately the young
Gainsborough. Later in his career his work increased in
scale, and he concentrated on portraits and fancy pictures of a
more sentimental nature.

A chalk drawing for the figure of the woman is in the
British Museum (Ingamells and Raines 1978, no.278).

41

JOSEPH VAN AKEN *c.*1699–1749

41 A Musical Party on a Terrace *c.*1725
Inscribed 'JVanhaecken.f.' bottom left
Canvas 30 × 25 (76.2 × 63.5)
Prov: ...; bequeathed to the Gallery by Irene Law
1976
Towner Art Gallery, Eastbourne

A typical example of the kind of genre that the Antwerp-born
Joseph Van Aken (among others) brought with him when he
settled in England in about 1720, with his brother Alexander
(died 1757) as assistant. Another brother, Arnold (died
1736), specialised in landscapes and fish (a large set is in
Fishmongers' Hall), as well as small conversations, none of
which has been identified to date. Like the *fête galante*

subjects which Mercier brought from France (30), such
groups were rarely painted as portraits, but more as an
elegant version of the earlier peasant feasts of Brouwer and
Teniers. As, however, the British picture-buying public of
the newly emerging middle classes was not on the whole used
to buying paintings for their own sake, but only as portraits,
be they of houses, horses or relatives, the genre was soon
translated into the informal small-scale group portrait or
conversation piece, that became one of the most typical
products of British painting in the 1730s. Hogarth in
particular quickly realised the scope for innovative variety it
added to portraiture, while it remained for Gainsborough to
recapture something of the poetic mood that had been its
original inspiration.

The Van Akens soon diversified into a lucrative side-line

of portraiture, namely, drapery painting, to the extent that Horace Walpole could write that 'almost every painter's works were painted by Van Aken', most notably perhaps those of Hudson and Ramsay.

JOSEPH VAN AKEN *c.*1699–1749

42 A Sportsman and his Servant in the Grounds of a Country House *c.*1725–30
Canvas $27\frac{1}{2} \times 45$ (69.8 × 114.3)
Prov: ...; Lady Lee of Fareham (as 'The Return from the Shoot'), sold to Agnew's 1954; Ian Askew of Lewes; ...; Sotheby's 12 March 1986 (108, repr. in col.) bt Lane Fine Art for present owner
Nathaniel Robertson Collection, Connecticut, USA

Van Aken soon responded to the requirements of the English market for portraiture and sporting paintings, yet an un-English element of decorative fantasy is retained here in the background statue of Bacchus (it occurs in the backgrounds of other Van Aken paintings, such as 'An English Family at Tea' in Gallery 3) and in the attractive side-wings of the foreground. These differ markedly in style from the general landscape, and could have been added by one of the other Van Aken brothers, either Arnold or Alexander (see 41).

42

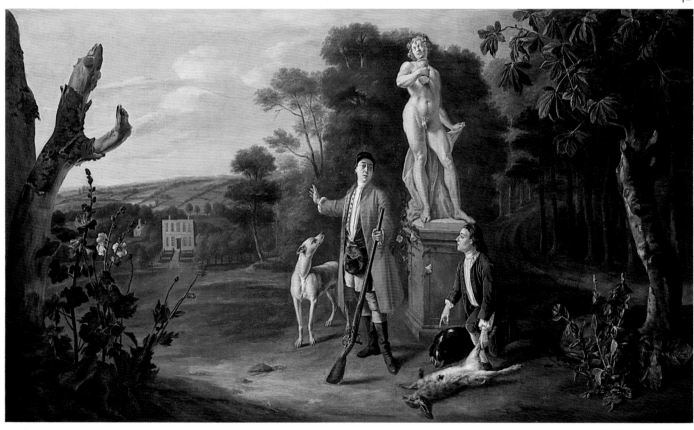

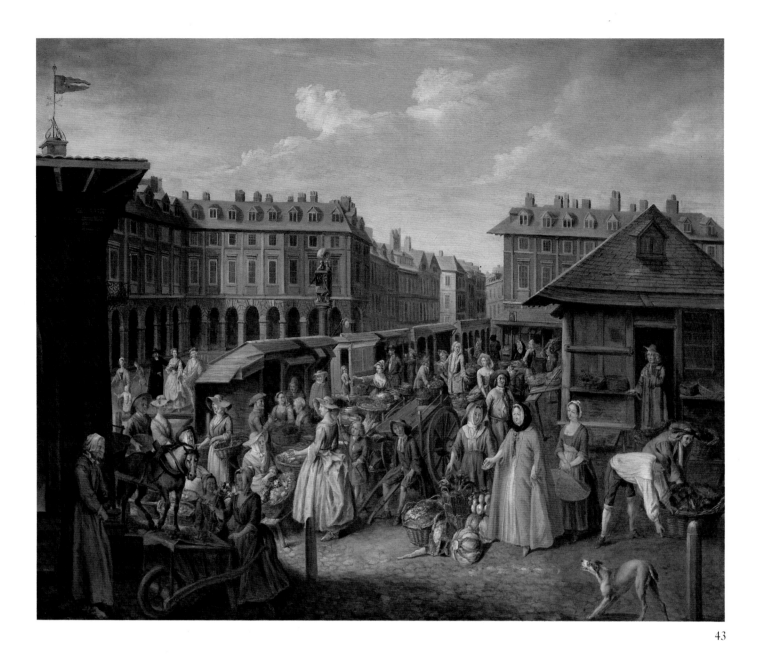

43

JOSEPH VAN AKEN *c.*1699–1749

43 **Covent Garden Market** *c.*1726–30
Inscribed 'JVA' in monogram on shaft of wheelbarrow
on left (the 'J' in old-fashioned script with transverse
bar, frequently misread as an 'F')
Canvas 25 × 30⅛ (63.5 × 76.5)
Prov: ...; anon sale, Christie's 12 July 1946 (129);
Vicars Bros. 1948; ...; the late Mrs W.M. Gladstone,
sold Christie's 26 March 1976 (150) bt Leger, from
whom bt by lender 1977
Lit: J. Hayes, *Catalogue of Oil Paintings in the London
Museum,* 1970, pp.21–2, no.1, pl.1 (for related version)
Government Art Collection

Covent Garden Piazza was first laid out in 1631 as a formal
green flanked by the garden of the Earl of Bedford's house
and Inigo Jones's church of St Paul. The column with a
sundial topped with a golden ball was erected about 1668, as
an ornament to the market which had begun to develop

towards the end of the century. As the formal square was
gradually leased to market stalls, the area became one of the
earliest locations in London to attract painters with its
atmosphere and characters. At least three versions of this
view by Van Aken are known (one is in the Bank of England,
another in the Museum of London) of which this is the only
signed one. The view shows the Market looking east from the
portico of St Paul's church (visible on the left), towards
Russell Street at the far end. Van Aken often used the same
figures in different groupings, for instance the lady and
Scottish gentleman and a clergyman in the distance on the
left, and the lady buying vegetables in the right foreground,
her maid standing behind her with the shopping basket. The
characters would have been probably recognisable to con-
temporaries. The emphasis is on the characters rather than
the topography, and the high skyline gives it a closed-in feel
very remote from the open urban panoramas the subject
inspired later.

44 The Thames from Richmond Hill 1720–23
Canvas $42\frac{7}{8} \times 90\frac{1}{2}$ (109 × 230)
Prov: According to an old inscription, painted for the
2nd Earl of Radnor (d.1723); ...; Lady Millicent
Hawes by 1921, sold to Agnew, sold to (?Hahn) 1925;
...; Leggatt, from whom bt by the Ministry of Works
1955
Lit: Harris 1979, p.238, fig.259; Raines 1980,
pp.53–4, no.56
Government Art Collection

One of Tillemans's best panoramic landscapes, of a view
popular with artists from the seventeenth century onwards.
It looks down the slope of Richmond Hill towards Richmond
village at the bottom towards the right, and Ham House in
the distance on the left. Also on the left, but on the other side
of the river, is Twickenham village and Orleans House (then
James Johnston's) and the Octagon; the prominent building
in the bend of the river on the right is Cambridge House. The
Octagon was added to James Johnston's house in about 1720,
while Marble Hill House, which was built *c*.1724–9 to the
left of Cambridge House, has not yet been begun.

Although essentially topographical in character, Tillemans's
Thames views show a much greater concern with the sky and
with local colour than do those of his predecessors. His
horizontal and rather plain design is enlivened here by a
particularly well-developed foreground that manages a
satisfactory transition to the middle distance, something
early landscape painters found hard to achieve (for instance
Griffier, 101). The figures disporting themselves at a famous
beauty spot are particularly well observed, and populate the
landscape with greater conviction than is usual at this period.

44

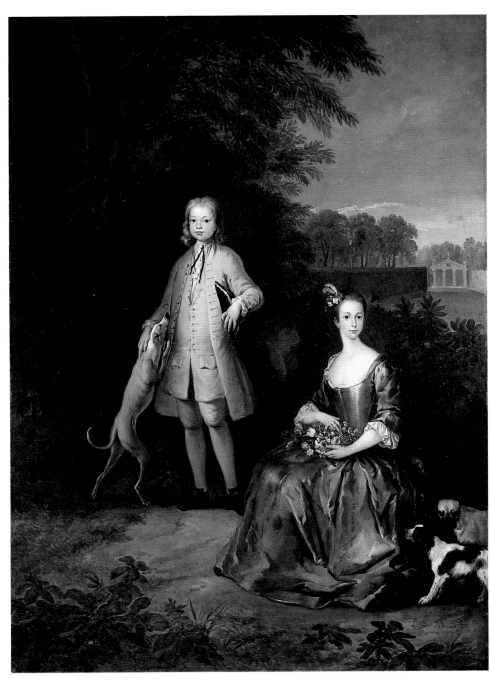

PETER TILLEMANS 1684–1734

45 Portrait of Master Edward and Miss Mary Macro *c*.1733
Inscribed 'Peter Tillemans F' bottom left foreground
Canvas $46\frac{1}{8} \times 34\frac{3}{4}$ (117.2×88.1)
Prov: Painted for Dr Cox Macro, and first recorded at Little Haugh Hall *c*.1734, by descent to the Patteson family, and on permanent loan to the Norwich Castle Museum since 1984
Lit: Raines 1980, pp.30, 58, no.79, pl.19a
Norwich Museums Service (Norwich Castle Museum)

The sitters are Edward (d.1766) and Mary (1719–1775), children of the Rev. Dr Cox Macro (29) and his wife Mary, née Godfrey. The bosky wilderness in which the children are posed is contrasted with the formal garden in the background, in which an avenue of clipped hedges leads to a summerhouse in the classical taste, a contrast of scene to which many fashionable gardens of the day aspired. The children's pet dogs represent the three favourite domestic breeds of the period – a whippet, a spaniel, and a pug.

Although Tillemans painted few portraits, he was evidently quite at ease with conversations on a scale smaller than life like this, a fact which should be borne in mind when considering that he was the teacher of J.F. Nollekens and Arthur Devis.

PETER CASTEELS 1684–1749

46 Still-Life of Flowers on a Ledge 1725
Inscribed 'PCasteels Pinx/1725' bottom left
Canvas $36\frac{1}{2} \times 49\frac{3}{4}$ (92.7 × 126.4)
Prov: ...; bt on the London art market *c.*1960
Trafalgar Galleries

Casteels, who came to England from Amsterdam with his
brother-in-law Tillemans in 1708, became, after the death of
Bogdani in 1724, the leading painter of flowers and bird
pieces, a branch of painting that was for some reason to
remain almost entirely the province of painters from abroad.
Such paintings were usually conceived as part of an architec-
tural setting, as overdoors or chimney pieces, and demand for
them decreased as the taste for more intimate and less formal
interiors grew. This painting has typical overdoor pro-
portions, and with its low vantage point is clearly designed to
be seen from below.

Casteels was well thought of by his contemporaries and
became a Director of Kneller's Academy in 1711, but retired
from painting in 1735 when business grew slack, and became
a calico designer instead.

PETER CASTEELS 1684–1749

**47 Fantastic Still-Life in a Classical
Landscape** *c.*1710–30
Inscribed 'P.Casteels F.' bottom left
Canvas 32½ × 32½ (82.5 × 82.5)
Prov: At Boynton Hall, Yorkshire, since painted, by
descent to J.E. Strickland, sold Boynton Hall sale,
Spencer & Sons 22 November 1950 (386) bt by lender
Exh: The Irresistible Object: Still Life 1600–1985,
City Art Gallery, Leeds, 1985 (14, repr.)
Leeds City Art Galleries

A typical though unusually exuberant example of the kind of
decorative painting used in grander houses throughout the
early eighteenth century. Its perfectly square format betrays
its function as a component part of an architectural setting, as
does its contemporary frame, designed by William Kent.
The painting is known to have been the overmantel of a
chimney piece at Boynton Hall, Yorks. Any one of the
elements assembled here – classical architecture, antique
urns, verdant landscape, game, fowl, hounds or flowers –
would have sufficed for an overdoor, but evidently the more
focal position of a chimney piece required greater abundance.
English painters like Thornhill and Wootton, Marmaduke
Craddock and Lambert ventured into this genre at a lower
level of technical competence, but the style never developed
native roots and remained on the whole the prerogative of
immigrant painters.

47

JOHN STANNEY active 1730

48 Vanitas with Skull and Hourglass 1730
Inscribed 'John Stanney F.A°. 1730' bottom left
Canvas 28½ × 23½ (72.4 × 59.7)
Prov: …; Christie's 2 April 1971 (129), bt Cohen &
Son
Trafalgar Galleries

This painting by Stanney, about whom nothing further
is known, is freely adapted from a 'Vanitas' of 1664 by
Cornelius Gysbrechts (Ferens Art Gallery, Kingston upon
Hull), adding a hunting horn and some details that would
have amused the Monks of Medmenham. It serves to illus-
trate the dependence of the still-life on Dutch seventeenth-
century models and its inability to find a native idiom
throughout most of the eighteenth century. It had practically
no exponents throughout the first half of the century, with
a few exceptions like Charles Collins (a good example,
'Lobster on a Delft Dish', 1738, hangs in Gallery 3), and later
the Smiths of Chichester (186), who concerned themselves
largely with dishes of food, and oddities like Stanney, who
may have been an amateur.

48

JOHN LAGUERRE active 1721, died 1748

49–52 Four Scenes from the Opera of 'Flora, or Hob in the Well' 1720–30
Canvas, each $35\frac{1}{2} \times 36\frac{1}{2}$ (89.5 × 92.5)
Prov: ...; said to come from the Forman Collection; with Sabin Galleries by 1964, bt Paul Mellon, and presented to the lender 1981
Lit: Vertue v, p.68; Whitley 1928, I, p.15; R.S. Kraemer, 'Drawings by Gravelot in the Morgan Library', *Master Drawings*, xx, no.1, 1982, pp.15–16, pls.21a–d
Yale Center for British Art, Paul Mellon Collection, New Haven

49 Hob Taken Out of Ye Well

50 Hob Selling Beer at the Wake

51 Hob Continues Dancing Inspite of his Father

52 Hob's Defence

49

Flora, or Hob in the Well or *Hobb's Wedding* was an adaptation of Thomas Doggett's (d.1721) *The Country Wake* (first performed in 1690) into the comic ballad opera form by John Hippesley in 1730. It was said that Hob in *The Country Wake* was 'Jack' Laguerre's best part 'which he acted with true comic simplicity'.

John (or 'Jack') was the son of the history painter Louis Laguerre (10) and was also, according to Vertue, a gifted painter. However, he preferred the stage and became a successful singer – his father died at the Lincoln's Inn playhouse during a benefit performance for his son. He was also a scenery painter, but being indolent and thriftless, died in want. Vertue wrote on his death that of 'his paintings and drawings for the playhouses – his design of Hob in the well, those prints were remarkable and many were sold.' These designs show a general resemblance to Gravelot's infinitely more elegant illustrations of the text for the 1737 edition, and it is quite possible that both were based on the actual stage performance. For all their crude technique they have a narrative liveliness and concern for natural action on several levels that anticipate, however distantly, Hogarth's narrative cycles like 'The Election'. It is not known if they come from a larger set.

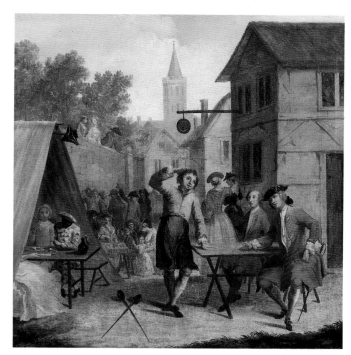

50

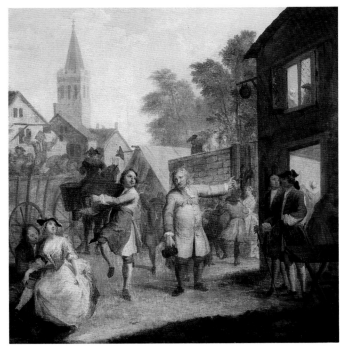

51

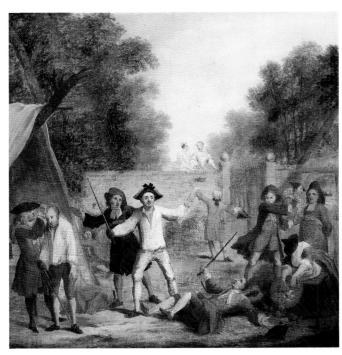

52

53 The Wedding of Stephen Beckingham and Mary Cox 1729–30
Inscribed 'Nuptiae: Stp Beckingham: Argr/ June: 9th: 1729: Wm Hogarth: Pinxt:' lower left
Canvas 50½ × 40½ (128.3 × 102.9)
Prov: Painted for the sitter, and by descent to his grand-daughter Dorothy Charlotte, wife of the Hon. George Montagu; bequeathed by her in 1821 to her half-sister Elizabeth Catherine Gregory; thence to her niece Luisa Beckingham, wife of Edward Taylor; her daughter Emily Octavia, wife of William Deedes of Sandling Park and Saltwood Castle, Kent, and by descent to William Deedes by whom lent to the Whitechapel Art Gallery 1906; ...: James Carstairs by 1926, sold to Knoedler & Co., New York, 1935, from whom bt by lender 1936
Exh: Hogarth, Tate Gallery 1971 (28, repr.)
Lit: Charles Fortescue-Brickdale, 'Notes on Hogarth's Picture of the Wedding ... of Stephen Beckingham and Mary Cox', typescript, 1937, Metropolitan Museum New York; H.W. Williams, *Bulletin of the Metropolitan Museum*, XXXII, 1937, p.30, repr. on cover

Metropolitan Museum of Art, New York. Marquand Fund 1936

This is a formal wedding portrait, representing a solemn moment in the ceremony: the parson, wearing his red doctoral hood, holds his service book inscribed 'of Matrimony', and the bridegroom has his ring ready. The Beckinghams were county gentry with a tradition for going into the law: Stephen Beckingham (d.1756) was admitted at Lincoln's Inn in 1718, and the couple's son Stephen in 1748. The painting is first recorded at the Beckingham country seat at Bourne Place, Kent, soon after 1768, as 'My father's Wedding. Hogarth pinxit'.

We do not know who the other sitters are, but the elderly gentleman in black on the left might be the bride's father, Joseph Cox (1677–1737), Attorney-at-Law at Kidderminster, widowed in 1727. If Hogarth was observing the same conventions here as in the Cholmondeley conversation piece (67) – and the brace of putti emptying the horn of plenty over the bridal couple suggests that he was – then it is quite possible that the lady in blue, standing slightly apart from the group, could represent the deceased mother of the bride. This would explain the carefully painted funerary tablet behind her, which otherwise makes little sense in the contrived setting. This is clearly based on the recently completed interior of St Martin-in-the-Fields, although the actual wedding took place in St Benet's, St Paul's Wharf, on the date inscribed on the painting.

The neatly painted architecture contrasts with the robust handling of the communion rail and carpet below, which suggests that it was painted by an assistant who specialised in architectural details – one would have been readily found in

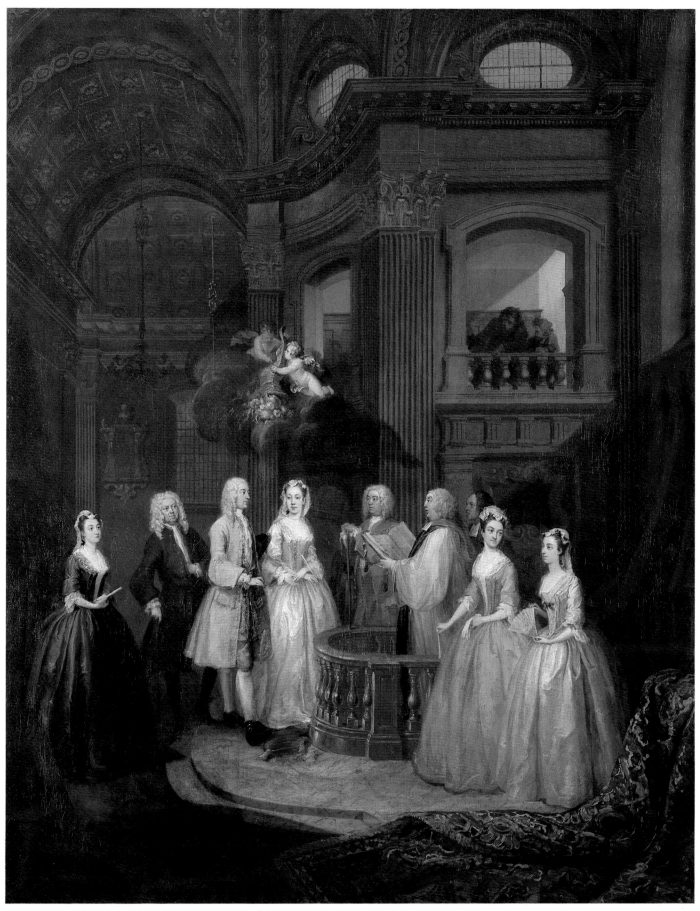

53

the studio of Thornhill, whose daughter Jane the painter had married in March that same year. Certainly the painting does not seem to have been planned as a whole, for the group is lit from a different angle from the architecture, and the charming putti are an afterthought painted right over the architectural background. They help to break up the conventional line of heads at the bottom of a tall architectural space such as is normally seen in the groups of Hamilton and Philips (62 and 60). However, Hogarth's attempt to enliven the composition apparently ran into trouble: the left foreground was originally filled with a kneeling figure arranging the hassocks (which are still there), which for some reason was painted out. This recalls John Nichols's severe criticism of Hogarth in 1782 that 'an artist who, representing the marriage ceremony in chapel, renders the clerk, who lays the hassocks, the principal figure in it, may at least be taxed with want of judgment.' He was probably speaking of the lost marriage scene in 'The Happy Marriage' series, but the fact that such a detail also occurs in the wedding scene of the 'Rake' (78) suggests that Hogarth, frustrated in his intentions in an early commissioned work, subsequently made a point of including such a feature where he had only himself to please.

The freely painted carpet seems to be a later attempt by the artist to introduce some interest into the foreground, and other pentimenti show that the design cost him a considerable struggle.

WILLIAM HOGARTH 1697–1764

54 Horace Walpole aged 10 1727–8
Canvas 17 × 14 (43.2 × 35.6)
Prov: ...; in the collection of Charles Bedford *c.*1800, Grosvenor Charles Bedford sale, Christie's 3 July 1852 (20 as 'Hogarth – Portrait of Horace Walpole aged ten') bt in, offered again at Christie's 1 March 1861

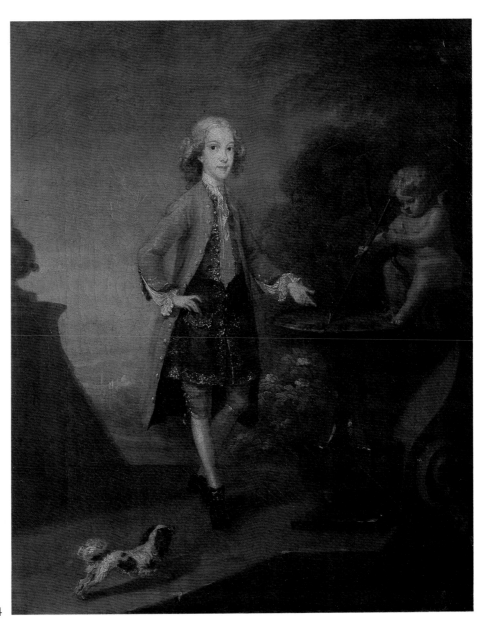

54

(33, attributed to 'Le Mercier') bt Henry Farrer, sold
Christie's 15 June 1866 (83 as by Hogarth) bt King;
...; 5th Earl of Lonsdale, Lowther Castle by 1939,
thence by descent
Lit: C. Kingsley Adams & W.S. Lewis, 'The Portraits
of Horace Walpole', *Walpole Society*, XLII, 1970, p.23,
pl.25
Private Collection

The identity of the sitter is traditional, and Walpole himself
is not known to have ever mentioned being painted by
Hogarth. The style, however, is quite consistent with
Hogarth's known work around 1730, and possibly even
earlier. The boy is pointing towards the numeral x on the
sundial as if to indicate his age, and if the identification were
correct, this would date the painting to 1727, which seems
very early, but not impossible.

Horace Walpole (1717–1797) bought George Vertue's (30
and 71) note-books from his widow in 1758 and used them as
a basis for the first history of British artists, his *Anecdotes of
Painting in England*, begun in 1760 and published 1762–80.
He was a not uncritical but genuine admirer of Hogarth,
whom he described as 'that great and original genius', and a
collector of his works.

JOHN VANDERBANK 1694–1739

55–58 Four Scenes from Don Quixote 1730–7
Panels, each $16 \times 11\frac{1}{2}$ (40.6 × 28.2)
Prov: ...; Grimm(?); anon. sale Christie's 19 July
1985 (91A, repr.)
Lit: H.A. Hammelmann, 'John Vanderbank's
"Don Quixote"', *Master Drawings*, VII, 1969,
pp.3–15; Einberg & Egerton 1987, no.160
Courtesy of Harrari & Johns, London

55 **Don Quixote and Sancho Panza after the
Battle with the Gallant Biscayan (Part I,
Chapter 10)**
Inscribed 'I° Vanderbank f' bottom right

56 **Don Quixote meets the Galley-slaves (Part I,
Chapter 22)**
Inscribed 'I°Vanderbank 17 . . .' bottom right

57 **Don Quixote and the Penitents (Part I,
Chapter 52)**
Inscribed 'I°Vanderbank' bottom left

58 **Don Quixote makes his Will (Part II, Chapter
74)**

This set of four panels belongs to nearly forty known similar
scenes from *Don Quixote* which Vanderbank painted during
the 1730s. They are related to but not direct replicas of some
of the more than sixty illustrations, most of them engraved
by Gerard Vandergucht, which he drew for an edition of
Cervantes's novel published by J. & B. Tonson in the original
Spanish in 1738, and in English in 1742. The bulk of the
drawings (the earliest dating from 1723) is in the British
Museum and in the Pierpont Morgan Library, New York,
but the panels are more widely dispersed: examples belong to
the Tate, Manchester City Art Gallery, York Art Gallery,
the Huntington Art Gallery, San Marino, Marble Hill
House, Twickenham, and various private collections. Quite
a few can be traced back to the collection of the nineteenth-
century book-seller James Toovey. Hogarth was to have had
a share in illustrating Tonson's project, but for some reason
his six plates were not used.

It is not quite clear why Vanderbank painted such a vast
set over so long a period, except that perhaps they sold well,
or were part of some extensive decorative scheme. The artist,
whom Vertue considered to be the most able painter after the
death of Kneller, led a dissipated life and was constantly in
debt; he may have found it easy to paint small panels from his
already extant designs for a quick sale. Vertue also reported
on his death that in the last years of his feckless life he was
fortunate to have a landlord willing to have his rent paid in
anything Vanderbank cared to paint, in particular 'Storys of
Don Quixot'.

55

56

57

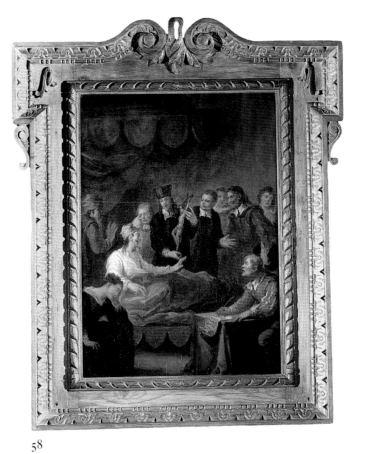

58

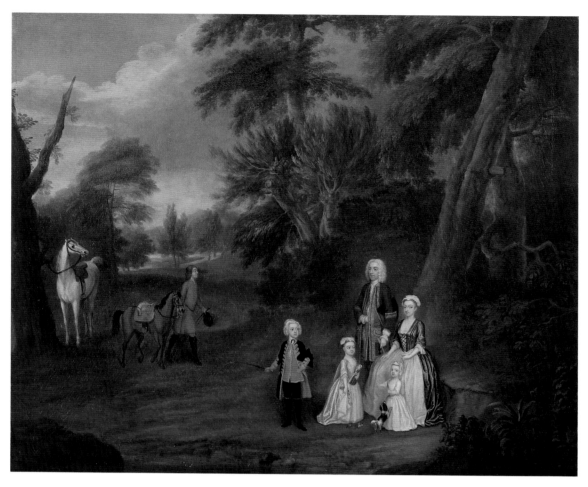

CHARLES PHILIPS 1708–1747

59 Thomas Hill of Tern and his Family in a Landscape 1730
Inscribed 'CPhilips:pinxit./1730' lower left
Canvas 34½ × 43½ (87.5 × 110.5)
Prov: Painted for Thomas Hill of Tern, by descent to
Thomas Noel-Hill, 8th Lord Berwick, by whom
bequeathed with the contents of Attingham Park to
the National Trust 1947
Lit: Dorothy Wolley, 'Thomas Hill of Tern,
1693–1782. A Preliminary Sketch', unpublished MS
1986, Berwick Papers, Shropshire Record Office;
Attingham Park, National Trust guide, 1985, p.53,
no.117

National Trust, Attingham Park, Shropshire

The sitters are Thomas Hill of Tern Hall (1693–1782), his
first wife Anne Powis (d.1739), his surviving son Richard
(d.1734) and daughters Margaret and Ann.

Thomas was the son of Thomas Harwood, a prosperous
Shrewsbury draper, but took the name Hill (like several
other relatives) to fall in with the plans of his uncle, the Hon.
and Rev. Richard Hill of Hawkstone, who, to quote Dorothy
Wolley, 'having no children of his own, devoted his out-
standing financial acumen to building up estates and wealth
specifically to advance the children of his brother and sisters'.
Thomas was 'bred a merchant' (banker), and was a man
entirely in his uncle's mould. After Eton he was sent on a tour
of Europe in 1712 with instructions from his uncle to employ
himself 'in reading, writing, arithmetique and in learning the
language of ye town where you are.' In fact, Thomas became
perfectly fluent in French, which stood him in good stead in
his lifelong involvement in continental investments and
business travels abroad. His long life was a singleminded
pursuit of wealth and influence, with little room for any
outside interests except horses and a good table. His
continental contacts did nothing to stimulate an interest in
painting, architecture or connoisseurship, and he continued
to live in London, and in the modest Queen Anne house of
Tern Hall, to which almost nothing was done for fifty years.
His was an unflamboyant personality that went well with the
patronage of native talent like Philips.

Typically for the times, eight of the children of his first
marriage died young, including his beloved first great
dynastic hope, 'pretty Dick', shown here. It fell to his son
Noel (1745–1789) to remodel Tern in the 1780s into the
grandiose Attingham Park we know today and finally to bring
a peerage into the family as the 1st Lord Berwick.

60

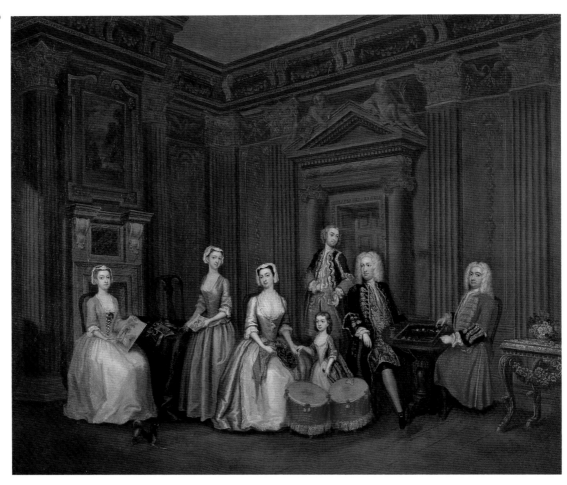

CHARLES PHILIPS 1708–1747

60 Algernon, 7th Duke of Somerset, with his Family 1732
Inscribed 'C.Philips pinxit 1732' bottom left
Canvas $29\frac{1}{2} \times 36$ (75 × 91.5)
Prov: Painted for the principal sitter, thence by descent
Exh: The Conversation Piece in Georgian England, Iveagh Bequest, Kenwood, 1965 (36); *Noble Patronage,* Hatton Gallery, Newcastle upon Tyne, 1963 (27, pl.x)
Lit: Edwards 1954, pp.66–7, 171, no.94, repr. in col. as frontispiece

The Duke of Northumberland

Seated at the games table are, according to an old inscription, Col. Tomkins Wardour in scarlet, and Algernon Seymour, 7th Duke of Somerset (later 1st Earl of Northumberland) in blue. The little boy at the kettle-drums is his son Lord Beauchamp (1724–1744), with Col. Browne standing behind. In the centre, Frances, Duchess of Somerset is seated with some needlework; beside her stands, botanising, her daughter Elizabeth, later Duchess of Northumberland. She married Sir Hugh Smithson, Bart., the patron of Canaletto (see 176).

The lady in yellow, seated on the left, is said to be Miss Herbert, who married a Mr Prigot in Holland. It is surprisingly rare to see a bowl of fresh cut flowers, as on the table here, in this kind of interior.

Philips never attempted any kind of 'business' that might disturb the static nature of his compositions, and relied for effect on neatness and on bright and cheerful colouring which must have been the key to his popularity. It was a style that was later effectively developed by Devis. This is generally considered to be Philips's best work.

MARCELLUS LAROON 1679–1772

61 A Nobleman's Levée *c.*1730
Canvas 37 × 30 (94 × 76.2)
Prov: …; described by Sir John Hawkins in 1776
without mentioning owner; …; ?John Tomlinson,
sold Christie's 13 June 1806 (88 as Hogarth 'The Levy
of a Prime Minister'); …; recorded at Southill Park,
Biggleswade, 1815; thence by descent
Exh: Marcellus Laroon, Aldeburgh and Tate Gallery
1968 (10, repr.)
Lit: R. Raines, *Marcellus Laroon*, 1967, pp.78–9, 114,
no.13, repr. in col. as frontispiece
Private Collection

Laroon's main career was in the army and the bulk of his
paintings in oil date from after he retired with the rank of
Captain in 1732. He had been trained partly by his father, a
painter of the same name (d.1702) and partly at Kneller's
academy which he attended 1712–15, while on half-pay from
the army. He was also something of a musician and a singer,
and a boon companion of the painters and actors who lived
around Covent Garden. He developed his own unusual,
rather wooden technique, which nevertheless borrowed
many elements from the French *fête galante* tradition, as well
as from the genre scenes of Teniers.

According to Vertue, he painted for his own pleasure,
which may explain why none of his conversations appear to
be of recognisable clients or settings, although many of them,
including this one, look as though they ought to be. The only
certain identification (from a self-portrait in the Mellon
Collection) would seem to be that of the artist himself looking
over the right shoulder of the red-coated hussar on the left.
The grandee wearing the Garter sash and combing his wig
has been identified as the Duke of Marlborough, the Duke of
Buckingham and as the Prince of Wales, while Sir Oliver
Millar has suggested John, Duke of Montagu, at Montagu
House. Be that as it may, the interior is a fine representation
of the disposition of various kinds of paintings in a noble
house, from the marine overdoor, decorative landscape
overmantel and ancestral portraits, to the Baroque Old
Master and the huge battle piece on the left. It shows Laroon
fitting comfortably, though in his own idiosyncratic way,
into the contemporary conversation piece style of Gawen
Hamilton and Charles Philips, while showing an interest
in informal individual actions that would not be alien to
Hogarth, although Laroon never had the impulse to moralise.

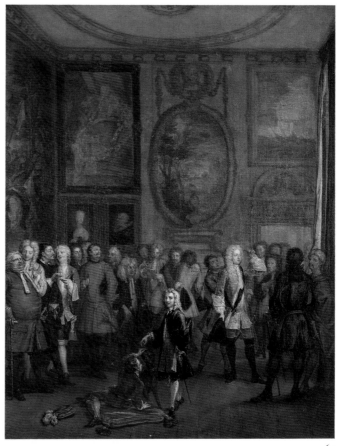

61

GAWEN HAMILTON *c.*1697–1737

62 The Porten Family *c.*1736
Canvas 49½ × 39½ (125 × 100.4)
Prov: Presumably painted for James Porten, and by
descent to his son Sir Stanier Porten, thence by family
descent to the Rev. Thomas Burningham by 1888,
when lent to the R.A.; …; Christie's 24 July 1953
(20 as by Hogarth) bt Bellesi; …; Mortimer Brandt
Gallery, New York, from whom bt by the lender 1953
Exh: R.A., Winter 1888 (45 as by Hogarth)
Lit: Dictionary of National Biography, 1909, XVI,
p.167 under Sir Stanier Porten

*Museum of Fine Arts, Springfield, Massachusetts. The
James Philip Gray Collection*

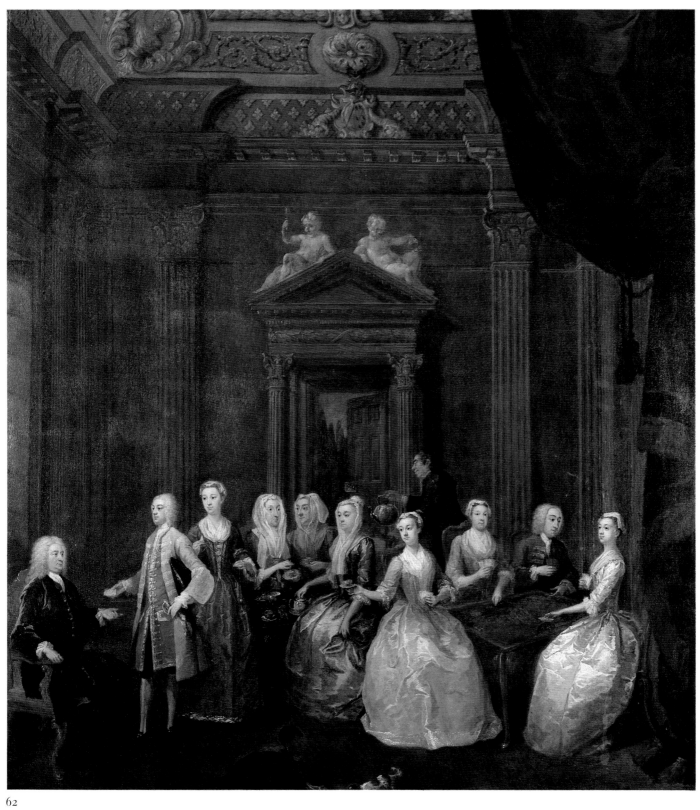

62

The gentleman seated on the left is James Porten, a London merchant of Huguenot descent, who resided in Putney until his business failed in 1748. His only son Stanier (knighted in 1772, died 1789) entered the diplomatic service and eventually became Keeper of State Papers at Whitehall. He is seen standing on the left, holding a letter addressed to his father (a black boy is trying to rescue another letter from the dog in the foreground).

Porten's younger daughter Judith married Edward Gibbon of Buriton in June 1736. It is possible therefore that they are the couple on the right, and that their marriage or engagement prompted the commissioning of this picture. They were the parents of Edward Gibbon (1737–1794), the historian, who spent some part of his childhood at his grandfather's house at Putney, and later lodged in the boarding house his eldest aunt Catherine set up for Westminster School after her father's ruin. One would like to assume that she is the efficient looking young woman with a knotting shuttle beside Stanier, in which case the middle daughter, who later married Mr Darrel of Richmond, would be the young lady seated at the card table, holding out a cup. This arrangement would echo the four children's heirarchic positions within the family in terms of their proximity to their father. Such formality would be in keeping with the deliberately grandiose setting which, though unlikely to be real, expresses the family's aspirations, with its coat-of-arms between two horns of plenty above the doorway, which itself is topped by putti emblematic – somewhat ironically in the circumstances – of prudence (holding a mirror) and temperance (pouring a jug of water).

The painting is typical of Hamilton's handling of large figure groups, which are always agreeably well-mannered but show little invention (compare this, for instance, with Hamilton's most important commission, the Earl of Strafford group of 1732, no.63).

GAWEN HAMILTON c.1697–1737

63 Thomas Wentworth, Earl of Strafford, and his Family c.1732
Canvas 37 × 33 (94 × 84)
Prov: Presumably painted for the sitter's family, thence by descent
Exh: English Taste in the Eighteenth Century, R.A. 1955 (45)
Lit: Edwards 1954, p.170, no.92, repr. Ottawa version
Private Collection

The main sitter is Thomas Wentworth (1672–1739), 3rd Baron Raby and 1st Earl of Strafford, a distinguished soldier under Marlborough and for a time British Ambassador to Berlin. He is shown with his wife Anne, daughter and heiress of Sir Henry Johnson of Bradenham, his son William, and his three daughters Anne, Lucy and Henrietta.

This painting is generally considered to be an autograph replica by Hamilton of a painting, signed and dated 1732, which is now in the National Gallery of Canada, Ottawa – family portraits were often commissioned in multiples for presentation to family and friends. This was certainly one of Hamilton's most important works, noted by Vertue in 1732 as 'a family piece of the present Earl of Strafford himself and his Lady. his son and daughters in the Conversation manner. the disposion genteel & agreeable – the Countenances like & freely pencilld, draperys Silks & decorations well toucht & disposd. upon the whole this is esteemd a master piece of Mr. Hamiltons painting: who as much like Hogarths works as can be. (& this he did for Reputation being the Earls great generosity to give him ten guineas only for it –)'. As the last part of the sentence was inserted later, it is just possible that Vertue got it slightly wrong and the low payment was actually for the replica.

Although the formula is the same as in more bourgeois works like 'The Porten Family' (62), what must have impressed here is the daring glimpse of a magnificent Palladian staircase hall in the background, resplendent with painted trophies and *trompe l'oeil*, and servants chatting on the staircase.

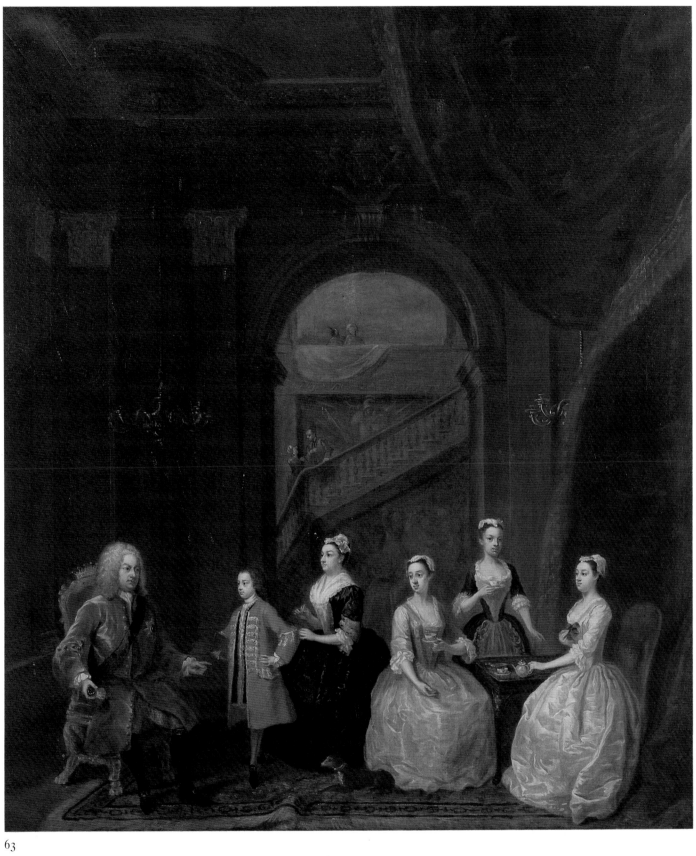

63

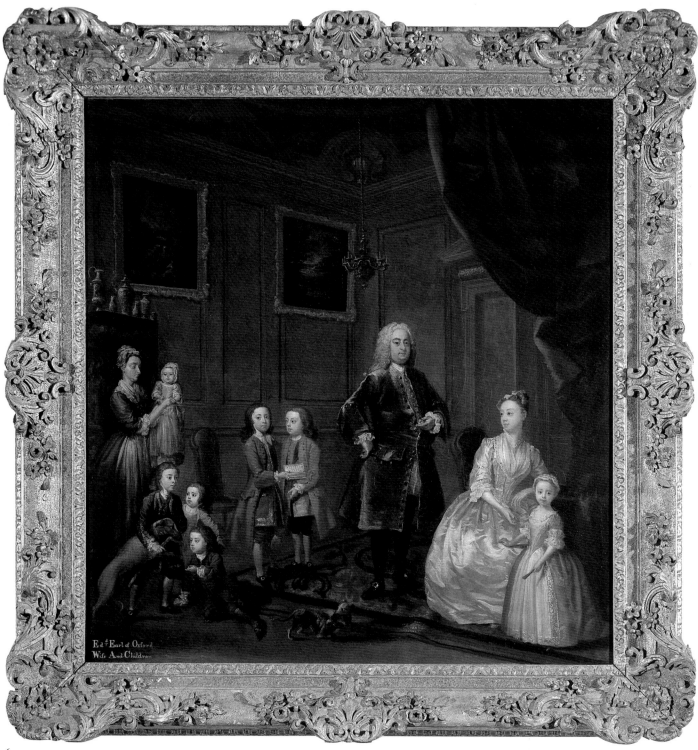

64

64 Edward Harley, 3rd Earl of Oxford and his Family 1736
Inscribed 'Ed^d Earl of Oxford/Wife And Children' in later hand, bottom left
Canvas 34 × 33 (86.5 × 83.8)
Prov: Presumably painted for the sitter, thence by descent
Exh: Art Treasures of the Midlands, City Art Gallery, Birmingham, 1934 (261, as by Hogarth)
Lit: Vertue I, p.19, III, pp.48, 61, 71, 81
Edward Harley Esq

In the centre of the group stands Edward Harley (d.1755), later 3rd Earl of Oxford, beside his wife Mortimer, daughter of John Morgan of Tredegar. The five boys are Edward (1726–1790), later 4th Earl; John, later Bishop of Hereford; Robert; William, later Prebendary of Worcester; Thomas, Mayor of London in 1768 and builder of Berrington Hall, Leominster. The two girls are Sarah (1731–1737) and, in the arms of a splendid nanny, Martha, born in 1736.

Like most of Hamilton's works, this one has been attributed to Hogarth in the past, in this case with more justice than usual, for this must surely be one of his liveliest and most attractive compositions. The figures are not overwhelmed by their setting (like 62), but share a convincing interior with a few prized possessions. The children and pets are allowed more natural movement than elsewhere, and the characters are particularly sensitively drawn. One can understand why Vertue felt that Hamilton 'may well be esteemed a rival to Hogarth . . . having as much justness, if not so much fire'. In fact, on Hamilton's death in October 1737, Vertue wrote that 'it was the opinion of many Artists . . . that he had some peculiar excellence wherein he out did Mr. Hogarth in Colouring and easy gracefull likeness'. What Vertue was getting at was that Hamilton could always be relied upon to be, as he wrote earlier, 'genteel & agreeable', well-mannered in other words, where Hogarth was often driven to challenge some aspect of the conventional idiom, with varying success.

Vertue had generous patrons in two successive Earls of Oxford, and was well acquainted with the family of the third, so that it may well have been his warm praise of Hamilton's qualities that led to this commission.

(*Reproduced before cleaning*)

65 'A Conversation of Virtuosis at the Kings Armes' (A Club of Artists) 1734–5
Inscribed with the names of the sitters as given below
Canvas 34½ × 43⅞ (87.7 × 111.5)
Prov: Said to have been commissioned by Hamilton's fellow artists, and first mentioned by Vertue in an unfinished state in 1734; won in a raffle by Joseph Goupy, who reputedly sold it to the Prince of Wales, but possibly the 'piece in oil by Hamilton with portraits by several artists' mentioned by Walpole in an untraced Goupy sale in March 1765; . . .; recorded at Mount Morris, Horton, Kent (seat of the Robinson family) 1808, and by descent to Miss Elizabeth Montagu (great-grand-daughter of Mathew Robinson), from whom bt by the lender 1904
Lit: Kerslake 1977, pp.340–2
National Portrait Gallery

The sitters can be identified by the inscriptions near them (reinforced by a later hand, sometimes incorrectly) as follows (from left to right): 'Vertue G', in brown, holding a book (George Vertue, 1683–1756, engraver and antiquary); 'Hyssing', in grey, leaning on back of chair (Hans Hysing, 1678–1752/3, painter); 'Dahl', in brown, seated, holding a landscape drawing (Michael Dahl, 1656–1743, painter); 'Thomas Aht' (originally probably 'Art'), seated behind table, in blue (William Thomas, active 1722–37, architect); 'Gibbs (?Ar)', in grey, holding a rolled paper (James Gibbs, 1682–1754, architect); 'J. Gouppy', in brown, gesturing left (Joseph Goupy, *c*.1680–*c*.1770, painter and etcher); 'Robinson', in grey coat with silver lace, seated, holding a pen (Mathew Robinson, *c*.1694–1778, amateur and virtuoso); 'Bridgman/Gar;', in light blue, seated, leaning to right (Charles Bridgeman, died 1738, landscape architect); 'Barren', in pale brown, holding a scroll and looking to left (Bernard Baron, 1696–1762, engraver); 'Woolet' (originally 'Wooton'), in brown coat and green gold-edged waistcoat (John Wootton, *c*.1686–1765, landscape and animal painter), resting a hand on the shoulder of 'Rysbrac St', in dark grey, holding dividers and one hand on an antique female bust (John Michael Rysbrack, *c*.1693–1770, sculptor); behind the bust Hamilton, holding brush and palette (without inscription); and lastly 'Kent', in brown, holding dividers (William Kent, 1684–1748, painter and architect).

Vertue described this painting in 1734 with great enthusiasm as a 'Conversation of Virtuosis that usually meet at the Kings Armes. New bond Street a noted tavern. is truely a Master piece as far as is done, truely shows him a Master of Art.' It was commissioned 'in the Interests of Mr. Hamilton', and each sitter is said to have paid four guineas; the completed picture was then raffled, and fell to Goupy. In this select gathering of leading artists of the day Hogarth is notable by his absence, but perhaps that was to be expected

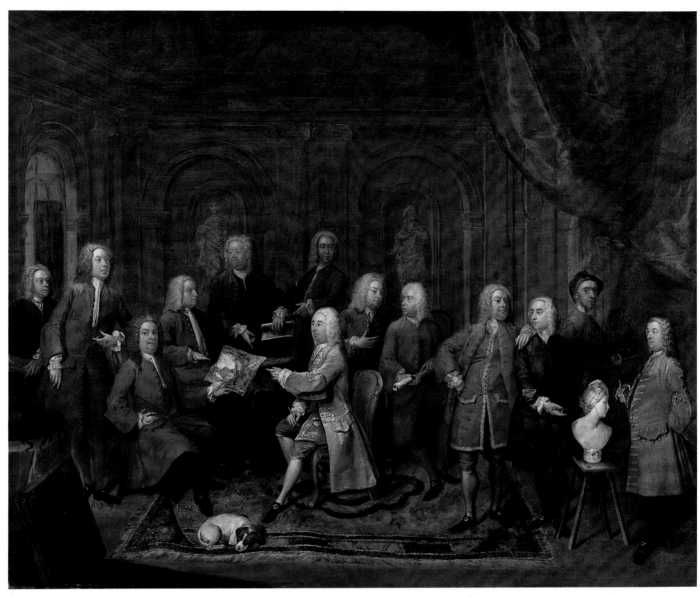

65

in a group which included several Catholics and Tory sympathisers and whose aim was to promote his chief rival Hamilton.

WILLIAM HOGARTH 1697–1764

66 The Jones Family *c.*1730–1
Canvas $27\frac{1}{2} \times 35\frac{1}{2}$ (69 × 90)
Prov: Commissioned by Robert Jones of Fonmon 1730; first recorded at Fonmon in 1743, thence by descent
Lit: J. Steegman, *Portraits in Welsh Houses*, 1962, II, p.94, pl.16A; A.D. Fraser Jenkins, 'The Paintings at Fonmon Castle', *Glamorgan Historian*, VII, 1971, pp.59–71

Ann Lady Boothby, Fonmon Castle

This is presumably the 'Family of five figures [ordered by] Mr. Jones, March, 1730' which Hogarth included in his list of unfinished paintings on 1st January 1731 (British Library Add MS 27995, folio 1). It is also probably '1. The Family Peice, 2 feet 4 Inch? in Length, 3 feet in Breadth' in the inventory of paintings at Fonmon Castle compiled in November 1743 after the death of Robert Jones. A note appended to the inventory adds that 'Mrs. Jones . . . says ye family peice cost about 23 guineas' (Glamorgan Record Office D/D F F/190).

Portrayed are Robert Jones II (1706–1742) of Fonmon, standing, wearing a brown coat and blue waistcoat. Seated on his left, dressed in dark blue, is his mother Mary Edwin (1682–1756), widowed since 1715, leaning on the rim of a fountain in a rocky niche, with a spaniel for company. Beside him stands his elder sister Mary (d. *c.*1760), while his younger siblings Oliver (d.1736) and Elizabeth (d.1737) are seated on the left. Behind them is a not entirely compre-

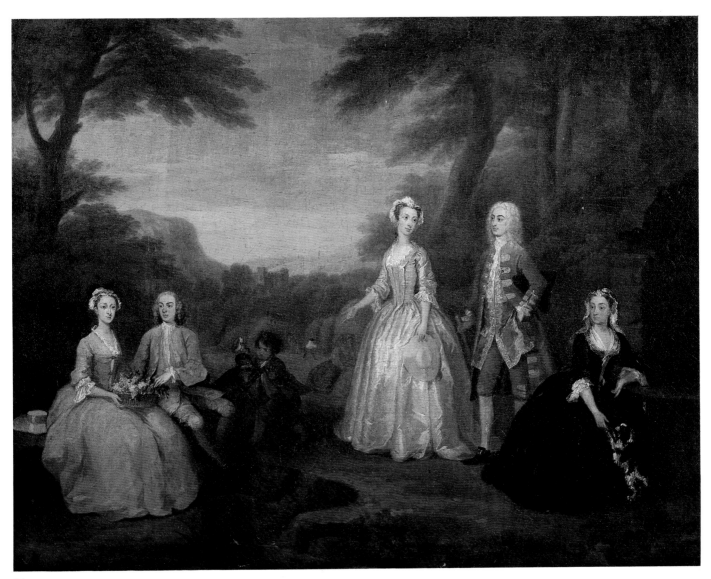

66

hensible scene of a barefoot boy apparently trying to recapture a monkey that has slipped its collar (or stolen his lunch?). The company is gathered in rural retirement on the banks of a tiny stream that spills out from the fountain, against a background of haymakers working and disporting themselves in the meadows. In the distance is a mountainous impression of Wales, and a crenellated structure that is not unlike Fonmon even as it looks today: Hogarth presumably worked up the background from descriptions or a rough sketch provided by the owner, for it is unlikely that the commission would have taken him to Wales.

This painting shows Hogarth's growing ability to let his figures occupy their space with greater assurance and more movement than they did, for instance, in no.53, as well as his natural delight in telling detail.

WILLIAM HOGARTH 1697–1764

67 **The Cholmondeley Family** 1732
Inscribed 'W Hogarth Pinxt 1732' on base of column, lower right
Canvas 28 × 35$\frac{3}{4}$ (71 × 90.8)
Prov: Painted for Viscount Malpas, later 3rd Earl of Cholmondeley, thence by descent
Exh: Hogarth, Tate Gallery, 1971 (42, repr.); *The Treasure Houses of Britain*, National Gallery of Art, Washington, 1985–6 (163, repr. in col.)
Lit: Millar 1963, p.183, no.555; Paulson 1971, I, pp.305–6, fig.109
The Marquess of Cholmondeley

The group was commissioned by George Cholmondeley, Viscount Malpas, later 3rd Earl of Cholmondeley (1702–1770), who is seen seated in the centre in a blue coat, wearing

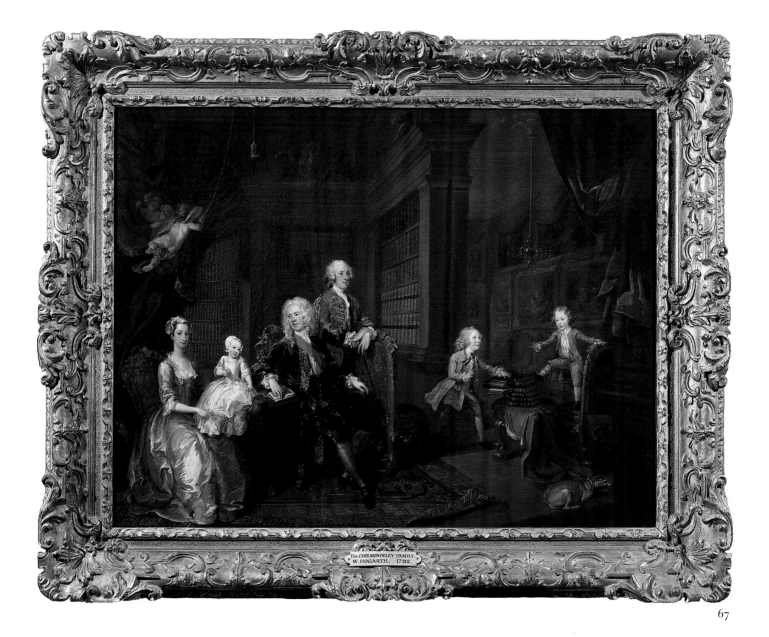

the riband of the order of the Bath. He turns towards his wife Mary (1705–1731), daughter of Sir Robert Walpole, who holds their youngest son Frederick (d.1734). Behind him, wearing a red military coat, stands his brother James (1708–1775), a Colonel of the 34th Regiment of Foot, who later became a General. He appears to be watching the antics of Lord Malpas's two young sons, George (1724–1764), his heir, and Robert (1727–1804), who entered the Church and became Rector of St Andrew's, Hertford. Robert married Mary Woffington (sister of the famous actress Peg Woffington), whom Hogarth was to paint in the costume of Mary Queen of Scots in 1759 (Petworth).

The painting was probably commissioned in memory of Lady Malpas, who died of consumption in France late in 1731; her body was lost in a shipwreck while being conveyed home in April 1732. Her stiff pose shows that Hogarth copied her likeness from another painting, and according to a time-honoured convention her other-worldly status is marked by the putti hovering over her head. As in Hamilton's con-

versations (62), the family coat of arms is set high above Lord Malpas, and if the painting were cut off at this point, it would be a fairly conventional work of the period. What makes it unusual is Hogarth's determined bid to introduce life into the picture in the form of the playing boys, a display of violent action that few painters of the day would have dared to tackle, least of all in a work with as serious a burden as this one. Even the dog is unconventionally posed, and it is difficult to say whether it is shrinking away from the ghostly presence, or merely fed up with the noise. The background is probably a distillation of Lord Malpas's library and picture collection at his house in Arlington Street.

The picture must have given satisfaction, for in the following year Hogarth was asked to paint the heads of Lord Cholmondeley, as Lord Malpas had now become, the Prince of Wales, and others in a large sporting piece by Wootton in the Royal Collection, at 5 gns a head. The Earl's head in it is so close to this picture that it has been suggested that both were done from the same sitting.

WILLIAM HOGARTH 1697–1764

68 A Performance of 'The Indian Emperor or The
 Conquest of Mexico by the Spaniards' 1732–5
Canvas 51½ × 57¾ (131 × 146.7)
Prov: Commissioned by John Conduitt in 1732, and
still incomplete in 1735; probably by descent to his
daughter Catherine, Lady Lymington; sold Heath's
Rooms 20 December 1750 (as 'Persons of Quality
Acting a Play'), together with bust of Newton; ...;
possibly acquired by Lady Caroline Lennox, 1st Lady
Holland; recorded in the collection of the 2nd Lady
Holland in 1778, thence by descent
Exh: The Georgian Playhouse, Hayward Gallery 1975
(6, repr.)

Lit: Paulson 1971, I, 301–5, 540–1 nn.1–5, pls.107 a, b;
Webster 1979, pp.79–80, 84–5, repr. in col.;
F. Haskell, 'The Apotheosis of Newton in Art', *Past
and Present in Art and Taste*, New Haven 1987, pp.1–5
Private Collection

The painting commemorates an important event in the
family of John Conduitt (1688–1737), Master of the Mint. In
1731 Dryden's heroic interpretation of the Spanish conquest
of Mexico, *The Indian Emperor*, was revived at Drury Lane,
and the Theatre's manager Theophilus Cibber coached
Conduitt's only child Catherine and a number of children of
some very distinguished friends to perform the play privately
to a small and select audience at Conduitt's house in Great
George Street. It was such a success that the children were

68

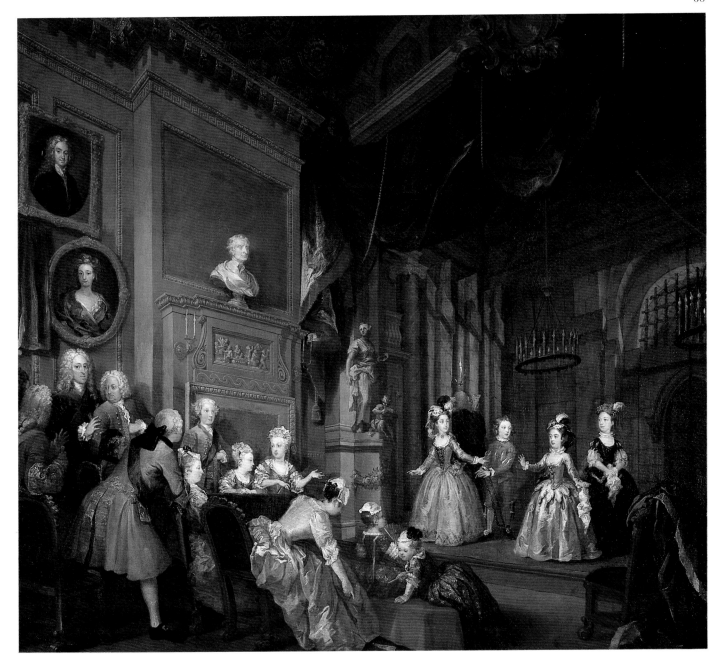

68 **A Performance of 'The Indian Emperor or The
 Conquest of Mexico by the Spaniards'** 1732–5

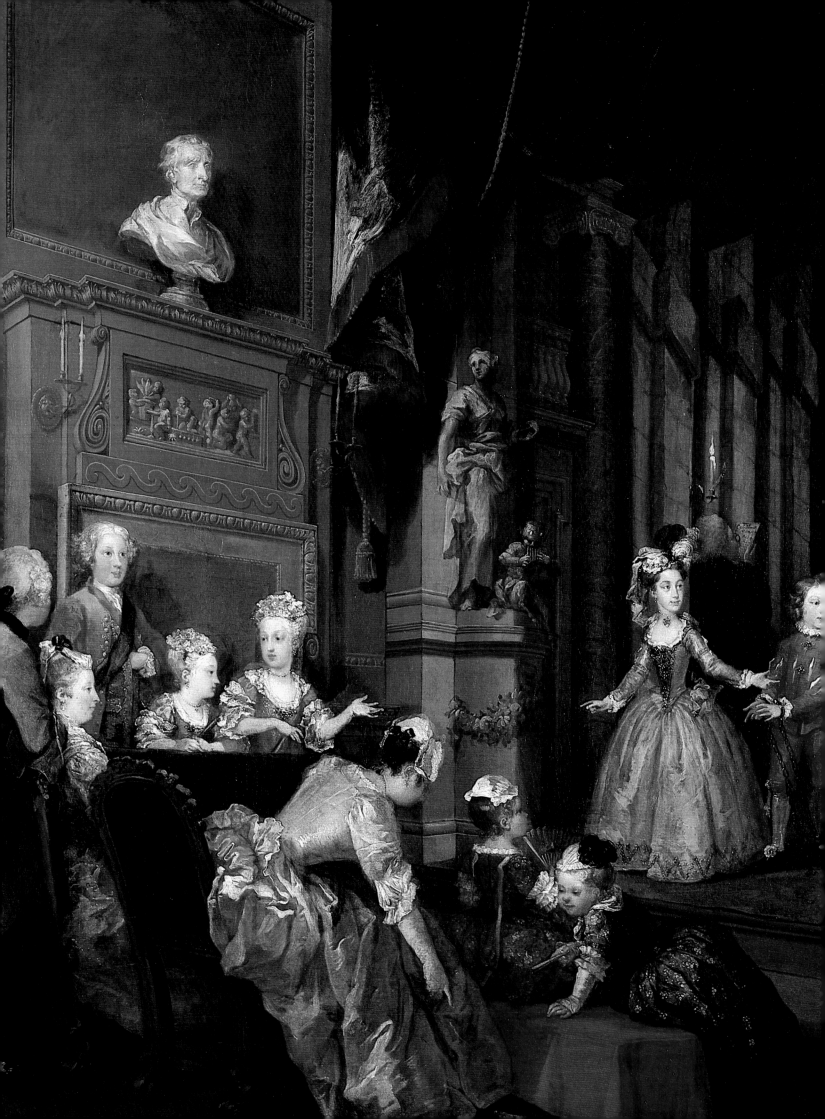

asked to repeat it before the King and Queen at St James's Palace on 27 April 1732. Family correspondence shows that by then Conduitt had already commissioned this painting from Hogarth, who was still working on it in 1735.

The sitters are identified from an engraving made by Boydell in 1791, based probably on family information. The focus is on the children: Catherine Conduitt is the girl in black on the right, Cortez is played by the Earl of Pomfret's son Lord Lempster, with his sister Lady Sophia Fermor (in yellow) on his right, and the daughter of the Duke of Richmond, Lady Catherine Lennox (later the 1st Lady Holland) on his left. Dr Desaguliers, the distinguished mathematician and friend of the family, is acting as prompter from the wings.

In the audience, the place of honour beneath the chimney overmantle is given to the royal children, William, Duke of Cumberland, and the two little Princesses Mary and Louisa. The lady in white in the foreground is their Governess Mary, Lady Deloraine, instructing one of her two small daughters to pick up her dropped fan. The Duke of Richmond leans on the back of his wife's chair, while the Earl of Pomfret, wearing the red sash of the order of the Bath, speaks to a man traditionally identified as Thomas Hill, Secretary to the Board of Trade and a friend of the family. The tall Duke of Montagu stands with his back to the wall.

The host and hostess are modestly present only as portraits, as is the most distinguished member of their family, the recently deceased Sir Isaac Newton, whose bust, possibly by Roubiliac, dominates the room. Conduitt had been his assistant and friend, had married his favourite niece Catherine, succeeded him as Master of the Mint in 1727, and became his first biographer. As Francis Haskell points out, he was a learned man with a penchant for devising elaborate and precise programmes to commemorate his world-famous uncle: the bas-relief below the bust, showing boys with various attributes symbolic of Newton's achievements, is practically identical with the one he sketched out for Rysbrack's monument to Newton in Westminster Abbey, which had just been completed in 1731. It is more than likely that the complex theme of this painting was devised by him also. For Hogarth it was a chance to be associated, as his father-in-law Sir James Thornhill had been, with the family of the greatest Englishman of his time, as well as with circles of the highest court patronage. The challenge stimulated him to produce one of the most beautiful and original masterpieces of the early British School.

PHILIP MERCIER ?1689–1760

69 **'The Music Party': Frederick, Prince of Wales, and his Sisters** *c.*1733
Canvas 30½ × 22½ (77.5 × 57.1)
Prov: ...: W.E. Biscoe of Holton Park, Oxford, sold Christie's 20 June 1896 (6) bt Davis; ...; Lord Astor by 1942, when bequeathed to the lender
Lit: Millar 1963, pp.174–5; Kerslake 1977, pp.338–9; J. Ingamells & R. Raines, 'A Catalogue of the Paintings, Drawings and Etchings of Philip Mercier', *Walpole Society*, XLVI, 1978; *Handel*, National Portrait Gallery, 1985, pp.142–3, no.112 (for National Portrait Gallery version)
National Trust, Cliveden

The painting shows Frederick, Prince of Wales (1707–1751) playing the cello, in the company of his three eldest sisters, generally identified (from left to right) as Anne, Princess Royal (1709–1759), at the harpsichord, Princess Caroline (1713–1757) with a mandora, a form of lute, and Princess Amelia (1711–1786), listening, with a volume of Milton in her lap. In the background is the Dutch House at Kew, the home of Princess Anne before her marriage to Prince William of Orange in 1734.

69

A smaller version of this painting in the National Portrait Gallery is signed and dated 1733; in a third, unsigned, variant which has been in the Royal Collection since at least 1767, the group has been transposed into the Banqueting House at Hampton Court. All three are likely to be very close in date.

As the Prince was on notoriously bad terms with his sisters and is said not to have been on speaking terms with Princess Anne throughout 1733, the reasons for commissioning several versions of this group are not clear, unless it be a case of keeping up appearances. It is factual in so far as the Prince learned to play the bass-viol in 1732–3 with great enthusiasm, and contemporaries describe him playing the violoncello (shown here) to his staff at Kensington in the summer of 1734.

Mercier had painted full-lengths of all the Princesses in 1728, and taught painting to Princess Anne; in 1728–9 he was appointed Painter, Page of the Bedchamber and Librarian to the Prince of Wales. There must have been many members of the royal household who had dealings with several of the warring members of the royal family and who may have wanted a memento that showed them in apparent harmony with each other. Be that as it may, the variations on this theme do demonstrate that for all its seemingly naturalistic informality, the conversation piece could be a highly artificial and contrived object.

70

JOHN THEODORE (Dietrich) HEINS Senior
1697–1756

70 A Musical Party at Melton Constable 1734
Inscribed 'Heins.Fec: 1734' bottom left under empty chair
Canvas 40 × 50 (101.5 × 127)
Prov: Family descent since painted
Exh: *Music and Painting*, Castle Museum, Norwich, 1961 (11, repr.)
Lit: D. Singh, *Portraits in Norfolk Houses*, 1927, II, p.19, repr.; T. Fawcett, 'Eighteenth Century Art in Norwich', *Walpole Society*, XLVI, 1978, pp.71–90
Private Collection

Heins was a painter of German origin who settled in Norwich in about 1720 and was its leading resident portrait painter until his death. He had a son of the same name (d.1771) who also painted, but was chiefly a miniaturist and topographical etcher. Like Verelst (107), he was another of those artists from abroad who adapted readily to the British vogue for small informal group portraits in the 1730s and 40s.

Duleep Singh (1927) identified the sitters as follows, though it is not quite clear on what grounds: '(1) In the centre, Sir Jacob Astley in blue, playing a violoncello. (2) Mr. Cobb, seated, in grey, playing a violin at the same desk. (3) Mr. Ansell, in grey, standing behind him and playing the double bass. (4) Capt. Jasper, in brown (back centre) at the harpsichord. (5) Mr. Whiteley, in black, looking over him towards the sinister. (6) Mr. Rhemish, in grey, playing 1st flute on dexter side of harpsichord. (7) Mr. Pfeffer, also in grey and profile to the sinister, playing 2nd flute. (8) Rev. Mr. Wall, seated on the sinister side in black without wig, playing a violin. (9) Heins the artist, standing in green next to the chair and looking towards the dexter. (10) Rev. Mr. Browne, seated, profile towards sinister, and on that side of No.9 playing a violin. (11) Capt. Philip Astley, in red, seated in front of all, taking snuff. (12) Mr. Humphrey Cotton, in drab, in the sinister corner, full face, playing a violin. (13) Rev. Mr. Shaw at the same desk, in black, playing the violin. (14) Rev. Thos. Astley standing further towards the sinister, in black. (15) Mrs. Thos. Astley, behind on his right, in blue, seated. (16) Child, Edward Astley. (17) Lucy, Lady Astley. (18) Miss Isabella Astley. (19) Miss Blanche Astley. (20) Elizabeth, Lady Astley.'

If correct, the list shows that all members of this considerable orchestra are amateurs, and demonstrates how seriously cultivation of the polite arts was taken among the local gentry. Until the 1730s Norwich was the largest city after London, and its wealth supported a more wide-ranging artistic life than did most other county towns. The Astleys of Melton Constable had German family connections themselves, which may explain the special favour extended to the artist, who is part of the assembly.

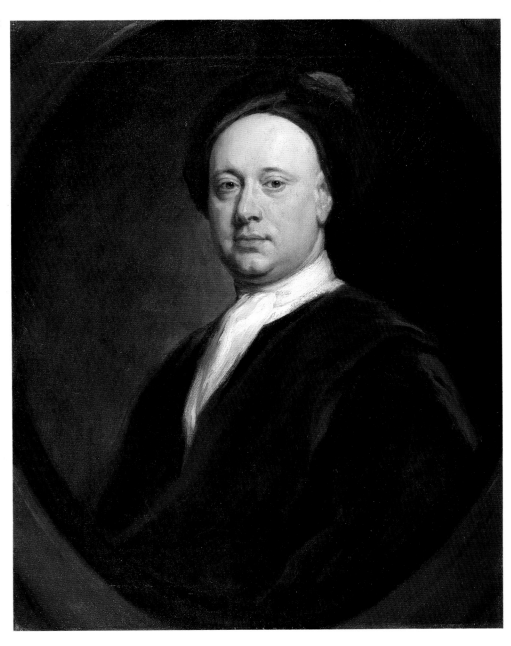

JONATHAN RICHARDSON Senior
c.1665–1745

71 George Vertue 1733
Inscribed 'Geo.Vertue Engrav., Lond, AEta.
L.173(3?)' on the back, now covered by relining
Canvas 29½ × 24½ (75 × 62.3)
Prov: Given by the sitter's widow to the British
Museum 1775, transferred to the National Portrait
Gallery 1879
Exh: Allan Ramsay: His Masters and Rivals, National
Gallery of Scotland, 1963 (33)
Lit: Kerslake 1977, pp.285–7, Vertue III, p.69; pl.819
National Portrait Gallery

This is presumably the portrait referred to by Vertue in 1733
as 'painted excellently by Mr. Richardson Senr.' (the record

of the inscription on the back may have misread a 3 for an 8).
Certainly it was in 1733 that Vertue made his biographical
notes on Richardson, which are obviously based on personal
information. This was Vertue's favourite image of himself,
painted by an artist whom he admired as 'the last of the
Eminent old painters' of the age of Kneller, Dahl and Jervas.
What Vertue calls his 'greater stile' is particularly evident
here when compared with the portrait by Gibson (30) which,
though earlier, was painted by a younger man, with a more
informal outlook.

Richardson had an immense portrait practice throughout
the first forty years of the eighteenth century. His technique
on the whole was dull but masculine, and came to life in
friendship portraits like this. He was greatly influential as a
teacher (Hudson and Knapton were among his pupils) and as
a writer on artistic theory and connoisseurship.

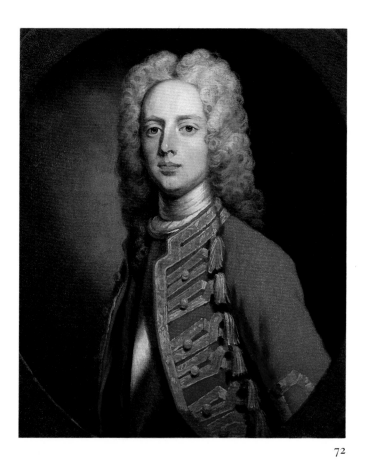

72

HANS HYSING 1678–1753

72 Sir Peter Halkett of Pitfirrane(?) 1735
Inscribed 'H.Hysing/pinx./A°1735' bottom left inside false oval
Canvas 29⅞ × 24⅞ (76 × 63.2)
Prov: ...; bt by lender 1951
Exh: Allan Ramsay, his Masters and Rivals, National Gallery of Scotland 1963 (4)
Lit: Waterhouse 1981, p.190, repr.
National Galleries of Scotland

The sitter is traditionally thought to be Sir Peter Halkett, 2nd Bart., of Pitfirrane; the uniform-style coat and breast-plate show that he was a military man.

The Swedish-born Hysing settled in London in 1700 and studied under his compatriot Dahl (18) for many years. No works by him later than 1739 are known. His style is considered to be somewhat livelier and more advanced than Dahl's and he forms an important link between the first and second generations of Georgian painters, not least because the 21-year-old Ramsay worked in his studio in 1734, round about the time when this portrait was painted.

WILLIAM HOGARTH 1697–1764

73 Self-Portrait with Palette *c.*1735–40
Canvas 21½ × 20 (54.5 × 51)
Prov: Presumably bt from Mrs Hogarth by Samuel Ireland *c.*1781, engraved by him 1786; ? Ireland sale 1801; ...; Lord Kinnaird by 1813; ...; bt by Paul Mellon 1965, and presented to the lender 1981
Exh: William Hogarth: A Selection of Paintings from the Collection of Mr & Mrs Paul Mellon, National Gallery of Art, Washington, 1970 (12, repr.)
Lit: Paulson 1971, I, pp.450, 556, n.64, pl.170
Yale Center for British Art, Paul Mellon Collection, New Haven

This fine unfinished study is the earliest known portrait of the artist. It has the penetrating gaze of a man observing himself inquiringly in a mirror, without the guarded distance of a face presented to the public, and is full of flashes of unresolved painterly experiment. He first painted himself wearing a black velvet cap, the outline of which is barely concealed by the wig which he later decided to paint over it. This is left loosely blocked in and was never taken further towards being evened out with smooth detail and finishing glazes. The same goes for the deep scar over his right eyebrow (a feature of which he is said to have been rather proud), which is blocked in with energetic, impastoed brush strokes, but lacks the finishing glazes that would have shaded it in. At some stage he decided to present himself with the tools of his trade, and threw in the idea of a palette where there is no room for it – yet it is already loaded with a message: the paint dabs on it shade from white to bright red. As he later explained in his *Analysis of Beauty* (1753), he saw the brilliant, clear colours as represented by 'firm red', and white (because 'nearest to light') as equal in 'value as to beauty'. Technically the painting is very like the uncorrected first drafts of his writings, where jumbled ideas pour out too fast to submit to sensible grammar and spelling, full of false starts and unresolved sentences and phrases.

Tidied up and smoothed out, Hogarth used the same face-mask in his famous 'Self-portrait with Pug' (Gallery 2), finished in 1745 but begun much earlier, where he elaborated the manifesto-theme with a palette bearing his ideal 'Line of Grace and Beauty'. Only there he first painted himself in a wig (as here), and later changed it to a cap, a circumstance which with innumerable other pentimenti shows his characteristic restless search for an image that would satisfy.

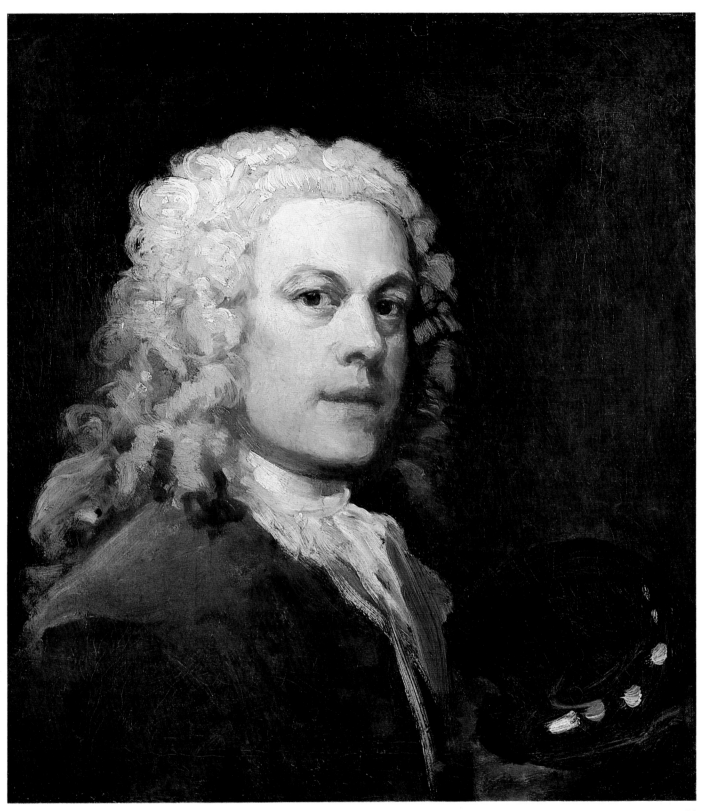

73

WILLIAM HOGARTH 1697–1764

74–81 The Rake's Progress 1733

Eight canvases, each 24½ × 29½ (62.2 × 75)
Prov: Sold at the artist's auction 27 February 1745
to William Beckford of Fonthill; Fonthill sale,
Christie's 27 February 1802 (86) bt Sir John Soane,
by whom left to the Museum 1833
Exh: Hogarth, Tate Gallery, 1971 (64–71, repr.)
Lit: Paulson 1971, I, pp.322–33, 405–6, pls.120–7;
Webster 1979, pp.48–60, repr.

The Trustees of Sir John Soane's Museum

The set was painted as a sequel to Hogarth's immensely
successful 'Harlot's Progress', the prints of which were
published in 1732. He probably began work on the 'Rake'
very soon after, as he advertised for subscriptions for the
prints in October 1733. In an advertisement published in
November 1734, he invited potential subscribers to view the
completed set of paintings in his studio. In the event he held
back the publication of the prints until the Engravers'
Copyright Act was passed in 1735, although this did not, in
the end, stop them from being pirated.

Stories of the downfall of men and women of easy virtue in
pictorial and literary form were known throughout Europe
long before, but Hogarth's English interpretation of the
subject is his own. It is based on the accepted view that a
miserly father will always be followed by a wastrel heir; a
humanitarian angle is provided by Sarah, the seduced and
jilted servant girl who stays faithful to him to the end.

Engraving was foremost in Hogarth's mind when he
painted the set (this was where his income chiefly came
from), at a time when he was exceptionally successful and
busy. As a result, the paintings seem uneven in execution and
show many adjustments and changes, possibly over a con-
siderable period of time. Hogarth's moral comments are
encapsulated in innumerable details that are much clearer in
the prints; only the gist of the story is given here.

74 I: The Rake Taking Possession of his Estate

Tom Rakewell has come down from Oxford on 1 May 1727,
following the death of his rich father, a money-lender. In a
grim room that is being draped for mourning, full of tokens
of the old man's obsessive miserliness, Tom loses no time in
indulging his suppressed vanity and has himself measured
for a new suit. He pays off with gold coin the indignant
mother of Sarah Young, a servant girl whom he had seduced
at Oxford, and who has followed him to London. Sarah,
pregnant and weeping, her trusting innocence shown by the
demure rose tucked into her bosom, holds the ring with
which he falsely pledged his faith. Tom's vacant expression
shows that he is devoid of any feelings of compassion. His
essential lack of prudence is underlined by the fact that he is
already being rooked by the attorney who is compiling an
inventory of the dead man's possessions.

75 II: The Rake's Levée

Tom has acquired a stately home and ineptly apes his
fashionable betters by dispensing indiscriminate patronage.
His want of real taste is shown by the mixture of incom-
patible pictures on the wall (game-cocks and classical
mythology), among which 'The Judgement of Paris' mocks
his own pretensions. Attired in elegant morning undress, he
holds a levée like a great nobleman to receive people offering
their services. The individual characters, all of whom would
have been recognisable to Hogarth's contemporaries, in-
clude a villainous-looking bodyguard, a jockey, a dancing-
master with his kit-violin, a huntsman, a music master, a
French fencing master, a quarter-staff instructor, landscape
gardener, poet, tailor. Tom, however, shows interest only in
the paid bully, thus betraying the fact that his real in-
clinations lie with things coarse, rather than civilised, or even
fashionable.

76 III: The Rake at the Rose-Tavern

It is three o'clock in the morning, and Tom is feasting with
prostitutes in a private room of the notorious Rose Tavern in
Drury Lane, after an evening of hooliganism on the streets –
the lantern and staff he has captured off a night-watchman lie
on the ground beside him, and his sword is unsheathed. His
unbuttoned pose is the antithesis of all accepted norms of
gentlemanly ease, and doubly shocking in a century when
deportment counted for much. Two prostitutes relieve him
of his watch, while the rest of the company drink themselves
into a stupor. A ragged street singer by the door bawls out
indecent songs, and a professional stripper in the foreground
prepares for her act, which she will perform standing on the
pewter dish held by the pimp in the background. Again,
Hogarth has taken for his models well-known characters
from the sleazy side of London life.

77 IV: The Rake Arrested, Going to Court

Tom has ambitions to shine at court, but has run through his fortune. As he is carried in a hired sedan towards St James's Palace, wearing splendid court dress, to attend a public levée on Queen Caroline's birthday, he is arrested for debt by two bailiffs. We know the date, as the Queen's birthday was on 1 March, St David's day, when Welshmen wore leeks in their hats as they do here. Sarah Young, who happens to be passing, bails him out with her meagre earnings – the inscription and contents of the box show that she is now a respectable milliner. The sign of 'HUDSON/SADLER' above Tom indicates where his money has gone. In the commotion, a street urchin steals his gold-topped cane, while the lamplighter is so carried away by the *fracas* that he lets his oil spill over, as if 'anointing' Tom's wig. Tom is now a marked man.

78 V: The Rake Marrying an Old Woman

Tom seeks to repair his fortunes by marrying a rich lustful old woman. The scene is set in a dilapidated church in Marylebone known for its vicar's willingness to celebrate secret or rushed weddings. The hunchbacked, one-eyed and lame bride eagerly awaits her ring, while Tom ogles her pretty maid. The degrading nature of the match is echoed by the courtship of the two dogs on the right. In the background, Sarah and her mother are ejected from the church by a crone guarding the door.

79 VI: The Rake at a Gaming House

Tom soon loses his second fortune in a low gambling den. The house, like his world, is on the point of destruction – a night-watchman rushes in to warn the company that the house is on fire, and a horrified servant holds up a light to see the smoke curling in below the ceiling. As Tom rages against fate, a black dog – the traditional symbol of depressive melancholy – stands up and barks at him.

80 VII: The Rake in Prison

Tom is now in a shared room at the Fleet, the debtors' prison. He has tried to raise money by writing a play; the rejected manuscript lies on the table beside him. Other prisoners pursue similarly hopeless schemes: the speculator on the right carries a 'Scheme for paying ye Debts of ye Nation', at the back an alchemist works at his 'fool's gold', the inventor's failed attempt at making functional wings hangs from the top of the four-poster. Sarah and her little girl by Tom, have come to visit, and Sarah faints away in distress as Tom's wife, now a thin harridan, abuses him for his past affair; the gaoler demands garnish-money, the beer-boy wants to be paid. Tom's despair knows no way out.

81 VIII: The Rake in Bedlam

Tom's mind has given way, and he has been confined to Bedlam. Stripped of his vanities by revengeful fate, he becomes a noble figure: Hogarth has modelled his prostrate form on Cibber's statues of Melancholy and Raving Madness that used to surmount the gates of Bedlam Hospital (now in the Museum of London). He is surrounded by every type of madness then known, but each also reflecting one of his own sins: his vanity by the mad tailor with his tape measure, his disdain of accomplishment by the crazed musician, his faithlessness by the melancholiac deranged by his love for the famous prostitute whose initials are engraved on the stair-rail (visible only in the print), his abuse of religion by the religious maniac, his attempt to milk the intellect by the deranged astronomer, his bid for power at court by the man who imagines himself an emperor, his greed by the man dressed as Pope (greed was seen as one of the chief sins of the Papacy). Sarah has brought him food, and has probably paid for him to be unshackled (views differ on this), as a melancholy madman is unlikely to be violent. A contemporary commentary states that 'he was afterwards confined down to his Bed in a dark Room where he miserably expires'.

Bedlam was open to visitors, who could come and look at the inmates as if in a zoo. As Sarah's tears flow in compassion, two such ladies titter heartlessly in the background at the misfortune of others.

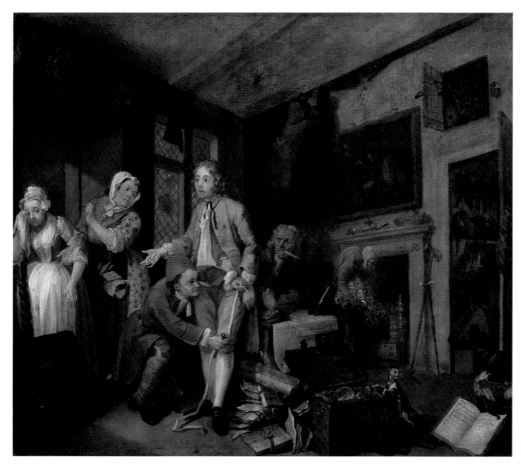

74

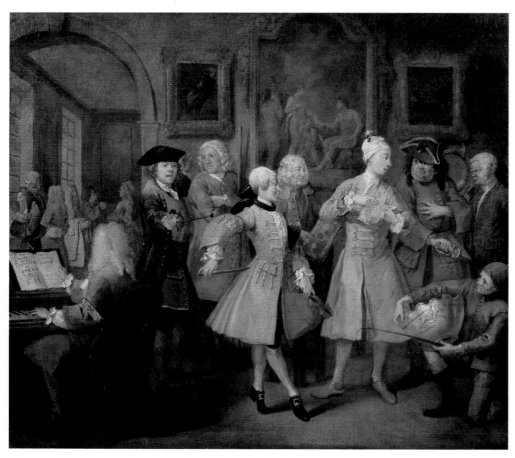

75

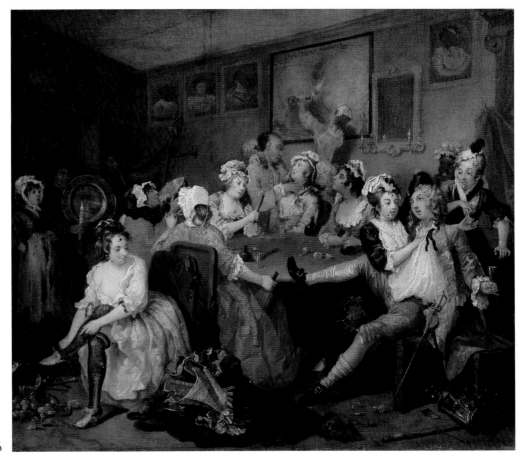

76

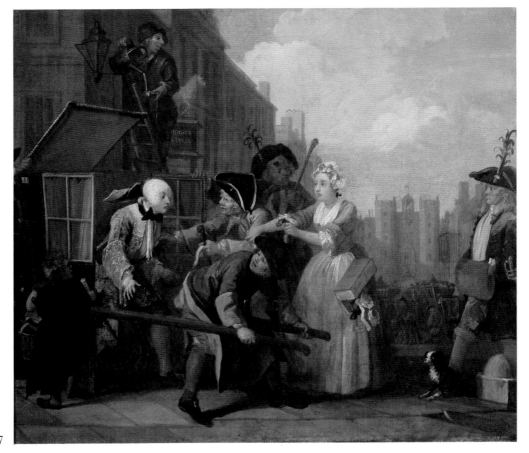

77

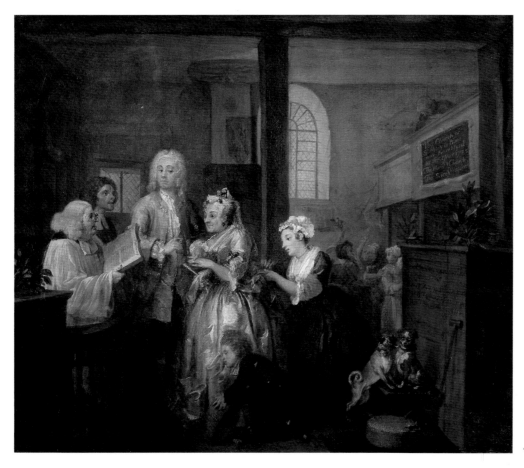

78

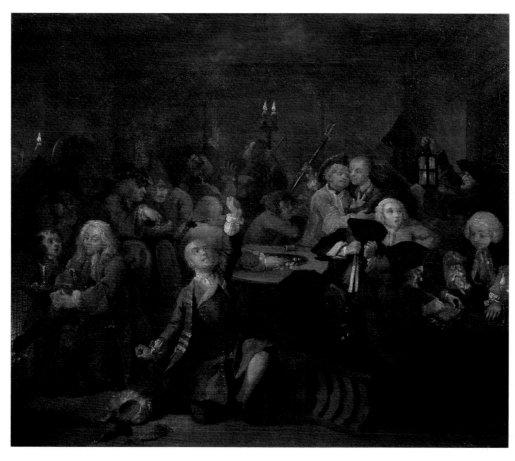

79

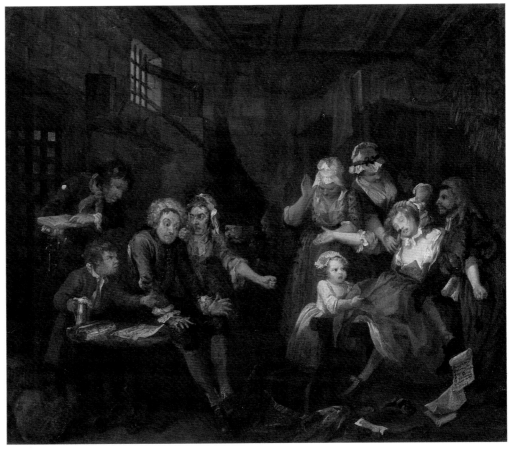

80

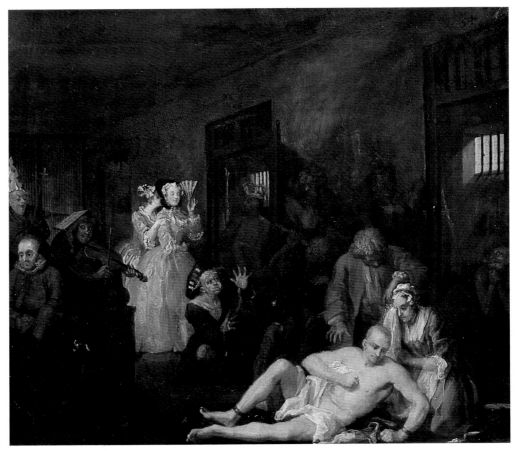

81

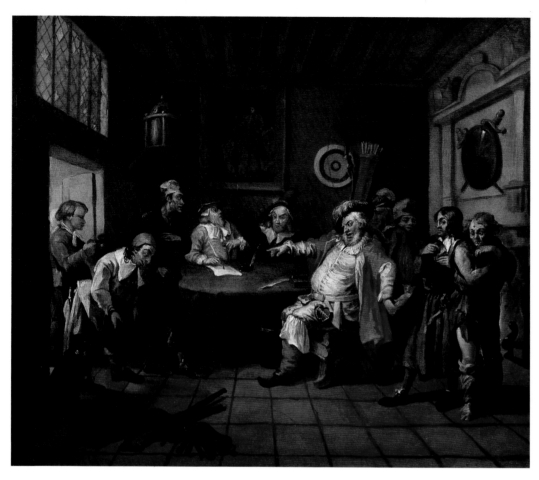

WILLIAM HOGARTH 1697–1764

82 **Falstaff Examining his Recruits** 1730
Inscribed 'W. Hogarth Pinx. 1730' bottom left
Canvas 19½ × 23 (49.5 × 58.5)
Prov: ...; Earl of Essex by 1777; bt by David Garrick;
Mrs Garrick's sale 23 June 1823 (20) bt Mr Coote; ...;
Sir Arthur Helps by 1874, sold to H.W.F. Bolckow,
his sale Christie's 2 May 1891 (106), bt Agnew for the
Earl of Iveagh, thence by descent
Exh: The Conversation Piece in Georgian England,
Iveagh Bequest, Kenwood, 1965 (25)
Lit: A.P. Oppé, *The Drawings of William Hogarth,*
1948, pp.32–3, nos.23, 24, pls.20, 21; Beckett 1949,
p.65, pl.4; Webster 1979, p.12, repr. in col. p.14
Private Collection

The subject is taken from Shakespeare's *Henry IV, Pt.2,* Act
3, scene 2. Just as Hogarth's scene from *The Beggar's Opera*
of 1728 (a later version is on view in Gallery 3) is the earliest
painted representation of an actual stage performance, so
'Falstaff' is the earliest known painting of a scene from
Shakespeare, and as such stands at the beginning of a genre
that was to challenge most British painters until well into the
nineteenth century.

The lighting from the front, steep perspective and boxed-
in look of the room suggest that this is also the record of an
actual performance (it would be hard to guess which, as the
play was performed frequently), but it differs from 'The
Beggar's Opera' in that it excludes the audience and the
curtain. It is, however, the same size as the undated version
of 'The Beggar's Opera' now in the Birmingham Art Gallery,
and it is possible that they were meant to be pendants. There
are similar preparatory chalk sketches for both scenes in the
Royal Collection, made on identical paper, which suggests
that at some time Hogarth may have thought of the scenes as
being related.

WILLIAM HOGARTH 1697–1764

83 **The Pool of Bethesda** *c.*1735
Canvas 25 × 30 (62 × 74.5)
Prov: Probably one of the 'large sketches in oil of the
"Pool of Bethesda" and of "The Good Samaritan" '
noted by J. Nichols in Samuel Ireland's collection in
1781; ...; Sir George Beaumont by 1814, by descent
to the Trustees of the Beaumont Estate, from whom bt
by R.B. Beckett 1948; sold to the lender 1955
Exh: English Baroque Sketches, Marble Hill House,

83

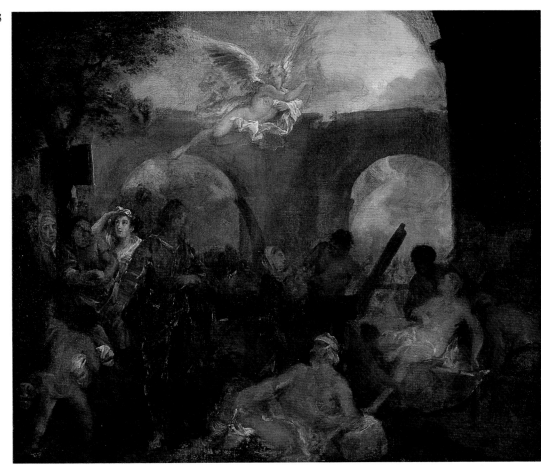

Twickenham, 1974 (68); *James Gibbs, Architect,*
1682–1754, Orleans House, Twickenham, 1982 (47)
Lit : J. Nichols, *Biographical Anecdotes of Hogarth,*
1781, p.67* (double numbers); Paulson 1971, I,
pp.353, 378–80, 382–8, pl.140; T. Friedman, *James*
Gibbs, New Haven and London, 1984, pp.217–20
Manchester City Art Galleries

Preliminary sketch for the large canvas on the west wall of the
main staircase in St. Bartholomew's Hospital, Smithfield,
where it still hangs. When the administrative block of the
hospital was nearing completion in 1734, negotiations were
in progress for the Venetian Jacopo Amiconi to paint the
decorations. Hogarth, however – who, incidentally, had been
born in St Bartholomew's Close nearby – offered his services
for free, as indeed James Gibbs, the architect of the hospital,
had done before. Like all benefactors, Hogarth was made a
Governor of the hospital, and between 1734 and 1737 he
produced two enormous canvases on the two subjects
deemed most suitable for hospitals, namely, 'The Good
Samaritan' (where the landscape background is plausibly
attributed to George Lambert), and 'Christ healing the lame
man at the Pool of Bethesda'. The last was hung over the
staircase in April 1736, the 'Samaritan' in July 1737. They
were Hogarth's first works on a grand scale or 'History

Paintings', and even Vertue, who did not like him, admitted
that it was a remarkable effort for a painter hitherto known
only for engravings and small conversation pieces, and 'is by
every one judged to be more than could be expected from
him'.

This seems to have been a determined attempt by Hogarth
to inherit the mantle of his father-in-law Sir James Thornhill,
who had died in 1734. It led, however, to no further work,
except that Hogarth painted a portrait of Gibbs (now lost,
engraved in 1747) and of John Lloyd, son of the hospital's
rent collector of the same name (dated 1738, now in the Yale
Center for British Art, New Haven), as a mark of gratitude
for help in securing the commission.

Although many influences from Thornhill to Ricci (11)
contributed to this work, Hogarth's conception is typically
individual. Christ (for whom, as one can see from this sketch,
Hogarth first made nude studies), the angel, and other main
figures come from the Italian Baroque tradition, but the
surrounding crowd consists, especially in the finished
painting, of naturalistically observed sick people suffering
from medically recognizable diseases. Hogarth's own moral
comment is incorporated from the beginning: behind the
miraculously healed man a poor woman with a sick child is
being pushed aside by a servant clearing the way for his rich
mistress.

84 Satan, Sin and Death *c.*1735–40
Canvas 24⅜ × 29⅜ (61.9 × 74.5)
Prov: . . .; in David Garrick's collection by 1767; Mrs
Garrick's sale Christie's 23 June 1823 (not in
catalogue, but probably MS lot 79* in Christie's
master-copy) bt T.S. Forman, by descent to W.H.
Forman, thence his sister-in-law Mrs Burt, and *c.*1889
his nephew Major A.H. Browne of Callaly Castle,
Northumberland, sold Sotheby's 27 June 1899 (56) bt
Charles Fairfax Murray; . . .; G. Greer, sold Sotheby's
9 December 1964 (91, repr.), bt Sabin Galleries, from
whom bt by Tate Gallery (T 00790) 1966
Exh: Hogarth, Tate Gallery 1971 (91, repr. in col.)
Lit: Einberg & Egerton 1987, no.95
Tate Gallery

This unfinished sketch is an illustration to Milton's *Paradise
Lost*, Book II, lines 648–726, which describe the awesome
meeting of Satan, Sin and Death at the Gates of Hell, to find
that they are all incestuously related. The passage was
singled out as representing the key to the whole work by
Jonathan Richardson the elder in his commentary on Milton,
and was widely discussed by him with fellow artists, in-
cluding Hogarth, around 1734. The date of *c.*1735 or slightly
later for this painting seems consistent with Hogarth's style
at that period.

Milton's *Paradise Lost* is, along with Shakespeare and
Swift, one of the three volumes on which Hogarth rests his
self-portrait of 1745 (Gallery 2), showing thereby the work's
fundamental importance to him in his ambitions both as a
commentator on moral issues and as a history painter.

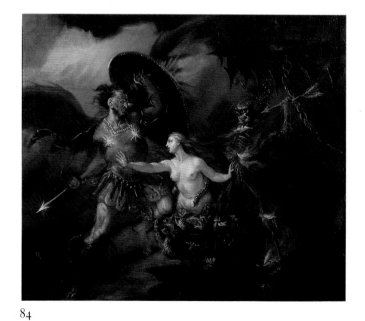

84

**85–86 Two of a Set of Four Views of Westcombe
House** 1732
Canvas, each 35 × 49¼ (89 × 124.5)
Prov: Probably painted for the 9th Earl of
Pembroke; first recorded at Wilton 1751, thence by
descent
Lit: Sidney, 16th Earl of Pembroke, *A Catalogue of
the Collection at Wilton House*, 1968, nos.34–7,
pls.20–1; Harris 1979, pp.246, 258–9, pls.273a–d
The Earl of Pembroke, Wilton House

85 View of Westcombe House, Blackheath
Inscribed 'G.Lambert 1732' on masonry, bottom
right

**86 View of Westcombe House, Blackheath from
the Pond**

In all probability painted for Henry Herbert, 9th Earl of
Pembroke (1693–1751), also known as the 'Architect Earl',
one of the chief promoters of the Westminster Bridge project
(126). Westcombe House at Blackheath was built for him
*c.*1730 by Roger Morris, when Henry Herbert was still Earl
of Montgomery. The Earl almost certainly had a hand in its
design. In 1733 he inherited the Earldom of Pembroke and
went to reside at Wilton, and Westcombe, said to have had an
interior of chillingly classical discomfort, was eventually sold
and demolished before the end of the century.

Lambert was commissioned to record its appearance in a
set of four views which constitute a radical departure from
the conventional house-and-garden perspectives of contem-
poraries like Wootton and Tillemans, and which take their
inspiration from Dutch seventeenth-century landscape
painting. He painted two views looking up towards the house
from the grounds, and two looking into the grounds from the
terrace surrounding the house. In none of them does the
building dominate the landscape, but becomes an integral
part of it. Lambert's methods are demonstrated by the exist-
ence of a topographical drawing for no.86 (British Museum
Map Room, King's Collection, 11 × 22 in, 28 × 56 cm,
XLI/29/G, signed 'G:Lambart'), which corresponds with the
oil in every detail, except for the foreground and figures,
which were added later for picturesque effect. According to
reliable early reports that are in no way contradicted by style,
the figures and the shipping, where relevant, were added by
Hogarth and Scott respectively.

In the end the paintings are not a very good record of the
appearance of the house itself, which may have displeased the
owner and be the reason why in 1750 the Earl's commission
to paint a similar set of Wilton House went to Richard
Wilson, and also why Lambert's initiative in this branch
never developed any further.

85

86

87

88

89

90

BALTHASAR NEBOT active 1730, died after 1760

87–90 Four Views of the Gardens at Hartwell House, Buckinghamshire 1732–8

Prov: Probably painted for Sir Thomas Lee, 3rd Bt, and bt with Hartwell House by Sir Ernest Cook in 1938; bequeathed by him to the National Art-Collections Fund 1954, and given to the lender 1955
Exh: The Glory of the Garden, Sotheby's (76, repr. in col.) 1987
Lit: Harris 1979, pp.188–9, figs 194d, c, f, g, col. pls.xxd, e, g; T. Friedman, *James Gibbs*, 1984, pp.182–9, 291–2, figs. 204–11
Buckinghamshire County Museum, Aylesbury

87 The Bowling Green and Octagon Pond to the North, with Aylesbury Church in the Distance
Inscribed 'B. Nebot P. 1732' on the roller
Canvas $31\frac{3}{4} \times 39\frac{3}{4}$ (80.5 × 101)

88 North-west Area of the Gardens, with Two Bastions and Men Scything
Canvas $31\frac{3}{4} \times 39\frac{3}{4}$ (80.5 × 101)

89 In the Wilderness behind Topiary Avenues on the West Side, with Various Gibbs's Temples
Canvas $27\frac{7}{8} \times 36$ (70.8 × 91.5)

90 The Topiary Avenues behind the Wilderness, with the George II Column on the Left
Inscribed 'B. Nebot' on the roller
Canvas $27\frac{3}{4} \times 36$ (70.5 × 91.5)

These are four views from a set of eight, all at the Aylesbury Museum, one of which appears to be signed and dated 1732, and another 1738. They record the appearance of the new gardens at Hartwell House, Buckinghamshire, laid out in the 1730s for Sir Thomas Lee, 3rd Bart (1687–1749), to replace an earlier formal Stuart topiary garden. Some of the features still survive today, though in a much altered state.

The garden was filled with a remarkable number of temples, statues, eye-catchers and other ornamental buildings, many of them designed by James Gibbs, who worked on various projects at Hartwell until 1740. Some of the walks had classical themes, others, like those converging on a statue in Portland stone of George II for which Henry Cheere was paid £42, patriotic ones. The formal topiary sections contrasted with a remarkable Wilderness (89) through which one could glimpse (from left to right) the Column of William III

and the Menagerie, the Church, an arcaded pavilion, a round Gothic tower which still stands, and a stepped Pyramid inspired by Vanbrugh. The theme of pastoral delights was carried into the house itself, where the hall has an overmantel relief of Horace in the garden of his estate at Tivoli. The birds in the sky are not mere props, but herons from the heronry. The whole set is particularly fascinating in that it records many aspects of the labour-intensive maintenance of the gardens, as well as the pleasures of its owners.

Quite a few such sets, most of them by foreign artists like Nebot, Rysbrack and Rigaud, are known from the 1730s, when the increasing wealth of landowners encouraged many to re-design and expand their gardens. It was inevitable that a public form of such pastoral 'amusements' would soon appear in venues like Vauxhall Gardens (149), Ranelagh and other pleasure gardens around London.

WILLIAM HOGARTH 1697–1764

91–94 The Four Times of the Day 1736

Hogarth's set, which was split up in 1745, is a burlesque of the time-honoured convention, still current in the pastoral poetry of the day, which hinged on the quadripartite cycles established in antiquity: the four times of day, the four seasons, the four temperaments, the four ages of man, and in this case possibly also the four stages of matrimony. It is the mixture of these elevated classical allusions with the downbeat present which provides the spice of the series. Many of the details are, naturally, much clearer in the engravings which Hogarth published in 1738. These were very popular, and Hogarth allowed the designs to be copied in the 1740s as decorations for Jonathan Tyers's (149) Vauxhall Gardens.

91 Morning

Canvas 29 × 24 (73.6 × 61)
Prov: Sold at the artist's auction 27 February 1745 to Sir William Heathcote, by descent until 1938, when acquired by Lord Bearstead, by whom bequeathed to the National Trust
Exh: Hogarth, Tate Gallery 1971 (77 repr.)
Lit: Paulson 1971, I, pp.398–405, pls.148b, 149b, 151a (col.); Webster 1979, pp.65–8, repr. pp.72–3; S. Shesgreen, *Hogarth and the Times-of-the-Day Tradition*, Ithaca 1983, figs.34–41.
National Trust, Bearstead Collection, Upton House

In this first scene an old maid is seen crossing Covent Garden Square at precisely five minutes to eight, to attend early morning prayers at St Paul's Church, whose portico looms on the right. Like a modern-day 'Aurora', the goddess of dawn, she is dressed in resplendent yellow that lights up the gloomy winter's day. The suggestion might be that she comes from Lord Archer's house on the extreme right, the last nobleman's house left in the once-grand square after the nobility moved west to escape the expanding vegetable market and the proliferating bagnios and taverns. The most notorious of these was Tom King's Coffee House (its name is inscribed over the door) whither, it was said, young noblemen and bloods would repair 'after Court, in full dress' for a night of debauchery. Some of them make free with the market girls, and are obviously in no need of the fire at which the old and the destitute are trying to warm themselves. In the background, a crowd gathers around the equally notorious charlatan Dr Rock, who is selling his venereal pills. As Shesgreen has pointed out, the maid's piety might be a sham (as, incidently, is the Church's aridly classical portico – the real entrance is at the side), for St Paul's Covent Garden was apparently a well known venue where the reasonably respectable could look out for a partner or an assignation. The view that the old maid might be on a manhunt is supported by her unsuitably youthful and cold-defying attire, and her unchristian lack of concern for the freezing foot-boy who carries her prayer-book. Contemporary writers (*Gentleman's Magazine*, July 1738, p.357) also praised this scene as a deserved ridiculing of the then new custom according to which grown women, if unmarried, still wanted to be addressed as 'Miss', 'with all the hoity-toity of a Girl of fifteen, yet [being] upwards of fifty-three'.

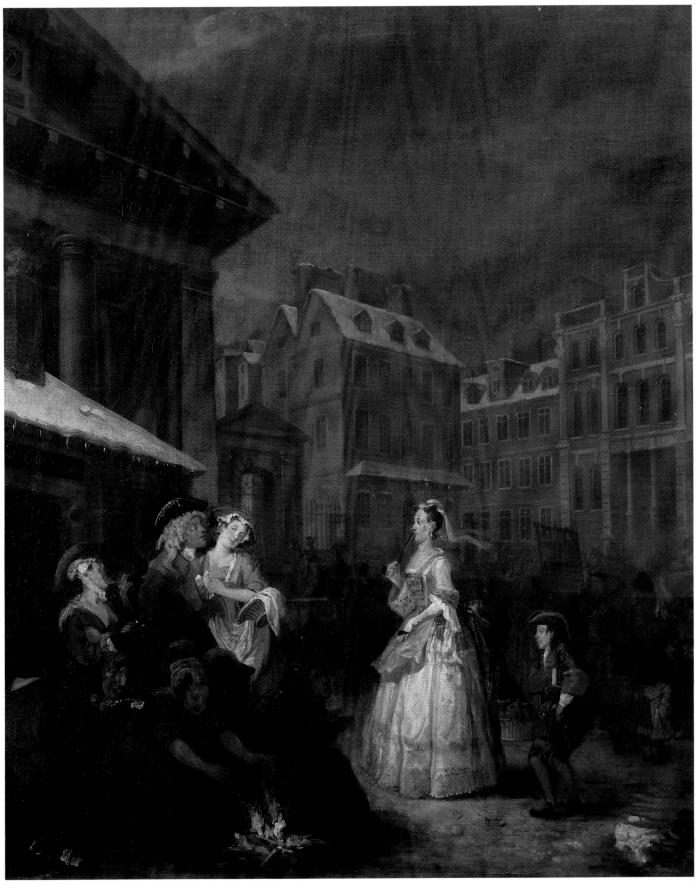

91

92 Noon

Inscribed '1736' on the sign of The Baptist's Head
Canvas 29½ × 24½ (75 × 62.2)
Prov: Sold at the artist's auction 27 February 1745 to
the Duke of Ancaster, and thence by descent
Lit: As 91

*By Kind Permission of the Grimsthorpe and Drummond
Castle Trustees*

A congregation of sober French Huguenots is emerging from
the L'Eglise des Grecs, the French church in Hog Lane,
Soho. The clock of St Giles in the background stands at
12.20, and they are presumably going home to a well-ordered
meal. Opinions differ about the splendidly overdressed (in
the French style) couple on the left, but it is possible that they
have just been married and are in their wedding clothes. The
kite hanging from the eaves of the church above them could

then represent the season of spring – a good time to fly kites –
and the flighty coming to rest, for the overdressed little boy
in front of them could well be their son, the fruit of a less
respectable past, hinted at by the severely disapproving look
of the man standing directly behind them.

On the other side of the kennel, choked with rubbish and a
dead cat, debauchery is in no way concealed by art, and the
local rabble (this was a very poor district) indulge merrily in
their earthy lusts. Shesgreen points out that traditional
allegories of 'Noon' tend to centre on an alfresco meal under
the auspices of the gods who rule this time of day, Apollo and
Venus. In the burlesque, however, their 'world is filled with
gastronomic frustration', from the quarrelling couple in the
Good (because silent: she has no head) Woman Tavern,
where the wife throws the joint out of the window in a
temper, to the spilt food and broken dishes in front of The
Baptist's Head Tavern. The amorous servant girl could then

93

be seen as a sensuous 'London Venus', and the red-coated figure of French artifice might stand for Apollo, the god of the Arts.

93 Evening

Canvas $29\frac{1}{2} \times 24\frac{1}{2}$ (75×62.2)

Prov: as 92

Lit: as 91

By Kind Permission of the Grimsthorpe and Drummond Castle Trustees

'Evening' is traditionally represented by a contemplative sunset walk, tinged with melancholy. Diana, who dwells in green groves sacred to her, is associated with it. Here a London family is on their way home after a Sunday afternoon walk to Sadler's Wells, the Vauxhall Gardens of the humbler sort. The oppressed looking husband's stained hands show that he is a dyer by trade, his wife's red face indicate a heatwave in summer. Hogarth emphasised this in his print by using coloured inks for the dyer's hands and the wife's face. Their weariness is expressed in their faces, their drooping pregnant spaniel and their bickering children, one of whom has lost a shoe which is retrieved by their maid. They are passing the tea-garden of the Sir Hugh Middleton Tavern, named after the London benefactor who was probably responsible for the drain that is now fouling the canal in the foreground.

The wife, an unchaste modern Diana, is pregnant, and a visual pun shows that her husband is a cuckold. He is her Acteon too, for she holds up a fan painted with a pastoral representation of Diana and Acteon. The arcadian pastoral mode is also parodied by the prosaic treatment of a milkmaid ungracefully going about her task in the background.

94 **Night**

Canvas 29 × 24 (73.6 × 61)

Prov: as 91

Lit: as 91

Exh: Hogarth, Tate Gallery 1971 (80, repr.)

National Trust, Bearstead Collection, Upton House

'Night' depicts autumn, more precisely 3 September, Oak Apple Day, when oak branches were displayed to commemorate Charles II's escape from pursuit in the Boscobel Oak, candles were placed in the windows and bonfires lit in celebration. The view looks up Charing Cross towards the statue of Charles I, with the brightly lit windows of the Golden Cross Inn behind. Between the Rummer Tavern on one side, and the Cardigan's Head bagnio on the other, the Salisbury Flying Coach has come to grief as its horses shy

before the bonfire in the road. It might be a spoof of the torchlight processions and triumphal car of night of Proserpine, the goddess of the underworld. With typical burlesque inversion, instead of going to sleep, everyone, except the vagrants under the barber's windowsill, is preparing for activity: the link-boy is kindling his torch, a man is being shaved, the inn-keeper refills his beer-barrel. A furniture-laden cart passes in the background; it belongs to lodgers moving under cover of darkness to escape the quarterly rents. In the foreground a drunken Freemason in full regalia (he has been identified with the corrupt magistrate Sir Thomas de Veil) is escorted home by a colleague, typifying perhaps the escape married men sought from domesticity in clubs, secret societies and endless drinking sessions.

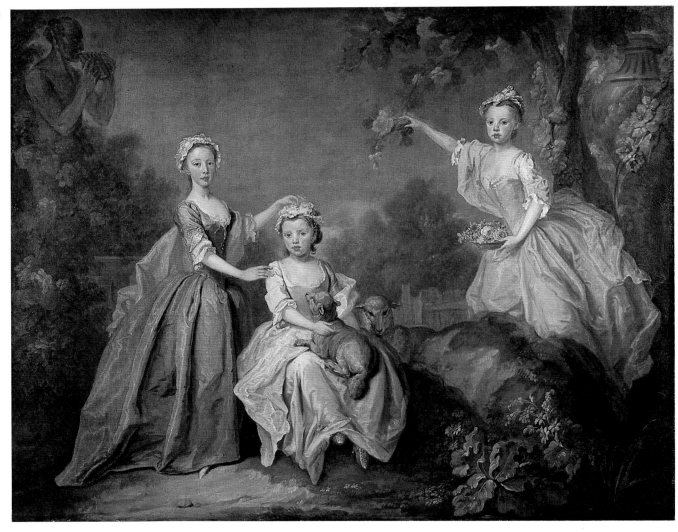

BARTHOLOMEW DANDRIDGE
1691–*c*.1754

95 The Ladies Noel 1736–40
Inscribed 'B.Dandridge/Pinx' bottom left corner
Canvas $46\frac{7}{16} \times 61\frac{11}{16}$ (118 × 156.7)
Prov: By family descent to Major Maurice Noel of
Minsterworth; ...; C. Marshall Spink by 1957, from
whom bt by the lender
Exh: The Conversation Piece in Georgian England,
Iveagh Bequest, Kenwood, 1965 (9, pl.IV B)
Lit: Waterhouse 1978, pp.184–5; A.K.J. Farrington,
typescript catalogue entry in Manchester Art Gallery
Manchester City Art Galleries

Elizabeth (1731–1801), Jane (b.1733) and Juliana (1734–
1760) were the three eldest daughters of the 4th Earl of
Gainsborough of Exton Park, Rutland, and his wife
Elizabeth Chapman, whom he married in 1728. There were
to be thirteen children, and as their first son, Baptist, born in
June 1740, is not included, the group must have been painted
before then. Elizabeth, seated with a lamb on her lap, died
unmarried; Jane, kneeling on the bank, married Gerard

Anne Edwards of Welham Grove, Leicestershire. His for-
midable mother, the immensely wealthy heiress Mary
Edwards, was Hogarth's most important patron, and there
are equally delightful childhood portraits of Gerard by
Hogarth, one at Upton (National Trust), and one in a private
collection. Julia, dressed in blue, married George Evans, 3rd
Baron Carbery of Uffinton House, Rutland.

Dandridge was a very successful portrait painter known
for his vigorous and inventive conversation pieces, and fluent
French-influenced brushwork. He introduced more move-
ment into English portrait groups than anyone bar Hogarth,
which does not, however, quite mean that he aimed for
genuine naturalness. For all the picture's nod towards the
pastoral *fêtes galantes* of Watteau and Mercier, the sitters are
not really involved in their pursuits, but hold their poses
for the benefit of the spectator. Vertue thought highly of
Dandridge, calling him a 'sprightly genius', and described in
1729 how he worked with 'a small model of the persons to be
disposed in a family piece, each single figure placed upon a
plane, whereby he could see to dispose the groopes & lights &
shades to very great advantage' – a method also used later by
Devis and Gainsborough.

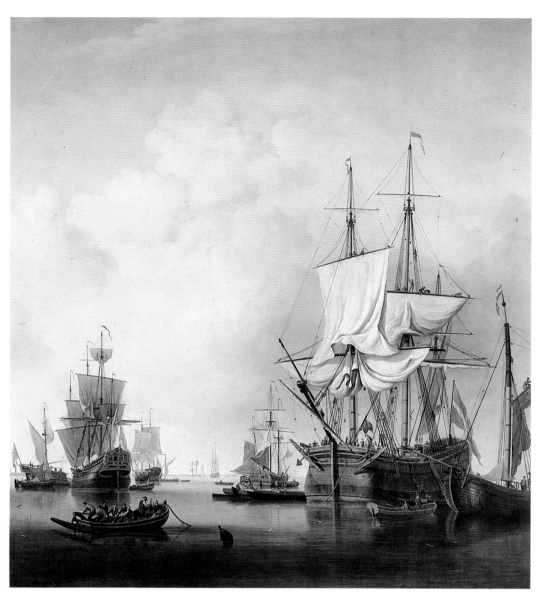

SAMUEL SCOTT *c.*1702–1772

96–97 A Pair of Marine Overdoors 1736
Prov: Possibly painted, with no.97, for William, 3rd
Earl Fitzwilliam; ...; Fitzwilliam sale, Christie's
11 June 1945 (65, together with no.97 as lot 64, as
by Van de Velde) bt M. Bernard, from whom bt by
the lender
Lit: Kingzett 1982, pp.19–20, pls.2a, 3c
National Maritime Museum, London

These two marines are splendid examples of the growing
taste for complementary pairs and sets, the basic prerequisite
of the ordered, balanced hang of the well-appointed
Georgian interior. The way in which such paintings were
hung is admirably demonstrated in no.61.

96 A Danish Timber Bark Getting Under Way
Inscribed 'Saml Scott 1736' bottom right
Canvas $89\frac{1}{2} \times 86$ (227.3 × 218.5)

The painting shows a Danish merchant ship with its anchor
up, hoisting sail in a river estuary, surrounded by other
merchant ships and smaller craft. The painting need not be
the record of an actual event, as Scott used the main vessel in
other, later, compositions. The calm water and sky are in
harmony with the peaceful pursuit of trade (Denmark was at
this time a peaceful and prosperous trading partner of Great
Britain, and its chief supplier of timber), and the main
burden of the painting, apart from its decorative qualities,
lies in the contrast it provides to its pair.

Nothing is known of Scott's early training, but he
modelled himself closely on Willem van de Velde, and was
undoubtedly England's most eminent marine painter until
he took to painting views of London in the 1740s. Signifi-

97

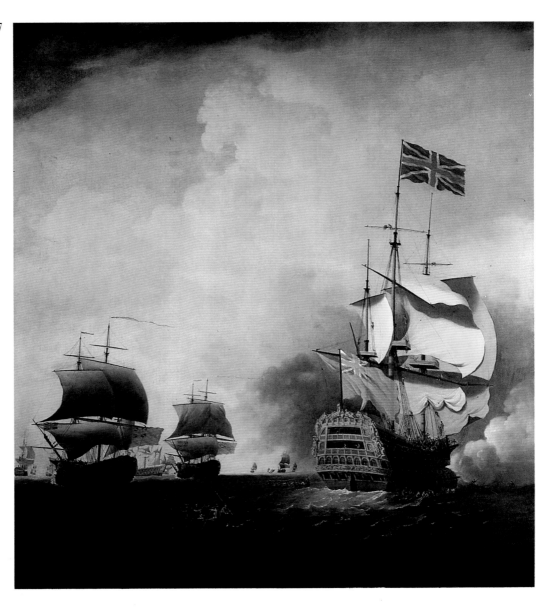

cantly, this pair passed for the work of Van de Velde until cleaning revealed Scott's signature. A preparatory drawing for the whole composition belongs to the National Maritime Museum (Kingzett 1982, p.80, D13).

97 A Flagship Shortening Sail
Inscribed 'Saml Scott 1736' bottom right on spar
Canvas 90 × 86½ (228 × 219.7)

A view from the starboard quarter of a British three-decker firing a gun, with two third rates passing to windward of her on the starboard tack and other ships in the fleet behind. Appropriately, the warships set sail on a dark and choppy sea, in a stiff breeze, with the sky echoing the mood of threat and action. The Union Flag denotes the presence of an Admiral of the Fleet, and the picture could commemorate the expedition to Lisbon led by Sir John Norris, Commander-in-Chief in the Channel, which set sail from Spithead in May 1735 in response to a request from the Portuguese Government for help against Spain. Kingzett suggests that the fact that the large vessel on the right does not correspond with Norris's flagship *Britannia* may be because she remained in Lisbon until 1737, and Scott had to use other models.

Several preparatory drawings for the painting are listed by Kingzett.

GEORGE LAMBERT 1700–1765

98 The Ruins of Leybourne Castle, Kent 1737
Inscribed 'G.Lambert 1737' centre foreground
Canvas $40\frac{1}{2} \times 38$ (103 × 96.5)
Prov: ...; with Spink & Son 1957, from whom bt by
the lender
Exh: George Lambert, Iveagh Bequest, Kenwood,
1971 (9)
Government Art Collection

Throughout the 1730s Lambert was moving away from the
purely topographical tradition and introducing a more
picturesque manner of painting native scenery in which he
tried to convey a sense of relationship between buildings and
the landscape in which they stood. He began the use of
pictorial devices like showing the buildings not from the
unnaturally elevated viewpoint usual until now, but from a
low one which produced a more dramatic outline against the
sky and gave more scope to developing the middle ground.

The sprightly figure group in the centre is not by Lambert,
but could be by Hogarth, or by Joseph Nickolls (113–115),
whose figure style was sometimes very close to Hogarth's,
and whose hand can be detected in the figures of a number of
Lambert's landscapes.

BALTHASAR NEBOT active 1730–after 1765

99 Covent Garden Market 1737
Inscribed 'B.Nebot F.1737' lower left centre, along
edge of the market-woman's stool
Canvas $25\frac{1}{2} \times 48\frac{3}{4}$ (64.0 × 123)
Prov: ...; Lord Dover by *c*.1835, by descent to 4th
Viscount Clifden, sold by his executors Robinson &
Fisher 25 May 1895 (?686 as by Pugh) bt for the
National Gallery, transferred to the Tate Gallery 1955
(N 00453)
Lit: Einberg & Egerton 1987, no.138
Tate Gallery

A view from the south-east of the Piazza, looking west,
towards the east front of St Paul's Church. Although already
larger than in Van Aken's view (43), the market began to
expand rapidly after *c*.1740. Nebot enlivens the topography
with genre scenes of well-known contemporary Covent
Garden characters. The subject was evidently a popular one,
and Nebot painted several versions of this picture.

98

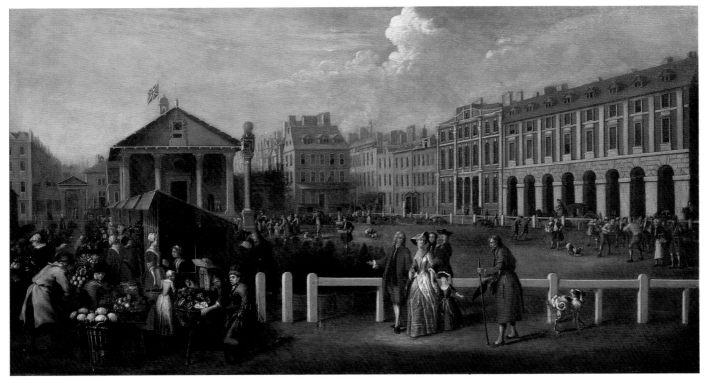

99

100

RICHARD WILSON 1713–1782

100 The Hall of the Inner Temple after the Fire of 4 January 1737 1737
Inscribed 'R Wilson / 1737 / The fire / [...]' on mirror, centre foreground
Canvas $25\frac{5}{8} \times 37\frac{1}{2}$ (65.1 × 95.3)
Prov: ...; probably Cock's 17–18 May 1737 (32) but presumably not sold, as it appears to have been one of the paintings in the Garnons Bequest to the National Gallery 1854 (N 02984); transferred to the Tate Gallery 1929
Exh: *Richard Wilson*, Tate Gallery 1982 (1, repr.)
Tate Gallery

Although Wilson first practised as a portrait painter, this topographical London view of an actual event that destroyed part of the Inner Temple in January 1737, is his earliest known dated work. Without the signature it would be hard to attribute to Wilson, but it does betray his hand in the thick and energetic use of paint; more importantly, it shows his early interest in landscape.

The main reason for painting it may have been the presence of Frederick, Prince of Wales – seen here in the centre group with the Garter star on his breast – in the hope of eliciting his patronage. This, however, failed to materialise, and the painting may have passed from its 1737 sale back into the painter's hands, for it appears to have been among the paintings from his retirement home in Colomendy which his descendants presented to the National Gallery.

101

JOHN GRIFFIER the Younger active 1738–1773

101 The Thames during the Great Frost of 1739–40
1739
Inscribed 'Jn.º Griffier f. 1739'
Canvas 18½ × 25½ (47 × 64.8)
Prov: ...; anon. sale, Sotheby's 28 April 1965 (105) bt
Agnew, from whom bt by the lenders
Exh: The City's Pictures, Barbican Art Gallery, 1984
(6, repr. in col.)
Lit: R.J.B. Walker, *Old Westminster Bridge*, 1979,
pp.112, 229, pl.18; V. Knight, *The Works of Art of the
Corporation of London*, 1986, p.123, repr.
Guildhall Art Gallery, the Corporation of London

Before the Thames was deepened and embanked, and
particularly while the massive structure of Old London
Bridge (174) slowed down the current, the river froze over in
the severe winters that occurred every decade or so. Frost
Fairs were then held on the ice, mostly in booths constructed
from the oars and canvases of the Thames Watermen. On
this occasion the frost lasted from Christmas 1739 until
February 1740 and proved to be one of the first setbacks in
the long-drawn out saga of the construction of Westminster
Bridge (126, 174, 177). The first two piers of its central arch
can be seen embedded in the ice on the right. Nevertheless
the structure survived the test, and work could continue after
the ice had cleared.

This bird's eye view harks back to a much older topo-
graphic tradition of landscape painting which the Griffier
family of painters, who originally came from Amsterdam,
carried well into the eighteenth century in England. The
panoramic approach clearly aims to record as many details of
an unusual event as possible, and may have been meant as a
model for engravings which were sold as souvenirs from
printing presses set up on the ice, although no engraving after
this particular composition has yet come to light.

The view shows the curve of the river at Whitehall, with St
Paul's, the Tower of London and the new City churches in
the background. A foot-track leads across the ice from
Whitehall Stairs to Lambeth Marsh just above Cuper's
Gardens. The view was probably initially taken from an
upper window of Montagu House.

JOSEPH BAKER active 1742–died 1770

102 **View of Lincoln Cathedral from the West** 1742
Inscribed 'J Baker/Pinx.ᵗ 1742' on gravestone lower left
Canvas 41 × 52½ (104.2 × 133.3)
Prov: ...; the Earl of Lincoln, sold Christie's 4 July
1937 (11) bt Gooden & Fox Ltd; sold to Sir Geoffrey
Harmsworth Bt, from whom bt by the lender 1976
Lit: K.M. Longley & J. Ingamells, *The beautifullest
Church. York Minster 1472–1972*, cat. of exh. at York
Art Gallery, 1972, no.19
*Lincolnshire County Council, Recreational Services:
Usher Art Gallery, Lincoln*

A fine example of provincial view painting, by an artist who
may have been trained in London.

An engraving after this by F. Vivares was published on
29 September 1750, together with Vivares's engraving of
Baker's view of York Minster. No oil painting is known for
the York view, but Baker's fine drawing for it is in the York
Art Gallery (20¼ × 28¼, repr. Longley & Ingamells 1972).
The set was repeatedly republished and re-engraved there-
after.

The Usher Art Gallery also owns a 'View of the Cathedral
and City of Lincoln from the River', *c.*1750, $32\frac{9}{16} \times 43\frac{1}{4}$
(82.6 × 109.9), by Baker, which exists in at least three
versions (one in the Yale Center for British Art, New Haven,
and another in a private collection). None of them appears to
be signed, but the handling and figures are very close to this
view. Understandably, they have been attributed to Lambert
and Scott in the past.

Otherwise little is known about the artist, except that he
was also 'master of the comedians at York' – in other words,
director of the York theatre – an instance of the close ties
between the theatre and landscape painting which had its
roots in scenography.

102

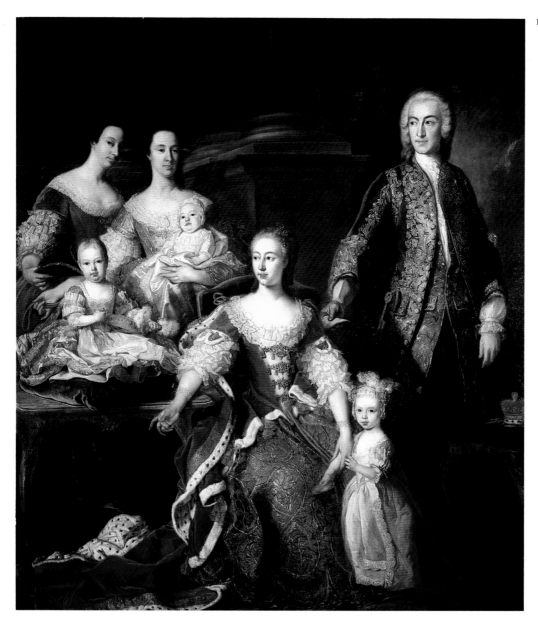

JEAN-BAPTISTE VANLOO 1684–1745

103 Augusta, Princess of Wales, with Members of her Family and Household 1739
Inscribed 'J.B.Vanloo . . . 173[?9]'
Canvas $87\frac{3}{4} \times 79$ (220.3 × 200.7)
Prov: Probably painted for the Princess; seen by Walpole in her Dressing Room at Kew in September 1761; transferred to Buckingham Palace 1860
Lit: Millar 1963, pp.178–9, no.538, fig.191
By Gracious Permission of Her Majesty The Queen

The Princess Augusta (1719–1772), seated, in an ermine-lined robe, holds Princess Augusta (1737–1813) at her knee; Prince George (the future George III, 1738–1820) is seated on the table behind her. His hat is held by Mrs Herbert (d.1755), Woman of the Bedchamber to the Princess, and appointed Governess to Princess Augusta in 1738. Next to her stands Lady Archibald Hamilton (d.1752), who was from

1736 Keeper of the Privy Purse, Lady of the Bedchamber, and Mistress of the Robes to the Princess. She is holding the infant Prince Edward, Duke of York (1739–1767). On the right, holding out a letter and wearing his key of office as Vice-Chamberlain of the Princess, stands Sir William Irby (1707–1775), later Lord Boston.

Vanloo arrived in England from France in December 1737, preceded by his reputation as a court painter, and met with immediate success. His style, while indubitably more cosmopolitan than that of any contemporary British portraitist, had none of the French flamboyance that the English mistrusted. 'His great Success', wrote Vertue, 'is likeness, naturaly, without flaterry', and, one might add, an emphasis on sumptuous clothes, glossily painted by assistants. By the time he returned to France in 1742, he had set a mould for the rising generation of British portrait painters like Thomas Hudson, which only outstanding or eccentric talents like Ramsay or Hogarth were to break in the immediate future.

JOSEPH FRANCIS NOLLEKENS 1702–1748

104 Conversation Piece of Five Figures in a Garden

1740

Inscribed 'J.Nollekens Fecit 1740' bottom right

Canvas 50 × 40 (127 × 101.6)

Prov: ...; Duke of Norfolk; bt by Leggatt Bros by 1961, from whom bt by lender

Exh: The Pursuit of Happiness, Yale Center for British Art 1977 (64, repr.)

Lit: Vertue III, pp.137–8

Yale Center for British Art, Paul Mellon Collection, New Haven

Nollekens is said to have come to England from Antwerp in the early 1730s and worked initially with Peter Tillemans (29). Vertue writes that he was 'a little spritely man' who produced copies of Watteau and Pannini (very likely his chief income, as 'ruin pieces' by Nollekens appear in many eighteenth-century sales), as well as conversations in 'a pleasant free manner' which were popular with people of fashion.

The grandiose Palladian setting of this unidentified group, with its meticulously painted antique urn and vast Italianate garden structure around a Triton fountain set amid overblown trees, has the distinct feeling of a Pannini-inspired capriccio. The patently English sitters, on the other hand, solidly posed with their harpsichord and obedient dog, would look more at home in a modestly conventional Georgian interior. Musical groups set at the foot of flamboyant garden staircases were a Flemish equivalent of the French pastoral *fête galante* (41), and it is possible that this is a fanciful adaptation of the genre to the needs of British small-scale portraiture.

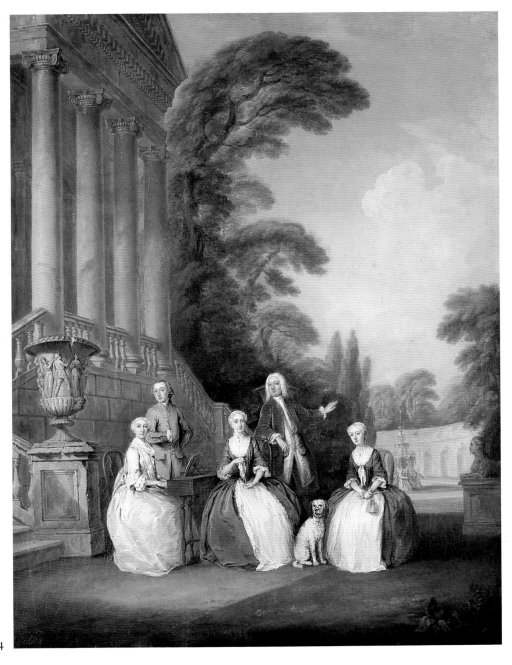

104

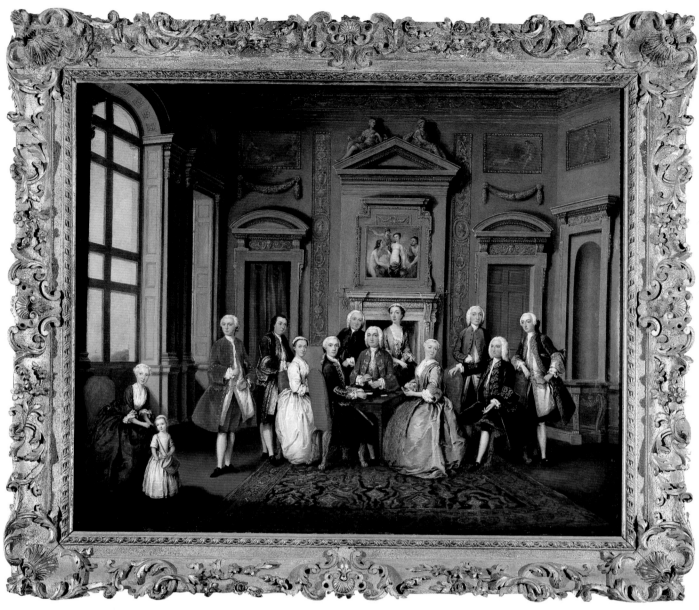

JOSEPH FRANCIS NOLLEKENS 1702–1748

105 A Family in a Palladian Interior ('The Tylney Group') 1740
Inscribed 'J.Nollekens F.1740' bottom left
Canvas 35 × 44 (86.3 × 109.2)
Prov: ...; possibly Wanstead House sale, Robins,
June 1822, 10th day (318 as 'Nollekens-Interior of
Saloon of Wanstead House with an Assemblage of
Ladies and Gentlemen. A Conversazione'); ...; Sir
William Henry Salt Bt; ...; Canon Arthur Evans, by
descent to John Evans, by whom presented to
Summer Fields School, Oxford; sold to Arthur Tooth
1976
Exh: Rococo Art and Design in Hogarth's England,
Victoria & Albert Museum 1984 (B 3, col. pl.XVII)
Lit: M.J.H. Liversidge, 'An Elusive Minor Master,
J.F. Nollekens and the Conversation Piece', *Apollo*,
XCV, January 1972, pp.34–41, fig.8
*British Rail Pension Funds Works of Art Collection, on
loan to Fairfax House, York*

This group of twelve adults and an infant boy has been
identified in the past as the 1st Earl Tylney (d.1750) with his
family and friends, on the grounds that the painting may
have been sold from the Wanstead House collection in 1822.
Wanstead was a vast classical edifice built in 1714–20 by
Colen Campbell for the merchant banker Sir Richard Child,
who later became the 1st Earl Tylney. Child was Nollekens's
most important patron and many of his works appeared in
the Wanstead sale. A version of this painting still belongs to a
branch of Lord Tylney's descendants. The problem is that
the room cannot be connected with Wanstead, which had no
Venetian windows such as the one shown here.

The interior is, however, a model of Palladian taste, décor
and arrangement, and the family is evidently a very wealthy

one. The classic style is carried through to the paintings: the grisaille overdoors appear to show the story of Meleager hunting the boar, and the overmantel may represent the story of Pandora. Every architectural detail is picked out in lavish gilding.

Nollekens's figure style is very close here to early Mercier (69) and displays a thin, translucent touch that betrays its Franco-flemish origins, although he tends to pose his figures in a much more stiff and conventional way that is closer to Philips than any continental models.

THOMAS BARDWELL 1704–1767

106 The Broke and Bowes Families 1740
Inscribed '. . . fecit 1740' bottom left
Canvas $38\frac{1}{2} \times 43\frac{1}{2}$ (97.2 × 110.5)
Prov: Presumably painted for Philip Broke, and thence by descent
Lit: Great Welnetham Parish Registers 1561–1850, The Suffolk Green Books, 1910, XV, pp.517–8; M. Kirby Talley, 'Thomas Bardwell of Bungay, Artist and Author 1704–1767', *Walpole Society*, XLVI, pp.149–50, fig.16
Private Collection

The seated gentleman is Philip Broke of Nacton (1708–1762), M.P. for Ipswich, seen with the ladies of the Bowes family into which he married. On the left are, standing, his wife Ann (d.1755), with their second child Elizabeth (bapt. 6 November 1739) and, seated, his mother-in-law Elizabeth Thurland (d.1747), widow of Martin Bowes Esq. (d.1726) of Bury St Edmunds. On the right are Ann's two unmarried sisters Elizabeth (d.1770) and Isabella (d.1779). The scene is probably set in Mrs Bowes' house, as one of her daughters is about to hand her a letter addressed 'To Mrs Bowes/in/ Bury'. She must have been a lady of some wealth, for when announcing the marriage of Philip Broke in January 1733, the *Gentleman's Magazine* described her daughter Ann as 'Miss Bowes of Bury St Edmunds, a fortune of £15,000'.

It will be noticed that the shape and frame of the painting matches the empty frame in the centre of the picture: normally one would have expected it to hold a portrait of the deceased paterfamilias, but perhaps a visual pun was intended in this case.

The painting has suffered in the past, and the artist's signature is no longer visible. However, stylistically it fits well into Bardwell's early *oeuvre*, and was described as 'a conversation small picture by Bardwell' in a house catalogue as early as 1797.

106

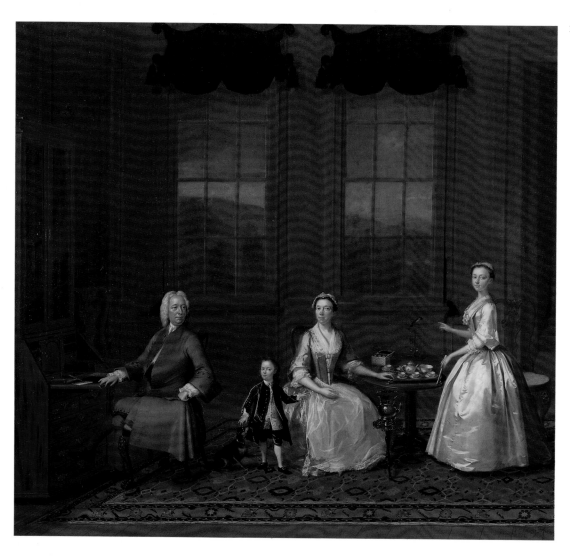

WILLIAM VERELST active 1734, died c.1756

107 The Gough Family 1741
Inscribed 'W.ᵐ Verelst P.ᵗ 1741' bottom right
Canvas 30 × 33¾ (76.2 × 85.8)
Prov: Presumably painted for Sir Henry Gough,
thence by family descent
Exh: The Conversation Piece in Georgian England,
Iveagh Bequest, Kenwood, 1965 (44, pl.va)
Lit: J. Fowler & J. Cornforth, *English Decoration in
the 18th Century,* 1974, pp.103–4, fig.84
Private Collection

The sitters are Sir Henry Gough, 1st Bart. (1708–1774) of
Edgbaston, his second wife Barbara (d.1782), daughter of
Reynolds Calthorpe of Elvetham, and the children of his first
marriage to Catherine Harpur (d.1740). It should be added
that family genealogies in the Hampshire and Staffordshire
Record Offices state that there were no children from this
marriage, but they may have died young. As Sir Henry
married Barbara Calthorpe in July 1741, the picture may
have been painted to mark the event.

The Goughs were a typical wealthy merchant family who

had built their fortune on trade with India and China, and
were consolidating their position through gradual acqui-
sition of land, manorial lordships and titles. Sir Henry was
created a Baronet in 1728, and his son Henry (b.1749)
became MP for Bramber, and after inheriting the Elvetham
estates in 1788, was elevated to the peerage in 1796 as Baron
Calthorpe, of Calthorpe in Norfolk.

In spite of presenting a meticulous inventory of the
family's obvious wealth, from the beautifully carved high-
backed chairs in the background, to the silver tea-kettle with
a coat of arms engraved on its side, from the bureau-book
case with its well-designed gilt handles and urn finials, to the
fashionably draped curtains from which furniture historians
can deduce the exact workings of the sashes, the painting has
an informal modesty that avoids any hint of vulgar display. It
is a fine example of the kind of taste that stood behind the
popularity of the small-scale conversation piece of the 1730s
and 1740s, a style that blended particularly well with similar
traditions in Dutch painting brought in by immigrants like
the Verelsts, and which found its best native expression in
the work of Arthur Devis.

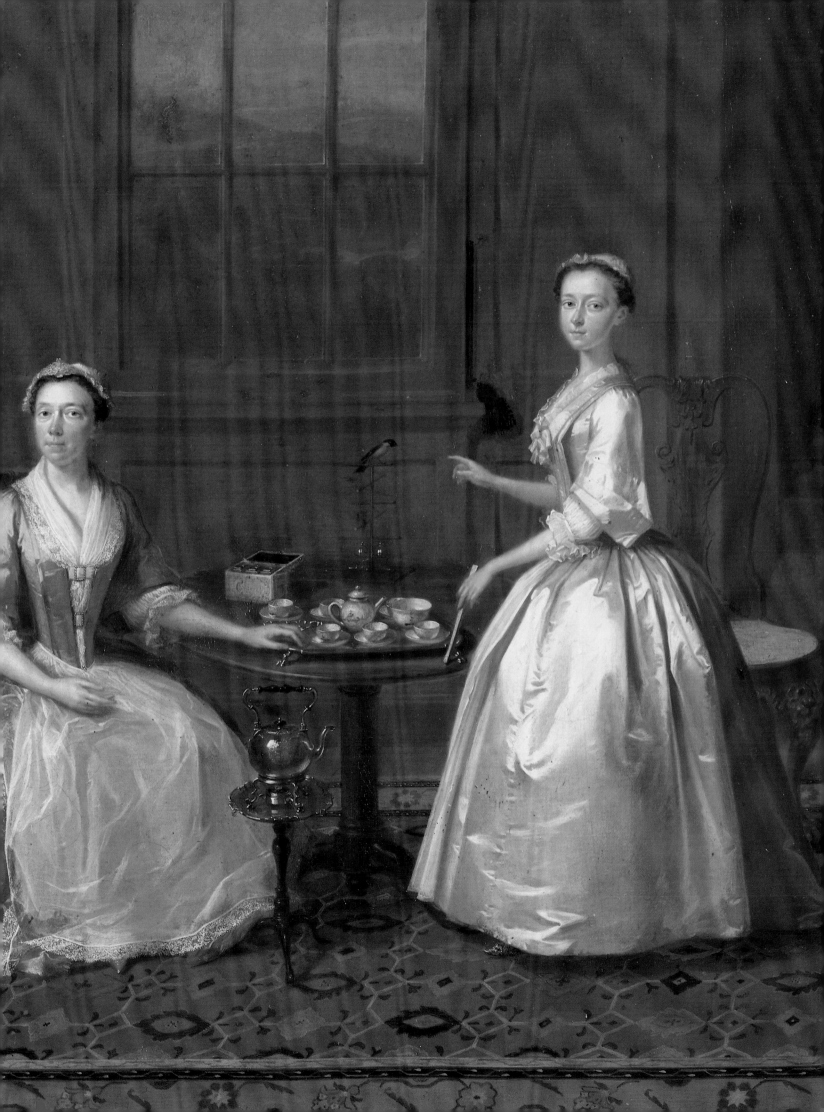

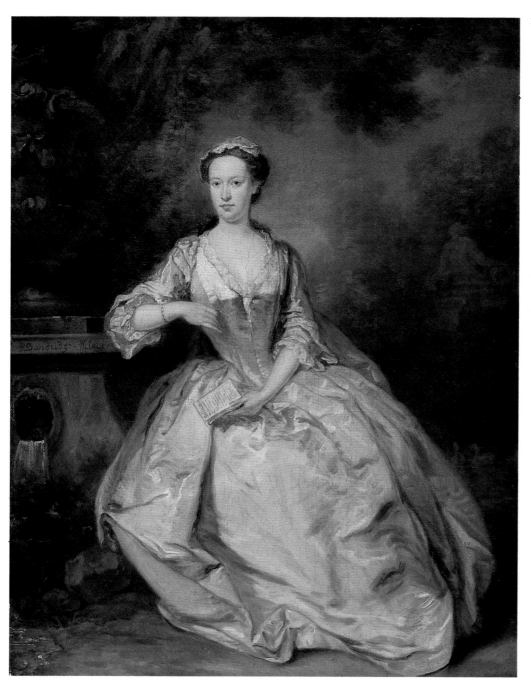

BARTHOLOMEW DANDRIDGE
1691–*c*.1755

108 A Lady Reading 'Belinda' Beside a Fountain
c.1740–5
Inscribed 'B.Dandridge.Pinx.' on pedestal of urn, and
'Belinda' on book
Canvas 20¾ × 16¾ (52.5 × 42.5)
Prov: ...; Col. J.G. Round, bt by Paul Mellon 1961,
and presented by him to the lender 1981
Exh: Painting in England 1700–1850, R.A. 1964–5
(26)
*Yale Center for British Art, Paul Mellon Collection,
New Haven*

In this gentle painting of an unknown lady, Dandridge
approaches the French pastoral idiom of Watteau and
Lancret as closely as he ever would. Its silvery tone and light
touch, poetic garden setting and easy pose combine to
produce a genuinely pensive mood rarely achieved in British
painting before Gainsborough.

Vertue repeatedly compared Highmore and Dandridge as
worthy rivals and, writing in 1731, contrasted Highmore's
'hard and smaller manner' (still apparent in later works like
131) with Dandridge's 'broader great manner', with its 'full
& free pincill' and 'light easy design'.

It is not known if *Belinda* is meant to be a specific work of
literature; it was a commonplace to address ladies by that
name in poetry.

FRANCIS HAYMAN 1708–1776

109 The Wrestling Scene from 'As You Like It'

c.1740–2

Canvas 20¾ × 36¼ (52.7 × 92.1)

Prov: Possibly painted for Jonathan Tyers, and possibly the 'Scene from As You Like It' in the sale of Jonathan Tyers Jnr, Christie's 28 April 1830 (28) bt Gilmore; ...; Anon sale (Sir Alec Martin), Christie's 19 November 1948 (131 as by De Troy), bt Jameson (?bt in); ...; Dr Brian Rhodes, sold Christie's 28 July 1950 (173 as by De Troy) bt in, offered again at Christie's 18 December 1953 (77 as Hayman) bt Agnew, from whom bt by the Tate Gallery (N 06206)

Exh: *Shakespeare in Art*, Arts Council 1964 (12); *Francis Hayman*, Yale Center for British Art, New Haven, and Iveagh Bequest, Kenwood, 1987 (37)

Lit: Allen 1987, pp.16, 114, 151–2, col. pl. VII

Tate Gallery

The incident represented here comes from Act I, Scene IV of Shakespeare's *As You Like It*, when Orlando has thrown the Duke's champion Charles to the ground, while a delighted Celia, the Duke Frederick, and others look on.

The painting, which judging from its oblong shape, dating on grounds of style, as well as its Tyers provenance, may have been a trial design for the Vauxhall supper box project (see 146; no large version is known), is one of the most delightful Rococo interpretations of a Shakespearean subject. Its fresh colouring and fluid handling is of a high enough quality to pass for De Troy as recently as 1950, and is in marked contrast to the more academic and serious mode to which Hayman aspired in his later years (such as 211).

The design is an adaptation of Hayman's upright illustration of *c*.1740–41 of the same scene for Sir Thomas Hanmer's *de luxe* edition of Shakespeare published in 1743–4 with illustrations by Hayman and Gravelot (Allen 1987, repr. p.152). It shows Hayman at the point at which he was most influenced by his elegant French draughtsman collaborator, an influence which at this stage – and on this small scale – transferred readily into paint.

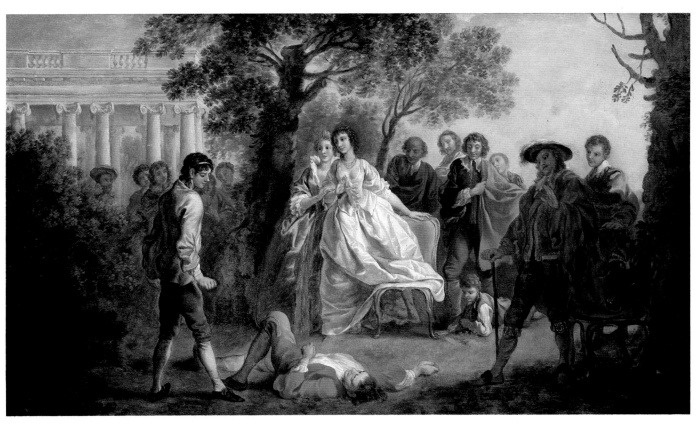

109

HUBERT FRANÇOIS (Bourguignon)
GRAVELOT 1699–1773

110 Le Lecteur or The Judicious Lover *c.*1745
Canvas $12\frac{1}{4} \times 9\frac{3}{8}$ (31.1 × 23.4)
Prov: ...; ?the artist's sale, Paris, 19 May 1773; ...;
acquired in Paris by Mr & Mrs Eliot Hodgkin, from
whom bt by the Greater London Council for Marble
Hill House 1968
Exh: Rococo Art and Design in Hogarth's England,
Victoria & Albert Museum 1984 (D20, repr.)
Lit: R. Edwards, 'Two Versions of Gravelot's Le
Lecteur', *Apollo*, June 1958, p.212, repr.; *To Preserve
and to Enhance*, Iveagh Bequest, Kenwood 1975,
no.11, repr. in col.
Marble Hill House (English Heritage), Twickenham

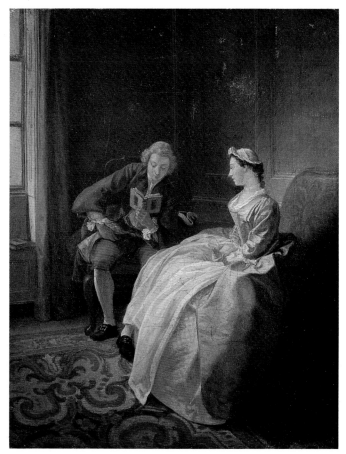

110

This charming genre piece shows, according to an engraving
by F. Marchand, 'The Judicious Lover' wooing his aloof
lady by reading her plaintive passages from Ovid. The verse
of an engraving after this painting by René Gaillard,
published in Paris in 1756 (as a companion piece to Boucher's
'La Marchande des Modes'), makes it clear that the lady is
meant to be English. Her figure alone was engraved by
C. Grignon in England in 1745, which is about the right date
for the dress and the furnishings of the interior. The en-
gravings attribute the painting to Gravelot, and there is an
identical version of this picture in the York Art Gallery,
signed with his initials 'H.G'. This documentation is useful,
as Gravelot rarely painted in oils, and his main contribution
to British art was in the field of Rococo design and elegant
figure drawing.

As a pupil of Boucher, Gravelot was a brilliant exponent of
the French Rococo style, and soon after his arrival in
England in 1732 Vertue expressed the hope that his superior
technique would 'furnish this Nation with many things ... of
a much better taste'. He was thinking of etching, but in the
event Gravelot's drawing academy in the Strand and his
position as drawing master at the St Martin's Lane Academy
after it opened in 1735 was to have a profound influence on
leading painters like Hogarth, Hayman, Highmore and
Gainsborough. This, and the fact that by the time Gravelot
returned to France in 1746 he had been involved in almost
every major scheme for illustration and design in this
country, as well as in the designs for popular venues like
Vauxhall Gardens, makes him one of the main agents in the
development of the Rococo taste in England during this
period.

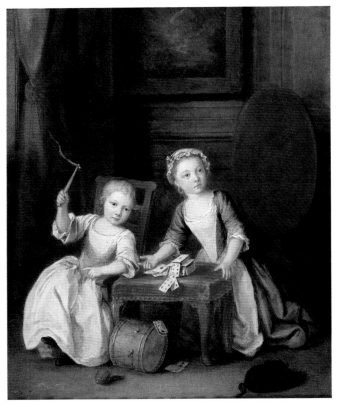

111

JOSEPH FRANCIS NOLLEKENS 1702–1748

111 **Two Children of the Nollekens Family** 1745
Inscribed 'J.Nollekens 1745'
Canvas $14\frac{1}{8} \times 12\frac{1}{4}$ (36.0 × 31.0)
Prov: ...; Paul Mellon by 1967, presented to the
lender 1981
Lit: Vertue III, p.138; M.J.H. Liversidge, 'An Elusive
Minor Master, J.F. Nollekens and the Conversation
Piece', *Apollo*, XCV, January 1972, pp.34–41
*Yale Center for British Art, Paul Mellon Collection,
New Haven*

The children are probably Jacobus (b.1741) and Maria
Joanna Sophia Nollekens (b.1739), lovingly observed in the
traditional childish pursuits of building houses with cards
and spinning tops. The boy's drum and cap lie on the floor,
and the children's small size is emphasised by the round table
folded away in the background.

This and the following picture are among Nollekens's
most delightful works and were probably among those
mentioned by Vertue at the sale of Nollekens's pictures after
his death in 1748 as 'several small pictures of children at
different plays exercises & amusements from the life. his own
children pretty pleasant designs which was really lately done
& the best of his works'.

They are typical of the unaffected studies of childhood
that began in the early eighteenth century as part of the age
of enlightenment, and that had found their first popular ex-
pression in the works of artists like Lancret and Chardin.

JOSEPH FRANCIS NOLLEKENS 1702–1748

112 **Two Boys of the Nollekens Family Playing at
Tops** *c.*1745
Canvas $12\frac{1}{4} \times 10\frac{1}{8}$ (31.0 × 25.7)
Prov: ...; Paul Mellon by 1960; presented to the
lender 1976
Lit: As 111
*Yale Center for British Art, Paul Mellon Collection,
New Haven*

The sitters are probably the painter's two eldest sons Joseph
(1737–1823), the sculptor, and John Joseph (b.1735).

112

JOSEPH NICKOLLS active 1726–1755

113 The Fountain in the Middle Temple 1738
Inscribed 'Jo.Nickolls Pinx' bottom right
Canvas $24\frac{1}{2} \times 29\frac{3}{4}$ (62 × 75.6)
Prov: ...; in the collection of the Society of the
Middle Temple by 1930
Exh: Richard Wilson's Early Contemporaries, Tate
Gallery 1982 (9)
Lit: J. Nichols, *The History and Antiquities of the
Parish of Lambeth*, 1786, pp. 116, 161; B. Williamson,
Catalogue of Paintings . . . in the Middle Temple, 1931
The Honourable Society of the Middle Temple

Fewer than half a dozen works – all London views – can be
attributed with any certainty to this gifted artist, about whom
practically nothing is known. A mention of his involvement
in a decorative design of 'a beautiful landscape painting of
ruins and running water' at Vauxhall Gardens suggests that
he may have also worked as a scenery painter. It is clear that
he was a skilled artist in the Dutch townscape tradition, who
must have produced more works than are known at present.
He comes close to Scott in his sensitive treatment of light and
atmosphere, and to Hogarth in the liveliness of his figures.
Most of his signed paintings have been attributed to them in
the past. This painting was engraved in 1738, as a pair to a
'View of the Stocks Market', both prints naming Nickolls as
the painter. Precise detail, nicely judged and never over-
stated, holds one's interest right into the depth of the picture,
from the delivery-man chatting to the maidservant in the
doorway on the left, to the Holy Lamb on the roof of the
Honourable Society's chapel. Pictures like this speak of a
well-developed and sophisticated view-painting tradition in
London well before the arrival of Canaletto, of which we as
yet know very little, but of which Wilson (100) must have
been well aware.

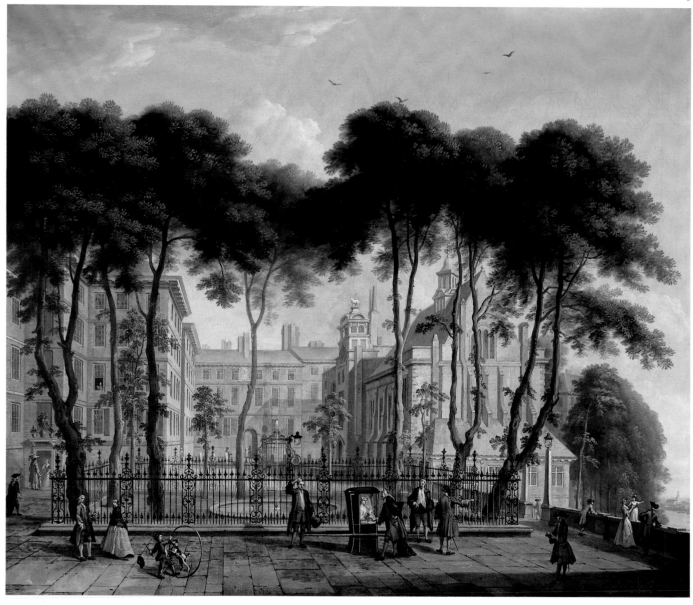

113

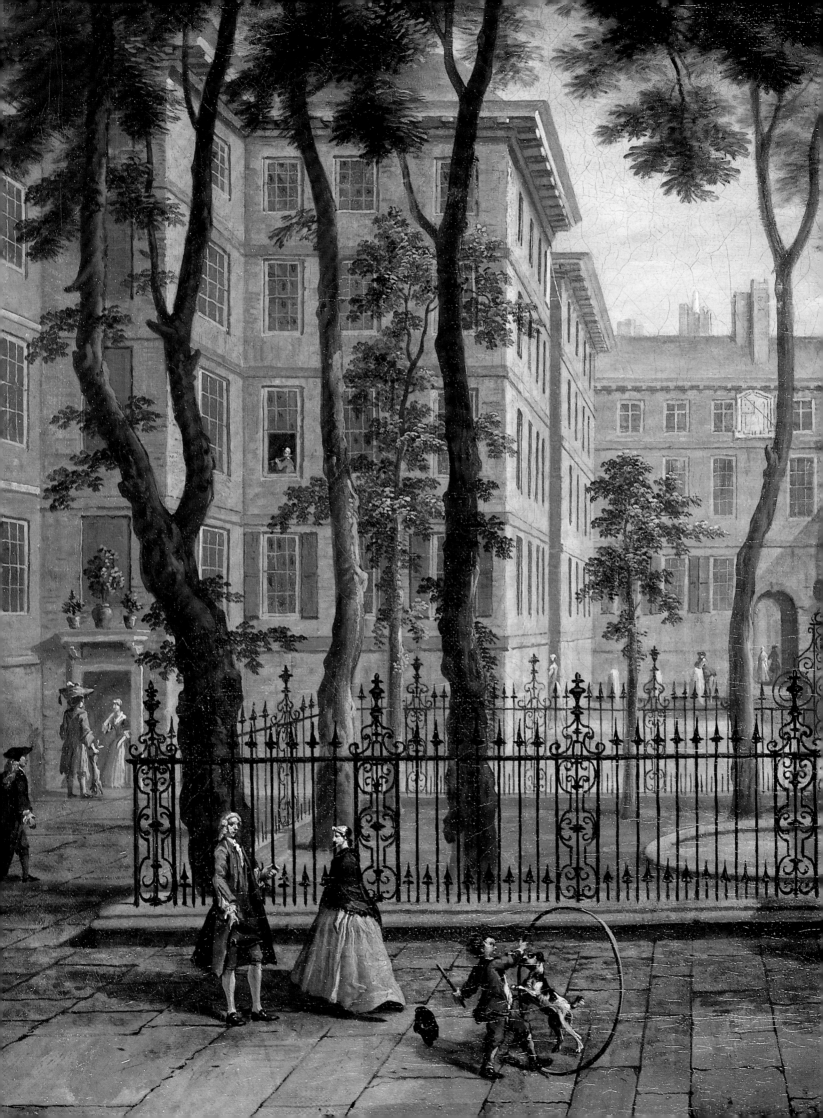

JOSEPH NICKOLLS active 1726–1755

114 St James's Park and the Mall *c.*1745
Canvas 41 × 54½ (104.1 × 138.4)
Prov: ...; first recorded in the Royal Collection in 1808
Lit: Millar 1963, pp.195–6, pl.208
By Gracious Permission of Her Majesty The Queen

The view shows the east end of the Mall, with Westminster Abbey in the distance, and a glimpse of Horse Guards Parade on the left. The view gives a wonderfully lively impression of one of the favourite pastimes of the London public throughout the eighteenth century (see also no.9), that of promenading up and down the Mall, in order to see and be seen. The whole gamut of the social scale is represented: the stout figure of the man seen from behind on the left, wearing a hat and the ribbon of the Garter, is probably George II. The prominent group in the forefront, just off centre right, is led by Frederick, Prince of Wales, accompanied by a number of companions who include a gentleman wearing the ribbon and star of the Garter, possibly the 1st Duke of Newcastle (1693–1768), and another wearing the insignia of the Bath. The rest of the scene is filled with milkmaids, soldiers, sailors, clergymen, foreigners and people of fashion.

It is hoped that comparison with no.113 and no.115 will confirm the recent attribution of this painting to Nickolls.

(*Reproduced before cleaning*)

114

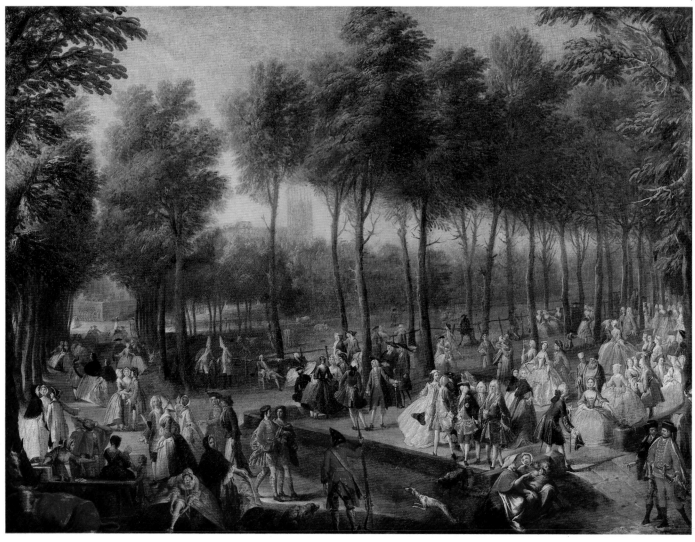

114 St James's Park and the Mall *c.*1745

115 A View of Charing Cross and Northumberland House 1746

Inscribed 'J° Nickolls Pinx/1746' bottom left
Canvas 20 × 30 (50.8 × 76.2)
Prov: ...; acquired by the lender before 1974
National Westminster Bank p.l.c.

The view is of Charing Cross, looking at Le Sueur's statue of Charles I, and up the Strand, with the turrets of Northumberland House on the right. This is one of the most convincing views of a busy London thoroughfare painted in the year of Canaletto's arrival in London. Nickolls's paintings are made particularly attractive by their lively and well-observed figures, which can range from the crude to the very elegant in the manner of Jacques Rigaud. It is possible to distinguish his hand in some of the better figure groups in the landscapes of George Lambert.

115

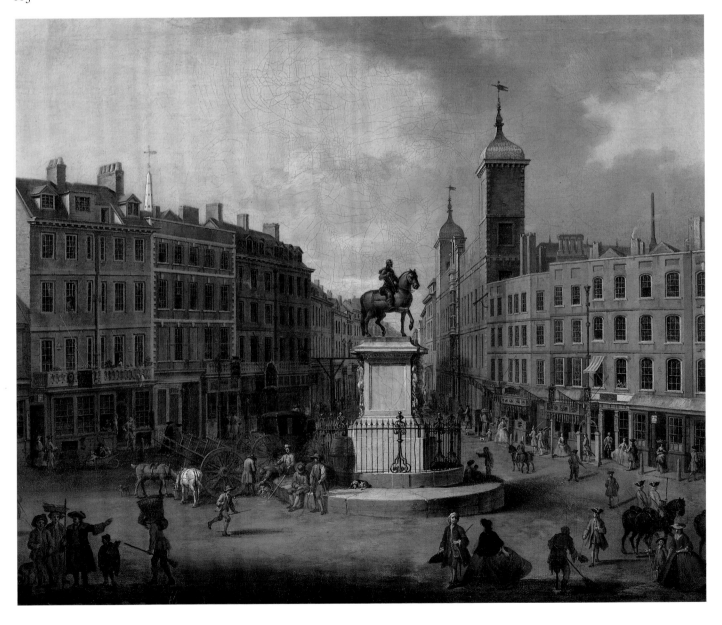

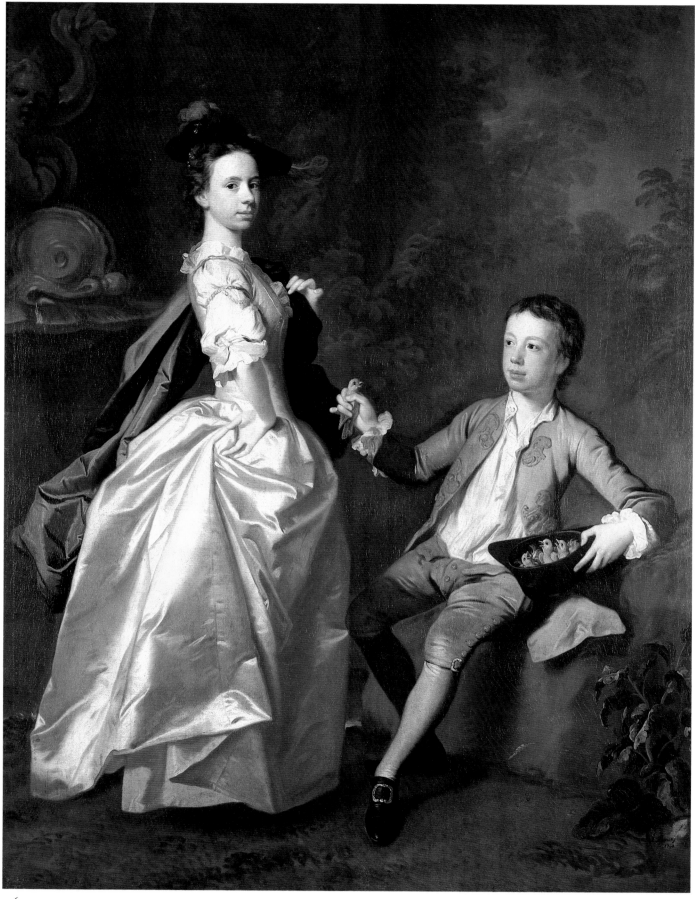

116

116 **The Hon. Rachel Hamilton and her Brother Charles** 1740
Inscribed 'A.Ramsay 1740' lower left
Canvas $67\frac{1}{2} \times 54\frac{1}{2}$ (171.5 × 138.5)
Prov: Painted for the 6th Earl of Haddington, and thence by descent
Exh: Masterpieces of the Eighteenth Century, R.A. 1954–5 (61)
Lit: Smart 1952, pp.33, 42, 130
The Earl of Haddington

Rachel (d.unm.1797) and Charles (1727–1806), later a Lieutenant Colonel in the Dragoon Guards, were the children of Charles, Lord Binning, and the brother and sister of Thomas, 7th Earl of Haddington, who was also painted by Ramsay.

Ramsay returned in 1738 from Italy, where two years of study under Francesco Solimena, Imperiali and at the French Academy in Rome had given him a grasp of technique and graceful elegance that was altogether new in British painting. His success was immediate, especially among the Scottish nobility. From the start, his portraits, like Hudson's, depended greatly on the then supreme drapery painter Joseph Van Aken (*c*.1699–1749), whose skills, however, Ramsay channeled into much more assured and swagger compositions.

This impressive portrait has much the same mixture of adult formality and childish whimsy as Hogarth's 'The Graham Children' (120), without, however, the latter's sheer exuberance that enabled Hogarth to capture something of the vulnerable transience of childhood.

117 **Thomas, 2nd Baron Mansel of Margam with his Half Brothers and Sister** 1742
Inscribed 'A.Ramsay/1742' on ledge lower left
Canvas $49\frac{1}{2} \times 39\frac{1}{2}$ (124.5 × 100.3)
Prov: Painted for the sitter and thence by descent
Exh: Pictures from West Wales Houses, Glynn Vivian Art Gallery, Swansea, 1973 (28, repr.)
Lit: J. Steegman, *Portraits in Welsh Houses*, 1962, II, p.114, pl.26A
Private Collection

Thomas, 2nd Baron Mansel of Margam (1719–1744) was the son of the Hon. Robert Mansel, and grandson of the 1st Lord Mansel, whom he succeeded in 1723. His father died before succeeding to the title, and his mother Anne, daughter of Admiral Sir Clowdisley Shovel, married secondly John Blackwood. Thomas is shown here with his Blackwood half-brothers and half-sister.

The painting shows Ramsay applying his Italian training, and perhaps even more his training at the French Academy at Rome, to what could have been a fairly conventional sporting painting. As it is, the subtly restrained colour scheme and elegant design put all the emphasis on the informal relationship between the figures and on an unusually convincing representation of the sense of touch.

The painting is in a particularly splendid contemporary frame.

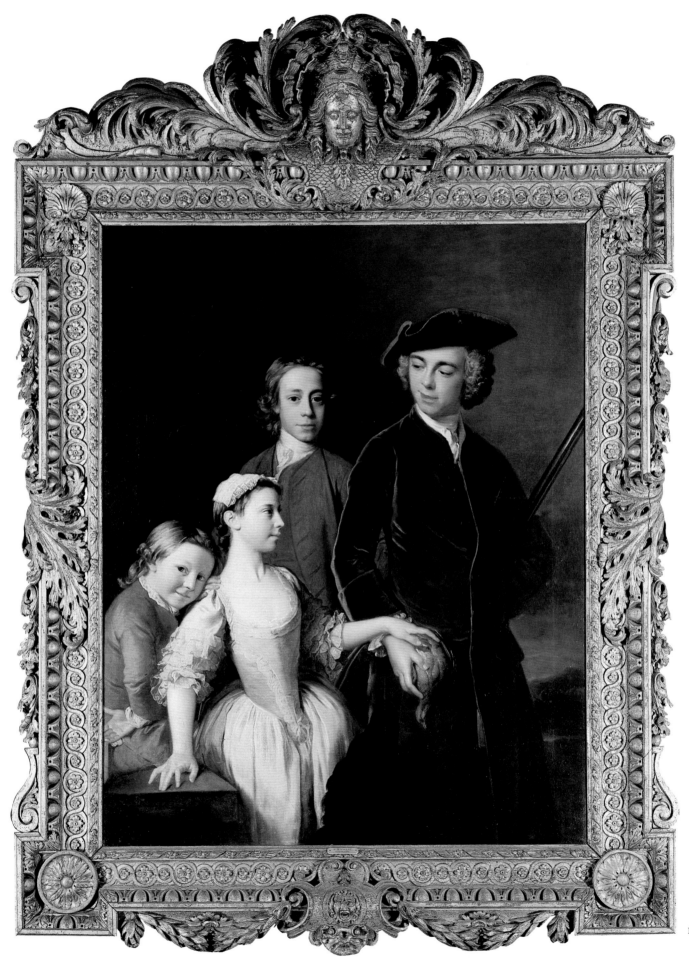

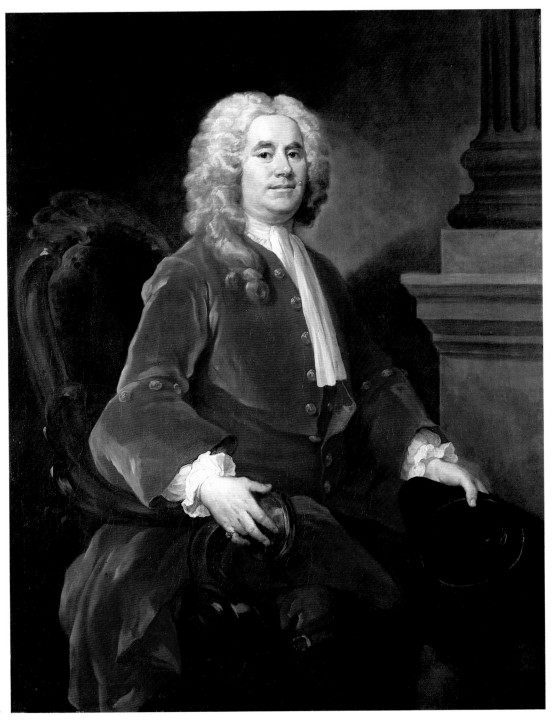

118

WILLIAM HOGARTH 1697–1764

118 **William Jones, F.R.S.** 1740
Inscribed 'W.Hogarth Pinx.ᵗ 1740' bottom right corner
and 'Wᵐ Jones Esq.ʳ' on base of column
Canvas 50 × 40¼ (127 × 120)
Prov: Probably painted for George Parker, 2nd Earl of
Macclesfield, and by descent to Viscount Parker, sold
Christie's 16 March 1984 (94, repr. in col.) bt by
lender
National Portrait Gallery

William Jones (1675–1749) was one of the most outstanding mathematicians of his day. The son of a modest Welsh farmer, his gifts were recognised early and he received a good education. He collaborated with Sir Isaac Newton and Halley, and was elected Fellow of the Royal Society in 1712, and its Vice-President in 1737. He was mathematics tutor to Philip Yorke, later Lord Hardwicke, and to Thomas Parker, 1st Earl of Macclesfield, and the latter's son George (c.1697–1764), later 2nd Earl, and President of the Royal Society. For many years Jones and his family lived at Shirburn Castle, Oxfordshire, as guests of both father and son. The 2nd Earl inherited his father's interest in science and astronomy, and was a driving force behind the Act of 1752 for the adoption of the Gregorian calendar in England, which involved 'losing' eleven days (see 196). Jones edited some of Newton's works in 1711 and was engaged in an ambitious introduction to Newtonian philosophy when he died in 1749. He bequeathed the manuscript to the 2nd Earl for completion, together with his notable library, but the project was not continued, and the library was sold in 1801. Jones married Maria, daughter of George Nix, a London cabinet maker who was the chief rival of Chippendale; she was apparently no mean mathematician herself.

This splendid portrait was painted at about the same time as Hogarth's 'Captain Coram' (157) and shows his impressive ability to convey, when he wanted to, an image of vitality, intelligence and utter dignity with a minimum of fuss. The 2nd Earl was, like Hogarth, a Governor of the Foundling Hospital (its Vice-President 1750–64), and may have been prompted to commission this portrait as a result of knowing 'Coram'. Indeed Hogarth also painted a portrait of the Earl, a pendant to this, which is still in the family's possession. With this commission Hogarth must have felt that he was continuing his family's association with arguably the greatest personality of the age, Sir Isaac Newton, begun with Thornhill's portrait of c.1710 (12), his own conversation piece of his descendants (68), and now portraits of two of Newton's most distinguished friends and collaborators.

WILLIAM HOGARTH 1697–1764

119 Mary Blackwood, Mrs Desaguliers 1741
Canvas, circular, 27 (68.5) diameter
Prov: Presumably painted for the sitter, and by descent to her grandson William R. Cartwright of Aynhoe, in whose collection first recorded in 1820; thence by descent
Lit: Webster 1979, p.185, no.118, repr.
Private Collection

The sitter is Mary, daughter of John Blackwood, the dealer and collector, who married Thomas Desaguliers (1725–1780), Lieutenant-General and Colonel Commandant of the Royal Artillery. As Chief Firemaster at Woolwich arsenal for thirty-two years, Desaguliers was the first scientific maker of cannon and the first regular investigator into the power of gunnery in the English army. He was the son of Dr Theophilus Desaguliers, the prominent natural philosopher and Freemason who appears in Hogarth's 'Indian Emperor' (68).

With its lustrous silks and pearls, and in its colour scheme and pose, this portrait deliberately courts comparison with a number of well-known female portraits by Van Dyck, in particular perhaps those of Anne Carr, Countess of Bedford, of which a number of variants exist (the best is at Petworth). Yet, unlike Hudson and Knapton, the treatment here does not have the air of masquerade or fancy dress, but is more a respectful quote from one of the artists Hogarth admired most, in a manner that was later to become the hallmark of Reynolds's female portraits.

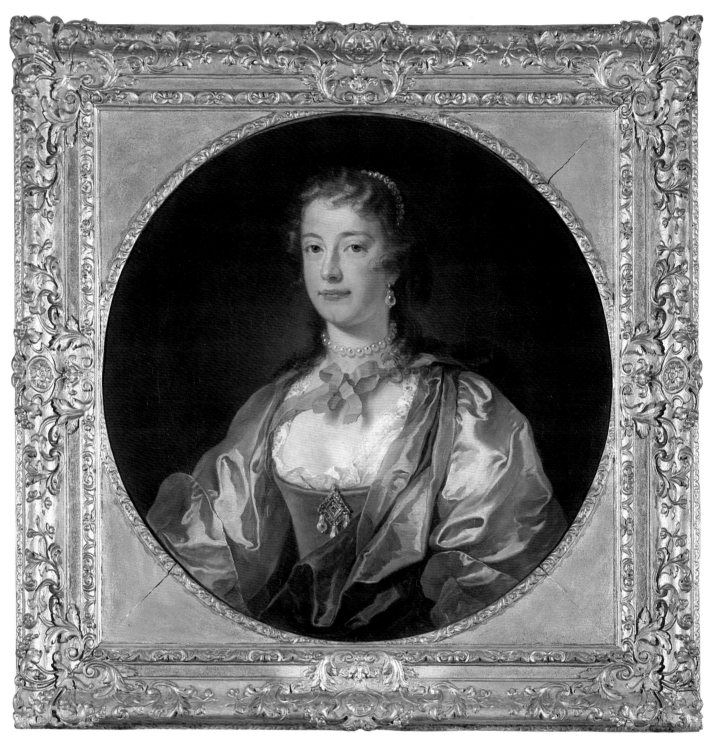

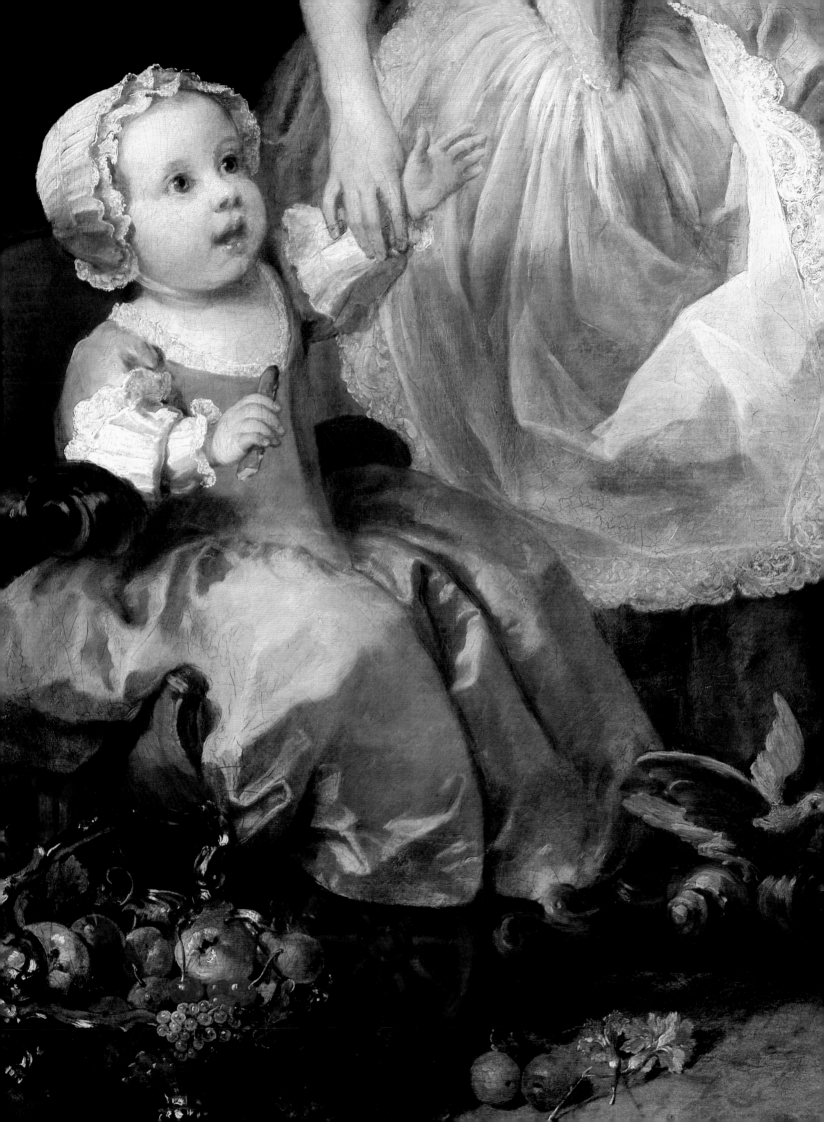

WILLIAM HOGARTH 1697–1764

120 The Graham Children 1742
Inscribed 'WHogarth/Pinxt 1742' bottom right corner
Canvas $63\frac{1}{4} \times 71\frac{1}{4}$ (160.5 × 181)
Prov: Presumably painted for Daniel Graham, the
children's father, and first recorded in the collection of
Richard Graham (d.1816) in 1805; with William
Seguier by 1817, by whom sold to George Watson
Taylor, sold Robins 24 July 1832 (50) bt Lord
Normanton, from whom bt by Lord Duveen and
presented to the National Gallery; transferred to the
Tate Gallery 1949, and returned to the National
Gallery 1986
Exh: Hogarth, Tate Gallery 1971 (112, repr. in col.)
Lit: M. Davies, *National Gallery Catalogues, British
School*, 1946, p.74; D. Mannings, 'A Note on the
Interpretation of Hogarth's Graham Children',
unpublished article, 1978; R. Cowley, 'An airy
habitation: an investigation into the cultural
background of William Hogarth's "The Graham
Children"', unpublished article, 1987
The Trustees of the National Gallery, London

The sitters are three children of Daniel Graham (1695–
1776), apothecary to the royal household and the Chelsea
Hospital, and his second wife Mary Crisp; Elizabeth (the
eldest girl in blue, later Mrs Tomlinson), was a daughter of
Mary Crisp's first marriage. The others are, in the centre,
Henrietta Catherine (b.1735), who married her cousin
Daniel Malthus, and was the mother of Thomas Robert
Malthus, the economist, Anna Maria (the baby), who
married Thomas Ryves, and Richard Robert (1734–1816),
the boy playing the bird organ, who succeeded his father as
apothecary to the Chelsea Hospital in 1747 (the post was a
sinecure and the work was carried out by deputies). The
Grahams and the related Malthuses were wealthy apo-
thecaries in Pall Mall who prepared the anointing oils for the
coronations of both George I and George II, and had been
apothecaries to the royal household since Queen Anne;
Daniel's father had also been Apothecary General to the
Army. With Richard Robert the professional impetus of the
family began to decline, although he resided in the Chelsea
Hospital apartments until the end of his life.

One of Hogarth's rare full-length portraits on the scale
of life, it is also, like Coram (157), one of his master-
pieces. It deliberately invites comparison with Van Dyck's
famous 'Five Eldest Children of Charles I', in conscious
reference perhaps both to the Grahams' connections with the
royal household, and to Hogarth's own acknowledged ad-
miration for Van Dyck. It is a refreshingly direct study of
children in their natural habitat, yet typically for Hogarth, it
cannot avoid being also a comment on the human condition
in general, employing a whole range of traditional emblems
to this end, although these are beautifully integrated into
the domestic setting. The representation of Orpheus charm-
ing the beasts on the bird-organ alludes to the temporary
harmony that art can impose on wild nature, just as the
Cupid listening atop the clock on the left, guarding the scythe
and hour-glass of Father Time, suggests that Love can make
even Time itself depart for a while. The goldfinch flutters in
its cage, safe from the tabby cat that gazes at it with utter
greed and fascination, and the children play in their pro-
tected world, still watched over by love rather than time.
Only the eldest girl is aware of the outside world, even
though she still holds two cherries, the 'fruit of Paradise',
traditionally associated with childhood. The still-life of a
silver basket, fruit and carnations in the bottom left-hand
corner may be also symbolic, and is as fine a piece of bravura
painting as any to be found in Hogarth.

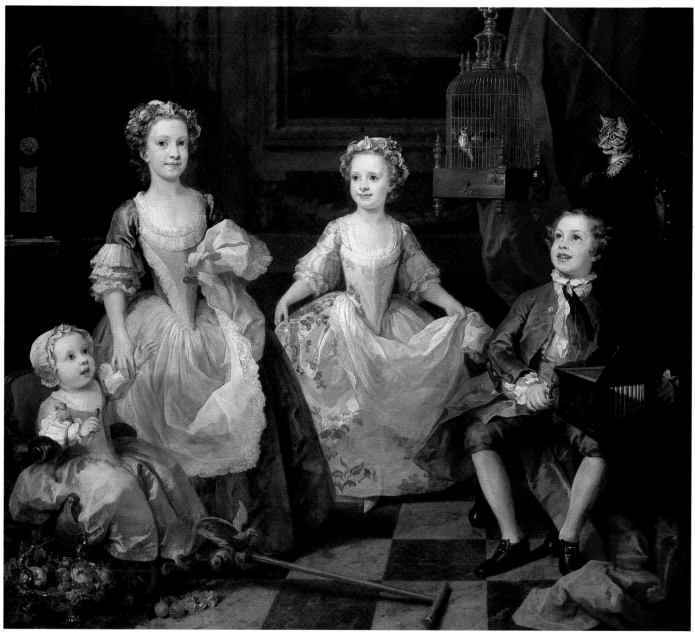

120

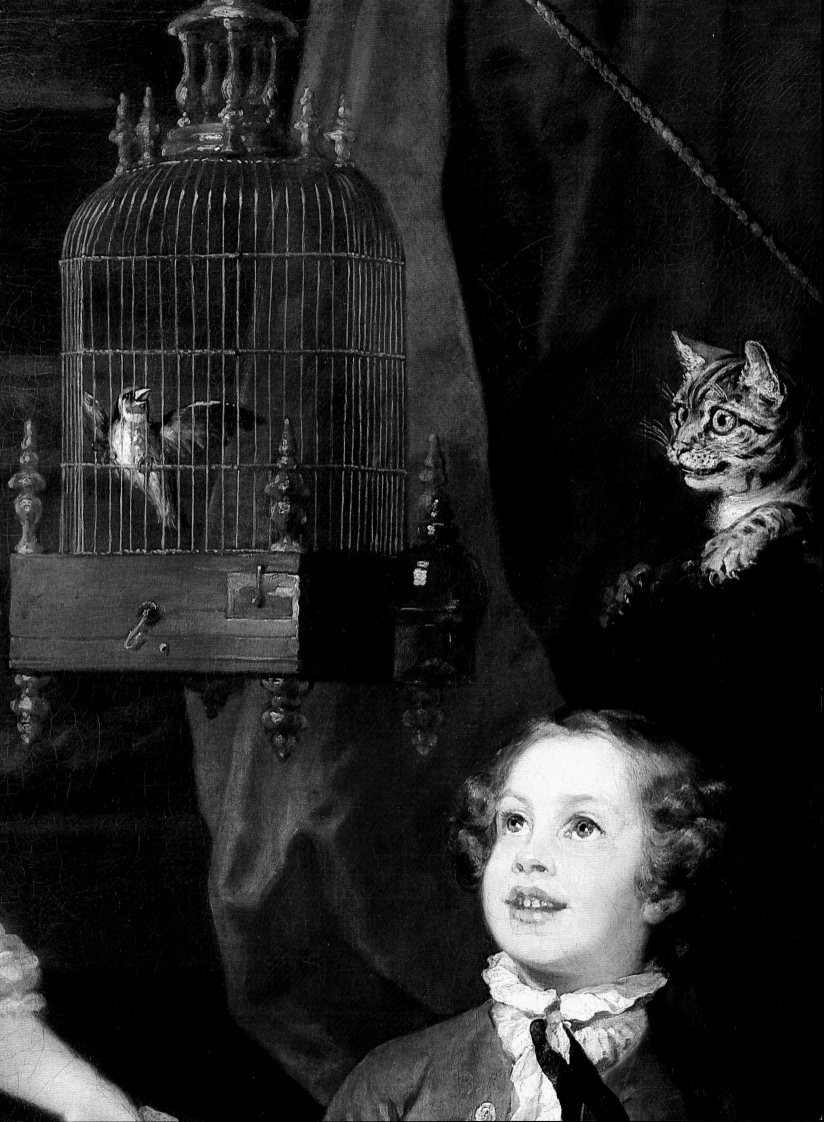

GEORGE KNAPTON 1698-1778

121-124 Four Portraits of Members of the Dilettanti Society 1741-4
Canvas, each 29½ × 24 (75 × 61)
Prov: Presented to the Society by the sitters when painted
Lit: C. Harcourt-Smith, *The Society of Dilettanti: Its Regalia and Pictures*, 1932, pp.47-48, 50-51, 59-62
The Society of Dilettanti

The Society of Dilettanti was founded in 1732 by a group of gentlemen who had travelled in Italy and wanted to maintain an interest in the antiquarian and artistic pursuits which they had enjoyed while abroad. Like the Kit-cat (23-27), it was essentially a convivial club, though intellectually a very distinguished one, and in this case one whose members also amused themselves with elaborate, possibly sub-masonic, rituals. George Knapton was a foundation member, and its official painter from 1736 until 1763. He painted altogether twenty-three portraits of members, mostly in fancy dress, which are still in the Society's possession.

121 Sir James Gray, K.B., in Van Dyck Costume 1741
Inscribed 'Sʳ James Gray' top left

Sir James Gray, Bt (d.1773) was a founder member of the Society and played an important part in its affairs. As British Resident in Venice 1744-53, he was invited to look out for suitable candidates for the Society, and authorised to propose them by letter. It was on his recommendation that the Society elected as members James Stuart and Nicholas Revett, and became linked with, and supported, their great publication on the *Antiquities of Athens*, 1762. As Envoy Extraordinary to the King of Naples and the Two Sicilies 1753-61, Sir James took a leading part in the discoveries at Herculaneum. He was appointed Minister Plenipotentiary to the King of Spain in 1761, and Privy Councillor in 1769.

The two volumes on the table in front of him are inscribed 'Don Quixote' and, on top, 'Novelas Exemplares'.

122 Charles Sackville, 2nd Duke of Dorset, as a Roman Consul 1741
Inscribed 'Duke of Dorset' top left, and 'CAROLUS SACKVILLE COMES / MIDDLESEXIAE FLORENTIAE IN FESTIS / SATURNALITIIS .ANNO 1738 SUB / PERSONA CONSULIS ROMANI AB / EXERCITU REDEUNTIS.' upper centre right

The inscription translates as 'Charles Sackville, Earl of Middlesex, in the Christmas festivities at Florence in the year 1738, in the guise of a Roman Consul returning from the army'. As Charles Sackville, Earl of Middlesex (1711-1769), succeeded his father as 2nd Duke of Dorset in 1765, the inscription in the top left-hand corner must have been added

121

122

after that date. There is a full-length of him at Knole by Frans Ferdinand Richter in which he is shown wearing the same Roman dress.

As Lord Middlesex he toured Italy twice, first in 1730–3, as a result of which he was made a member of the Society, and again in 1736–8. It was probably on this second visit to Venice in May 1737 that he formed his passion for Italian opera. Horace Walpole, who accused Sir Francis Dashwood and Lord Middlesex of having been seldom sober during the whole time they were in Italy, said that the latter had spent 'immense sums' on trying to promote Italian opera in this country, and it was no doubt under his influence that in April 1743 the Dilettanti Society passed a resolution that 'the scheme for carrying on of Operas is highly worthy of the Countenance of the Society of Dilettanti', though nothing seems to have come of it.

123 Samuel Savage in Masquerade Costume 1744
Inscribed 'Sam! Savage Esq!' top left

Unfortunately little is known about the subject of one of Knapton's finest portraits. In a letter dated 22 May 1733, Colonel Burges, the Resident in Venice, mentions 'Mr. Savage' and 'Mr. Feake' amongst the English there. Martin Folkes records in his Journal that when he was in Rome he was visited by Mr Savage on 1 November 1733. Mr Savage returned to Venice the following year, and his departure for Vienna was reported by Colonel Burges on 26 March 1734.

Samuel Savage and Samuel Feake were elected to the Dilettanti Society in 1738. Both were proposed by Daniel Boone, a Director of the East India Company and of the Bank of England. The only record of Samuel Savage having taken any part in the affairs of the Society is that on 1 May 1748 it was resolved 'that Mr. Savage be requested to accept the Function of Arch Master of the Ceremonies for the year Ensuing, and he accepted it accordingly'.

124 Sir Bourchier Wrey in a Ship's Cabin with a Punch Bowl 1744
Inscribed 'S! Bourchier Wray' top left

Sir Bourchier Wrey or Wray, Bt (d.1784), of Tawstock Court, North Devon, succeeded his father as 5th Baronet in 1726. He was Colonel of the North Devon Militia, an M.P., and the head of an ancient family seated at the Manor of Trebditch in Cornwall. It is not known when he visited Italy. He was elected to the Society of Dilettanti in 1742, proposed by Sir Francis Dashwood.

Sir Bourchier, whom Horace Walpole called 'a very foolish knight', is depicted in the stern cabin of a ship, which has a strong list to port. The china punch bowl, which he is holding, is inscribed with a line from the *Odes* of Horace: 'Dulce est Desipere in Loco' (It is sweet on occasion to play the fool).

123

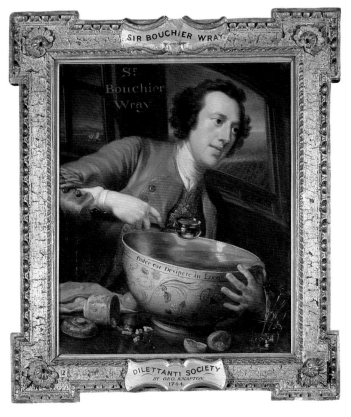

124

GEORGE KNAPTON 1698–1778

125 Portrait of Frances Macartney *c.*1745
Canvas 50 × 40 (127 × 101.5)
Prov: ...; Great Brampton House Antiques by 1982;
Mrs Pamela Howell

Private Collection of Mrs Pamela Howell, Great
Brampton House

Frances Macartney (1724–1789) married Fulke Greville,
Baron Brooke of Wilbury, Wilts. She was the author of *Ode*
to Indifference. She is shown here in masquerade dress,
holding a mask.

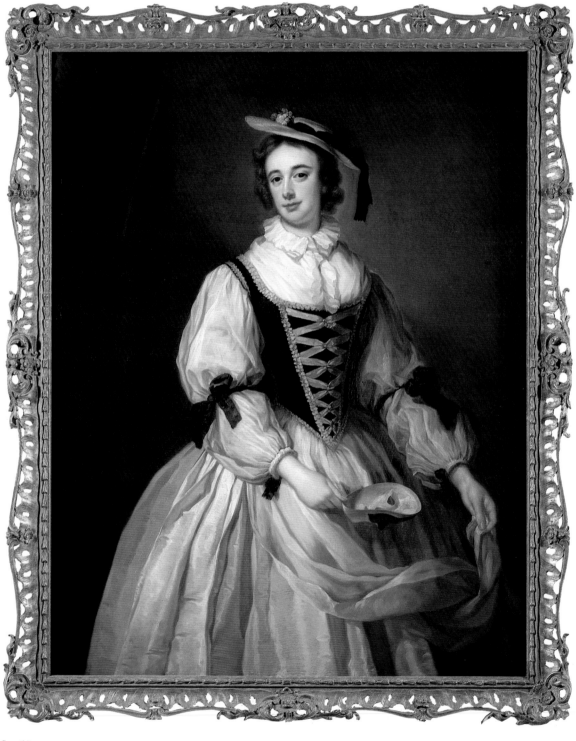

125

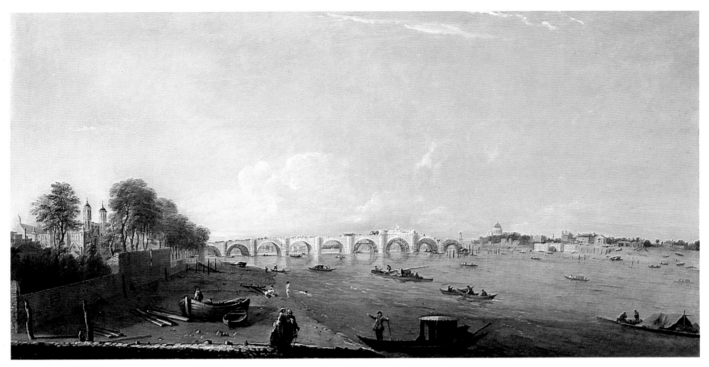

126

RICHARD WILSON 1713–1782

126 Westminster Bridge under Construction 1744
Inscribed 'R Wilson/1744' on plaque in wall lower left
(very faint)
Canvas 28 × 57½ (72.4 × 146)
Prov: ...; F.A. Durell, by descent to his great-grand-
daughter Joan Durell-Stables, bequeathed 1980 to a
relative by whom sold to Spink & Son, from whom bt
by the Tate Gallery 1983
Exh: Richard Wilson, Tate Gallery 1982 (5, repr.)
*Lit: The Tate Gallery 1982–4: Catalogue of
Acquisitions,* pp.83–4, repr.
Tate Gallery

The painting shows the bridge as it was in the late summer of
1744, practically completed on the Westminster side, and
with only the abutment ready on the Surrey bank. The view
looks downstream from near Westminster Stairs, with St
Stephen's Chapel (then used as the House of Commons) and
Westminster Hall on the left, and St Paul's and the City
visible beyond the barge houses and timber yards of the
south bank on the right. A city couple, dressed in their best,
descend the stairs towards the ferry, perhaps to visit
Vauxhall Gardens on the opposite side.

The bridge was the major civic building project of the
century and ended the immemorial monopoly of London
Bridge as the city's only crossing of the Thames. Work on it
was in progress from 1739 until 1750, and in that period it
was painted at all stages of construction by almost every
aspiring view-painter of the day. Among all of them, this
early work by Wilson is the only one to treat the view more as
a landscape than an urban prospect, capturing something of
the feel of the muddy banks of the river at low tide in a way
that was not to be matched until Scott's view of the lower
reaches of the Thames of the 1750s.

Although the painting's long narrow dimensions are
evidently designed to conform with the shape of an over-
mantel, it is unfortunately not known for whom it was
painted, although there must have been a ready market
among the many wealthy tradesmen and commissioners
involved in the project, as is confirmed by the existence of
another version, dated 1745, now in the Philadelphia
Museum of Art.

EDWARD HAYTLEY active 1740–61

127–128 Two Views of the Temple Pond at Beachborough Manor 1744–6
Canvas, each 20¾ × 25⅝ (52.7 × 65)
Prov: Painted for James Brockman of Beachborough Manor, by descent to Mrs W. Arkle; ...; acquired by the lender under the terms of the Everard Studley Miller Bequest 1963
Lit: The Montagu Family at Sandleford Priory by Edward Haytley, exhibition catalogue, Leger Galleries London, 1978; Harris 1979, pp.163, 165, 220–1, figs.237a–b; E. Devapriam, 'Two Conversation Pieces by Edward Haytley', *Apollo*, CXIV, August 1981, pp.85–7, pls I–II
National Gallery of Victoria, Melbourne. Everard Studley Miller Bequest 1963

127 The Brockman Family and Friends at Beachborough Manor: The Temple Pond Looking towards the Rotunda

128 The Brockman Family and Friends at Beachborough Manor: The Temple Pond from the Rotunda

A letter from Mrs Elizabeth Robinson, dated 28 December 1743, to her daughter Elizabeth Montagu, describes Haytley working on a preparatory drawing for a 'landskip from ye life' for her neighbour James Brockman, of which no. 127 is clearly the result. It identifies most of the figures as friends and relations of the Brockmans of Beachborough Manor, near Hythe, Kent, including, in the foreground, Squire James Brockman (1696–1767) himself, standing beside his niece Mary Brockman seated on a stool sketching the Temple. The Squire was unmarried and Mary acted as his housekeeper. It is interesting that the 'Miss Hymore', who is seen walking beside the Rev. Edmund Parker on the right, is probably Susannah, daughter of the painter Joseph Highmore, who was on visiting terms with the Brockmans. According to Emma Devapriam, the same letter mentions another drawing by Haytley (unfortunately lost) of Miss Highmore falling into the pond while fishing, and being rescued by the Rev. Parker, who pulled her out by the leg.

Brockman's meticulously kept cashbook in the British Museum records payments to Haytley from 1740 onwards, for things like 'mending sundry pictures' and supplying frames. The largest is for £20.7.6 on 6 May 1746 'in full for pictures and frames', and is most likely to be for the above two paintings.

Mrs Robinson's letter also makes it clear that the Temple which is the focal point of both pictures was yet to be built at the time when Haytley began sketching, and Brockman's account book shows that work on it and the construction of the pond were still going on throughout the summer of 1744. She also amusingly describes the Squire's agonizing over what to call the pond: he thought 'pool' sounded better, while 'serpentine river' was too grand ('temple pool' or 'sacred pool' were also suggested).

No.128, showing the pool from the other end, must have been painted soon after as a companion piece to the above. Although the figures here are not identified, it is fair to assume that the gentleman seated in the Temple is again James Brockman.

This pair and their unusually pertinent documentation illustrate well the close association between landscape gardening and perspective view-painting, combined here with the informal conversation piece in a particularly attractive way.

Although Edward Haytley presented two landscapes to the Foundling Hospital sometime before 1751, his quality as a painter of landscapes and portraits is a relatively recent discovery.

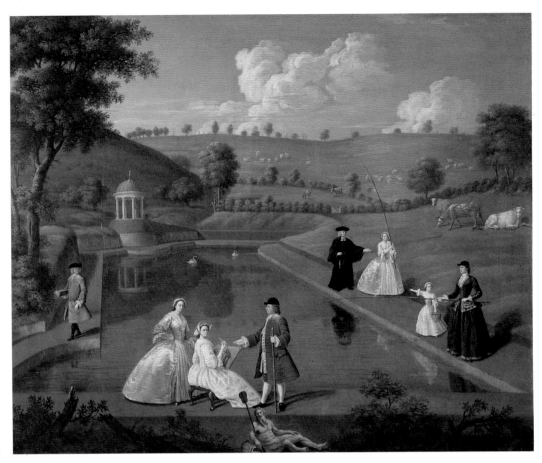

127

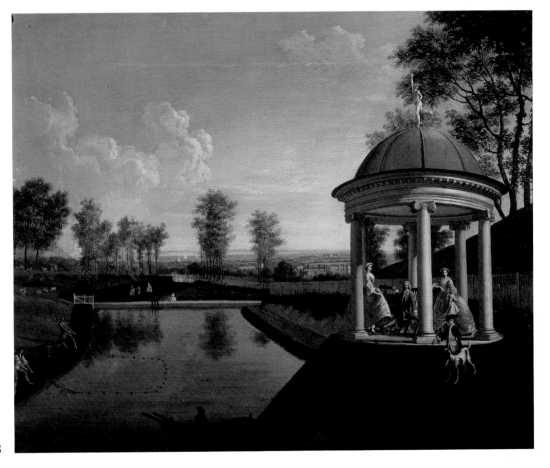

128

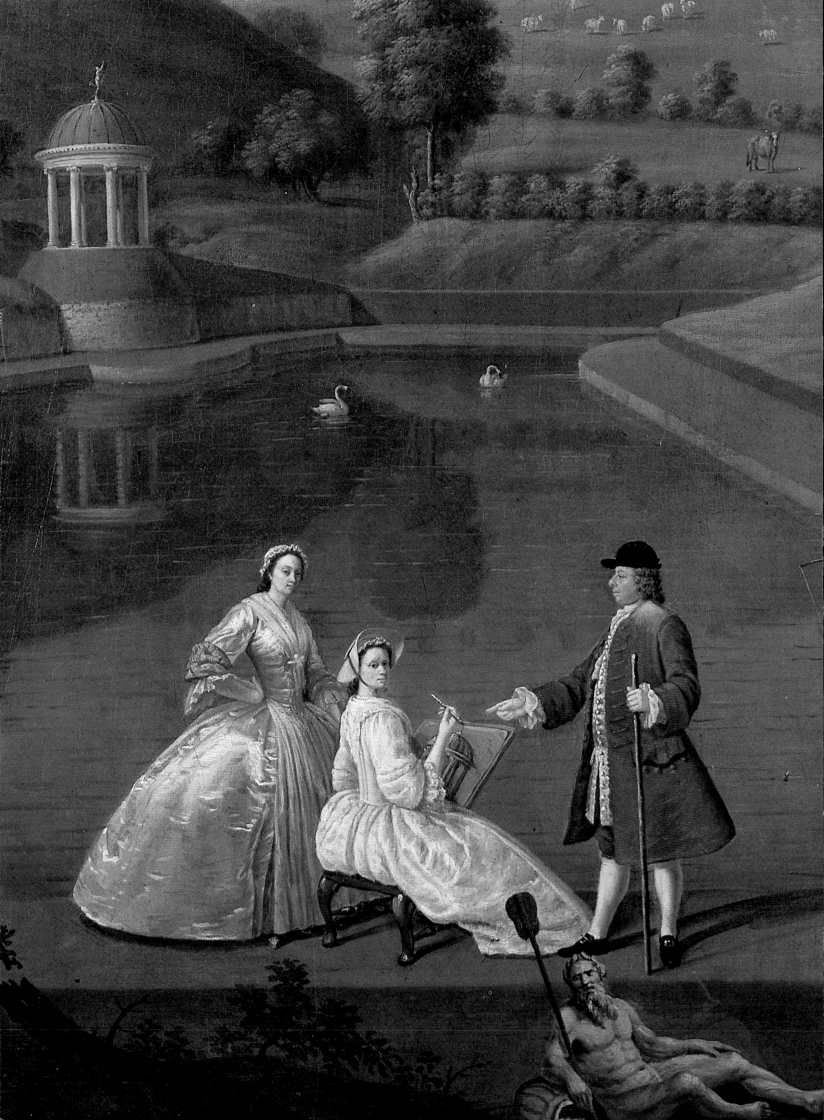

WILLIAM HOGARTH 1697–1764

129 The Dance (The Happy Marriage ?VI: The Country Dance) *c.*1745
Canvas $26\frac{5}{8} \times 35\frac{1}{8}$ (67.7 × 89.2)
Prov: In Hogarth's studio until his death; Mrs Hogarth, from whom bt by Samuel Ireland before 1781, sold Sotheby's 7–15 May 1801 (406) bt Vernon; ...; W.B. Tiffin of the Strand by 1833; ...; Charles Meigh of Grove House, Shelton, Staffs by 1850, sold Christie's 21 June 1850 (105) bt Hoare; ...; William Carpenter of Forest Hill by 1875, bequeathed by him to the South London Art Gallery 1899, sold by the London Borough of Southwark to the Tate Gallery 1983 (T 03613)
Exh: Hogarth, Tate Gallery 1971 (148, repr. in col.)
Lit: Einberg & Egerton 1987, no.105

Tate Gallery

'The Happy Marriage' was to be a counterpart of the 'Marriage A-la-Mode' of *c.*1743 (National Gallery), but was never taken beyond the stage of several oil-sketches: another scene, 'The Staymaker', hangs in Gallery 2, 'The Wedding Banquet' is in the Royal Institution of Cornwall, Truro, fragments of 'The Marriage Procession' survive in the collection of the Marquess of Exeter, and three further reported sketches have been lost from sight since the late eighteenth century. Probably modelled loosely on Abraham Bosse's two series of engravings on the same theme, the story was to be an account of the courtship, marriage and virtuous life of a young country squire and his wife, in contrast to the immoral and doomed London marriage of the earlier set. This is probably – the story is far from clear – the final scene, where the young squire gives his first entertainment for the local tenants and gentry after inheriting his father's prosperous and well-run estate.

The painting is arguably one of the most brilliant

129

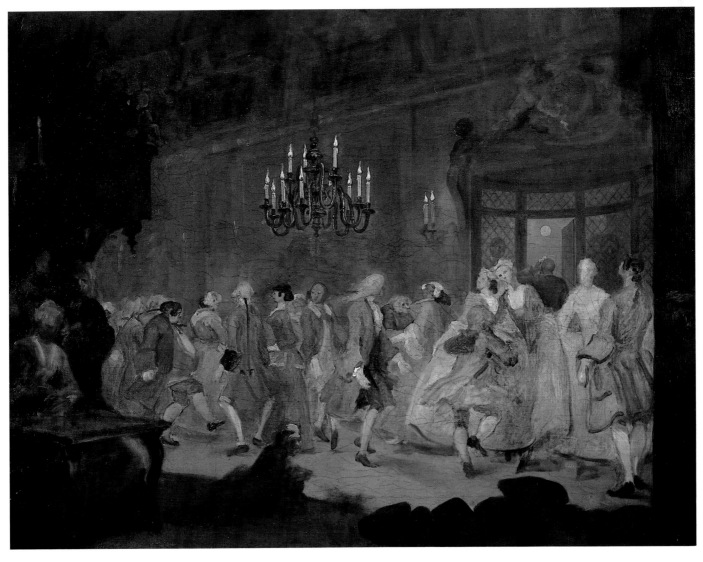

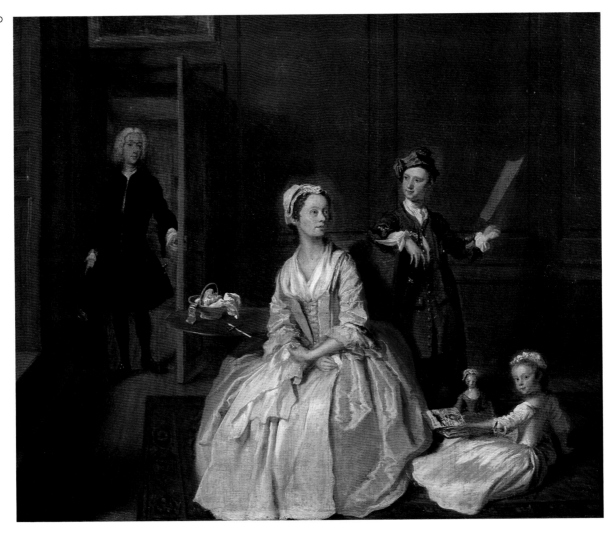

130

eighteenth-century renderings of swift movement in paint, and is a superb example of Hogarth's mastery of the medium. Not figures, but the two different sources of light, one from the moonlit window and the other from the dramatic central chandelier, are the most finished parts of the painting, showing the care with which the artist defined the complex spaces of the composition by means of light and shade. Hogarth's own attachment to the design is demonstrated by the fact that he later worked it up for Plate II of his *Analysis of Beauty*, published in 1753.

JOSEPH HIGHMORE 1692–1780

130 Conversation Piece, probably of the Artist's Family *c.*1732–5
Canvas $25\frac{1}{2} \times 30\frac{1}{2}$ (64.7 × 77.5)
Prov: ...; Earl of Plymouth by 1930, thence by descent
Lit: G.C. Williamson, *English Conversation Pieces*, 1931, p.6, col. pl.XII
Private Collection

Highmore married Susanna Hiller (d.1750) in 1716, and they had two children, Anthony (1718–1799) and Susanna (1725–1812). The seven years' difference between brother and sister would seem about right in this painting. It is also known that both were taught drawing and painting by their father and had artistic ambitions. If this identification of the sitters were correct, the putative age of the children would date the painting to the early 1730s, showing the Highmore family at their home in Holborn Row, Lincoln's Inn Fields, where the artist lived until his retirement. It would also make it one of the most affectionate and informal family conversations of the period.

131 Unknown Man with a Musket 1745
Inscribed 'Jos: Highmore pinx:1745' lower left
Canvas 19 × 14 (48.3 × 35.6)
Prov: ...; Williams & Sutch, London, sold to Leggatt
Bros., bt from them by R.F. Lambe 1938 and
bequeathed to the lender 1951
Exh: Joseph Highmore, Iveagh Bequest, Kenwood,
1963 (27, repr.)
Lit: J.W. Goodison, *Fitzwilliam Museum, Cambridge.
Catalogue of Paintings, III (British School)*, 1977,
pp.101–2, pl.8
The Syndics of the Fitzwilliam Museum, Cambridge

A good example of Highmore's small-scale full-lengths of
the 1740s, distinguished by their lively and elegant Rococo
style. Soundly designed, they could be enlarged to the scale
of life without any loss of effect.

It has been suggested that this could be the portrait of an
actor in a theatrical role, perhaps because of the man's
gesture towards the musket on the floor. His dress suggests
naval uniform.

132 Portrait of a Lady with a Pug 1738
Inscribed 'Jos Highmore Pinx.1738.' on base of
column, lower left
Canvas $49\frac{3}{8} \times 31\frac{1}{8}$ (125.4 × 79)
Prov: ...; Lord Mount Temple; ...; Agnew's, from
whom bt by the lender 1952
Exh: Allan Ramsay: His Masters and Rivals, National
Gallery of Scotland 1963 (34)
Lit: Lewis 1975, pp.525–6, no.214
Sheffield City Art Galleries

Highmore, who was a painter of superior intellectual gifts,
was one of the few painters of the first half of the eighteenth
century who could echo, as in this portrait of an unknown
lady, the style of Van Dyck without making it look like
masquerade dress.

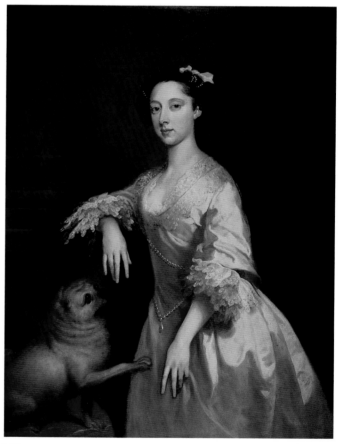

132

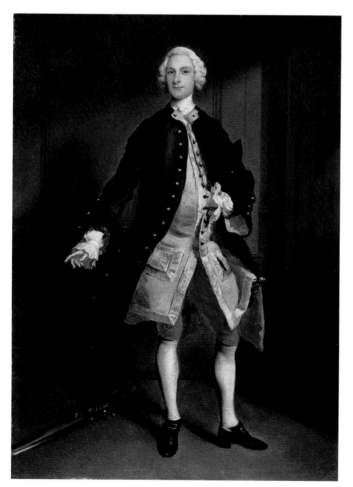

131

JOSEPH HIGHMORE 1692–1780

133 Samuel Richardson 1747

Inscribed 'Jos: Highmore/pinx: 1747.' lower right
Canvas 49 × 39¼ (124.5 × 99.6)
Prov: Bequeathed by the sitter's wife 1773 to Martha
Richardson Bridgen, and bequeathed by her husband
Edward Bridgen in 1787 to Richardson's other
daughter Anne Richardson, with a request that it
should be given to the Stationers' Company after her
death; bequeathed by her to her nephew Philip
Ditcher 1803; ...; Richard Phillips by 1804, given to
the Stationers' Company by an unknown donor in
1811
Exh: Painting and Sculpture in England 1700–1750,
Walker Art Gallery, Liverpool, 1958 (14); *Joseph
Highmore,* Iveagh Bequest, Kenwood, 1963 (31)
Lit: Kerslake 1977, pp.231–5, pl.685; Lewis 1975,
pp.479–87, no.144
*The Worshipful Company of Stationers and Newspaper
Makers*

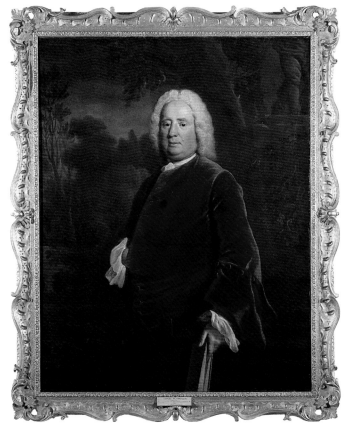

133

Samuel Richardson (1689–1761), printer and novelist, was
born in Derbyshire into a respectable working-class family
and apprenticed to a London printer in 1706. He married
his master's daughter, and by 1719 ran his own printing
business. His first novel *Pamela* (134–145) was published
with immense success in 1740, to be followed by *Clarissa* in
1747–8, which was similar in form and only slightly less
successful, partly because Richardson transposed the subject
into the tragic mode, and to a higher social level in which
he was less at ease. Highmore painted a suitably solemn
full-length (now lost) of the heroine Clarissa in 'Vandyke'
dress. Richardson's last novel *Sir Charles Grandison* was
published in 1753.

Richardson held the office of Master of the Stationers'
Company in 1754; the Company's companion piece to this
portrait, showing Richardson's second wife Elizabeth Leake,
was destroyed in the blitz. A replica of this portrait is in the
National Portrait Gallery, which also owns a small full length
of him by Highmore painted in 1750.

The portrait matches admirably Richardson's own de-
scription of his appearance to his admirer Lady Bradshaigh
in 1749: 'My countenance . . . has nothing severe or
forbidding . . . Short, rather plump than emaciated, . . . one
hand generally in the bosom . . . observing all that stirs on
either side of him without moving his short neck . . .
smoothish faced, and ruddy cheeked, sometimes looking to
be about sixty-five, at other times much younger . . .' It was
this kind of realism that made his name as a writer, and which
was in harmony with the bourgeois portraiture of the day.

JOSEPH HIGHMORE 1692–1780

134–145 Twelve Scenes from Samuel Richardson's 'Pamela' 1744
Canvas, average size 25 × 30 (63 × 76)
Prov: Remained in Highmore's studio, and sold
in his retirement sale, Langford's 5 March 1762
(24); ...; Major Dermot McCalmont, Cheveley
Park, Cambridgeshire, sold Christie's
26 November 1920 (130 as by Cornelis Troost) bt
A.H. Buttery, bt from him by the National
Gallery and divided among the lenders
Exh: (as complete set) *Joseph Highmore,* Iveagh
Bequest, Kenwood, 1963 (15–26, II, VI, VIII, XI
repr.)
Lit: U. Hoff, *Catalogue of European Paintings
before 1800 in the National Gallery of Victoria,*
1961, pp.69–71; Lewis 1975, pp.541–5,
nos.251–63; J.W. Goodison, *Fitzwilliam Museum
Cambridge. Catalogue of Paintings, III (British
School),* 1977, pp.102–5, II, XII repr. pl.7;
Einberg & Egerton 1987, nos.20–23, repr.
*The Syndics of the Fitzwilliam Museum,
Cambridge (II, V, VI, XII), National Gallery of
Victoria, Melbourne, Felton Bequest 1922 (III, IV,
VIII, X) and the Tate Gallery (I, VII, IX, XI)*

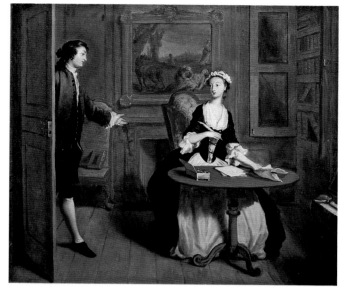
134

Samuel Richardson (133) published his novel *Pamela, or
Virtue Rewarded* in 1740–1. To his own surprise, it became
an immediate bestseller. It was a sentimental novel written in
letter form, describing the tribulations of a genteel and
beautiful lady's maid, Pamela Andrews, who, when left at the
mercy of her rakish employer Mr B, resists numerous
attempts to seduce her until he finally reforms and marries
her. It was the first work of literature that addressed itself
specifically to the taste of the increasingly prosperous middle
classes and which, like the small-scale conversation piece in
painting, charmed by its conscious informality and anti-
heroic insistence on the human dimension. In addition, the
romantic notion that a humble commoner could make it to
the aristocracy through sheer personal excellence was bound
to appeal, as did the interminable scenes of pursuit and near-
rape that could be read with impunity by the virtuous.
Pamela went into its sixth edition by 1742, and was almost
immediately translated into German, French, Italian, Dutch
and Danish.

Highmore painted his 'Pamela' set in 1744 specifically for
engraving; the prints by A. Benoist and L. Truchy were
published on 1 July 1745. They were not meant as illus-
trations to be bound with the text, but as a self-contained re-
telling of the story in visual terms, with ample explanations
engraved in the margin. It was an independent venture by
Highmore, and it was only as a result of this that Highmore
and Richardson met and became lifelong friends.

Highmore's paintings catch the spirit of the novel exactly
and are one of the most delightful products of what Sir Ellis

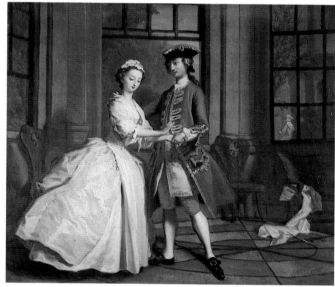
135

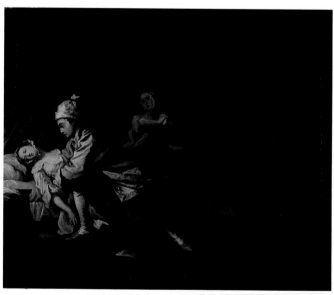
136

Waterhouse called 'the bourgeois sentimental decade'. Unlike Hogarth, his story-telling concentrates on simple elegance; it was his aim to make the burden of each scene apparent at a glance and not to clutter it with any detail that was not directly relevant to the central action.

The set remained on display in Highmore's studio for the rest of his working life, and was sold only in 1762, when he retired from professional painting to Canterbury in order to concentrate on writing pamphlets on art, philosophy and religion.

134 I: Mr B Finds Pamela Writing

This sets the scene for the letter-novel: Pamela sits down to write to her parents about the death of her beloved mistress, who had given her friendship and a good education. The lady's son, Mr B, enters to assure her of his goodwill and protection. 'The Good Samaritan' on the wall presumably refers to the generosity and benevolence of Pamela's former mistress.

135 II: Pamela and Mr B in the Summer House

The rake reveals himself: Pamela rebuffs his first attempt on her virtue.

136 III: Pamela Fainting

A yet more determined attempt is frustrated by Pamela swooning in distress.

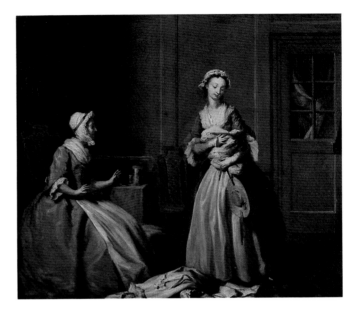

137

137 IV: Pamela Preparing to Go Home

The affronted Pamela decides to return to her poor, but honourable, parents. Watched by the sympathetic house-keeper, she discards her fine clothes and clutches a bundle of the meagre possessions she means to take with her. Her plans are overheard by Mr B.

138 V: Pamela Leaves Mr B's House in Bedfordshire

Pamela sits in Mr B's coach which she thinks will take her home, but which in fact has been ordered to take her to a country hideout where she will be completely at Mr B's mercy.

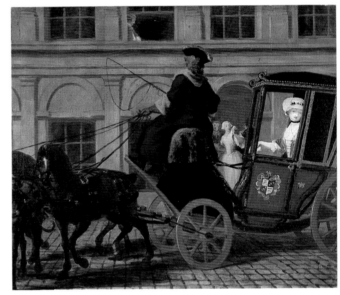

138

139 VI: Pamela Shows Mr Williams a Hiding Place for Her Letters

In the country hideout Pamela manages to evade the attentions of the fierce housekeeper Mrs Jewkes, her jailer, to enlist the help of the local parson Mr Williams

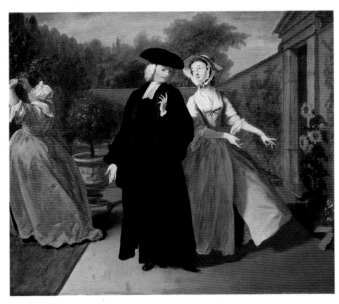

139

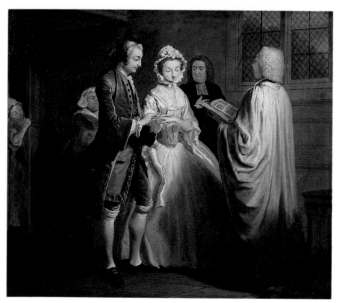

140

140 VII: Pamela in the Bedroom with Mrs Jewkes and Mr B

With Mrs Jewkes's assistance, Mr B hides in Pamela's bedroom to launch another assault on her, but is defeated by her falling into an uncontrollable fit of hysterics.

141 VIII: Pamela Greets Her Father

While Mr B is showing off Pamela's charms to neighbouring gentry, her father arrives unexpectedly to rescue her. The company is deeply affected by his probity and simple dignity.

142 IX: Pamela is Married

The reformed rake and Pamela are secretly married in Mr B's private chapel, with Mr Williams officiating, her father giving her away, and the now devoted Mrs Jewkes guarding the door against intruders.

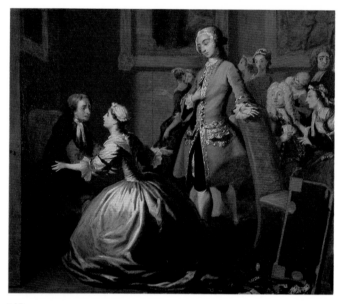

141

142

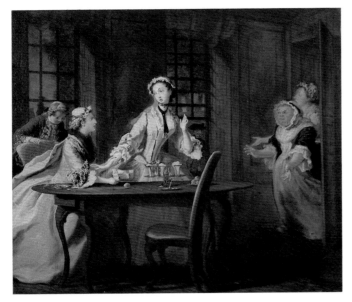

143

143 X: Pamela and Lady Davers

Unaware of her new status but resentful of Mr B's affection for her, his proud sister Lady Davers tries to humiliate Pamela. Soon, however, better acquaintance with Pamela's story and character win her over completely.

144 XI: Pamela Asks Sir Jacob Swinford's Blessing

Mr B's rich fox-hunting uncle, the last of his relations to continue to abominate Mr B's unequal match, is won over after mistaking Pamela for an Earl's daughter, and gives the marriage his blessing.

145 XII: Pamela Tells a Nursery Tale

The apotheosis of Pamela as a model wife and mother, which includes her generously welcoming an illegitimate daughter of Mr B's into the family circle. The painting over the fireplace reflects her madonna-like status.

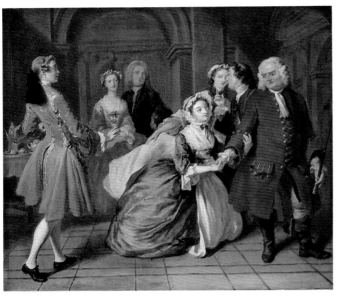

144

145

FRANCIS HAYMAN 1708–1776

146 The See-Saw *c*.1741–2
Canvas 54 × 95 (137 × 241)
Prov: Painted for Vauxhall Gardens; ...; Earl of
Lonsdale, sold from Lowther Castle, Maple & Co.
30 April 1947 (1897 as 'English School'); ...;
A. Carysforth of Blackburn; ...; Appleby Bros. by
1960, from whom bt by the Tate Gallery (T 00534)
Exh: *Francis Hayman*, Yale Center for British Art,
New Haven and Iveagh Bequest, Kenwood, 1987
(32, repr.)
Lit: Allen 1987, pp.108, 110–1, repr.; Einberg &
Egerton 1987, no.16, repr.

Tate Gallery

This painting is one of the few surviving examples of a series
of decorations on the theme of games and pastimes for the
supper boxes at Vauxhall Gardens. They may have been at
least partly inspired by Gravelot's series of popular engrav-
ings produced in the late 1730s under the title 'Jeux
d'Enfants', among them a plate called 'See-Sawing' from
which Hayman has borrowed several details.

The engraving of this scene by L. Truchy published in
1743 has a verse caption that makes it clear that the
apparently frivolous subject was also intended to carry a
moral about the dangers of a 'fall' in every sense of the word.
The evils of volatile emotions are emphasised not only by the
instability of the makeshift structure in the foreground, but
also by the ruined windmill or tower in the background and
by clear indications that the apparently care-free scene is in
fact the prelude to a fight.

The entrepreneur Jonathan Tyers (147) embarked on an
ambitious redevelopment of the Gardens in the early 1730s.
The summer of 1735 saw the opening of a concert building, a

kind of gigantic bandstand where an excellent orchestra
performed the latest hits by Handel, Arne and others to the
promenading guests, and in 1738 Roubiliac's famous statue
of Handel (now in the Victoria and Albert Museum) was
installed in the grounds. Its inspired combination of realistic
informality and elegant emblematics caught the taste of the
times exactly and proved an instant success. By the 1740s
more than fifty-three supperboxes were decorated with large
paintings on themes ranging from Shakespeare to children's
games, of which the above is one. They were treated rather
like stage scenery, being 'let down' all at once for part of the
evening, and 'viewing the paintings' was one of the great
attractions of the entertainment, not least because it allowed
one to stare at the elegant company dining in front of them.
Hayman designed the vast majority of these, and while most
were painted by assistants, this one is at least partly by his
own hand. A few designs were copied from Hogarth (93)
whose involvement was sufficiently great to earn him a
golden admission ticket for life as a mark of gratitude from
Tyers.

FRANCIS HAYMAN 1708–1776

**147 Jonathan Tyers with his Daughter Elizabeth and
her Husband John Wood** *c*.1750
Canvas 39 × 34 (99 × 86.3)
Prov: Probably painted for Jonathan Tyers or John
Wood; by descent through the Wood family to Mrs
Emily Ogilvie who bequeathed it on her death in 1916
to her cousin Mrs Jessie Marshall; ...; Sir George
Sutton Bart; ...; Mrs W.H. Miller, sold Sotheby's
23 November 1966 (79) bt Arthur Tooth & Son, from
whom acquired by Paul Mellon 1968 and presented to
the lender 1981

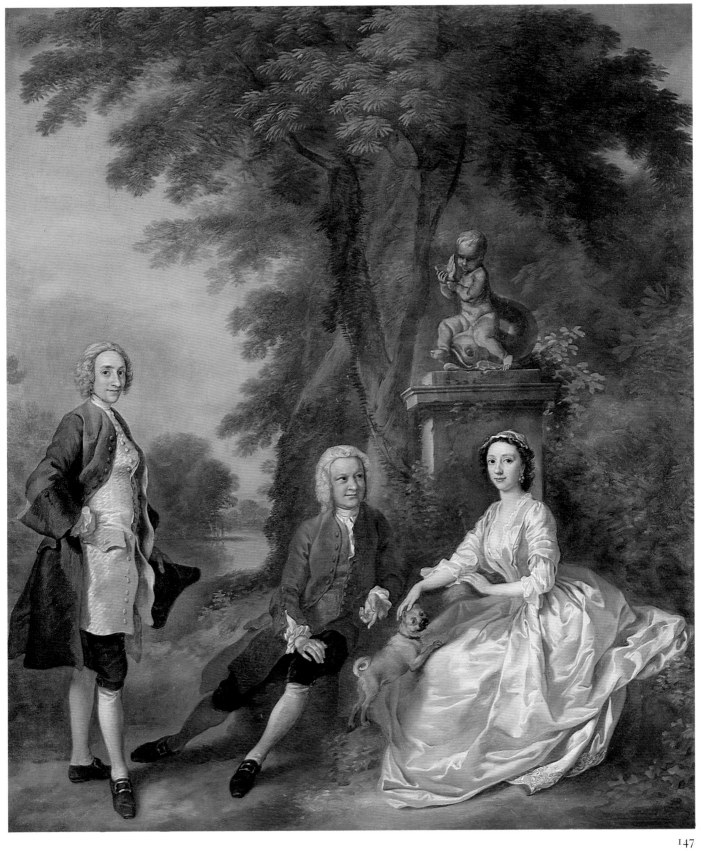

147

Exh: Francis Hayman, Yale Center for British Art, New Haven and Iveagh Bequest, Kenwood 1987 (23, repr.)
Lit: Allen 1987, pp.32, 101–2, repr.
Yale Center for British Art, Paul Mellon Collection, New Haven

The sitters are Jonathan Tyers (d.1767) and his younger daughter Elizabeth (1727–1802), with her husband John Wood standing on the left in a pose of impeccable eighteenth-century elegance. Although the exact date of their marriage is not known, it is said to have taken place in about 1750, and this is in all probability a betrothal portrait. As Brian Allen points out, Tyers's gesture towards the pug dog, a symbol of fidelity, and the (probably imaginary) garden sculpture of a dolphin and a putto with a dove, symbolic of long life, love and peace, are consistent with the marriage theme.

As Hayman and Tyers collaborated closely over the decoration of Vauxhall Gardens, it is not surprising that some of Hayman's best portrait groups are of members of the Tyers family. Among these this is perhaps one of the most accomplished, showing how greatly Hayman had profited from his association at the St Martin's Lane Academy with the elegant draughtsmanship of Gravelot, and possibly through him from the more distant example of Watteau's *fêtes galantes*. It is at this point that he is closest to the work of the young Gainsborough, who can be seen to take over where Hayman leaves off.

ANTONIO CANALETTO 1697–1768

148 Ranelagh Gardens: Interior of the Rotunda
c.1751
Canvas 20 × 30 (50.8 × 76.2)
Prov: Not known before present owner
Exh: *Canaletto*, Art Gallery of Toronto and National Gallery, Montreal, Canada, 1964–5 (105, together with 149)
Lit: Constable & Links 1976, p.414, no.421, pl.77 (Ranelagh) and p.421, no.431, pl.80 (Vauxhall)
Lord Trevor

Ranelagh Pleasure Gardens at Chelsea opened in 1742 to rival those at Vauxhall on the Surrey side of the Thames. Though smaller, they also had beautifully laid out grounds and the advantage of a canal on which a decorated gondola with an orchestra rowed up and down. There were shops where masked shopkeepers sold china, Japan ware and wine during masquerades and at one of these, to celebrate the Peace of Aix-la-Chapelle in May 1749, Horace Walpole was

particularly enchanted by rows of lamp-hung orange trees with potted auriculas below and festoons of natural flowers draped from tree to tree. The main attraction of the gardens was the huge, sumptuously decorated Rotunda, 150 feet in diameter, with two tiers of boxes where one could take tea. Its floor was a circular promenade where the assembled company could display the latest fashions. It also provided good music (the eight-year old Mozart played there in 1764), but was considered a more restrained and sedate alternative to Vauxhall, though for a time equally fashionable.

The painting is clearly a pendant to no.149, and is also very close to an engraving after Canaletto, published in 1751. Another view of the interior of the Rotunda by Canaletto, painted *c*.1754, is in the National Gallery.

ANTONIO CANALETTO 1697–1768

149 Vauxhall Gardens: the Grand Walk *c*.1751
Canvas 20 × 30¼ (508 × 768)
Prov: as 148
Exh: as 148, and *Rococo Art and Design in Hogarth's England*, Victoria and Albert Museum 1984 (F.14, col. pl.VII)
Lit: as 148
Lord Trevor

By the time Canaletto painted this view, Vauxhall had become an immensely popular summer venue – what we would now call a leisure centre – for all who could afford the boat ride across the river and the shilling entrance fee. It offered facilities for dining out, picnicking, listening to music, promenading, looking at paintings (146) and sculptures, and admiring novelties like mechanical fountains and trick illuminations to which new features were added every season. It was patronised by its ground landlord the Prince of Wales, for whom a special pavilion and withdrawing room had been built. Among London's places of entertainment, it was more up-market than Sadler's Wells (93) and provided more varied entertainment than Ranelagh (148).

A pleasure garden of one sort or another existed at Vauxhall since the seventeenth century; Jonathan Tyers (147) first leased the run-down site in 1728, reopened the refurbished gardens to the public in 1732, and by 1758 had bought the entire estate. The gardens finally closed down in 1859.

An engraving by E. Rooker after Canaletto, published in December 1751, is closely related to this painting and suggests its probable date. It shows the view that would have greeted visitors on entering, with the orchestra building on the right, supper-boxes and pavilions on both sides of the tree-lined central avenue, and the golden statue of Aurora as a focal point in the distance.

148

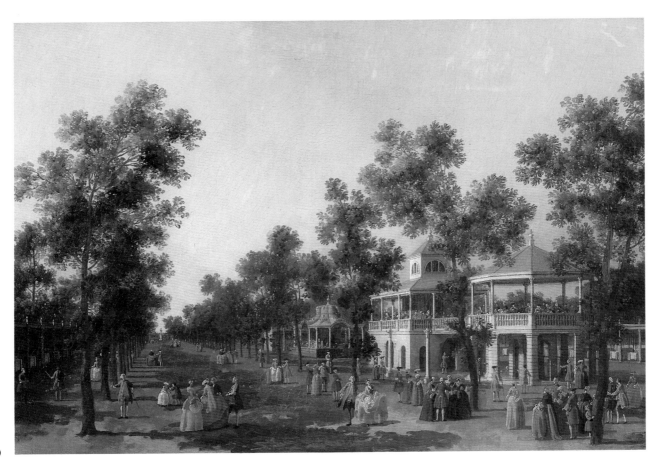

149

attributed to
BARTHOLOMEW DANDRIDGE
1691–c.1755

150 **Edward Harley, 4th Earl of Oxford, and his Sister Sarah** c.1737
Canvas 50 × 40 (127 × 101.6)
Prov: By descent from the sitters
Exh: Art Treasures of the Midlands, City Art Gallery, Birmingham, 1934 (447)
Private Collection

The sitters are thought to be Edward Harley (1726–1790), later 4th Earl of Oxford, and his sister Sarah (1731–1737), presumably about a year after they were included in the Hamilton family group of 1736 (64), but before Sarah's death in 1737. Although it is difficult to date the painting on grounds of costume, which changed very little in the decade and a half before the mid-century, a date of c.1745 has also been suggested, in which case the girl would be Martha, who was born in 1736. It then becomes difficult to reconcile the apparent ages of the sitters with the ten-year gap between her and Edward, and one would have to admit to the possibility of the boy being one of her younger brothers.

The late Sir Ellis Waterhouse also proposed Henry Pickering (fl.1740–1771) as the possible painter, but the marked Rococo elegance of the group and parkland setting would seem to be more compatible with Dandridge's style.

attributed to
EDWARD PENNY 1714–1791

151 **Margaret Cavendish Harley, Duchess of Portland** c.1745
Canvas 30 × 25 (76.2 × 63.5)
Exh: Art Treasures of the Midlands, City Art Gallery, Birmingham, 1934 (27)
Lit: S.H. Pavière, *The Devis Family of Painters*, 1949, pl.17, as by Devis
Private Collection

The sitter is traditionally thought to be Margaret Cavendish Harley (1715–1785), only surviving child of the 2nd Earl of Oxford. In 1734 she married William Bentinck, (1709–1762), 2nd Duke of Portland. Her father was George Vertue's most important patron, and generally preferred the company of literary men and poets to fashionable society. He collected books, manuscripts, medals and curiosities to the point of improvidence, and was a generous friend to Pope, Swift and Prior. Prior, who died in his house at Wimpole, was particularly attached to Margaret and celebrated her as 'My noble, lovely little Peggy'.

The painting has been attributed to Devis in the past but is clearly not by him. At present an attribution to Edward Penny, who specialised in small-scale full-lengths after his return from Rome in 1743, seems more likely.

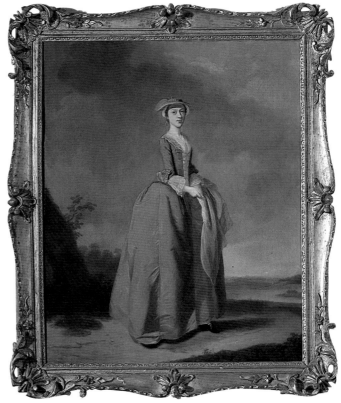

151

THOMAS GAINSBOROUGH 1727–1788

152 'Bumper': a Bull Terrier 1745
Inscribed 'Thos Gainsborough / Pinxit Anno / 1745'
and 'Bumper / A most Remarkable Sagacious / Cur'
on the back of the canvas
Canvas $13\frac{3}{4} \times 11\frac{3}{4}$ (34.9 × 29.8)
Prov: Probably painted for the Rev. Henry Hill, with
whose portrait by Gainsborough sold in anon (Rev. M.
Hill) sale Christie's 6 May 1910 (102) bt Grenlow; ...;
Shepherd, from whom bt by Sir Hickman Bacon 1910,
and thence by descent
Exh: *Gainsborough*, Tate Gallery 1980 (54, repr.)
Lit: J. Hayes, *Gainsborough*, 1975, p.201, note 1, pl.1
Private Collection

The owner of this 'most Remarkable Sagacious Cur' was
almost certainly the Rev. Henry Hill (1697–1775), rector of
Buxhall, Suffolk, in whose family's sale the painting first
appeared in 1910, along with portraits of himself and his
wife, also by Gainsborough. His portrait is lost, but that of
Mrs Hill now hangs in Montacute House, Somerset.

'Bumper' is Gainsborough's earliest dated work and
shows the eighteen-year old artist already in full possession
of his remarkable ability to make paint sparkle. His youthful
inexperience shows only in not being able to manage the
technicalities of a smooth transition from the foreground to
the wider landscape beyond, but the sinewy alertness of the
animal and the freshness of the realistic woodland setting
have no parallels in British painting of this period.

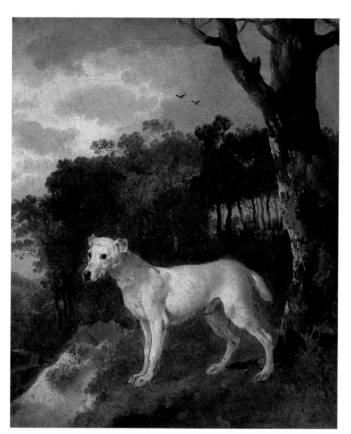

152

THOMAS GAINSBOROUGH 1727–1788

153 The Gravenor Family *c*.1747–50
Canvas $35\frac{7}{8} \times 35\frac{7}{8}$ (91 × 91)
Prov: Painted for the sitter, and by descent to his
daughter Dorothea who married Thomas Gladwin of
Ipswich; their daughter Dorothea (b.1765) who
married 1790 John Stanislaus Townshend of Hem
House and Trevalyn Hall, Denbighshire; by descent
to Maj. J. Townshend, sold Sotheby's 19 July 1972
(41, repr.) bt Colnaghi, sold to Nigel Broakes; with
Colnaghi 1977, from whom bt by lender
Exh: *The Conversation Piece: Arthur Devis and his
Contemporaries*, Yale Center for British Art, New
Haven, 1980 (55, repr.); *Gainsborough*, Grand Palais,
Paris, 1981 (3, repr.)
Lit: J. Hayes, *Gainsborough*, 1975, p.203, note 11,
pl.11
*Yale Center for British Art, Paul Mellon Collection,
New Haven*

This small conversation shows John Gravenor of Ipswich
with his second wife Ann Colman, and their daughters Ann
and Elizabeth. The last was to marry John Joshua Kirby
(1716–1774), topographical draughtsman and occasional
painter, who was one of Gainsborough's closest friends.

In spite of the essential stiffness of the figures which are
squashed somewhat uncomfortably into the foreground,
Gainsborough's genuine feeling for landscape has brought a
new dimension to the outdoor conversation piece. His thin,
fluid paint catches light and shade with the sensitivity of a
watercolour, especially in the beautiful silvery tones of the
girl in white and in the rain-laden clouds of the Suffolk sky.

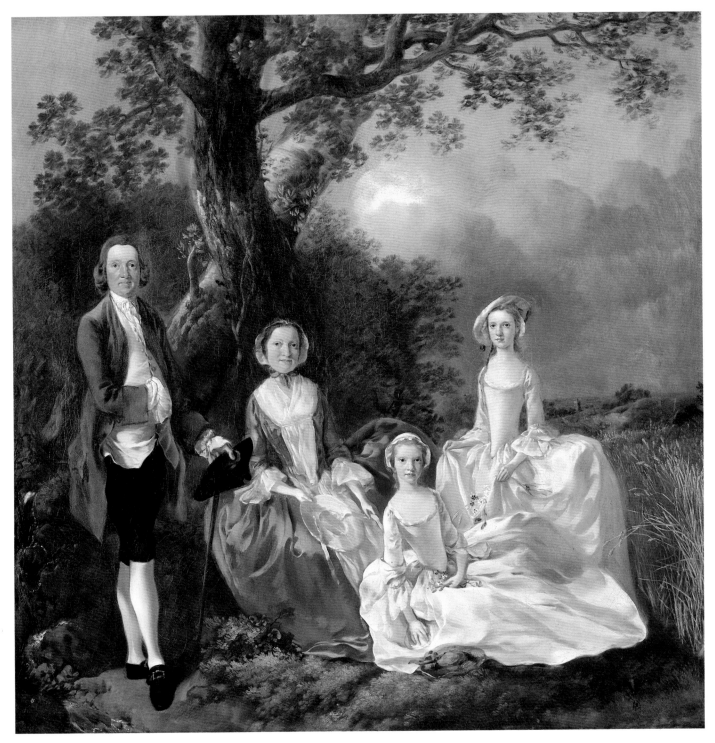

153

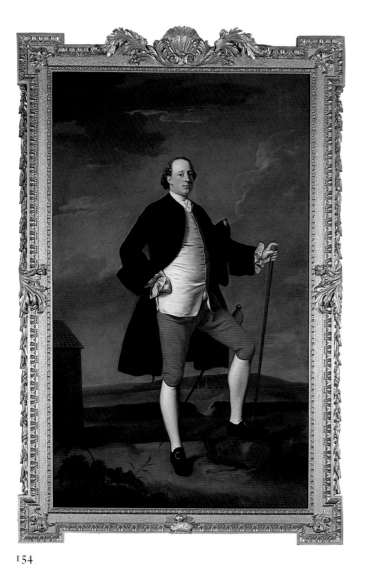

154

ALLAN RAMSAY 1713–1784

154 John Manners, Marquess of Granby 1745
Inscribed 'A.Ramsay 1745' bottom right
Canvas $92\frac{1}{2} \times 57$ (235 × 145)
Prov: Painted for John Dodd, for his gallery at
Swallowfield, Berks., sold Christie's 3 July
1783 (69);
...; at Billingbear, seat of the Neville family, by 1797,
and thence by descent
Exh: *Allan Ramsay*, R.A. 1964 (7)
Lit: R.J.B. Walker, *Catalogue of the Pictures at Audley
End*, 1964, p.22; Kerslake 1977, pp.101–2, pl.276
*The Hon. Robin Neville by Arrangement with English
Heritage*

The Marquess (1721–1770) was the eldest son of the 3rd
Duke of Rutland. As Commander-in-Chief of the British
Forces in Germany during the Seven Years' War, he was
both popular with the troops and successful against the
French. The portrait was painted for John Dodd, M.P. for
Reading, who collected paintings of his friends in his gallery
at Swallowfield in Berkshire. The gallery was dispersed after
his death.

When confronted with the requirement for the kind of
full-length that could dominate large rooms alongside the
parade portraits of painters like Kneller, Ramsay's in-
ventiveness did not blossom till much later and his approach
remained fairly conventional. What always set him apart,
however, was his clear sense of colour and an elegance of
design that made his sitters appear comfortably at ease even
in the most formal settings. Painted for a friend, this portrait
makes no play with elaborate dress or insignias of honour,
but commands respect by its austere dignity on a grand scale.

ANTONIO CANALETTO 1697–1768

**155–156 Two Views of London from Richmond
House** *c.*1747
Prov: Painted *c.*1747 for the 2nd Duke of
Richmond and thence by descent
Exh: *The Treasure Houses of Britain*, National
Gallery of Art, Washington, 1985–6 (157, 158,
repr. in col.)
Lit: Constable & Links 1976, pp.415–6, 425–6,
nos. 424, 438, pls.77, 81; J.G. Links, *Canaletto*,
1982, pp.148, 154, pls.140 (col. repr. of 'Thames
and the City'), 143 (detail of 'Whitehall'), 144
(col. repr. of 'Whitehall')
*Courtesy of the Trustees of the Goodwood
Collection, Goodwood House*

These two views are arguably the masterpieces of Canaletto's
ten years in England. Painted within a year or so of his
arrival, they show him rising to the challenge of an important
commission with consummate skill.

Canaletto's arrival in London was first brought to the
notice of Charles Lennox, 2nd Duke of Richmond, by his
former tutor Thomas Hill (see 68), who wrote to him in May
1746 that a view of the Thames taken by the artist from the
Duke's dining room windows would rival any of his Venetian
views. Both views here are taken from the upper windows of
Richmond House, front and back.

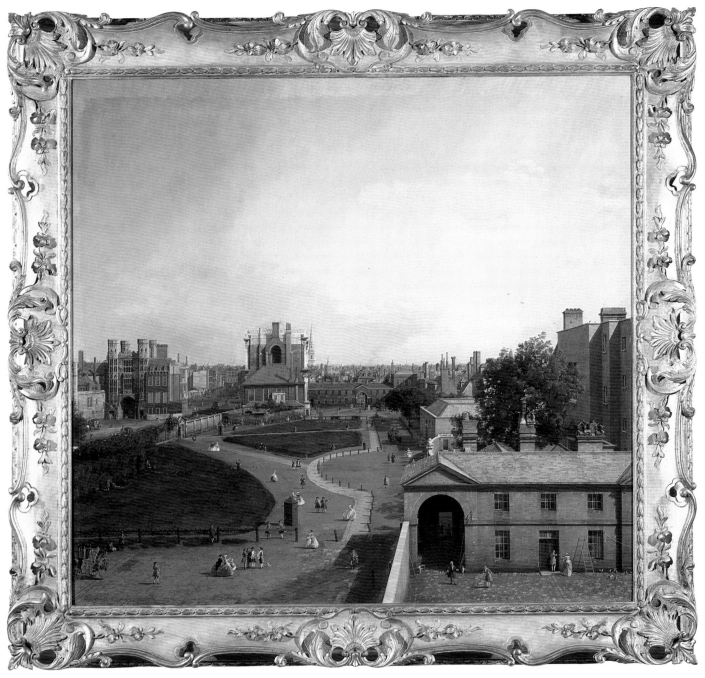

155

155 Whitehall and the Privy Garden from Richmond House

Canvas 43 × 47 (109.2 × 119.4)

This painting shows the stables of Richmond House in the right foreground; the figure in front of the arched gateway, wearing the blue Garter riband and approached by a bowing servant in yellow livery (the Duke's colours), must be the Duke himself. On the right is the tall back of Montagu House; the open space to the left is the Priory Garden, divided by a wall from Whitehall. The middle distance is dominated by the side of the Banqueting House, while on the left is the Holbein or Treasury Gate, one of the last remnants of Tudor Whitehall, removed as a traffic obstruction in 1759. Between them is the lower end of Charing Cross, affording just a glimpse of the equestrian statue of Charles I in the distance.

Several drawings for these views are listed in Constable, and there is a larger, broader version of this view in the collection of the Duke of Buccleuch.

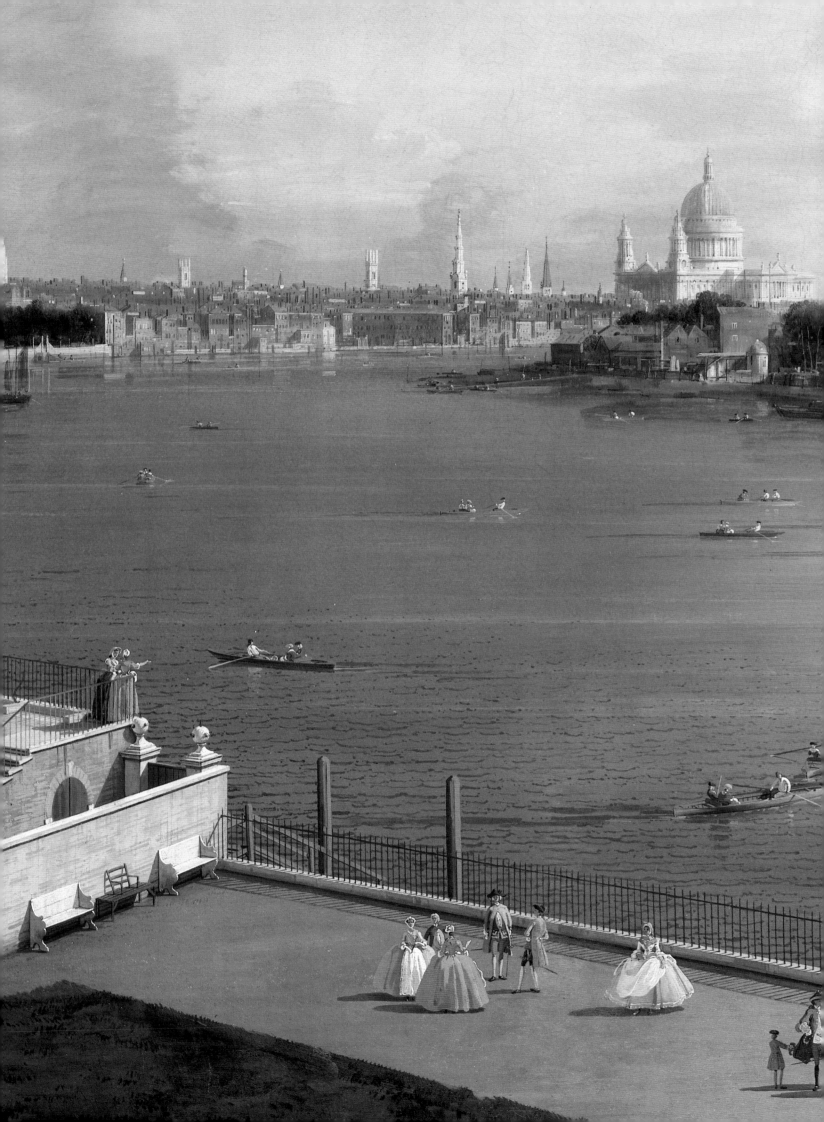

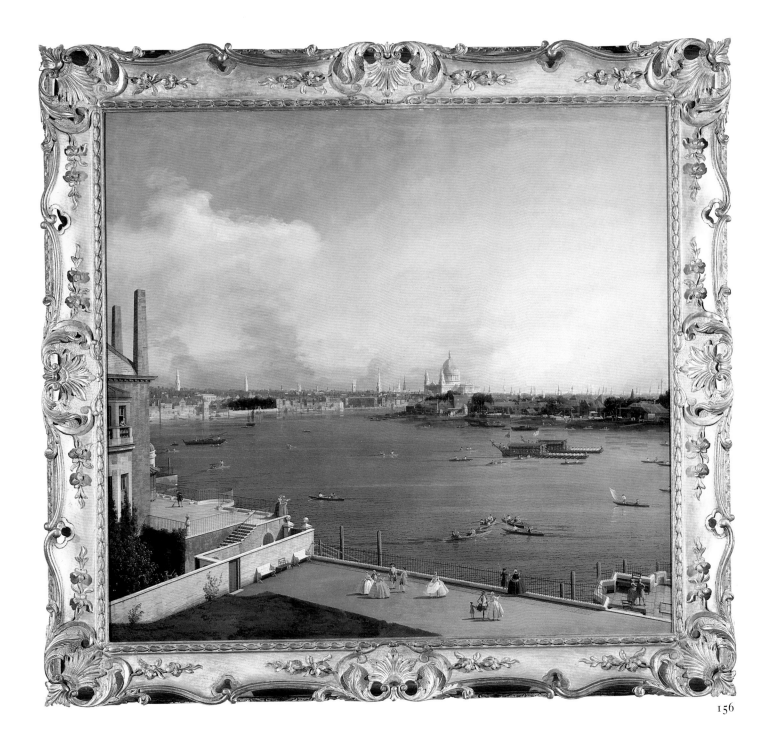

156

156 The Thames and the City of London from Richmond House

Canvas $41\frac{3}{4} \times 46\frac{1}{4}$ (106 × 117.4)

This pendant to no.155 shows the view looking north-east from an upper window of Richmond House. In the foreground is the terrace of Richmond House, adjoining that of Montagu House on the left. The view across the water shows, to the left, the Savoy, the trees and white wall of Somerset House stairs, the spires of St Mary-le-Strand, St Clement Danes, and St Bride's, all dominated by the magnificent bulk of St Paul's Cathedral.

THE FOUNDLING HOSPITAL:

'. . . this glorious establishment . . .'

They have lately built an hospital in London for exposed and deserted children; a noble institution, which this famous metropolis greatly wanted. We may say that in England everything is done by the people. This hospital is now a very large building, and was raised by the subscription of a few private persons, who were desirous of seeing such an establishment. The King subscribed to it like others, and the public benefactions are every day increasing.

When they came to propose the ornamenting some of the apartments of this hospital, the governors refused to apply any of the charitable contributions to this use. Upon which the most eminent artists, in every branch, had a meeting, and agreed each to furnish one or more pieces as a decoration to the principal rooms in the hospital. The project has been executed, and the several pieces exhibit now to public view, the different talents of the reigning artists in England . . .

The subjects are all taken from scripture, and relate to exposed children . . . The Portrait painters have furnished, either at full length, or otherwise, the pictures of those who had the principal share in this glorious establishment: in short, every kind of painting, and even sculpture itself, has contributed towards this decoration. This exhibition of skill, equally commendable and new, has afforded the public an opportunity of judging whether the English are such indifferent artists, as foreigners, and even the English themselves pretend.

André Rouquet,
The Present State of the Arts in England,
first published 1755

By the early eighteenth century, London was virtually the only capital in Europe without an institution for the reception of unwanted and abandoned infants. The Foundling Hospital was granted a Royal Charter in October 1739, after nearly twenty years of relentless campaigning by Captain Thomas Coram. It admitted its first children in temporary premises in 1741, the foundation stone for its own building was laid in September 1742, and by 1753 it was in full occupation.

The French enamel painter André Rouquet (1701–1758) worked in London from 1722 until his return to Paris in 1752. He was a close friend of Hogarth and in 1745 wrote an explanation of his prints for the French market. In 1754 Rouquet completed his booklet *L'Etat des Arts en Angleterre* (published 1755 and immediately translated into English), which was a shrewd attempt to correct French misconceptions about British contemporary art.

WILLIAM HOGARTH 1697–1764

157 Captain Coram 1740
Inscribed 'W.Hogarth Pinx!. 1740' lower left, on bottom step; also 'Painted and given by Wm. Hogarth, 1740' on a step beneath his feet; 'The Royal Charter' on roll of papers on table; and 'Cap!. Coram' on letter bottom right
Canvas 94 × 58 (239 × 147.5)
Prov: Presented by the artist to the Governors of the Hospital in May 1740
Exh: *Hogarth*, Tate Gallery 1971 (130, repr.)
Lit: Paulson 1971, I, pp.436–9, pl.160, II, pp.121–2; Nicolson & Kerslake 1972, pp.1–10, 68–9, no.40, pls.44, 45; H. Omberg, *William Hogarth's Portrait of Captain Coram*, Uppsala 1974; Webster 1979, pp.87–9, repr. p.94
Thomas Coram Foundation for Children

Thomas Coram (*c.*1668–1751) was born in Lyme Regis, Dorset, and made his fortune in shipping. He went to America in 1693 and was active as a shipbuilder in Massachusetts for some ten years. There he married, but as far as is known had no children. On his return to England he continued his business at Rotherhithe until about 1719, when he retired and devoted the rest of his life to charitable works among which the Foundling Hospital was the most important. He ceased to take an active part in the running of the Hospital after 1742, but kept in touch with its Governors, like Dr Mead. On 3 April 1751 his body was interred, as he had wished, in a vault under the Foundling Hospital Chapel, at a solemn ceremony in which the Hospital Charter was carried on a crimson cushion before the coffin.

Hogarth painted the portrait soon after Coram had received the Hospital's Royal Charter, the seal of which he is shown grasping firmly in his right hand. In the background is the shipping that made his wealth, and the globe at his feet shows 'The WESTERN OR ATLANTICK OCEAN' where he plied his trade. On the wall in the right background, somewhat hard to discern now, is a painting or relief representing Charity nurturing children. Hogarth glorifies here a sitter of undisguised humble origins on a scale hitherto reserved for nobles and statesmen. He painted it partly to show what he could do in the way of grand portraiture, borrowing the general formula from Baroque Continental antecedents. Yet such is the intense humanity of this beautifully painted image of an old man among the symbols of his achievement, that it refuses to fit into any glib and generalised style, and is rightly considered to be one of the masterpieces of a highly individual and quintessentially English genius.

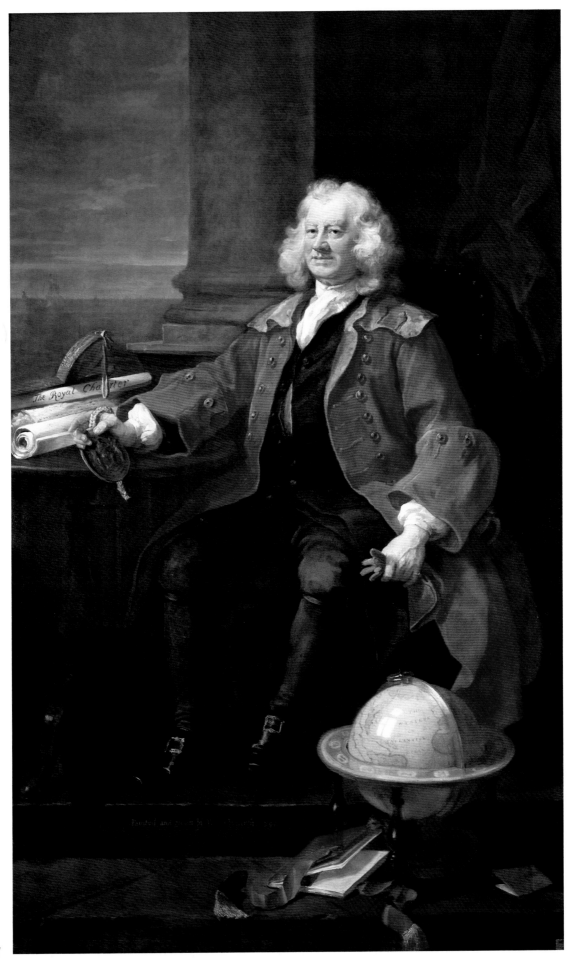

157

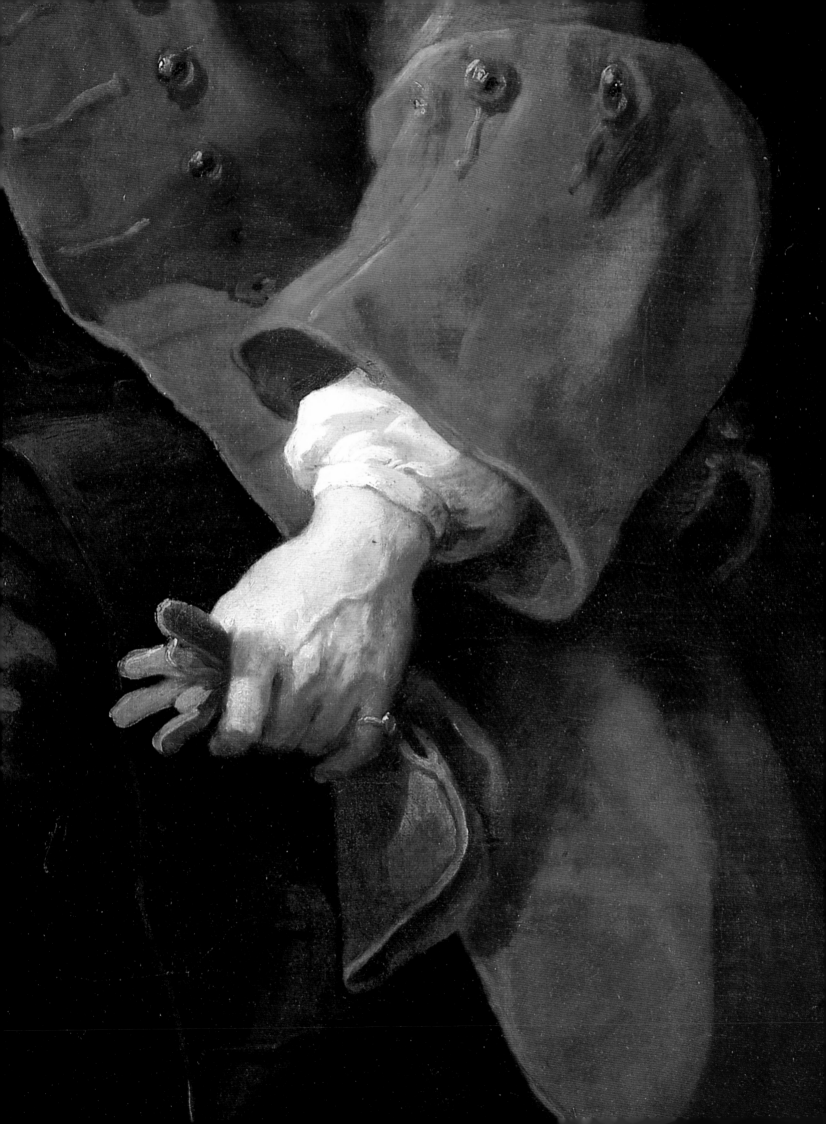

THOMAS HUDSON 1701–1779

158 Theodore Jacobsen 1746
Inscribed 'Theodore Jacobsen Esq.' bottom left, and
'PAINTED & GIVEN BY THO: HUDSON 1746', bottom
right, over an earlier inscription
Canvas $92\frac{3}{4} \times 53\frac{7}{8}$ (235.6 × 136.8)
Prov: Presented by the artist 1746
Exh: Thomas Hudson, Iveagh Bequest, Kenwood,
1979 (27, repr.)
Lit: Nicolson & Kerslake 1972, p.71, pls.65, 66
Thomas Coram Foundation for Children

Theodore Jacobsen (d.1772) came from a German merchant
family that had run the Steelyard in London more or less as a
private family concern until 1720. Thoroughly Anglicised
himself, he was a man of considerable intellectual gifts, a
Fellow of the Royal Society, the Society of Arts, and the
Society of Antiquaries. After retiring from commerce, he
practised as an amateur architect. Like Hogarth he was a
founder Governor of the Hospital in 1739, and offered to
design the Hospital's buildings free of charge. He is shown
holding Fourdrinier's engraving of the plan and elevations of
the Foundling Hospital, made probably soon after their
acceptance by the Governors in June 1742. In the same year
he was painted by Hogarth in a sympathetic half-length, now
at Oberlin College, Ohio.

Hudson shows him standing 'in that foolish cross-legged
style, which was to haunt British portraiture . . . for the next
40 years' (to quote Waterhouse's immortal phrase), leaning
on a plinth with a representation of Charity. The distinctive
buildings in the landscape behind him may represent his
country house, Lonesome Lodge, near Dorking.

158

ALLAN RAMSAY 1713–1784

159 Dr Richard Mead 1747
Inscribed 'Rich.ᵈ Mead M.D.' bottom left and
'Ramsay Pinxit' over an earlier inscription 'Painted
and given by Ramsay 1747' bottom right; also 'To Dr.
Mead' on letter on table
Canvas 93 × 57 (236 × 144.7)
Prov: Presented by the artist 1747
Exh: Allan Ramsay, R.A. 1964 (15)
Lit: Nicolson & Kerslake 1972, pp.29–30, 76, no.68,
pls.62, 63
Thomas Coram Foundation for Children

Richard Mead (1673–1753) was physician to George II from
1727, and was a man of considerable influence and wealth, a
figure of international renown not only in the medical world,
but also as a scholar, connoisseur and collector. The dying
Watteau came to consult him in 1719, leaving him two of his

paintings, and he was a good friend of Ramsay from the mid-1730s onwards. Mead was also a founding member of the Hospital, and acted to some extent as its honorary consultant. It must have been clear that a portrait of so famous a sitter would not only attract a great deal of public interest in the Hospital, but would also have a wide circulation in prints (it was engraved by Bernard Baron). It is thus cast in a suitably cosmopolitan Baroque tradition, in which Mead is presented making a rhetorical gesture of authority in front of a stone niche with a statue of Hygeia, the Goddess of Health. It is a

confident work of great distinction, as well as a great portrait of the man.

Ramsay presented the painting to the Hospital in 1747, where it had the desired effect: writing in 1751, Vertue comments that among all the full-lengths at the Hospital, it was the portrait of Mead 'which had the admiration of most people'.

A drawing by Joseph Van Aken of the complete composition, probably a costume study, is in the National Gallery of Scotland.

JOSEPH HIGHMORE 1692–1780

160 Thomas Emerson 1731
Inscribed 'Tho: Emmerson Esqr' on the curtain upper
left, and 'JosHighmore pinxt 1731;' on base of column,
centre right
Canvas 48 × 57¼ (122 × 145.4)
Prov: First recorded at the Hospital in 1749
Exh: Joseph Highmore, Iveagh Bequest, Kenwood,
1963 (7)
Lit: Nicolson & Kerslake 1982, pp.21, 26, 29, 52, 67
no.38, pl.42
Thomas Coram Foundation for Children

Thomas Emerson (d.1745) was a prosperous sugar baker in
Thames Street who was elected Governor of the Foundling
Hospital in 1739. His obituary in *The Gentleman's Magazine*
in January 1746 states that he 'left 12,000l to the Foundling
Hospital, and very large legacies to other public charities'.
Highmore's father's coal business was also in Thames Street,
and he may have been a friend of the family.

This very beautifully painted portrait carries the Kneller
tradition forward to a new era, and in its own more restrained
fashion, confers as much dignity on a commoner and a civic
benefactor as does Hogarth's later 'Captain Coram'.

160

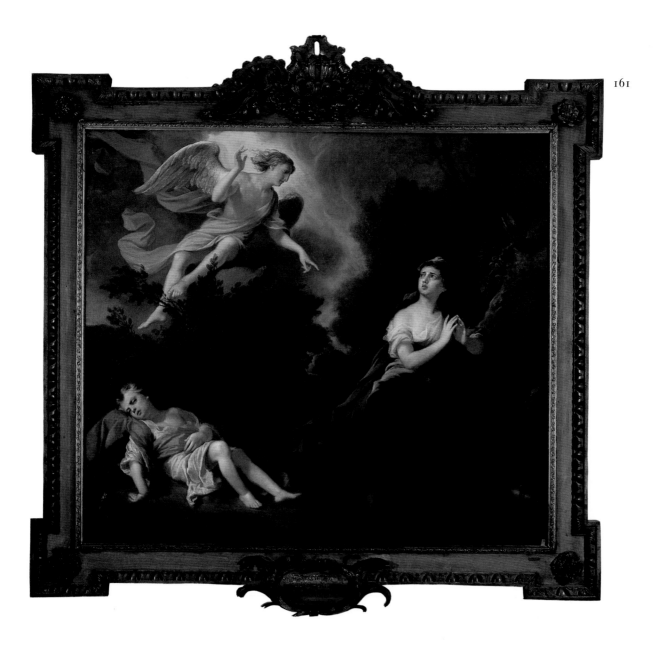

JOSEPH HIGHMORE 1692–1780

161 Hagar and Ishmael 1746
Inscribed 'Painted and/ [?presented] by / [. . .]
Highmore' on stone lower left
Canvas 68 × 76 (173 × 193)
Prov: Presented by the artist 1746
Exh: Joseph Highmore, Iveagh Bequest, Kenwood,
1963 (28, pl.VIII)
Lit: Nicolson & Kerslake 1982, pp.25–6, 67–8, no.39,
pl.50

Thomas Coram Foundation for Children

Highmore announced his intention of presenting a large
History Piece to the Foundling Hospital in 1745, and Vertue
went to his studio to inspect the work in progress. He liked
what he saw, and felt 'it promises much and shews that his
Genius is not so confind [i.e. to portraits] but it may extend
itself in that branch of painting with due commendation –
as a painter of History if he could meet with suteable
incouragement'.

Unlike the case of Hogarth, Highmore's contribution to
the Hospital was to remain the summit of his aspirations in
the Grand Manner. In spite of Vertue's praise, he was
probably more aware of his limitations than either Hogarth
or Hayman, and probably more reconciled to the fact that
'suteable incouragement' was hard to come by in this branch.
Although in itself a competent and dignified work, it is a
somewhat incoherent composition, and Highmore's difficul-
ties in conveying a sense of spatial depth, which matters less
in his smaller works, contribute here to its general sense of
awkwardness.

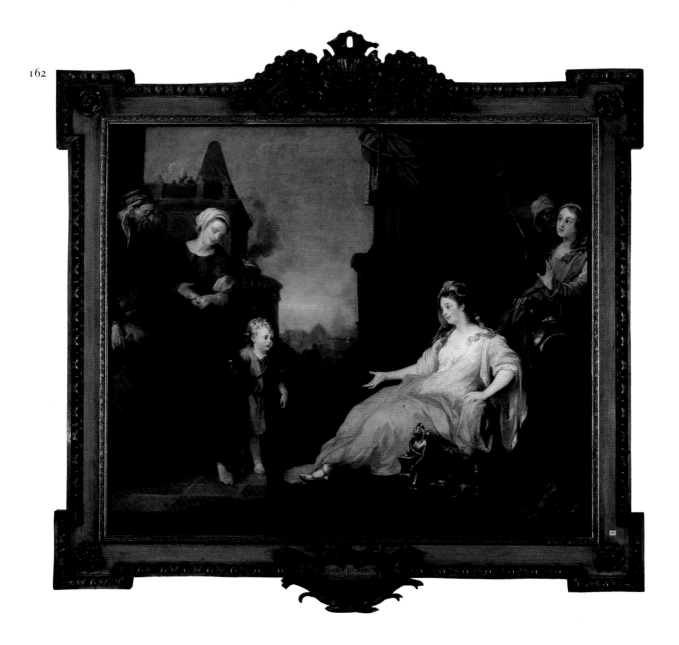

162

WILLIAM HOGARTH 1697–1764

162 Moses Brought before Pharaoh's Daughter 1746
Canvas 68 × 82 (172.7 × 208.3)
Prov: Presented by the artist 1747
Exh: Hogarth, Tate Gallery 1971 (132, repr.)
Lit: Nicolson & Kerslake, pp.25–7, 70, pl.52; Paulson
1971, II, pp.42, 45–8, pl.202
Thomas Coram Foundation for Children

The child Moses stands between his nurse (who, unbeknown
to the Princess, is also his mother and who is being paid for
her services by the Treasurer) and his adoptive mother,
resplendent in salmon pink, behind whom two servants
whisper scandalous gossip about the child's parentage.
Hogarth's fault lies, as Paulson aptly put it, 'in the in-
congruous mixture of the ideal and the particular', in this
case in the grandeur of the imaginary Egyptian setting, and
the caricatured servants in the corner, a combination that

offends the sense of order by falling between two styles.

It was one of the four pieces of religious history on the
theme of the rescue of children painted for the Court Room
of the Hospital and installed there early in 1747. The others
are Highmore's 'Hagar' (161), Hayman's 'Moses Found in
the Bullrushes', and 'Little Children Brought unto Christ'
by James Wills. The mastermind behind the scheme was
probably Hogarth, who seized this opportunity for British
artists to show their mettle in the coveted field of History
Painting. The results show that all painters were out of their
depth, although Vertue wrote when the paintings were
unveiled to the public that they were 'by most people
generally approvd & commended as works in history
painting in a higher degree of merit than has heretofore been
done by English Painters', and that it was generally allowed
'that Hogarth's peece gives most striking satisfaction &
approbation'.

THOMAS GAINSBOROUGH 1727–1788

163 The Charterhouse 1748
Canvas, circular, 22 (56) diameter
Prov : Presented by the artist in May 1748
Exh : Gainsborough, Grand Palais, Paris, 1981 (17)
Lit : Nicolson & Kerslake 1972, pp.25, 65–6, no.31,
pl.54; Hayes 1982, pp.350–2, no.23 repr.
Thomas Coram Foundation for Children

Presented by Gainsborough in 1748 (when he would have
been barely twenty-one), this is an accomplished work in the
Dutch topographical tradition. It is an accurate repre-
sentation of the view from the terrace at the Charterhouse
along the west walk of the cloister, showing the chapel tower
in the background on the left. At the same time it is much
more than a topographical view, and shows Gainsborough's
keen awareness of the fall of sunlight and the shifting nature
of the sky that already marks him out among contemporaries
in this field.

Charterhouse was founded in 1611 as an educational and
religious institution for poor brethren; it still exists, but
moved to Godalming in 1872.

Vertue wrote in 1751, perhaps mistakenly, that the
Hospital had three roundels by Gainsborough, but no other
mention or trace of them has been found.

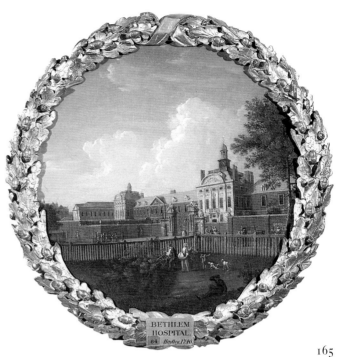

164

165

EDWARD HAYTLEY active 1740–1761

164 Chelsea Hospital *c.*1747
Canvas, circular, 22 (56) diameter
Prov : Presented by the artist before 1751
Lit : Nicolson & Kerslake 1972, pp.25, 67, nos.35, 36
Thomas Coram Foundation for Children

The Royal Hospital, Chelsea, was founded by Charles II for Army pensioners to rival Louis XIV's foundation of the Invalides. The buildings, designed by Sir Christopher Wren, were begun in 1682 and completed within three years. This shows the view towards the main court, as seen from the river.

165 Bethlem Hospital *c.*1747
Details as 164

Bethlem Hospital was set up in 1377 as a Priory of the Order of St Mary of Bethlem at Bishopsgate for the care of the acutely deranged. A second Hospital was eventually built at Moorfields, which is shown here, in a view from its front entrance. It was the setting for the final scene of Hogarth's 'The Rake's Progress' (81).

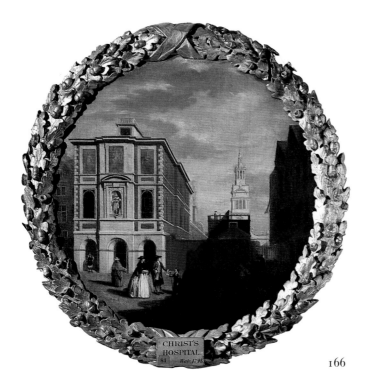

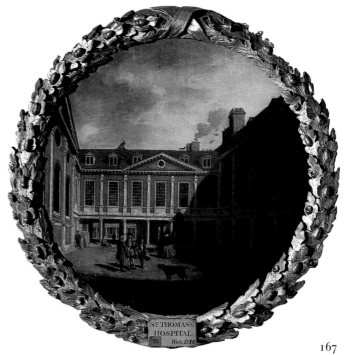

166

167

SAMUEL WALE 1721–1786

166 Christ's Hospital before 1748
Canvas, circular, 21 (53.3) diameter
Prov: Presented by the artist before 11 May 1748
Lit: Nicolson & Kerslake 1972, p.79, nos.77–9, pls.60, 59, 61
Thomas Coram Foundation for Children

The Hospital was founded by Henry VIII as a charity school for poor children. The painting shows the courtyard and entrance, and the tower of Christ Church, Newgate, in the distance.

Wale trained at the St Martin's Lane Academy under Hayman and Gravelot, and is best known as a prolific book-illustrator and designer, although he occasionally turned to history painting. As a landscape artist he is virtually unknown except for this set of three roundels. He became a founding member of the Royal Academy, and was its first Professor of Perspective.

167 St Thomas's Hospital before 1748
Details as 166

The view looks across one of the courtyards, towards the statue of Edward VI. The Hospital was founded in 1213 as an 'almery' for converts and boys, and was re-founded by Edward VI for the relief of the lame and the sick. New buildings were begun in 1692, and completed in 1732.

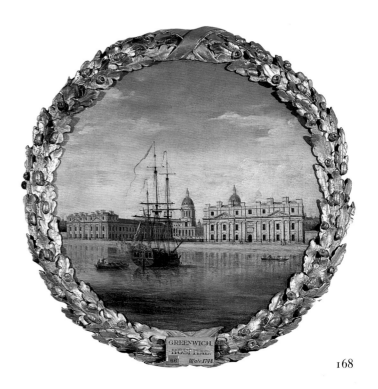

168

168 Greenwich Hospital before 1748
Details as 166

The Hospital was founded by Queen Mary in 1694 as a Naval Hospital and a counterpart to the Army Hospital at Chelsea. It was built by Wren, and received its first pensioners in 1705. It is seen here from the river.

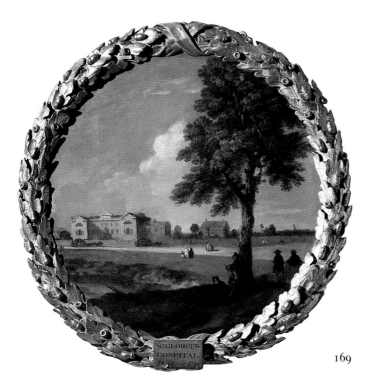

169

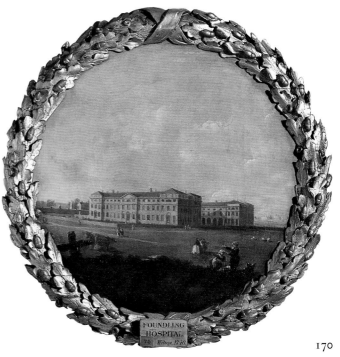

170

RICHARD WILSON 1713–1782

169 St George's Hospital *c*.1746–1750
Canvas, circular, 21 (53.3) diameter
Prov: First recorded at the Foundling Hospital in
1751
Exh: *Wilson*, Tate Gallery 1982 (8, repr.)
Lit: Nicolson & Kerslake 1972, pp.81–2, nos.85, 86
pls.55, 56
Thomas Coram Foundation for Children

The Hospital was designed in 1733 by Isaac Ware at Hyde Park Corner in what was then a green field site, well away from any habitation. It was rebuilt in its present form by Wilkins 1828–32.

There is no record as to when precisely the painting and its pair were presented to the Hospital, but it must have been before Wilson went to Italy in 1750. Stylistically 1746 seems about right, the year when many other paintings were presented. Like Gainsborough's roundel, this is not merely a perspective view, but a landscape in its own right.

170 The Foundling Hospital *c*.1746–1750
Details as 169

The buildings are seen across fields from roughly where Woburn Square is now. Open country reached down as far as Oxford Street.

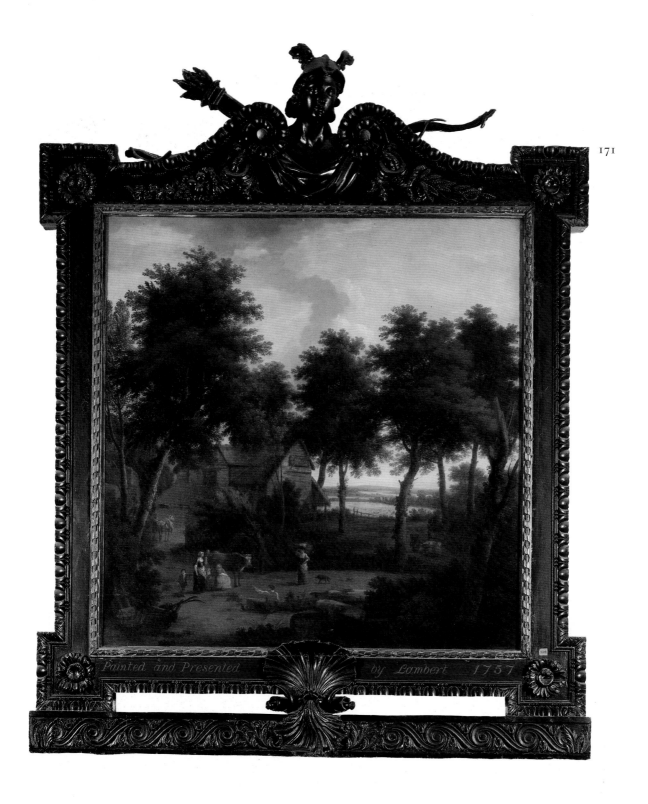

GEORGE LAMBERT 1700–1765

171 Landscape with Figures 1757
Inscribed 'PAINTED & GIVEN BY GEORGE LAMBERT
MDCCLVII' on stone centre foreground
Canvas 48 × 48 (122 × 122)
Prov : Presented by the artist 1757
Lit : Nicolson & Kerslake 1972, p.73, pl.75
Thomas Coram Foundation for Children

This is one of Lambert's non-topographical rustic English landscapes, painted somewhat in the style of Hobbema. The boy and girl being led along by a woman between a milk-maid at her work and the plough prominent in the left foreground, probably refers to the fact that the foundlings were fostered out in the country until the ages of four or five. Afterwards many of them were apprenticed as agricultural labourers and farm girls.

A very close small version, signed and dated 1753, belongs to the Castle Museum, Norwich.

CHARLES BROOKING c.1723–1759

172 A Man-of-War Firing a Salute c.1750–9
Canvas 40 × 58 (101.5 × 147.5)
Prov: ...; bequeathed by Mrs K.M.E. Morris 1956
(T 00115)
Lit: Nicolson & Kerslake 1982, pp.32–3, 61, for
Brooking and the Foundling Hospital
Tate Gallery

172

Brooking, who died before his 36th birthday, was the most
accomplished British marine painter of the mid-century. In
his brief career he found a special patron in the wealthy
barrister Taylor White (1701–1772), who was Treasurer to
the Foundling Hospital for twenty-seven years. It was
perhaps on his advice that Brooking painted in 1754 his
largest and most ambitious work, 'A Flagship Before the
Wind and Other Vessels', 70¼ × 123¼ (178.5 × 313), and
presented it to the Hospital. It is still in its collection, but too
large and fragile to move. It was the companion to an equally
large sea-piece by Monamy (which has unfortunately
disappeared), and both were recorded as hanging in the Boys
Dining Room, perhaps to inspire them with an enthusiasm
for the sea, as many went on to become sailors.

WILLIAM HOGARTH 1697–1764

173 The March to Finchley 1749–50
Inscribed 'Tottenham Court Nursery 1746' on the
inn-sign on the left
Canvas 40 × 52½ (101.5 × 133.3)
Prov: Won by the Hospital in a prize draw organised
by the artist in May 1750
Exh: Hogarth, Tate Gallery 1971 (149)
Lit: Nicolson & Kerslake 1972, pp.69–70, no.41,
pl.70; Paulson 1971, II, pp.86–96, pls.244 a, b, c
Thomas Coram Foundation for Children

It is difficult to imagine now how very real the possibility that
the Protestant Hanoverian monarchy might be overthrown
and replaced with a Catholic Stuart one seemed to people
living in the first half of the eighteenth century. The threat of
a French invasion was never far from people's minds. The
Jacobite rebellion of 1745, however doomed it might look
with hindsight, shook the Hanoverian government and the
populace profoundly. Hogarth's successful 'Calais Gate'
(Gallery 2) of 1748–9 showed French and Jacobite soldiery
guarding the approaches to France as objects of pathetic
deprivation, all brave show and no substance. Although this
is not a pendant to it, Hogarth develops the theme on British
soil as a contrast. Taking a topical event still acutely fresh in
people's minds, he shows the British soldiery suffering from
a surfeit of vitality and animal energy, before marching off in
the background, in perfectly disciplined columns, to guard
the northern approaches to London against a Jacobite
invasion.

Although at first sight it might look like a critical comment
on the debauchery of the troops, which is what George II
took it to be when he refused to give permission to have the
print after the painting dedicated to him, it is in fact a highly
patriotic work. The British flag rides triumphantly above the
melée, the Jacobites in the crowd plot fruitlessly, and un-
like the mindless puppet of the Grand Monarque in 'Calais
Gate', the British soldier is shown as an all-too-human
individual, called upon to make real choices and prepared
to offer his tough muscle (see the boxing match in the
background) for the defence of his country.

As usual, Hogarth elaborates the theme with countless
details that allude to contemporary personages and events
and that would have entertained 'readers' of the print for
hours. The setting is real, being the Tottenham Court
turnpike whence the Guards set off for their marshalling
camp at Finchley. In the central group is a handsome
grenadier who has to choose between a pretty wench selling
Hanoverian prints and sheets of *God Save the King*, and an
old Catholic scold selling Jacobite pamphlets, both pregnant.
The outcome is not hard to predict, as the soldier turns
towards the regimental drummer, drunk but able to perform,
who is giving the signal for the troops to break up, supported
by an impeccably turned out and beautifully painted boy
piper. The drummer is the real father of the boy tugging at
his coat – both have the same red hair – and the parting from
wife and child is genuinely painful.

In the opposite corner, however, Hogarth's hated demon
drink has completely vanquished a messenger, who refuses
the water-flask offered by his companion and calls for more

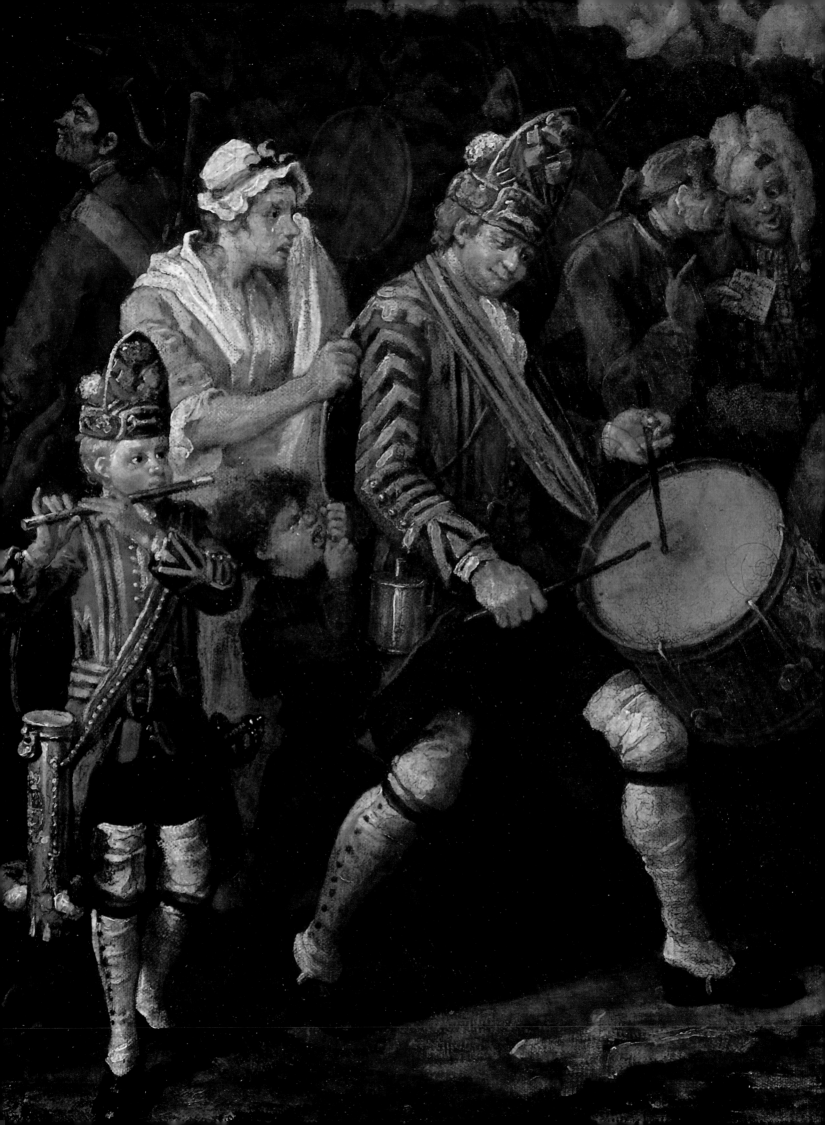

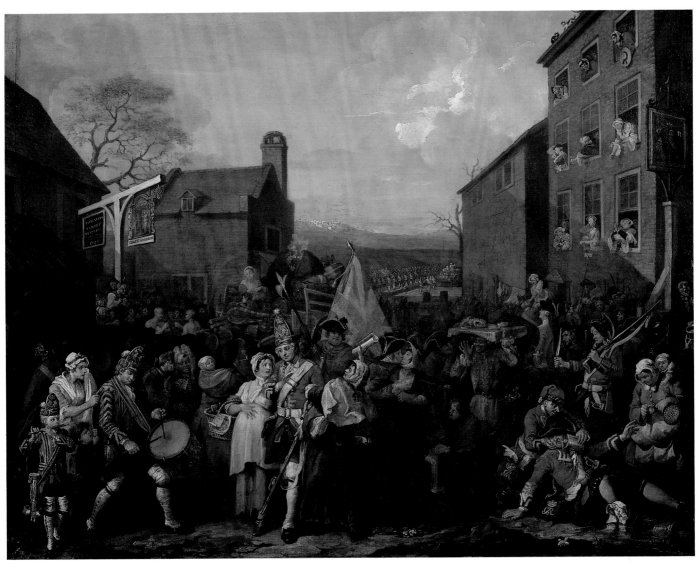

173

gin. A dowdy woman, perhaps his wife, pours him a measure, as her baby, in a heart-rending gesture observed from life, reaches for it too. Behind them is the King's Head Tavern, now turned into a cat-house (an eighteenth-century term for a brothel) by the company of Madam Douglas (note the Scottish name), who is seen praying ostentatiously for the safe return of her customers. Aligned with the inn-sign of the head of Charles II (who had no legitimate offspring) is the barren tree of the Stuart line. By contrast, the tree over the sign on the Adam and Eve ale-house opposite flourishes. The 'Tottenham Court Nursery' sign refers to Taylor's boxing school nearby, and the inn-keepers real name, Giles Gardiner, is inscribed under the sign of the legitimate parents of all mankind.

Hogarth offered the painting in 1750 as a prize in a draw for which tickets were distributed with subscriptions for the print. The winning number was among the batch of unsold tickets he gave to the Foundling Hospital.

174

SAMUEL SCOTT *c.1702–1772*

174–175 Two Views of the Thames 1748–9
Canvas, each 31 × 59 (78.7 × 149.8)
Prov: Painted, with its pair no.175, for Sir
Edward Littleton, 4th Bart., by descent to the 4th
Baron Hatherton, sold Christie's 9 June 1944 (94,
95) bt by Farr for the lender
Exh: London and the Thames, Somerset House
1977 (25, 24, both repr.); *The Treasure Houses of
Britain*, National Gallery of Art, Washington,
1985–6 (159, 160, both repr. in col.)
Lit: Waterhouse 1981, both repr. pp.335–6;
Kingzett 1982, pp.44–6, 56–7, no.175 repr. pl.16a
*The Governor and Company of the Bank of
England*

This pair is unusually well documented by surviving letters
from Scott to his patron Sir Edward Littleton (d. 1812),
dated between 28 June 1748 and 24 July 1749, which deal
with the progress, completion and dispatch of the paintings,
presumably to Sir Edward's seat Pillaton Hall in Stafford-
shire. As he was the son-in-law of Sir Richard Hoare, Lord
Mayor of London in 1746, Sir Edward's interest in the
paintings would have been more than topographical.

174 Old London Bridge

This view of London's 600-year-old and until 1750 only
bridge across the Thames is taken from St Olave's stairs (on
the left) on the Surrey bank, looking upstream towards the
northern bank, with the spires of St Michael's Crooked
Lane, St Magnus the Martyr and the Monument on the
right. The nearest buildings on the bridge on the left are the
Great Stone Gateway and Nonsuch House, with the remains
of Becket's Chapel further on.

Although its narrow, irregular arches were a danger to
shipping, its buildings unsound and its use as a roadway
woefully inadequate, it was an emotive ancient monument to
Londoners. A Court of Enquiry called in 1746 by the Lord
Mayor of London to consider plans for its improvement or
demolition made little headway for ten years, but aroused a
great deal of controversy and interest. Scott painted at least
eleven versions of this view from 1747 onwards until long
after the houses had been demolished in 1757, and many
copies were made by other hands. Most of them were paired
with a view of the Tower of London, or, as in this case, with
one of London's other controversial project, the new bridge
at Westminster. Several of these pairs are still intact, most
notably the splendidly framed versions of 1753 still in their
original setting in the Drawing Room at Felbrigg Hall,
Norfolk.

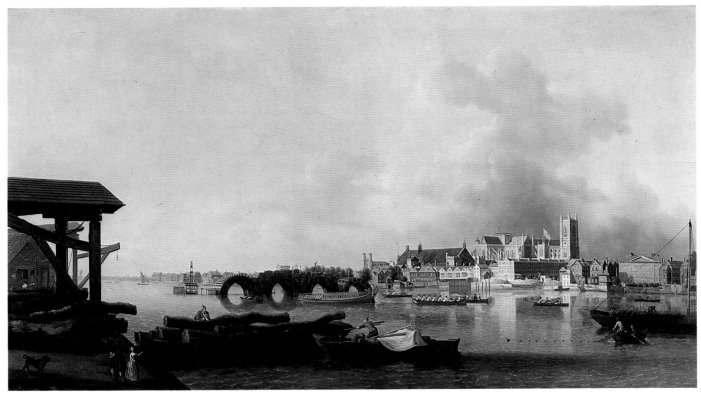

175 The Building of Westminster Bridge
Exh: Samuel Scott, South London Art Gallery 1978 (1)

The view is taken from one of the timber yards on the south bank, its wharf dramatically silhouetted on the left, looking upstream towards Millbank and Westminster. The towers of St John's Smith Square are just visible above the arches of the new bridge, while further to the right are the twin towers of St Stephen's Chapel (then in use as the House of Commons), the long roof of Westminster Hall, and Westminster Abbey, with only one of its Hawksmoor towers complete (the second was finished in 1744). In front of it are Manchester Court, Dorset Court and Derby Court on the extreme right.

Scott must have worked from earlier sketches, as the bridge is shown at the stage its construction had reached in about May 1742, with the two middle arches already turned, two others under construction, and Vauloué's pile-driving engine on the left making preparations for a fifth. Scott frequently introduced topographical inaccuracies and distortions for pictorial effect, as in this case in the position of the Abbey's north-west tower.

The barge in the centre bears the arms of the Ironmongers' Company, and is presumably rehearsing for the annual Lord Mayor's Procession in November; it is known that this was the Lord Mayor's barge in 1742.

As one of a pair, the painting reinforces the more obvious contrast between old and new also by balancing the turbulent water and dark tonality of no.174 with a calm and sunny evening atmosphere here.

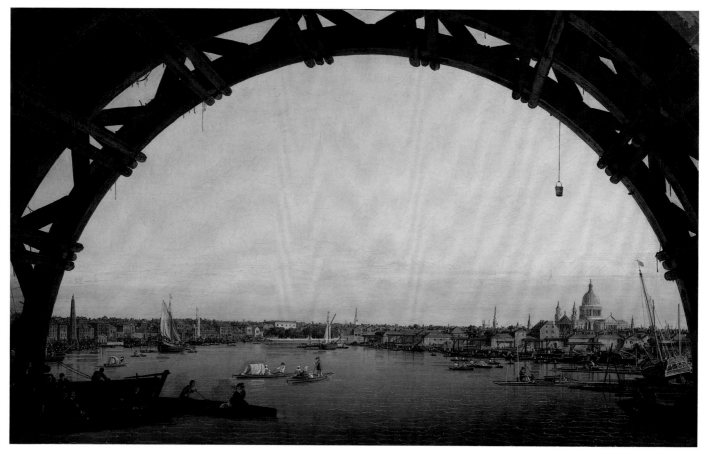

176

ANTONIO CANALETTO 1697–1768

176 London seen Through an Arch of Westminster Bridge 1746–7
Canvas $22\frac{1}{2} \times 37\frac{1}{2}$ (57×95)
Prov: Probably painted for Sir Hugh Smithson, Bt, 2nd Earl and 1st Duke of Northumberland; thence by descent
Exh: London and the Thames, Somerset House 1977 (10, repr.)
Lit: Constable & Links 1976, p.406, no.412, pl.74; J.G. Links, *Canaletto*, 1982, pp.151–2, pl.138
The Duke of Northumberland

Canaletto arrived in London from Venice in May 1746, and this is one of his first works for an English patron in this country. Very fittingly, it is of London's most important building project of the decade, the new bridge at Westminster, which was then nearing completion. This is probably the fourth arch from the Lambeth side, its wooden centring (not removed until April 1747) used as a spectacular frame for a view of London, with the Water Tower and York Water Gate on the left, the white block of Somerset House to the right of it, the spire of St Clement Danes dead centre, and St Paul's Cathedral on the right. The workman's bucket suspended from the bridge on the right adds a delightfully witty touch to an otherwise severely symmetrical composition, whose boldness and elegance must have come as a revelation to native painters like Samuel Scott (177).

An engraving by R. Parr after this painting was published by John Brindley in 1747 with a dedication to Sir Hugh Smithson Bt, soon to become 2nd Earl (and later still 1st Duke) of Northumberland and one of the most powerful men in the country. This, and the fact that Sir Hugh was also a commissioner for the Westminster Bridge project, makes it likely that the picture was painted for him. He became one of Canaletto's most important patrons in England.

[190]

177

SAMUEL SCOTT *c.*1702–1772

177 The Arch of Westminster Bridge *c.*1750
Panel $10\frac{5}{8} \times 15\frac{5}{8}$ (27×39.7)
Prov: Probably Scott's studio sale, Langford's, 4 April
1765 (13, 'A small view of part of Westminster
Bridge'); ...; Henry Graves & Co., from whom bt by
the National Gallery 1886; transferred to the Tate
Gallery 1949 (N01223).
Exh: Views of the Thames from Greenwich to Windsor,
Marble Hill House, Twickenham, 1968 (11); *Royal
Westminster,* Royal Institution of Chartered Surveyors
1981 (192)
Lit: Kingzett 1982, p.63, C
Tate Gallery

This view through the second and part of the third arch of the
bridge from the Westminster side shows the north bank of
the Thames looking towards the City. The main buildings
from left to right are the Fishmarket Wharf, Montagu
House, the York Water Tower, the Temple Gardens and the
spire of St Clement Danes.

This small panel, which Scott seems to have kept in his
studio, probably represents an early try-out of what was to
become one of his most monumental compositions, the large
'Arch of Westminster Bridge', of which the most developed
version is in the Tate (Gallery 4). Scott's alterations in the
five known versions show a concern with design that raises
the subject above mere topography, and was almost certainly
inspired by Canaletto's brilliant painting of 1746–7 (176),
which Scott would have known either from the original or
from the engraving.

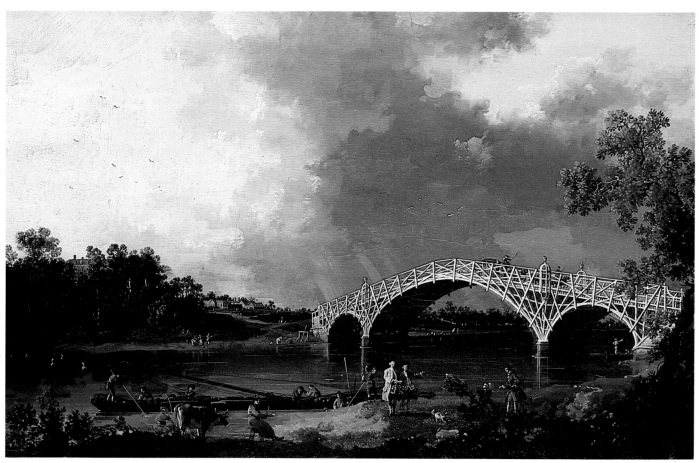

ANTONIO CANALETTO 1697–1768

178 Old Walton Bridge over the Thames 1754
A label on the back of the painting is inscribed:
'Walton Bridge. Behind this picture on the original
canvas / is the following inscription. by Canaletto. /
Fatto nel anno 1754. in Londra per la prima ed ultima
volta con ogni maggior attenzione / ad instanza del
Signior Cavaliere Hollis / padrone mio stimatiss°. /
Antonio Canal detto il Canaletto / It was necessary to
new line the picture in 1850 / so the inscription is hid.
/ John Disney / 1850'
Canvas 19¼ × 30¼ (48.8 × 76.7)
Prov: Painted for Thomas Hollis 1754, bequeathed by
him to Thomas Brand-Hollis 1774; bequeathed by
him to Rev. John Disney in 1804, sold by Mrs Edgar
Disney, anon sale Christie's 3 May 1884 (130) bt
Denison; C. Becket Denison, sold Christie's
13 June 1885 (858) bt H. Yates Thompson; …;
presented by Miss E. Murray Smith to Dulwich
College 1917
Exh: London and the Thames, Somerset House 1977
(15, repr. in col.)
Lit: P. Murray, *The Dulwich Picture Gallery*, 1980,
p.40, no.600, repr.

*By Permission of the Governors of Dulwich Picture
Gallery*

The view shows old Walton Bridge from the north bank of
the Thames, looking upstream. This particularly attractive
painting is one of Canaletto's most English works, in that it is
the only one known where he attempts to capture the fleeting
effects of weather with the hint of a rain-squall on the
horizon.

The painting was one of nine Canalettos owned by the
Whig radical, antiquary and collector Thomas Hollis
(d. 1774), of which at least six were painted specifically for
him. Whitley (1928) quotes an early catalogue of the Hollis
collection where the figures in the foreground are described
as being Thomas Hollis himself, his friend and heir Thomas
Brand, his servant Francesco Giovannini, and his dog Malta.
The inscription dates the painting very precisely to 1754.

The following year Canaletto painted an extended version
of this view (Yale Center for British Art, Paul Mellon
Collection) for Samuel Dicker M.P., who had paid for the
construction of the bridge in 1750, and whose house can be
seen among the trees on the left. The wooden bridge was
replaced with one of stone in 1780.

JOHN WOOTTON ?1682–1764

179 Lady Mary Churchill at the Death of the Hare
1748
Inscribed 'J.Wootton/ Fecit 1748' bottom left
Canvas $41\frac{3}{4} \times 61\frac{1}{4}$ (106 × 155.5)
Prov: ...; The Hon. Rachel de Montmorency,
Dewlish House, Dorset, from whom bt by Colnaghi
1962, sold to Paul Mellon 1963, and presented to the
Tate Gallery through the British Sporting Art Trust
1979 (T 02378)
Lit: Einberg & Egerton 1987, no.167

Tate Gallery

The lady has been traditionally identified in the de Montmorency family as Lady Mary Churchill (*c.*1725–1801), Horace Walpole's half-sister, the illegitimate daughter of Sir Robert Walpole by his mistress Maria Skerrett, whom he married after his first wife's death. In 1746 she married Charles Churchill (?1720–1812), the illegitimate son of her father's old friend General Charles Churchill by the actress Ann Oldfield. The red brick house in the background has not been identified. Lady Mary and her husband lived first at Farleigh Wallop, near Basingstoke, Hampshire, and later in a 'Gothick' house designed for them by Horace Walpole's friend John Chute.

The frame appears to be contemporary with the painting.

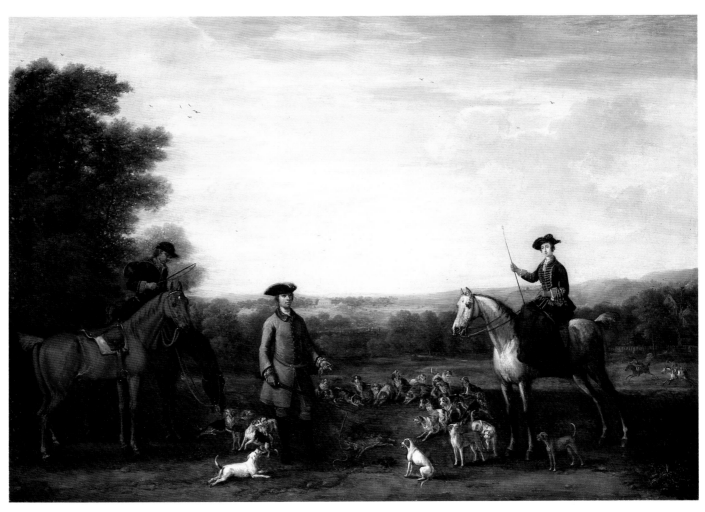

179

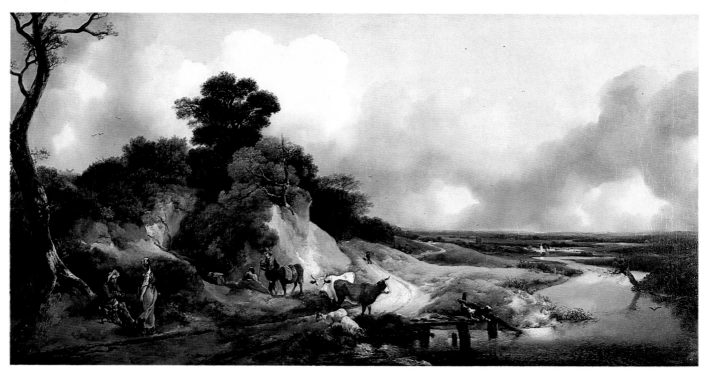

THOMAS GAINSBOROUGH 1727–1788

180 Extensive River Landscape *c.*1748–50
Canvas 30 × 59½ (76.2 × 151.1)
Prov: ...; T.M. Whitehead, from whom bt by
William H. Fuller in London in the 1890s; sold
American Art Association, New York, 25 February
1898 (33, repr.) bt James W. Ellsworth, Chicago; ...;
Knoedler, from whom bt by Kenneth Wilson 1927;
his daughter Hilary, Countess of Munster, from whom
bt again by Knoedler, sold to Alan P. Good, his sale
Sotheby's 15 July 1953 (15) bt Tooth, from whom bt
by the lender 1953
Exh: Gainsborough, Grand Palais, Paris, 1981 (19,
repr.)
Lit: Hayes 1982, pp.358–9, no.29, repr.
National Galleries of Scotland, Edinburgh

The long narrow format suggests that the painting was
intended for an overmantel, but if so, Gainsborough's richly
painted, expansive panorama represents a great advance
on current topographical and decorative painting. The ap-
parently realistic distance cannot be related to any particular
view, but its inspiration comes clearly from the artist's native
Suffolk, distilled in the light of Ruisdael and the Dutch
school of landscape painting, combined with a facility in
handling paint that is more akin to Boucher.

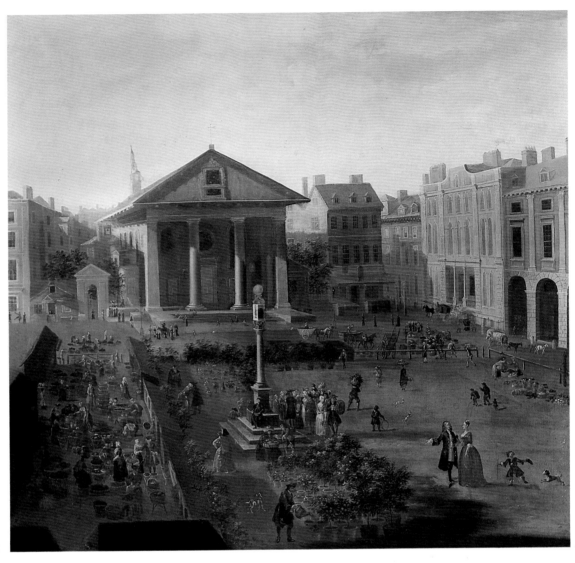

181

JOHN GRIFFIER the Younger active 1738–1773

181 Covent Garden from the South *c.*1740–50
Inscribed 'J.G.' lower left
Canvas $41\frac{3}{4} \times 45\frac{1}{2}$ (106 × 115.6)
Prov: ...; the Dukes of Bedford; Woburn sale
Christie's 19 Jan 1951 (22) bt Wheeler; ...;
M. Bernard, from whom bt by lender 1960
Exh: Capital Painting, Barbican Art Gallery 1984
(4, repr. on title page)
The Governor and Company of the Bank of England

Looking up from the Russell Street end of the Piazza towards the north-west corner and St Paul's church. The large house next to the arches of the Piazza on the right, with a coach at its door, belonged to Lord Archer, the last titled resident to remain in the square long after it ceased to be fashionable with the nobility after about 1730.

The double row of booths on the left soon proved inadequate and the market began to spill out towards the centre of the square. The space was needed particularly by the nurserymen in summer to display their potted trees and plants.

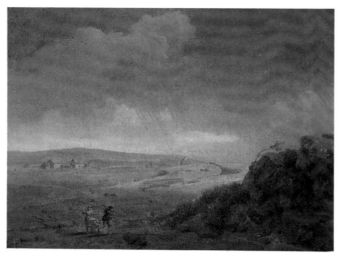

182

182 Moorland Landscape with Rainstorm 1751

Inscribed 'G:L:1751' bottom right
Canvas 12 × 16⅝ (30.5 × 42.3)
Prov: Possibly the artist's sale, Langford's
18 December 1765 (3, one of 'Six small landscapes');
...; English private collection, bt by the Tate 1985
(T 04110)
Lit: Einberg & Egerton 1987, no.129
Tate Gallery

Unlike any other known work by Lambert, this seems to be an exercise in pure landscape painting for its own sake – even his 'View of Box Hill', hanging in Gallery 3, has a famous landmark for its subject. The aim here seems to be to catch the fleeting effects of sunlight and weather on a bleak moorland landscape with a few farm buildings, stone walls and sheep. The location could be in the North of England in summer, where Lambert is known to have painted a number of famous views.

However, in spite of being very thinly and lightly painted (the pinkish-beige ground is clearly visible), it is unlikely to have been an on-the-spot sketch made in the open air, but was probably worked up from sketches in the studio later. Like his other work, it appears to have an artificially built-up foreground, with a rocky outcrop on the right. Its bent sapling, together with the streaks of rain and the windswept country couple in the foreground, help to create the breezy atmosphere of an open English landscape that is unusual for this period.

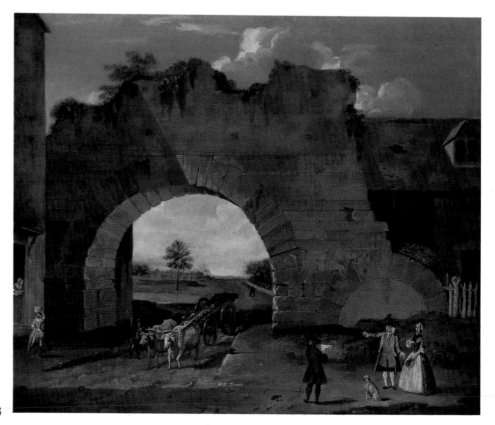

183

NATHAN DRAKE *c.*1728–1778

183 **Newport Arch, Lincoln** *c.*1750–5
Inscribed 'ND.Pinx.' lower left, initials in monogram
Canvas 32½ × 39 (82.3 × 99)
Prov: ...; Miss W.S. Richardson, by whom presented
to the lender 1926

*Lincolnshire County Council, Recreational Services: Art
Gallery, Lincoln*

Drake's aim here is not only to present a topographical record
of a venerable local landmark, but also to exploit it in terms of
visual drama, in a manner possibly stimulated by the
example of Canaletto (177) and Scott (176).

Although his work seems to have been confined to Lincoln
and York, Drake seems to have been well aware of metro-
politan trends and was ambitious enough to send works for
exhibition in London later in the century. The earliest record
of him as an artist is an engraving after his view of Boston,
Lincs., published in 1752. For most of his life he worked in
York, where his brother was a cabinet maker, as a painter of
portraits, country house views and landscapes. As the son of
the Rev. Samuel Drake, Rector of St Mary's, Nottingham,
and the brother of another distinguished cleric, one can
assume him to have been a man of some education, which
may account for the somewhat antiquarian touch of what
appears to be a group or tourists in the right foreground
admiring and sketching the Roman relic.

GEORGE LAMBERT 1700–1765

184 **The Great Falls of the Tees, Durham** 1761
Inscribed 'G.Lambert 1761' on rock centre
foreground
Canvas 23½ × 31 (59.7 × 78.7)
Prov: ...; discovered in a store in North Wales, sold
Christie's 13 July 1984 (79, repr. in col.), bt Spink
Exh: Society of Artists 1762 (50)

Spink and Son Ltd

The view is an almost exact repetition of a pastel by Lambert,
signed and dated 1746 (exh. Kenwood 1970, no.20), and
shows the durability of a favourite design over a long period.
The cloud formation and even the details of vegetation
remain unchanged after fifteen years, and only the figures,
while grouped in the same way, are no longer the arcadian
rustics of the earlier version, but contemporary tourists
gesticulating at the grandeur of the spectacle, while their
guides and porters rest in the foreground, turning their backs
to the familiar sight.

It also shows that in the latter part of his career Lambert,
whose views in the 1730s were very advanced among his
contemporaries in landscape painting, made little or no effort
to keep up with developments initiated by Wilson and
Gainsborough.

184

185

GEORGE SMITH of Chichester *c*.1714–1776

185 Winter Landscape *c*.1750–60
Inscribed 'Geo.Smith' lower left
Canvas 17 × 25 (43.2 × 63.5)
Prov: ...; Capt. A.W.F. Fuller, by whose widow
presented to the Corporation of Chichester 1962
Exh: The Smith Brothers of Chichester, Pallant House,
Chichester 1986 (5, pl.25)
Chichester City Council

Although styled 'of Chichester', the three Smith brothers
William (1707–1764), George (1714–1776) and John (*c*.1717–
1764) were not strictly speaking provincial painters, as they
trained in the St Martin's Lane Academy, maintained a
studio in London and exhibited there as soon as it became
possible to do so. Their works can hardly be distinguished
when not signed, but they were widely engraved and
reflected the taste of the times in landscape painting. Apart
from producing ideal landscapes in imitation of the
seventeenth-century classical painters (the Smiths special-
ised in pastiches of Claude), of the kind which practically all
British landscape painters of the day held in their repertoire,
they also catered, from the 1750s, for the growing interest in
rural scenery, cottage subjects and rural representations of
the four seasons that had their origins in Dutch and Flemish
'rustic' genre. They were practically unique in this country
in producing winter scenes, or 'frost pieces', like this
capriccio, which, unlike Griffier's earlier work (101), records
no particular time or place, but is purely an exercise in the
picturesque style, which here, with its ivy-clad ruin and stark
trees, borders on the Romantic.

GEORGE SMITH of Chichester *c*.1714–1776

**186 Still-Life with Joint of Beef on a Pewter
Dish** *c*.1750–60
Canvas 24 × 29 (61 × 73.7)
Prov: Purchased from the artist by the Duchess of
Northumberland for £1.1.0 (the Duchess's list no.686);
according to label on back in Mr Thomas Break's
collection 1765, sold Hobbs, 23 April, 1765; ...;
Capt. A.W.F. Fuller, by whose widow presented to
the Corporation of Chichester 1962
Exh: *The Smith Brothers of Chichester*, Pallant House,
Chichester 1986 (8, pl.27)
Chichester City Council

186

Apart from their particular brand of landscape (185), the
Smith brothers were among the few artists of the period to
specialise in a modest line of still-life painting. While
William's known work in this genre is confined to small
unemphatic fruit pieces, George developed a few stronger
compositions based on simple country foods, pewter and a
linen cloth, that have sufficient individuality not to look like
straightforward adaptations of Dutch prototypes. Signed
examples date from the early 1750s and some exist in many
versions or replicas, some of which may be the work of the
youngest brother John.

This particular piece was bought for the price of one
guinea from the artist by the Duchess of Northumberland,
wife of the 1st Duke of Northumberland (60), who evidently
continued her family's tradition of supporting contemporary
British artists.

ARTHUR DEVIS 1712–1787

**187 Gentleman and Lady in an Interior ('The
Duet')** 1749
Inscribed 'Artr Devis fe. 1749' on stretcher of
harpsichord, lower right
Canvas 45½ × 40¼ (115.6 × 103.5)
Prov: ...; Cecil Fane de Salis of Holly Cross House,
Henley-on-Thames, sold Christie's 11 March 1932 (97
as 'The Love Song') bt Gooden & Fox; sold to Ernest
E. Cook by whom bequeathed through the E.E. Cook
Fund to the National Art-Collections Fund 1955 and
allocated to the lender
Exh: *Arthur Devis*, National Portrait Gallery 1984
(17, repr.)
Lit: D'Oench 1979, pp.488–9, no.250
*The Trustees of the Victoria and Albert Museum,
London*

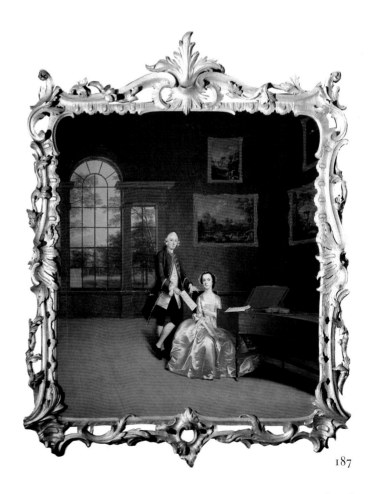

187

In spite of Devis's unrelenting attention to detail, the un-
known lady and gentleman are in no way crowded by the
accoutrements of good taste and civilised living, among
which a fashionable Palladian window, giving out on a park
and an orangery, receives almost as much attention as them-

selves. It is, as Ellen D'Oench rightly says in her catalogue, one of Devis's most meticulously crafted works, one that encapsulates admirably the genteel ideals of the age. Its Rococo charm is greatly enhanced by the fine contemporary carved scroll-work frame.

ARTHUR DEVIS 1712–1787

188 A Family Group on a Terrace in a Garden 1749
Inscribed 'Art: Devis/fe 1749' on tree stump lower left
Canvas 40 × 49 (101.5 × 124.5)
Prov: . . .; the Cave-Brown-Cave family, by descent to Geoffrey Clapham, sold Sotheby's 12 March 1969 (105) bt Leggatt, from whom bt by Jack R. Dick, sold Sotheby's 23 April 1975 (101, repr. in col.) bt C. Murray

Exh: Arthur Devis, National Portrait Gallery 1984 (28, repr.)
Lit: D'Oench 1979, p.487, no.248
British Rail Pension Funds Works of Art Collection, on loan to Fairfax House, York

One of Devis's most appealing works and a masterpiece of his individual and invariably well-bred style. The family taking its ease on a terrace, behind a delightful foreground frieze of vegetation, is unknown. Behind them is an impressive canal or reservoir with a row of nesting boxes for water fowl in the distance; judging from the fairly immature trees by the water's side, it is a fairly recent construction, but already well stocked with fish. The group playing with their baby-carriage and the child on the right straining towards them, but firmly held back by its leading strings by grandfather, is probably the closest Devis ever approached to movement and animation.

188

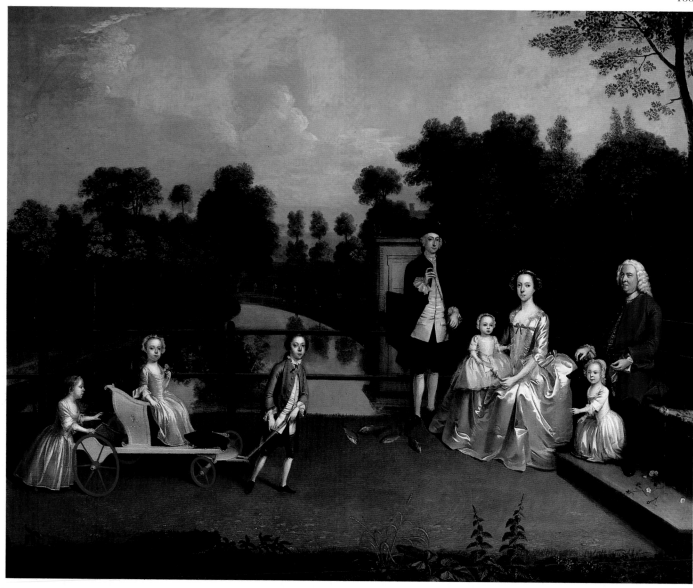

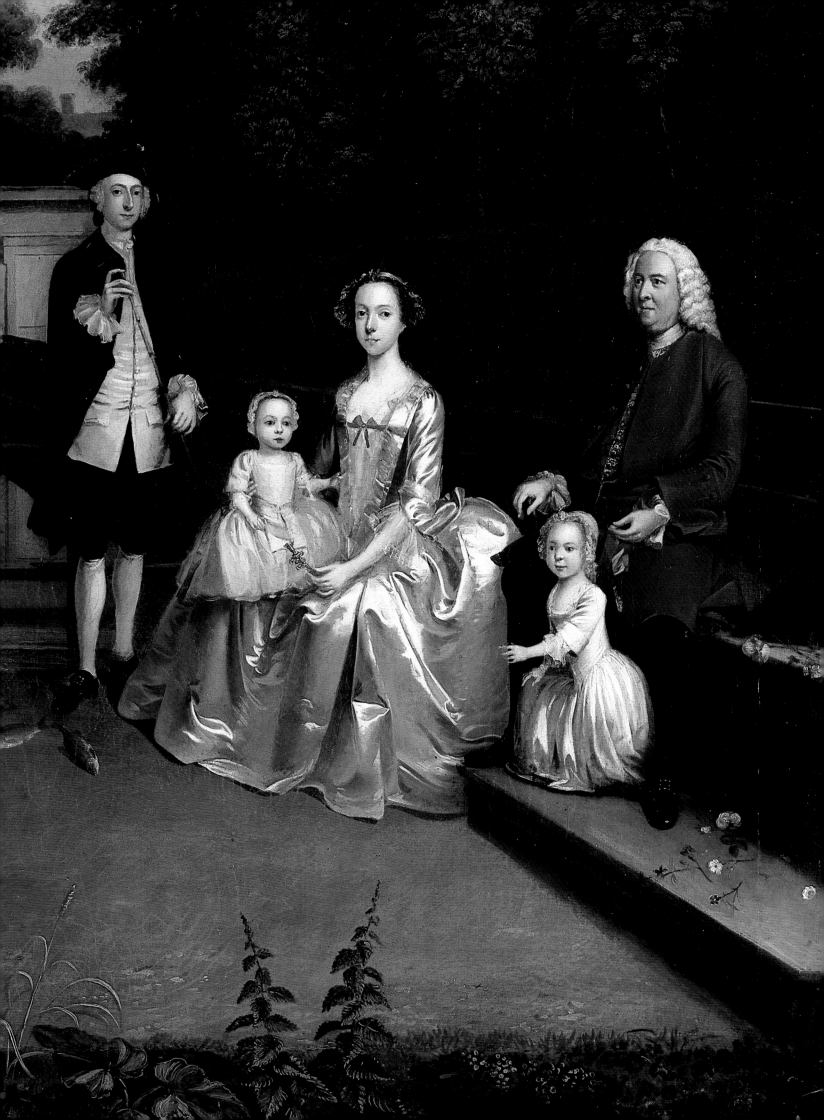

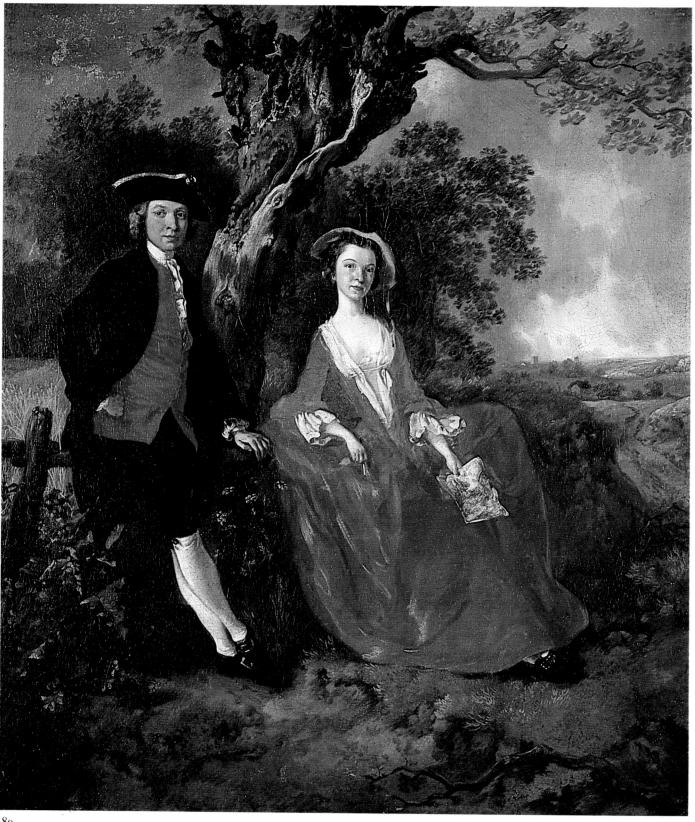

189

THOMAS GAINSBOROUGH 1727–1788

189 An Unknown Couple in a Landscape *c.*1750–5
Canvas 30 × 26⅜ (76.2 × 67)
Prov: ...; John Doherty of Birmingham by 1858; (?by
descent to) the Doherty family of Foxlydiate House,
Redditch 1880; ...; with Lesser; ...; J. Fairfax
Murray, by whom presented to the lender 1911
Lit: P. Murray, *The Dulwich Picture Gallery*, 1980,
p.61, no.588, col. pl.VII
*By Permission of the Governors of Dulwich Picture
Gallery*

This is one of Gainsborough's most delightful portrait
groups of the period when he worked as a young man in his
native Suffolk. It raises the small-scale portrait genre as
practised by his contemporaries Hayman and Devis to a new
level, not only by means of Gainsborough's superior gifts as
a draughtsman and painter, but also by his ability to inte-
grate the figures into a believable local landscape that was
neither overtly topographical, nor yet a mere backdrop.
Gainsborough was a born landscape-painter and had a flaw-
less instinct for combining it successfully with portraiture.
Significantly, he is not known to have painted any small-scale
full-lengths of this kind set in an interior.

SIR JOSHUA REYNOLDS 1723–1792

190 The Reverend William Beele *c.*1748–9
Canvas 29⅞ × 25⅖ (76 × 64)
Prov: ...; Sabin Gallery 1969, from whom bt by the
lender
Exh: Sir Joshua Reynolds PRA, City Art Gallery,
Plymouth 1973 (20, repr.)
Lit: Waterhouse 1973, pls.6, 7
Barber Institute of Fine Arts, University of Birmingham

William Beele (1704–1757) was appointed naval chaplain in
1727, and at the time of this painting was Chaplain to the
Dockyard at Plymouth, where Reynolds had most of his early
portrait practice.

 Although the artist had been apprenticed to his fellow-
Devonian Thomas Hudson from 1740 until 1743, little of
Hudson's smooth and bland style is visible in portraits such
as this. The strong chiaroscuro and powerful characteri-
sation are rather much closer to the work of Hogarth, who
was at the height of his powers in the 1740s. In 1749
Reynolds went for three years to Italy, where he learnt to
modify this style with echoes of the Italian old masters, a
move which appealed to the tastes of the English aristocracy
and gave him the success which had eluded Hogarth.

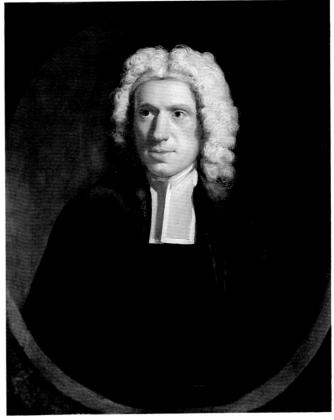

190

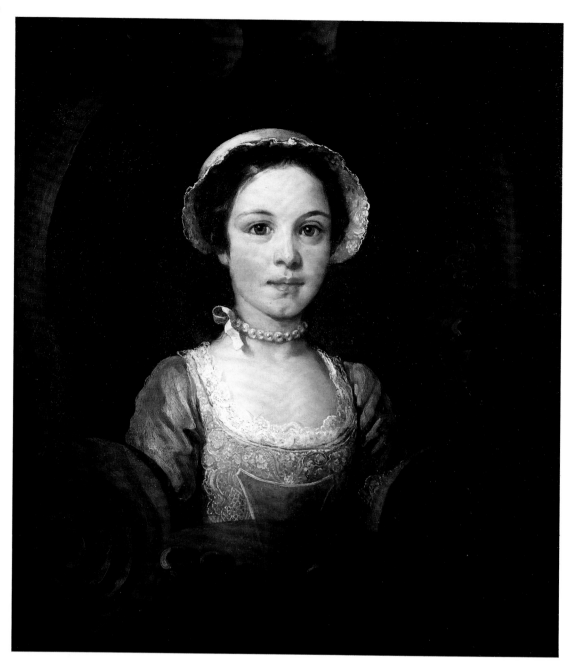

WILLIAM HOGARTH 1697–1764

191 Hannah, Daughter of John Ranby *c.*1748–50
Canvas $25\frac{1}{8} \times 22\frac{5}{8}$ (64 × 57.5)
Prov: Painted presumably for John Ranby, the sitter's
father, and thence by descent
Lit: J. Nichols, *Biographical Anecdotes of William
Hogarth*, 1781, p.68* (double numbers), 141;
E. Farrer, *Portraits in Suffolk Houses*, 1908, pp.72–3,
nos.12, 13 as (?) Edward and Mary Goate by an
unknown painter; *East Anglian Miscellany*, 1932,
pp.72–3
Property of a Lady

Hannah (1740–1781), was the natural daughter of John
Ranby (1703–1773) F.R.S., Principal Sargeant Surgeon to
George II and to the Chelsea Hospital. Ranby was a friend
of Hogarth and his neighbour at Chiswick. According to
Nichols, writing in 1781, he owned Hogarth's Rembrandt-
esque portrait of the engraver John Pine (now in the
Beaverbrook Foundation, Fredricton, New Brunswick) and
was himself painted by Hogarth, since Samuel Ireland's
collection had at that time a portrait 'of Mr. Ranby, the late
Serjeant-surgeon, who sat for the hero of the "Rake's
progress"'.

Hannah married Walter Waring (*c.*1728–1780) in St
George's, Hanover Square, on 18 July 1758. Her husband
was Tory M.P. for Bishops Castle, Salop, and later for

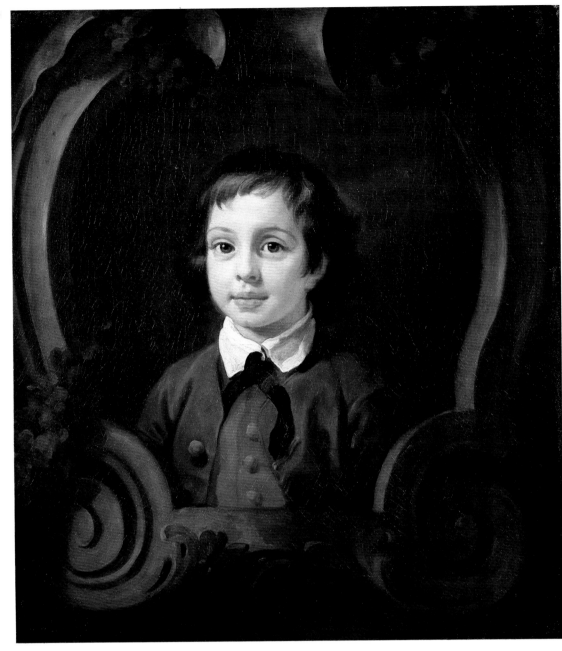

Coventry. In 1769 he inherited his cousin's estate at Groton, Suffolk, and both husband and wife are buried in Groton church.

Judging from the age of the sitter, the portrait seems to have been painted around 1748–50, about the time when Hogarth acquired his house in Chiswick. Stylistically, it seems to have been painted a little earlier than no.192. It was originally set in a plain false oval (still visible under the overpaint) on which the elaborate stone surround was later superimposed, presumably to match its pair. Although the surround is less vigorously painted than in no.192, the multitude of adjustments and pentimenti suggest that it was also painted by Hogarth, though with less creative enthusiasm.

WILLIAM HOGARTH 1697–1764

192 George Osborne, later John Ranby c.1750
Canvas $25\frac{1}{8} \times 22\frac{3}{4}$ (64 × 57.8)
Details as 191
Property of a Lady

George was born in 1743, the natural son of John Ranby (see 191). His mother, whom he held in loving memory, died in 1746, but her identity is unknown as his heirs effaced her name in such documents that are still in the family's possession. George was brought up as Ranby's heir, and in 1756 changed his name to John Ranby by royal licence. He went to Eton and Trinity College, Cambridge, and was admitted to the bar at Lincoln's Inn (where several of his father's friends

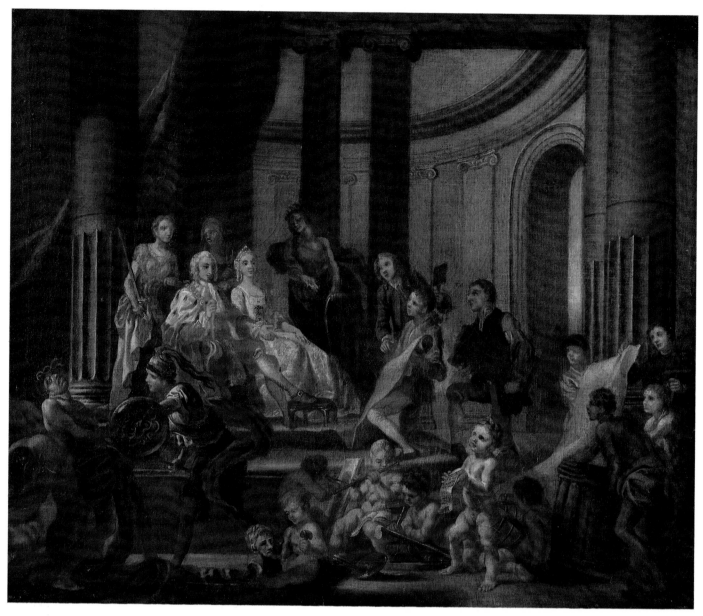

resided) in 1762. He was the author of several anti-Wilkes pamphlets, and his *Doubts on the Abolition of the Slave Trade* was warmly commended by his friend James Boswell. His marriage to Mary, daughter of Edward Goate, was happy but childless. He died on 31 March 1820, and was buried at Brent Eleigh, Suffolk.

The portrait has an unusually elaborate false stone surround reminiscent of the painted scrollwork surrounding Hogarth's decorations for the staircase of St Bartholomew's Hospital. The later alterations to its pair (192) suggest that Hogarth may have been asked to paint them in order to fit in with a particular decorative scheme (the frames of the paintings do not appear to be original). Stylistically, this portrait seems to have been painted later than the portrait of his sister.

FRANCIS HAYMAN 1708–1776

193 The Artists Presenting a Plan for an Academy to (?) Frederick, Prince of Wales, and Princess Augusta *c.*1750–1
Canvas 24 × 30 (63.5 × 76.2)
Prov: ...; Michael J. Upsall by 1965, sold J. Bright & Sons, Brixham, Devon, 5 June 1973 (137), bt A. Ballard; ...; Raymond Head, from whom acquired by lender
Exh: Francis Hayman, Yale Center for British Art, New Haven, and Iveagh Bequest, Kenwood 1987 (48, repr.)
Lit: Allen 1987, pp.4–7, 65–6, 122, fig.36
Royal Albert Memorial Museum, Exeter

In this sketch a group of artists present plans for an Academy to two royal personages who probably represent Frederick,

Prince of Wales, and Princess Augusta, attended by Minerva and Britannia, while Perseus banishes Envy and Vice on the left and cherubs emblematic of the Arts and Sciences gambol in the foreground. It appears to be a *modello* for a large picture that was never executed, probably because of the Prince's death in 1751. Brian Allen argues plausibly that it may have been intended for one of the four giant canvases for the Saloon of the Rotunda built at Vauxhall Gardens by Jonathan Tyers in the late 1740s to outdo the rival Ranelagh Gardens nearby: the four frames were to have been filled with portraits of the family of Prince Frederick, the ground landlord and chief patron of the gardens. It is also suggested that the huge group portrait of the Prince's family of 1751 by George Knapton (Royal Collection), which matches the known size of the Vauxhall frames, could have been intended for this set. Certainly the proportions and subject of

Hayman's sketch would have made a suitable pendant for it. In the event, the four spaces were filled by four different scenes of a suitably patriotic nature.

As far as is known, Hayman had always been a leading advocate for the establishment of a formal academy for British painters, run on Continental lines, and from 1753 onwards he chaired a committee that actively pursued this aim. Moreover, Vertue noted in July 1749 that the Prince had expressed great interest in the idea. The fact that the sketch shares a similar composition with Hayman's design for a subject entitled 'The Noble Behaviour of Caractacus Before the Emperor Claudius', published as an engraving in 1751, also points to Hayman's increasing concern with academic painting after the mid-century. It is also quite close in feeling to Verrio's sketch of a similar presentation scene for Christ's Hospital, painted *c.*1682 (Victoria & Albert Museum).

194

GAVIN HAMILTON 1723–1798

194 Elizabeth Gunning, Duchess of Hamilton 1752–3
Canvas 93 × 57 (236 × 145)
Prov: Painted for the 6th Duke of Hamilton, thence by descent
Exh: The Masque of Beauty, National Portrait Gallery 1972 (21, repr.)
The Hamilton Collection

Elizabeth (1734–1790) and Maria Gunning were the daughters of an Irish squire who were brought to London in 1750 by an ambitious mother, and who by their sheer good looks and deportment took society by storm. Their connections were good enough for them to be presented at court and for a year the 'Hibernian Maids' were one of the sights of London wherever fashionable gatherings took place: the titled stood on chairs to see their entrance at balls and crowds mobbed them in Vauxhall Gardens. Horace Walpole thought their unusual impact was due to the fact that there were two of them, both equally tall and handsome. By February 1752 Maria had married the 6th Earl of Coventry, and Elizabeth, James, 6th Duke of Hamilton. Widowed in 1758, she later married John, Duke of Argyll. This portrait shows her in her first year of marriage, not yet twenty, wearing the Hamilton colours of grey and crimson. The painting was mezzotinted by Faber in 1753.

Gavin Hamilton studied painting under Agostino Masucci in Rome until 1748 and brought back to England an aloof classical style that gives this painting the dignity of an antique statue. He practised as a successful portrait painter in London from 1752 until 1756, when he returned to Rome to devote himself entirely to History Painting and classical studies, leaving the field for this kind of portraiture to Reynolds and later Romney.

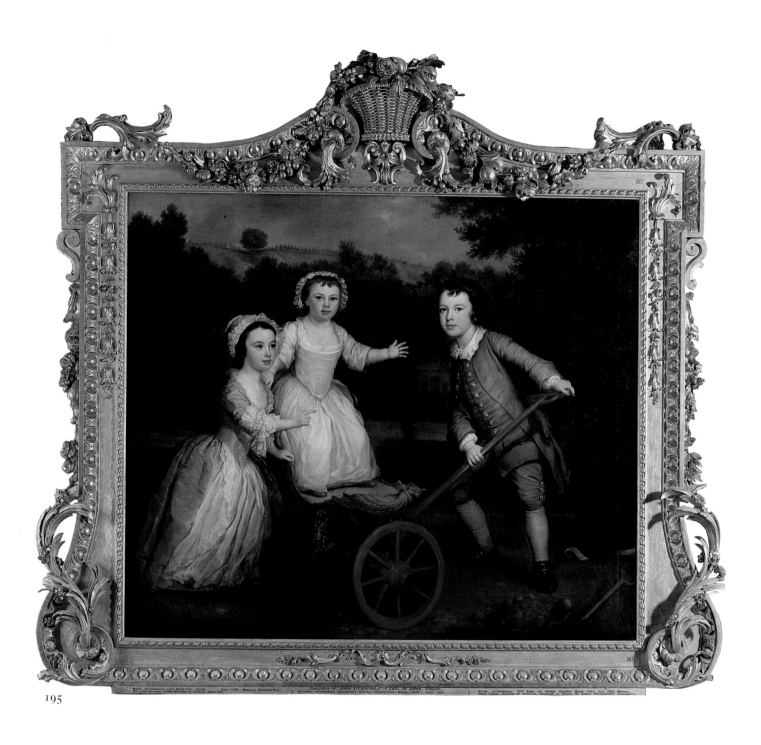

CHILDREN OF JOHN FITZPATRICK 1st EARL OF UPPER OSSERY.

195

GEORGE KNAPTON 1698–1778

195 The FitzPatrick Children *c.*1752–3
Inscribed 'John Earl of Upper Ossory.-Hon^ble. Gen.
Fitzpatrick. Lady Mary Fox' along bottom margin of
picture
Canvas 59 × 71 (150 × 180.5)
Prov: Presumably painted for John FitzPatrick, 1st
Earl of Upper Ossory, and sent from Ampthill to
Woburn by the Dowager Lady Holland at an
unspecified date before 1890
Lit: G. Scharf, *Catalogue of Pictures at Woburn Abbey*,
1890, pp.172–3; A.M. Bedford & E.M.S. Russell,
Biographical Catalogue of Pictures at Woburn Abbey,
1892, II, pp.1–10, repr.
*The Marquess of Tavistock and the Trustees of the
Bedford Estate*

The children represented are those of John FitzPatrick, Earl
Gowran (d.1758), who married Lady Evelyn Leveson
Gower, a sister of the Duchess of Bedford, in 1744, and was
created Earl of Upper Ossory in 1751. They are John
(1745–1818), later 2nd Earl of Ossory, Richard (1749–1813),
later Lt. General FitzPatrick, and Mary (d.1778), who
married Stephen Fox, 2nd Lord Holland.

The children are shown at play in a manner which not only
makes for a very charming composition, but is also, for the
conventions of large-scale portraiture of the period, re-
markably natural. Digging holes in the ground and giving
rough treatment to the splendid armorial baby cart (though
it is steadied by a more cautious elder sister) conjures up
something of genuine childish high spirits that are in no way
overwhelmed by the formal magnificence of the original
frame. The setting, with its unusually high horizon en-
livened by a line of newly planted trees, is presumably
the park of their home at Ampthill, Cheshire (demolished
1953–4).

After the 1st Earl's death, the 4th Duke of Bedford became
the guardian of John, the eldest boy in the painting, and the
close relationship between the two families probably ac-
counts for its presence at Woburn. The children remained
close as adults, and Lord Ossory deeply mourned the death
of his sister in 1778 – 'the most amiable person that ever
lived'; her son was to become his heir. He later sat to and
became friendly with Reynolds, and owned his portrait of
Laurence Sterne (222).

WILLIAM HOGARTH 1697–1764

196–199 The Election 1754–5
Four canvases, each 40 × 50 (101.5 × 127)
Prov: Bought from the artist by David Garrick
*c.*1762; Mrs Garrick's sale, Christie's 23 June
1823 (63) bt J. Wine for Sir John Soane and given
to the Museum 1833
Exh: Hogarth, Tate Gallery 1971 (186–9, repr.)
Lit: Paulson 1971, II, pp.191–206, 219–27,
340–2, 433–5, pls.248–51; Webster 1979,
pp.145–63, repr. in col. pp.154–5, 158–63
The Trustees of Sir John Soane's Museum

The set is Hogarth's most beautifully painted and complex
work, conceived on a much larger scale than any of his other
sets, and must represent the highest achievement of his art. It
was probably begun soon after the publication of his *Analysis
of Beauty* late in 1753, for he invited subscriptions for the
print of the first scene in March 1754. It is not known when
exactly he finished the entire set, but the year 1755 on the
sundial in the last scene suggests it was then. Difficulties with
engravers delayed the publication of the complete engraved
set until January 1758. As always, many details are made
clearer in the prints.

At least part of the series was inspired by the notoriously
corrupt Oxfordshire election of 1754, which was a contest
between the Tory country gentry and the Whig candidates
backed by the biggest local landowner, the Duke of Marl-
borough. Although there is no real architectural resemblance,
the bridge in Scene III just might suggest Vanbrugh's
equally massive bridge over the canal at Blenheim. Hogarth's
own attitude towards the parties appears to be impartial, and
his real targets are the foibles of human nature. In this series,
for instance, divine justice, which we see in the final scene
equated with natural law, moves in gradually on the dissolute
crowd in the form of the church: in the first scene it is a token
presence in a picture on the wall, in the second it looms on the
horizon, it dominates the middle distance in the third, and
finally stands before the candidate in the fourth.

The paintings are in their original finely carved and pierced
frames.

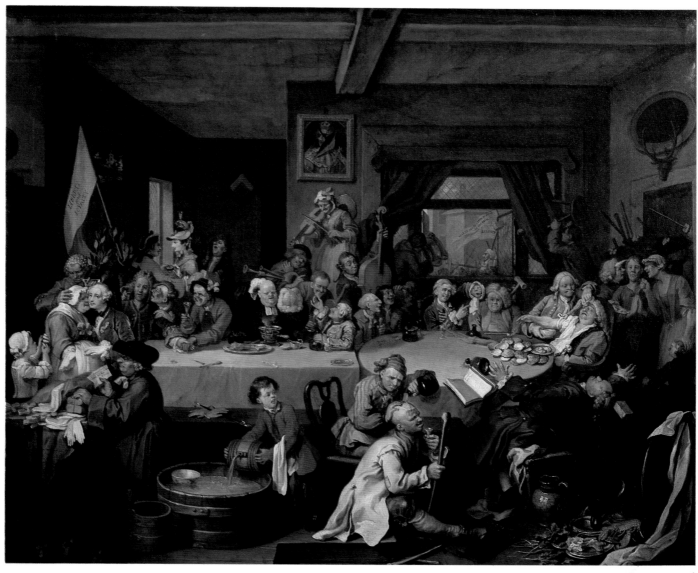

196

196 I: An Election Entertainment

Two Whig candidates are giving an election entertainment for the citizens and mayor of Guzzletown, while the opposition party riots in the street outside. The rioters carry the effigy of a Jew in protest against the liberal Jewish Naturalisation Act of 1753, which was unpopular with the Tories, and a banner against the Marriage Act of the same year, which outlawed clandestine marriages. A brick thrown by them has knocked out the Whig attorney who was registering party votes in a book. The Whigs' own strong-arm men are taking a rest in the foreground and are tending each other's wounds with strong drink. One of them has his foot on a banner inscribed 'Give us our Eleven Days', referring to the 1752 Act in which England conformed to the Gregorian calendar. The adjustment involved 'losing' eleven days from the calendar and led to riots, because the ignorant believed it also shortened their lives by that amount. The boy-waiter mixes a punch in a huge tub in which a punchbowl proper floats as if lost. On the left a seller of election rosettes and favours calmly scrutinises a sales receipt; his clothes mark him out as a Quaker, whose beliefs should have debarred him from profiting from corruption. Behind him is the elegant Whig candidate, Sir Commodity Taxem, for once compelled to submit to the attentions lavished on his handsome person by the lower orders with as good a grace as he can muster. The other candidate listens patiently to the ramblings of a barber and a cobbler. Behind them a pretty lady canvasser concentrates her attention on a handsome officer. Around the tables, the worthies of the town make the most of the food and drink; each is sharply drawn, with his own story to tell. At the head of the table, the mayor has collapsed in an apoplectic fit from a surfeit of oysters and is being bled by a barber-surgeon (the accepted treatment for most ills at that period). On the right, the only would-be honest man in the scene, a puritanical tailor who refuses to sell his vote, may yet succumb to temptation as his wife points out the need to provide for the children.

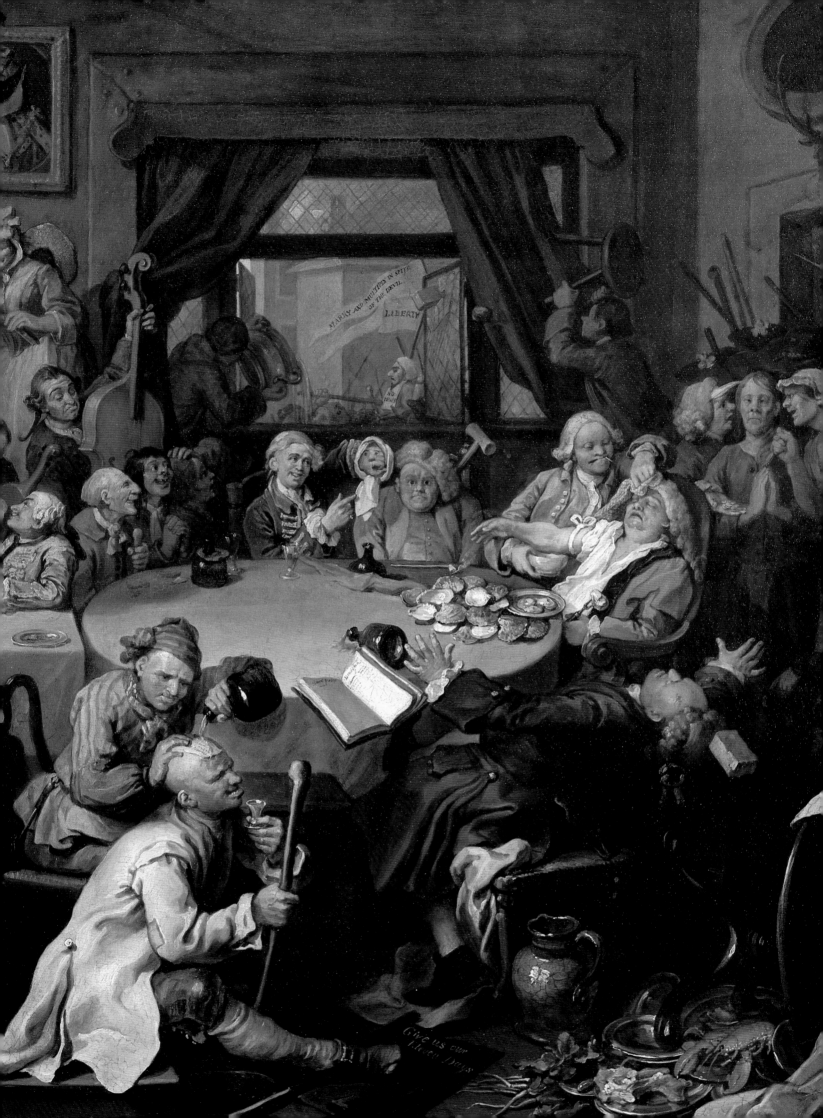

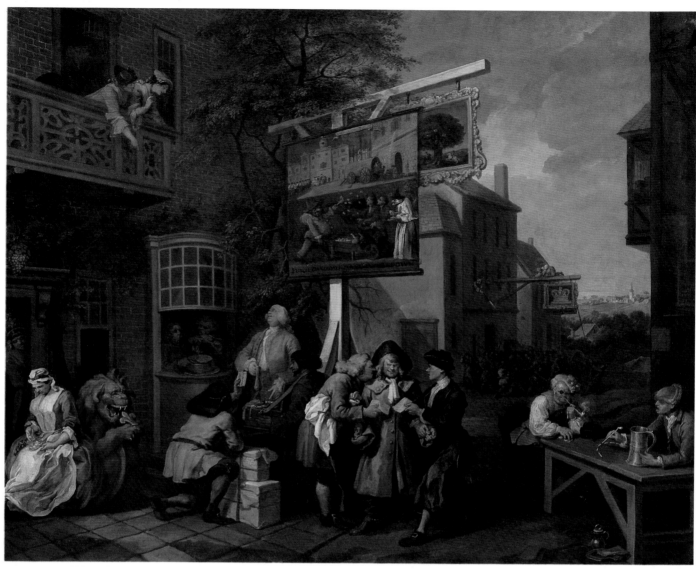

197 II: Canvassing for Votes

The scene is set in a country village, outside the Royal Oak public house. In front of it, a smooth Tory agent is trying to secure the interest of two ladies on the balcony with trinkets bought from a Jewish pedlar. Although women could not vote, they were presumed capable of influencing their menfolk, probably the two men smoking their pipes in the room behind them. In the background a mob is breaking up the Crown Tavern, which has been temporarily converted to a hated Excise-office. With fitting symbolism, the man sawing through the beam of its sign is unmindful of the fact that when it falls he will fall with it. In the centre, a sly countryman, nobody's fool, accepts bribes and invitations to dinner from the agents of both parties, his sideways look favouring the larger bribe. With deliberate irony, Hogarth has based the group on the classical subject of Hercules at the cross-roads, being asked to choose between Virtue and Pleasure.

In front of the Porto Bello ale-house on the right, a barber and a cobbler replay Admiral Vernon's great naval victory over Spain in 1739. England's past naval glory is thus contrasted with the defunct ship's figurehead of a British lion eating the lily of France, now serving as a tavern seat, across the way. The landlady sits on it counting her bribe-money, watched by a guardsman who ought to be out controlling the mob. Hogarth drove the point home in the print of 1758 by removing the lion's teeth: the Seven Years' War had broken out by then and England was ill-prepared to resist the French.

Over the inn-sign hangs a brilliantly painted show-cloth advertising a Punch-and-Judy show called 'Punch Candidate for Guzzletown'. It shows Treasury money being carted to Oxford, the scene of the most corrupt of the election contests of 1754. The show is going to be performed in the inn's courtyard, and a porter has just delivered the packaged puppets and leaflets to the party agent.

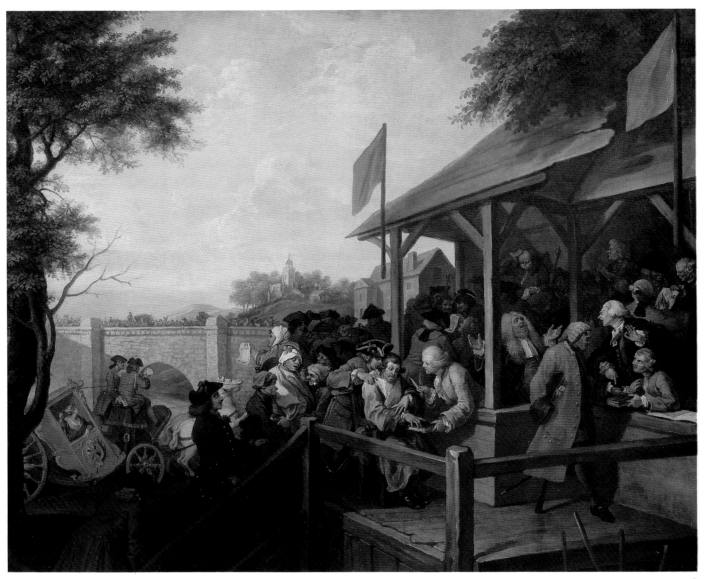

198 III: The Polling

The voters flock to the temporary polling booths. Two candidates sit at the back, one twisting his knuckles and the other mopping his brow with tension, while the beadle between them has fallen asleep from boredom. Agents have cajoled the maimed, the mad and the sick to come and give them their vote. In a grim and brilliantly painted vignette worthy of Daumier, two lawyers argue vehemently over the point whether the maimed soldier's hook can be accepted in law as the right 'hand' which has to be placed on the bible to take the oath.

On the left, Britannia's coach, drawn by the white stallions of the House of Hanover, has ground to a halt with a broken shaft. Instead of coming to her aid, her coachmen play at cards, each cheating the other. Presumably the able-bodied freeholders have not arrived to cast their vote because they are too busy rioting – the warring factions have blocked the bridge in the background, which bristles with their sticks and staves, while a rearing horse has its forelegs suspended perilously over the parapet.

199 IV: Chairing the Members

The election is over and the winning Tory candidate is carried through the streets in triumph (the other is visible as a shadow on the wall), in a grotesque parody of Le Brun's 'Battle of Granicus' in which the eagle of victory over Alexander's head is replaced with a goose. He is being led off the scene by a blind fiddler dancing to his own music. The procession's path, however, is blocked by a stubborn donkey laden with pails of offal. This has attracted a dancing bear who belongs to a crippled sailor, now forced to earn his bread by wandering around with performing animals. This splendidly painted figure wears a Whig rosette and has got into an argument with the opposition, setting off a chain-reaction that is about to topple the candidate.

The procession spills down the main road of a town situated, according to the milestone on the left, 19 miles from London. The setting, however, is allegorical. On one side is the solidly built, enduring structure of the church, on the other a ramshackle building under construction, designed in an impossible mixture of classical, Venetian and Chinese

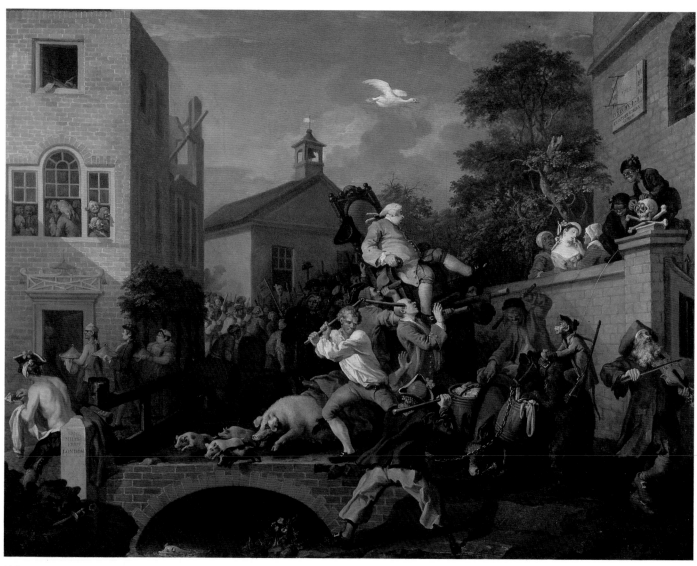

199

styles, and already in the process of falling apart. Inside, the nobles and officials of the political world gather for a celebratory feast. In the unglazed window above, an attorney draws up an indenture (in other words, a contract between two parties), suggesting that, whoever wins, the powerful conspire to remain in power. The strange square shape of the window is echoed by the sundial opposite (bearing the date 1755), which speaks of a different set of values: *pulvis et umbra sumus*, we are but dust and shadow. The truth of this is reinforced below, in a curious vignette on the pillar of the church gate: it consists of a book sculpted in stone, on which rests a skull and cross-bones, with a black chimney-sweep holding a pair of spectacles over its eye holes. This seems to refer to Newton's *Opticks*, his treatise on the nature of vision and light (Newton's coat-of-arms was the cross-bones on a black ground). Together with his *Principia*, which dealt with the law of gravity, it was perhaps the most influential book of the period, and to the eighteenth-century mind both were synonymous with Truth *per se*. Newton's most famous

statement was *hypotheses non fingo* (I do not frame hypotheses, that is to say, I work from direct observation only). As the candidate succumbs to the law of gravity, staring aghast at the face of truth, Hogarth seems to be saying that he, the artist, has invented nothing, but is merely presenting what he has observed. Significantly, the bridge between the two buildings is barred (on the side of the temporal establishment), and the only moderating influence seems to be the sober and sensible town hall in the middle, with its bell capable of sounding the tocsin when needed.

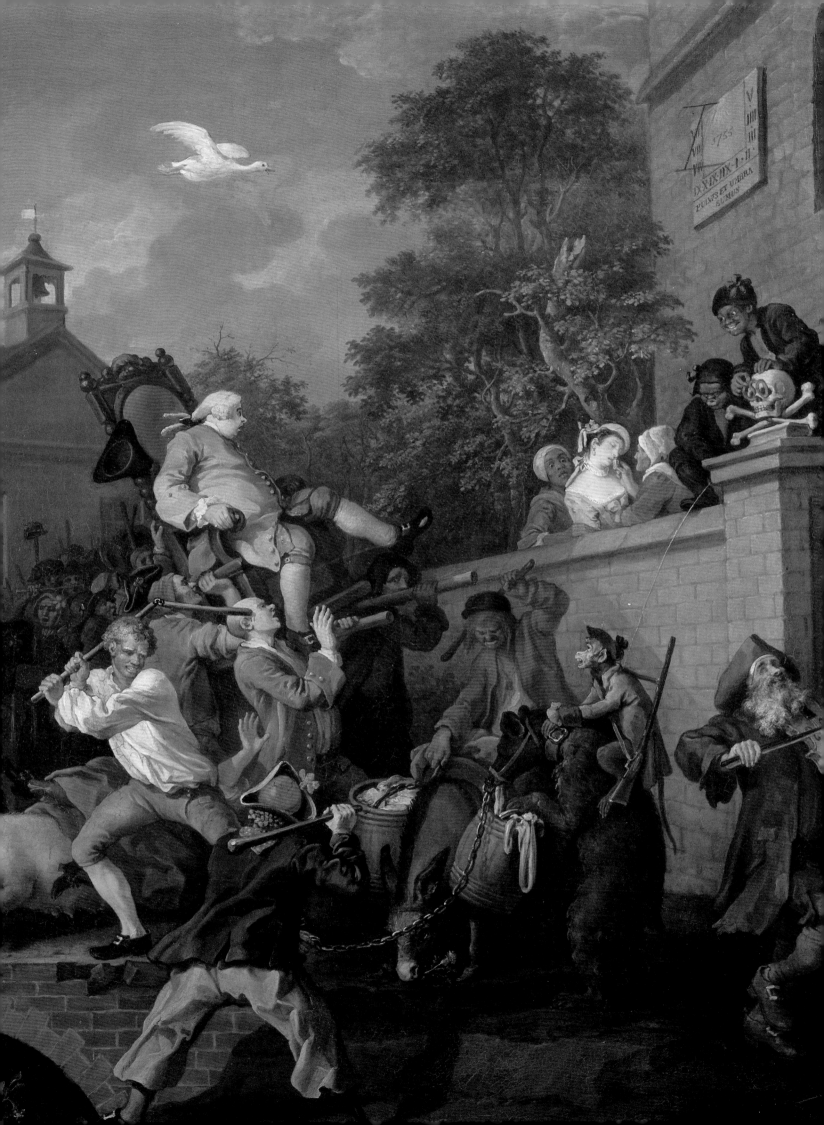

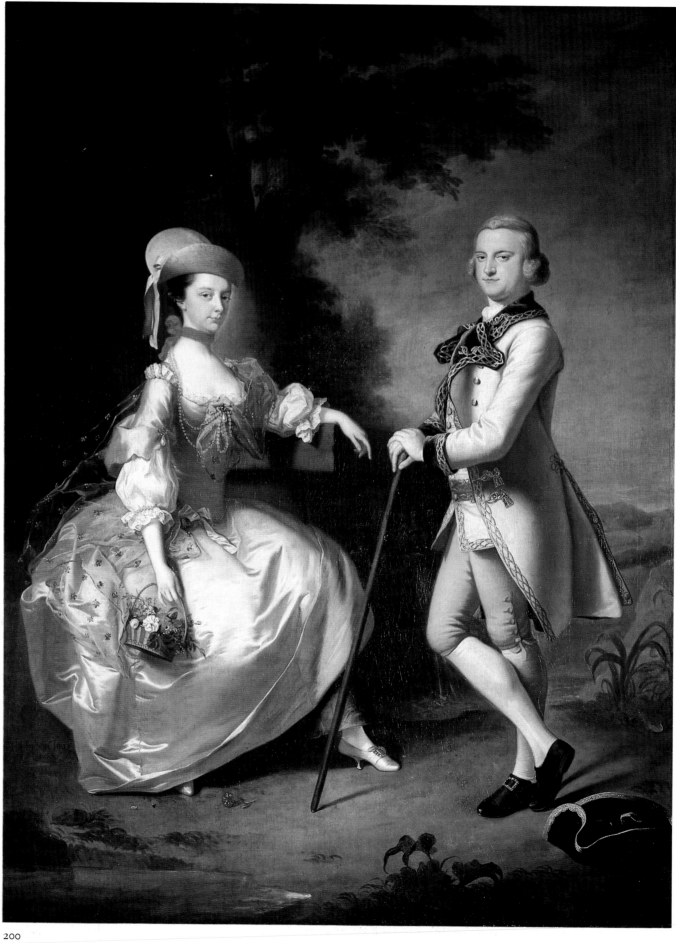

THOMAS HUDSON 1701–1779

200 Sir John Pole, 5th Bt., and his Wife Elizabeth 1755

Canvas 94 × 71 (231 × 118.5)
Prov: Painted for the sitter, and thence by descent
Lit: Waterhouse 1978, pp.200–1, pl.160; Ribeiro 1984, p.173, pl.72

By Permission of the Trustees of Sir John Carew Pole

Sir John Pole, 5th Bt. of Shute (d.1766), is shown here with his first wife Elizabeth (d.1758), daughter of John Mills of Woodford.

This handsome portrait was painted at the height of Hudson's successful career, in the year when he purchased a villa at Twickenham, in the vicinity of Horace Walpole and Samuel Scott, where he was eventually to retire. It is one of his most accomplished works, where he allows himself a lightness of touch that is in harmony with the alfresco setting and with the masquerade dress of the lady. Derived, at a long remove, from the portraits of Van Dyck and Lely, this has a Rococo gaiety of colour, and its bucolic air is enhanced by the lady's basket of flowers, saucily tilted hat, and an unusually daring display of ankle.

The date of the portrait also marks the zenith of Hudson's supremacy as the leading portrait painter of the British establishment, for it is from roundabout this time that fashionable clients began to turn in increasing numbers towards, as Horace Walpole put it, 'the better taste introduced by Sir Joshua Reynolds'.

A copy of the painting was sold at Sotheby's, New York, 30 May 1979 (275, repr.).

BENJAMIN WILSON 1721–1788

201 Charles Ingram, later 9th Viscount Irwin
*c.*1752–8

Inscribed 'CHARLES NINTH VISCOUNT IRWIN' lower left
Canvas 98 × 57 (249 × 145)
Prov: Painted for the sitter, by descent to Lord Halifax, who presented Temple Newsam to the City of Leeds 1922, and subsequently also the Irwin family portraits that hung there
Lit: Benjamin Wilson, 'Autobiographical Notes' in H. Randolph, *Life of General Sir Robert Wilson*, 1862; *Leeds City Art Gallery and Temple Newsam House: Catalogue of Paintings*, I, 1954, p.85, no.6

Leeds City Art Galleries, Temple Newsam House

Charles Ingram (1727–1778), who succeeded his uncle as 9th Viscount Irwin in 1763, was an important patron of Wilson, who was particularly favoured by Yorkshire sitters.

Born in Leeds, Wilson came to London early in life and became an accomplished etcher in the style of Rembrandt, whose chiaroscuro manner he also introduced into his portraits and theatre pieces. He was a friend of Hogarth, who encouraged the younger painter in his early career and even proposed to enter into partnership with him in order to obtain a greater share of Reynolds's growing portrait practice, a proposal which Wilson wisely declined. Despite his weak drawing, his own portrait practice prospered and during the 1750s he was seen by many as a serious rival to Reynolds, becoming wealthy enough to take over Kneller's old house in Great Queen Street. A friend also of Garrick, he had a lively interest in the theatre and was for a time manager of the Duke of York's Theatre in James Street. His work on electricity earned him a fellowship of the Royal Society, and in about 1769 he gave up painting to pursue his scientific interests.

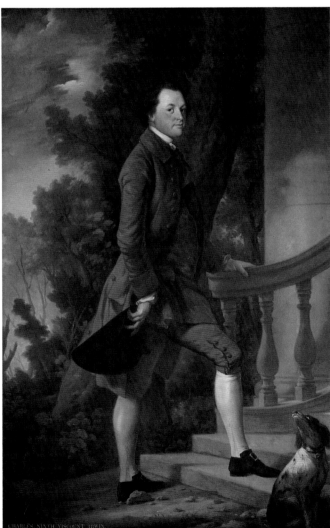

201

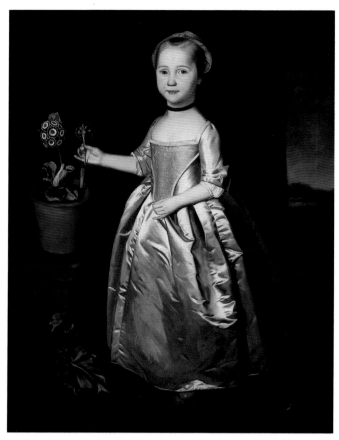

202

CHRISTOPHER STEELE 1733–1767

202 Martha Rodes 1750
Inscribed 'C.Steele/1750' bottom centre
Canvas $38\frac{1}{4} \times 31\frac{1}{4}$ (97.1 × 79.4)
Prov: From the sitter by descent
Exh: The Glory of the Garden, Sotheby's 1987 (86, repr. in col.)
Lit: Waterhouse 1981, pp.358–9, repr.
Private Collection

A native of Cumberland who never worked in London, Steele represents much of what is best in forthright British provincial portrait painting, although his firm professionalism was no doubt improved by a year's study under Carle Van Loo (brother of Jean-Baptiste, 103) in Paris. He settled in Kendal in 1750, where George Romney was apprenticed to him in 1755. Romney's early style (203), before his removal to London in 1762, was closely modelled on his.

GEORGE ROMNEY 1734–1802

203 Little Boy with a Dog *c.*1757
Canvas 36 × 27 (91.5 × 68.5)
Prov: By family descent
Exh: Four Kendal Portrait Painters, Abbot Hall Art Gallery, Kendal 1973 (14, repr.)
Private Collection

A good example of Romney's early provincial manner, which was very close to that of his first master, Christopher Steele of Kendal (202). It combines solid form with clear colours and a neat, uncluttered presentation that translated well into Romney's later broader style and handling after he moved to London in 1762, and which was more suitable for the Grand Manner to which he ultimately aspired.

The portrait was probably painted towards the end of Romney's apprenticeship to Steele, or soon after its completion in 1757.

ARTHUR DEVIS 1712–1787

204 Assheton Curzon, afterwards Viscount Curzon, and Dr Mather, his Tutor *c.*1754–5
Inscribed with the title on the reverse of the canvas
Canvas $27\frac{1}{4} \times 22\frac{1}{8}$ (69.2 × 56.2)
Prov: By descent to Assheton Curzon's great-granddaughter Mary Cecil, 17th Baroness Zouch, thence to her daughter the Hon. Mrs Barbara Frankland, sold Sotheby's 26 June 1980 (30, repr.), bt by lender
Exh: Arthur Devis, National Portrait Gallery 1984 (34, repr.)
Lit: D'Oench 1979, pp.308–9, no.43
Private Collection

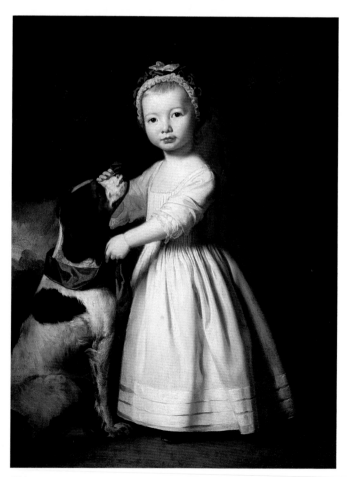

203

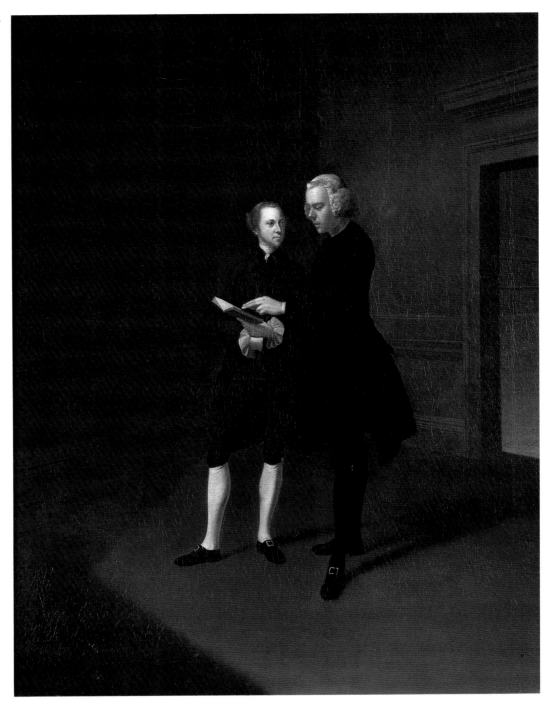

Assheton Curzon (1730–1820) of Penn House, Buckingham-shire, was the second surviving son of Sir Nathaniel Curzon, 4th Bt, and Mary, daughter of Sir Ralph Assheton, 2nd Bt, of Middleton. He was educated at Westminster School and Brasenose College, Oxford, and became Doctor of Civil Law in 1754, which is probably the date of this picture. The same year he became M.P. for Clitheroe, Lancashire, where his family had long been active in the Tory interest. He was ennobled in 1794 and created Viscount Curzon in 1802. Devis's son, Arthur William, painted him in his peer's robes at the age of ninety. Dr Roger Mather (1719–1768), also a Brasenose man, was a public orator from 1749–60, and later Rector of Whitechapel. He was employed by Curzon to teach him the art of public speaking after his election to Parliament.

In this late work Devis has abandoned his customary light and non-committal style for an attempt to explore light and shade and a real interaction between figures. The earlier conversation-piece convention, where the sitter poses for the spectator even when occupied in some domestic pursuit, gives way here to a genuine involvement with the task in hand, greatly increasing the range wherein character and individuality can be expressed.

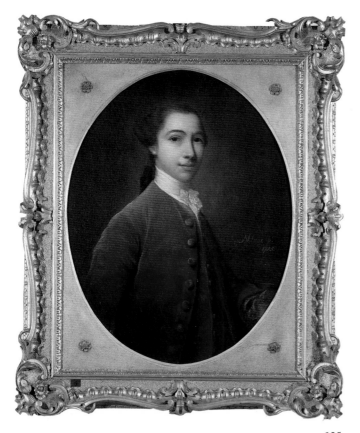

205

NATHANIEL HONE 1718–1784

205 David, Viscount Milsington 1753
Inscribed 'NHone pᵗ/1753' lower right
Canvas, oval 29 × 24 (73.5 × 61)
Prov: From the sitter by descent
Private Collection, UK

Hone was chiefly a miniature painter until 1760, but also painted very competent portraits in oil as early as 1741. His easy and elegant style as a portraitist, of which this is a good example, has a touch of slightly Frenchified Rococo brightness that has led some of his works to be attributed to Gainsborough.

Viscount Milsington was the eldest son of Charles, 2nd Earl of Portmore, and died in 1756 before succeeding to the title.

SIR JOSHUA REYNOLDS 1723–1792

206 Charles, 9th Lord Cathcart *c.*1753–5
Canvas 48$\frac{13}{16}$ × 39 (124 × 99)
Prov: Painted for the sitter and by family descent to Major General the Earl Cathcart, from whom bt by the lender 1981
Exh: *Sir Joshua Reynolds*, City Art Gallery, Birmingham 1961 (13); *Zwei Jahrhunderte englische Malerei*, Munich 1979–80 (120, repr.)
Lit: Whitley 1928, I, p.150; Waterhouse 1973, p.17, pl.13; D. Mannings, 'At the Portrait Painter's – How the painters of the eighteenth century conducted their studios and sittings', *History Today*, May 1977, p.287, repr.; E.G. Miles, *Thomas Hudson*, exh. cat., Iveagh Bequest, Kenwood 1979, no.6; MS catalogue entries by A.K.J. Farrington, Manchester City Art Gallery
Manchester City Art Galleries

As a young man Charles, 9th Lord Cathcart (1721–1776) had a distinguished military career. He served as aide-de-camp to the Duke of Cumberland at the battle of Fontenoy in 1745, where the English suffered a defeat at the hands of the French in the Wars of the Austrian Succession. His only brother was killed, and he himself received a shot in the face. He took great pride in the scar and wore over it a black silk lunette patch, as shown here. He was made a Knight of the Thistle in 1763, and served as Ambassador Extraordinary at the court of the Empress Catherine of Russia from 1768 until 1771.

A letter he wrote in October 1753 shows the kind of relationship that existed between Reynolds and his sitters: 'Again with Mr. Reynolds, and was disagreeably surprised with the figure. After some reasoning he came to the opinion that it would not do. I breakfasted with him and stood to him a good while. I thought it was much improved, and he was extremely satisfied with the alterations so we parted in a great good humour.' Reynolds was paid £31 for the picture.

After his return from Italy in 1753 Reynolds brought with him a new ability to infuse British portraiture with a cosmopolitan stylishness that set him apart from his contemporaries. Although the pose here is identical with one painted by Hudson in 1739 (both painters may have used a common Continental source), Reynolds's Venetian handling and use of deep shadowy effects at the expense of detail makes this a harbinger of the Grand Style to come.

206

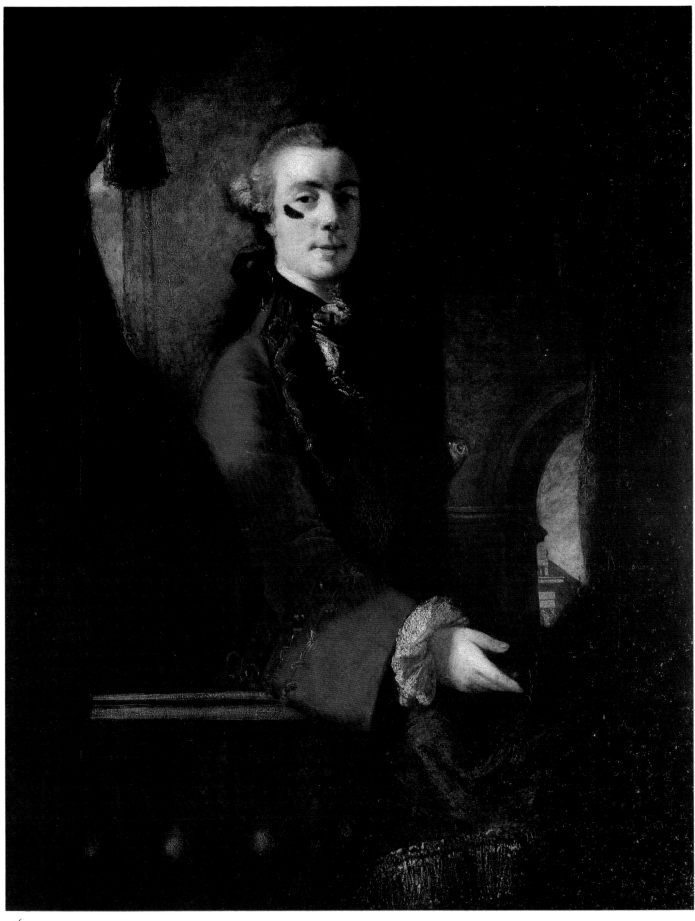

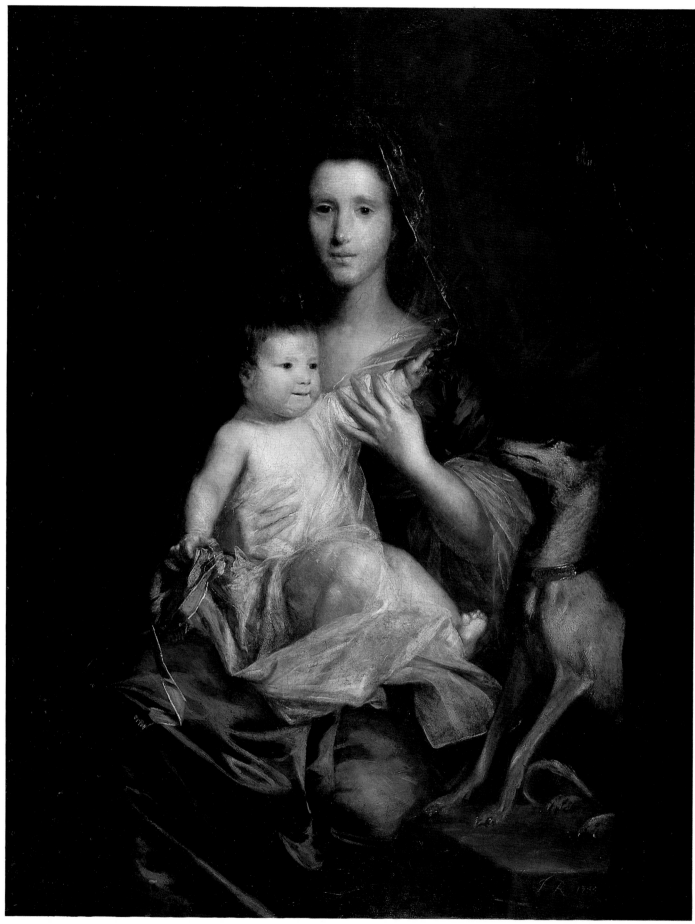

207

SIR JOSHUA REYNOLDS 1723–1792

207 Jane Hamilton, Wife of the 9th Lord Cathcart, and her Daughter, Jane 1755
Inscribed 'J R 1755' bottom right corner
Canvas 48¾ × 39 (124 × 99)
Prov: as for 206
Exh: as 206, Birmingham (14); Munich (121, repr.)
Manchester City Art Galleries

Jane (1726–1771) was a daughter of Admiral Lord Archibald Hamilton, Governor of Jamaica, and sister of James, Duke of Hamilton, and of Sir William Hamilton, Ambassador to Naples. She married Lord Cathcart (206) in 1753. Jane, their first child, was born in 1754, married John, 4th Duke of Atholl, in 1774, and died 1791. Lady Cathcart accompanied her husband to Russia, and wrote a journal describing her life there.

Reynolds's sitters' book for 1755 records that Lady Cathcart sat to him on 19 March, Jane on 6 and 12 February, and the greyhound on 27 January; the payment in December was for £37.16.0. In some early portraits Reynolds used a carmine pigment in the glazes of the flesh tones that was particularly susceptible to fading, as a result of which the sitters now appear unnaturally pale.

Evidently modelled on an Italian Madonna, Lady Cathcart's portrait, like that of her husband, is a new departure and shows the direction in which Reynolds meant to take British portraiture.

THOMAS HUDSON 1701–1779

208 The Thistlethwayte Family *c.*1757–8
Canvas 72¾ × 84½ (184.7 × 214.6)
Prov: Painted for the sitter, by descent through the family of Anne Thistlethwayte to Mrs D.I. Rowlands,

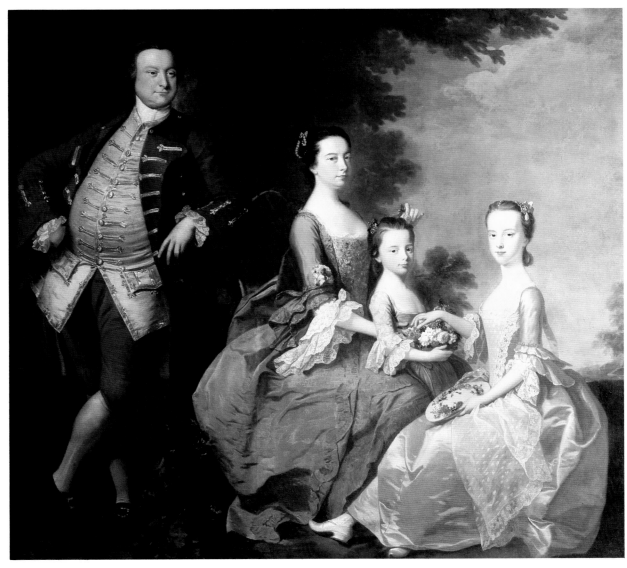

208

sold Sotheby's 12 March 1986 (41, repr. in col.) bt by the lender
Exh: Thomas Hudson, Iveagh Bequest, Kenwood 1979 (59, repr. in col.)
Lit: J. Boundy, 'An Unpublished Conversation Piece by Thomas Hudson. The Thistlethwayte Family', *Apollo*, CVII, October 1978, pp.248–50, col. pl. 1
Private Collection

The sitters are Alexander Thistlethwayte (1718–1771) of Winterslow, Wiltshire, and Southwick Park, Hampshire, M.P. for Hampshire, his wife Sarah, daughter of Edward Randoll, a Salisbury publican, and their daughters Catharine (b.1743) and Anne (b.1748), who married Thomas Somers Cox and inherited the painting.

The painting is a particularly fine example of grand domestic portraiture of the kind that was beginning to look old-fashioned by this time. Put together from a number of stock poses, it yet makes a pleasing if somewhat stiff ensemble, chiefly because of its crisp and harmonious Rococo colouring. Much of this must be due to the anonymous drapery painter, whose craft had become an almost independent art form (and a very lucrative one) throughout the middle of the eighteenth century, and was relied upon by most leading portrait painters with the exception of Hogarth and Gainsborough.

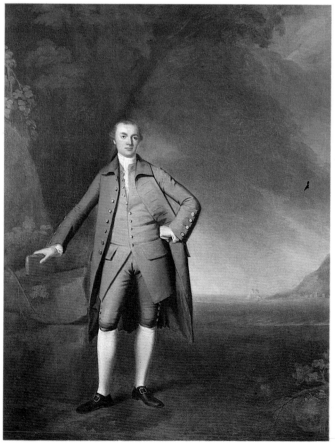

209

GEORGE ROMNEY 1734–1802

209 Captain Robert Banks *c*.1760
Canvas 49 × 40 (124.5 × 101.5)
Prov: Left by the sitter's family to Ann Waters, reclaimed by his grand-daughter Margaret Thompson, and thence by family descent until acquired by lender
Exh: Four Kendal Portrait Painters, Abbot Hall Art Gallery, Kendal 1973 (10, repr. on cover)
Abbot Hall Art Gallery, Kendal, Cumbria

Romney, who in the 1770s was to become the most fashionable portrait painter after Reynolds and Gainsborough, still exhibits here a provincial reticence that could, were it not for the hint of swagger in the pose and the grander sweep of the setting, easily place him in the same class as 'sophisticated' primitives like Devis.

The portrait was painted, according to Mary Burkett's exhibition catalogue of 1973, '*c*.1760, when Captain Banks (born 1734) lived in South Scales, Walney. When the family moved, it was not considered worth taking "as it was only painted by George Romney, the joiner," and it was left with an old servant, Ann Waters. Captain Banks' daughter, Mary, married John Thompson of Lancaster; their daughter, Margaret, went to Walney and reclaimed the portrait'.

WILLIAM HOGARTH 1697–1764

210 The Lady's Last Stake 1758–9
Canvas 36 × 41½ (91.5 × 104.8)
Prov: Painted for the 1st Earl of Charlemont;
Charlemont (= J. James) sale, Christie's 2 May 1874
(57) bt Vokins for L. Huth, in whose collection until
1891; ...; Agnew 1899, sold to J. Pierpont Morgan
1900; sold 1911 to Knoedler & Co, from bt by lender
1945
Exh: Hogarth, Tate Gallery 1971 (210, repr. col.)
Lit: Webster 1979, pp.173, repr. pp.169, 170–1;
S.A. Nash, *Albright-Knox Art Gallery: Painting and
Sculpture from Antiquity to 1942*, New York 1979,
pp.177–9, repr.
*Albright-Knox Art Gallery, Buffalo, New York,
Gift of Seymour H. Knox 1945*

In 1758 Hogarth was contemplating giving up comic history
painting (painting altogether according to some sources) for
portraiture, when his great admirer, the Irish peer James
Caulfeild, 1st Earl of Charlemont (1728–1799), persuaded
him into another commission with the flattering offer of
'leaving the subject to me and any price I asked'. The result
was his last 'comic history', a moral tableau rather than tale,
described in his own words as 'a virtuous married lady that
has lost all at cards to a young officer, wavering at his suit
whether she should part with her honour or no to regain the
loss which was offered to her'. Some twenty years later
Charlemont recalled that the letter on the floor was supposed
to be from her husband, inscribed 'My dearest Charlotte . . .
your affectionate Townly. – I will send the remainder of the
note by next post.' The painting over the mantelpiece was to
represent one of those darkened old masters that Hogarth

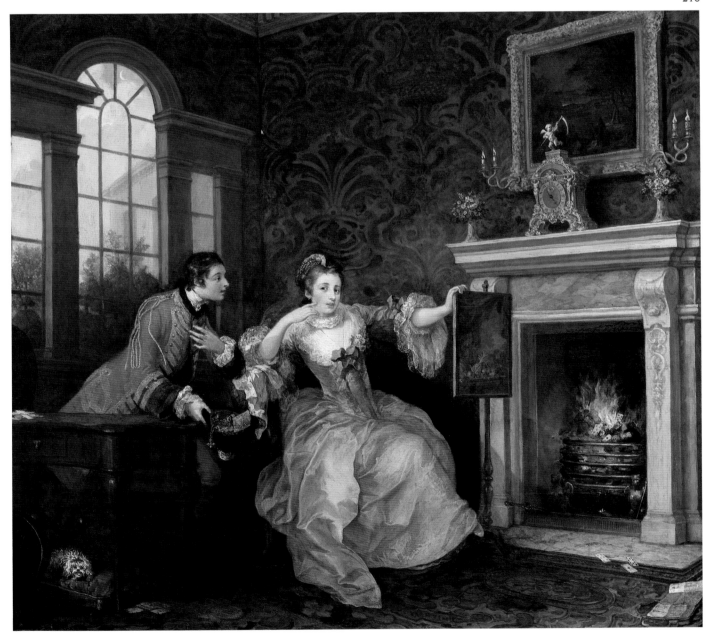

hated and that 'decorated by a long Dutch name, the connoisseurs of those times eagerly and dearly purchased at auctions'. The dog is a portrait of one that belonged to Signora Regina Mingotti, a leading singer at the Haymarket.

The picture freezes a moment of choice between good and evil (stressed by the urgent inscription on the clock 'NUNC NUNC'), with all the attendant symbolism in the surrounding objects one has come to expect of Hogarth. Yet so well integrated are they into an elegant, de Troy-like composition, that they in no way threaten to overwhelm the image as in some earlier works.

The painting was completed in 1759, although Hogarth kept it for another year in a futile attempt to engrave it. A good copy of the painting, not by Hogarth, is at Goodwood.

FRANCIS HAYMAN 1708-1776

211 David Garrick as Richard III 1760
Inscribed 'FH 1760' lower left
Canvas 36¼ × 28 (89.5 × 64.1)
Prov: ...; Charles Jennens, by descent to Baroness Howe by 1811; Howe sale, Gopsall Hall, Messrs Trollope 21–22 October 1918 (1165) bt W. Somerset Maugham and bequeathed by him to the National Theatre 1951
Exh: Society of Artists 1760 (25); *The Georgian Playhouse . . . 1730–1830*, Hayward Gallery 1975 (20, repr.); *Francis Hayman*, Yale Center for British Art, New Haven and Iveagh Bequest, Kenwood 1987 (42, repr.)
Lit: R. Mander and J. Mitchenson, *Guide to the Maugham Collection of Theatrical Paintings*, p.14, no.2, repr.; Allen 1987, pp.20, 61–2, 116–17, repr.
National Theatre of Great Britain

The scene shows the king in the final act on Bosworth Field, uttering the cry 'A Horse, a Horse! My Kingdom for a horse.' Richard III was one of Garrick's favourite Shakespearean parts, probably not least because it was the role which launched him on his spectacularly successful stage career in 1741. This painting almost certainly shows him in the revival of the play at Drury Lane, by command of the Prince of Wales, on 8 March 1759. Garrick was also painted in the role by Thomas Bardwell in 1741 (Russell Coates Museum, Bournemouth), by Hogarth in one of his most genuinely dramatic portraits in 1745 (Walker Art Gallery, Liverpool) and by Hayman's pupil Nathaniel Dance in 1771 (Stratford-upon-Avon).

The painting is particularly interesting in that Hayman chose to show it at the first exhibition of the Society of Artists in 1760 as, in the words of Brian Allen, 'a foretaste of the grander historical subjects that he aspired towards at the beginning of the new decade'. Although clearly connected with a particular performance, the painting attempts to raise its subject by showing Garrick not as an actor on the stage, but as a heroic character in a real battle setting, as if in a history painting. To add to its intellectual refinement, Hayman quotes the antique by giving Garrick the pose of the Borghese Gladiator, a vein that was to be exploited to the full by Reynolds. This accorded well with the increasingly grandiloquent taste of the times, and the picture was one of the few to be singled out for praise in contemporary reviews of the exhibition.

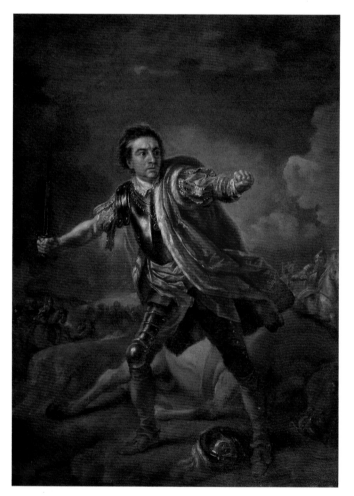

211

212

RICHARD WILSON 1713–1782

212 'Vale of Narni' *c.*1757–60
Inscribed 'RW' (the 'R' reversed) in monogram on stone lower right
Canvas 26 × 19½ (66 × 50.2)
Prov: Benjamin Booth by 1790, thence by descent
Exh: Wilson, Tate Gallery 1982 (79, repr.)
Lit: Constable 1953, pp.122–4, 206, pl.90b
Sir Brinsley Ford, C.B.E., F.S.A.

The title dates only from an engraving of 1822, although such a location would not be impossible. Benjamin Booth (1732–1807), the distinguished early collector of Wilson's works, lists it *c.*1790 in his own collection as 'View in Italy: Firs and Cypress's. Fortune teller/Figures on Bank by Roadside'; and indeed the beautiful Rococo composition of this small cabinet picture has more to do with the visual poetry of Italian landscape in general than with any particular topography.

Stylistically the painting fits well into the years immediately following Wilson's return in 1757 from his seven-years' sojourn in Italy, and epitomises the new kind of sensibility and vision he brought back to apply to the scenery of his native country.

213

RICHARD WILSON 1713–1782

213 Croome Court, Worcestershire 1758–9
Inscribed 'RW' (the 'R' reversed) in monogram on
tree on left
Canvas 48 × 66 (129.5 × 165)
Prov: Painted for the 6th Earl of Coventry, thence by
descent
Exh: The Origins of Landscape Painting in England,
Iveagh Bequest, Kenwood 1967 (32)
Lit: Constable 1953, p.173, pl.33a; D. Solkin, *Richard
Wilson,* 1982, p.196, no. 82, repr.
By Permission of the Croome Estate Trustees

Wilson painted this view in 1758–9 for George, 6th Earl of
Coventry (1722–1809) for 50 guineas, to record the com-
pletion of the first phase of the rebuilding of the house and
the new lay-out of the park by Lancelot 'Capability' Brown
that had been begun in 1751. Wilson was evidently asked to

add the tower of the new church, also designed by Brown,
immediately to the left of the house, although it was not com-
pleted until 1763. The house is seen from the south-west,
bathed in glowing sunlight that is almost as important
to the composition as the structure itself. In front of it is a
tranquil sheet of water in the form of the canal which Brown
had introduced to drain the marshy site. A preparatory
drawing for the left-hand side of the view (in the collection
of Sir Brinsley Ford) shows that, as in Lambert's view of
Westcombe earlier (86), the essential topography was care-
fully worked out in pencil first, and the picturesque fore-
ground with its flanking trees chalked in later in the studio for
compositional effect.

The prospect is a particularly fine example of the move
away from the precise delineation of a place towards creating
an artistic entity of house and landscape, an aim which the
painting shares with the new style of open or 'natural'
landscape gardening introduced by Brown. It called for an

enhanced responsiveness to atmosphere and mood and gave more importance to shifting elements like light and reflecting surfaces of water, and it was also one of England's chief contributions to the artistic style of the late eighteenth century.

SAMUEL SCOTT *c.*1702–1772

214 Covent Garden on a Market Day *c.*1756–8

Canvas $44\frac{1}{2} \times 66\frac{1}{2}$ (130 × 168.9)

Prov: Probably painted for Lord Royston, and in his house in St James's Square by 1761; by descent to the Earl of Hardwicke, sold Christie's 30 June 1888 (23 as by Canaletto) bt Agnew; ...; Sir Henry Hope Edwardes, sold Christie's 27 April 1901 (215 as by Canaletto) bt Colnaghi; ...; the Duke of Bedford by 1906, thence by descent

Exh: Samuel Scott Bicentenary, Guildhall Art Gallery 1972 (40), detail repr. p.45

Lit: Kingzett 1982, p.74, A

The Marquess of Tavistock and the Trustees of the Bedford Estate

Covent Garden looking west towards the church of St Paul and up King Street from a first floor window in the north-eastern corner of the square (not Scott's studio, which was in Henrietta Street to the left of the church). Half-way up on the right is the entrance into James Street beside which some scaffolding has been put up to carry out repairs to the stonework of the arches; the York Flying Coach (according to the notice on the wall) waits at the nearer arches, while the right foreground corner is enlivened by an altercation between a porter and a city gent over an accidentally overturned apple barrow.

In his diary entry for 31 July 1796 Joseph Farington refers to a view of Covent Garden painted by Scott with the assistance of Sawrey Gilpin, for which he received 150 guineas, the highest price Scott is known to have been paid for any work. Gilpin (1733–1807), who was considered the best animal painter after Stubbs in the latter part of the century, was apprenticed to Scott from 1749 to 1756, and worked as his assistant until 1758. Many of the figures, horses and carts are attributable to him, and the costumes also agree with the late dating of the painting.

A version, similar in size but less finished, belongs to the Museum of London, and a smaller oil sketch was formerly in the Paul Mellon collection.

214

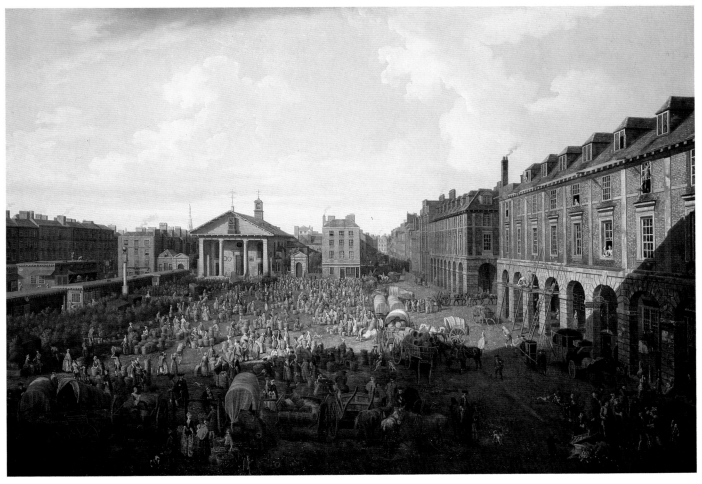

ALLAN RAMSAY 1713–1784

215 Lord John Murray 1759
Inscribed 'A.Ramsay/1759' lower left in light paint
Canvas 30 × 25 (76 × 63.5)
Prov: The sitters' daughter Mary, wife of Lieut.-
General William Foxlowe (d.1818), who assumed the
name and arms of Murray; his sister and heiress Anne
Foxlowe, who married into the present owner's
family; thence by descent
Exh: Allan Ramsay, R.A. 1964 (43, 44, repr.)
Private Collection

216 Mary Dalton, Lady John Murray 1759
Inscribed 'A.Ramsay/1759' lower left in dark paint
Canvas 30 × 25 (76 × 63.5)
Details as no.215

Lord John Murray (1711–1787) was the eldest son of the 1st Duke of Atholl and Colonel of the 42nd Royal Highlanders (the Black Watch) from 1745 to 1761. He was made a General in 1770. From 1734 to 1761 he was M.P. for Perthshire. In 1758 he married Mary Dalton (d.1765), grand-daughter and heiress of John Bright of Banner Cross, near Sheffield.

These seemingly straightforward portraits are in fact exquisitely attuned to each other both in their colours and in light and shade, and the sitters are surrounded by additional air and space by being placed lower than usual on the canvas.

Ramsay's famed ability to catch a likeness is given full play here, tempered with a gentle sensitivity towards his sitters, particularly women, that his rising rival Reynolds, whose strengths lay elsewhere, tried and largely failed to copy. This is society portraiture at its most coolly distinguished and well-bred, without the supporting framework of drapery painters, props or conscious mannerisms, with the exception perhaps of a hint of Frenchified elegance that went down particularly well with Ramsay's Scottish sitters.

Ramsay became effectively court painter on the accession of George III in 1760, and never felt the need to exhibit his works to the general public at the annual exhibitions of the Society of Artists which took place from that year onwards.

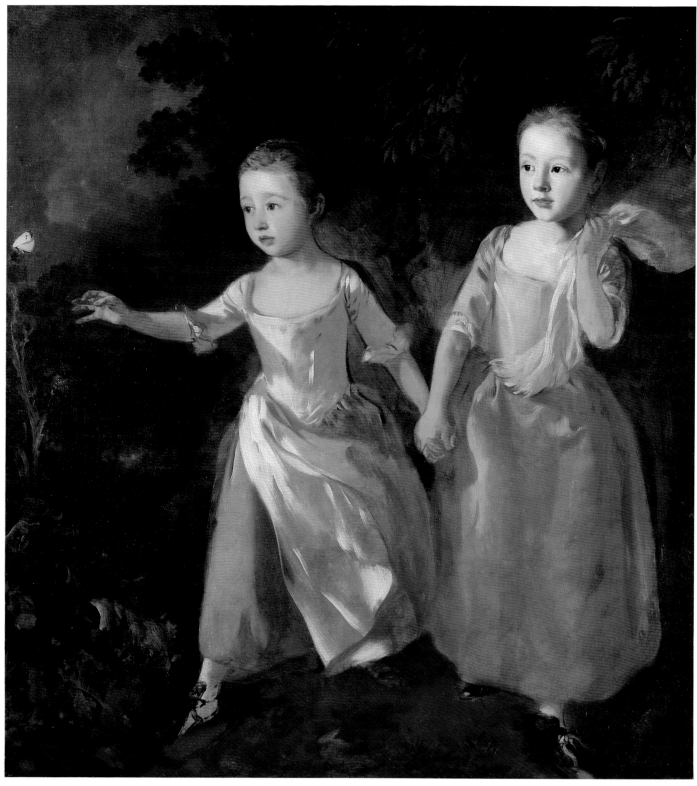

217

THOMAS GAINSBOROUGH 1727–1788

217 **The Painter's Daughters Chasing a Butterfly** *c*.1756
Canvas $44\frac{3}{4} \times 41\frac{1}{4}$ (113.5 × 105)
Prov: Sold or given by the artist to the Rev. James Hingeston (d.1777); ...; Owen Roe of Ipswich by 1856, bt by Henry Vernon *c*.1870 and bequeathed to the lender 1900
Exh: Gainsborough, Tate Gallery 1980 (62, repr.)
Lit: E.K. Waterhouse, *Gainsborough*, 1958, p.69, no.285 pl.52; M. Davies, *National Gallery Catalogues: The British School*, 1959, pp.38–9; M. Levey, *The Painter's Daughters chasing a Butterfly*, Painting in Focus No.4, National Gallery 1975
The Trustees of the National Gallery, London

This portrait of the painter's daughters Margaret (1752–1820) and Mary (1748–1826), shown respectively at about the ages of four and eight, is quite possibly Gainsborough's first attempt at a full-length on the scale of life. Untrammelled by the restraints of pleasing a paying patron, he has broken away completely from the doll-like style of his earlier conversation pieces and raised his art to an entirely new level. Utterly spontaneous, full of effortless rhythm and brilliantly painted, the picture would be a masterpiece in any company. Like only great painters can, Gainsborough has captured the fleeting poignancy of childhood, while the conviction of his rapid brush is backed by an acute observation of nature: even in its unfinished state, all that needs to be said in paint about the thistle, the female cabbage white butterfly, the grasping movement of a childish hand and the sound likeness (which Gainsborough always considered 'the principal beauty and intention of a portrait') is already present.

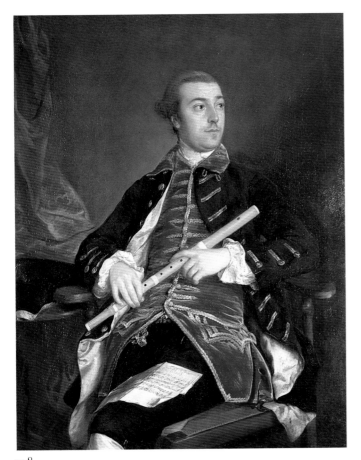

218

THOMAS GAINSBOROUGH 1727–1788

218 **William Wollaston** *c*.1759
Canvas 50 × $39\frac{3}{4}$ (127 × 101)
Prov: By descent from the sitter to F. Wollaston 1888; ...; E.J. Wythes, Copped Hall, Epping, sold Christie's 1 March 1946 (4) bt Gooden & Fox for the lender
Exh: Gainsborough and his Musical Friends, Iveagh Bequest, Kenwood 1977 (2); *Gainsborough*, Petit Palais, Paris 1983 (11)
Lit: E.K. Waterhouse, *Gainsborough*, 1958, p.96, no.733, pl.49
Ipswich Museums and Galleries

William Wollaston (1730–1797) of Finborough Hall, Suffolk, was M.P. for Ipswich in 1768, 1774 and 1780, and was appointed Colonel of the East Suffolk militia in 1769. He is shown here holding a one-keyed boxwood flute of the kind popular from the mid-century; the sheet of music is not playable.

Gainsborough was a passionate amateur musician himself, and his portraits of musical people are among his best and most sympathetic works. This sitter elicited from him one of his most splendidly alive, Rococo performances, one that succeeds in being both informal and grand at the same time. It was painted shortly before Gainsborough's move from Ipswich to fashionable Bath in 1759, and shows that he was more than ready to take on a more demanding clientele. Gainsborough also painted what is thought to be one of his earliest life-size full-lengths of the same sitter at about the same time as this painting, which is still in the possession of the sitter's descendants (Waterhouse 1958, no.734, pl.61).

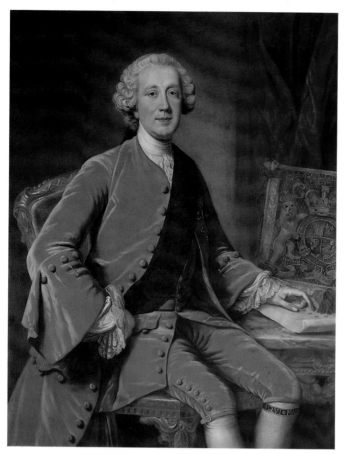

219

WILLIAM HOARE 1707–1792

219 Richard Grenville, Earl Temple *c.*1760
Canvas 50 × 40 (127 × 101.5)
Prov: always at Chevening
Lit: E. Newby, 'The Hoares of Bath', *Bath History*, I,
1986, pp.90–128
By Kind Permission of the Board of Trustees of the
Chevening Estate

Richard Temple Grenville (1711–1779), later Earl Temple,
entered Parliament as a Member for Buckingham in 1741,
and was, according to Walpole, 'an absolute creature of Pitt'.
In 1752 he succeeded to his mother's title and the great
estates of Wotton and Stowe. He was made Lord Privy Seal
in the Duke of Newcastle's administration in 1757, but
resigned the seal in November 1759 in protest at being
refused the Garter. However, two days later he resumed the
office at the request of the king (who disliked him intensely)
and was appointed a knight of the Garter on 4 February 1760.
This portrait was presumably painted soon after this date; in
October 1761 he resigned from office with Pitt.

Hoare studied for nine years in Italy, and returned to Bath
in about 1738, where he was the most fashionable portrait
painter in oil and pastel until the arrival of Gainsborough
in 1759. Stylistically he is considered to be the heir of
Richardson, whose grave and solid manner he carried well
into the late eighteenth century.

SIR JOSHUA REYNOLDS 1723–1792

220 The Children of Edward Holden Cruttenden
1759–62
Canvas $70\frac{7}{8} \times 67\frac{3}{4}$ (180 × 172)
Prov: ...; Charles Purvis, Darsham Hall, Suffolk; ...;
Mrs Clark Kennedy by 1885; ...; Mrs G.F.
Hampson, Thurnham Court by 1895; ...; with
Marshall Field, New York 1949, from whom bt by
lender
Exh: Masterpieces from the São Paulo Museum of Art,
Tate Gallery 1954 (21, repr.)
Lit: Waterhouse 1949, p.52, pl.54
Museu de Arte de São Paulo Assis Chateaubriand,
Brazil

Little is known about the family, but the children are said to
be portrayed with their Ayah who saved their lives in an
Indian uprising.

One of Reynolds's most successful group portraits with
children, it is in many ways a fitting successor to Hogarth's
'Graham Children' of the previous generation. Unlike
Hogarth, however, it requires no 'reading' of detail but
presents its subjects at a glance, in a composition of large
forms held together by strong effects of light and shade.

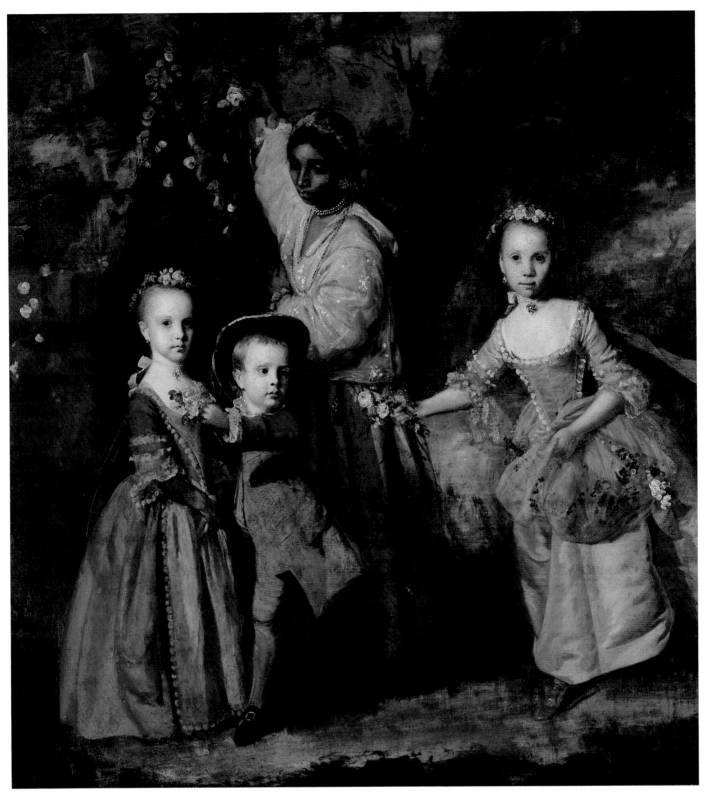

220

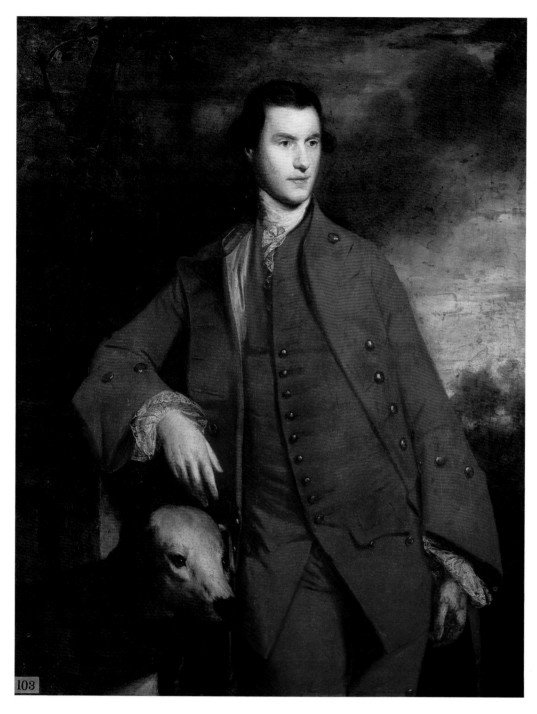

SIR JOSHUA REYNOLDS 1723–1792

221 Charles, 3rd Duke of Richmond 1758
Canvas $47\frac{5}{8} \times 39\frac{3}{4}$ (121 × 101)
Prov: Painted for the sitter, and thence by descent
Lit: Waterhouse 1949, p.44, pl.50
Courtesy of the Trustees of the Goodwood Collection, Goodwood House

Charles, 3rd Duke of Richmond (1735–1806) was painted by Reynolds in 1758, when the artist was well into the busiest period of his life, dealing with over a hundred sitters a year. Yet, as Waterhouse says, 'some of his most penetrating portraits date from these years', as he developed an easy, elegant style, superior and intimate at the same time, which he rarely captured again after gearing his presentation to the grand statements called for by the public exhibitions that commenced in 1760. Portraits such as these show where his innovative strength lay, in his ability to tune in to the unique personality of each sitter and to allow it to transcend the limits of fashion, status and pose.

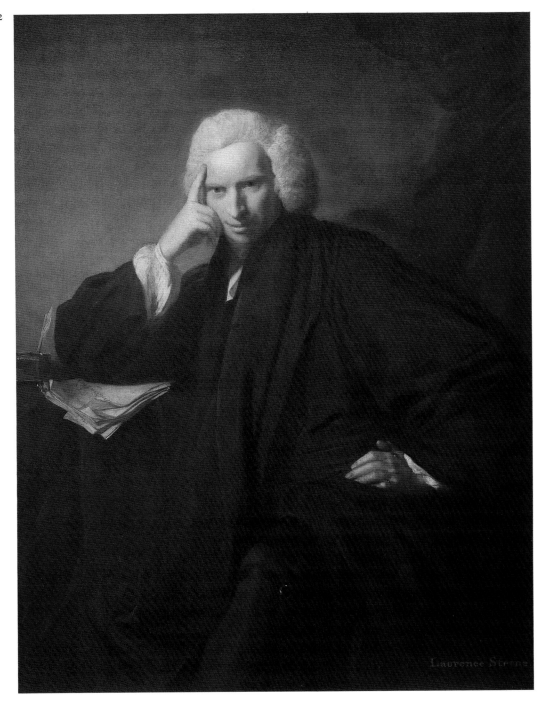

222

SIR JOSHUA REYNOLDS 1723–1792

222 Laurence Sterne 1760
Inscribed 'J Reynolds/pinx.ᵗ/1760' on paper under
sitter's right arm, and 'and [opin]ions [o]f/Tristram
Shan...' on top page of the same
Canvas $50\frac{1}{8} \times 39\frac{1}{2}$ (127.3 × 100.4)
Prov: In Reynolds's studio after 1761 exhibition, and
probably until 1768, though the lender to 1768
exhibition is uncertain; ...; recorded at Ampthill, in
the collection of John, 2nd Earl of Upper Ossory
1801; on his death in 1818 passed with Ampthill to his
nephew 3rd Baron Holland; bt from his widow by the
3rd Marquess of Lansdowne 1840; thence by descent
to Lady Mersey, from whom bt through Agnews by
lender 1975
Exh: Society of Artists 1761 (82) and 1768 (97);
Reynolds, R.A. 1986 (37, repr.)
Lit: Kerslake 1977, pp.260–9, pl.763
National Portrait Gallery

This painting was the first which Reynolds exhibited
publicly under the sitter's own name, an unusual departure
since it was customary to entitle exhibited paintings 'A
Lady', 'A Gentleman', 'An Artist' etc., regardless of how
well-known the personalities in question might be. This

circumstance, the fact of the great popular success of Sterne's just-published novel *Tristram Shandy* to which the portrait alludes, as well as the knowledge that Sterne was too impecunious to commission such a portrait himself, all suggest that Reynolds painted the literary lion of the moment on his own initiative, as a commercial venture for engraving. The result could be described as the first modern literary portrait of the first modern author. Sterne had completely broken with the literary conventions of the Augustan style, and had punctured Richardson's prolix bourgeois sentimentality with a fast, free-wheeling prose, packed with concentrated and precise irony, that still seems undated. Similarly, Reynolds has not painted a conventional servant of the Muses, nor yet a gentleman who dabbles in writing, but projects a unique sardonic character in the sense that we understand it today, in a way that contemporaries found both novel and disturbing.

Laurence Sterne (1713–1768) held a number of church preferments in and around York, but was more interested in writing and convivial company. *Tristram Shandy* was his first important publication; his *Sentimental Journey through France and Italy* was published in the year of his death.

Sterne greatly admired Hogarth and not only made references to his Line of Beauty in the first two volumes of *Tristram Shandy*, but also persuaded Hogarth (through friends) to contribute two illustrations to volumes of the novel published in 1760 and 1761.

ROBERT EDGE PINE *c.*1730–1788

223 King George II 1759
Canvas $87 \times 56\frac{1}{2}$ (221×143.5)
Prov: Engraved by W. Dickinson in 1766 as painted in 1759; bt from the artist by Sir John Griffin, later Lord Howard de Walden, in 1784 for 50 gns; at Audley End since
Exh: British Portraits, R.A. 1956–7 (516)
Lit: Millar 1963, p.188, no.569; R.J.B. Walker, *Catalogue of Pictures at Audley End*, 1964, p.20, pl.II
The Hon. R. Neville by Arrangement with English Heritage

The only portrait of George II (1683–1760) in old age, it shows him wearing the ribbon of the Garter, standing at the head of the King's Staircase at Kensington Palace. A Grenadier of the 2nd Foot Guards and a Yeoman of the Guard can be glimpsed through the balustrade. Pine told Lord Howard, who bought the painting from the artist in 1784, 'that he had taken the likeness, unseen by the King, as he was speaking to one of his attendants at the top of the great staircase at Kensington Palace', and Pine's bill (Essex Record Office D/DBy A43/4) proudly states that 'It has been universally allowed to be the most like of any in being'.

The result of this clandestine effort is a remarkably vivid impression of the fit and irascible monarch in his 76th year, showing a candour of expression that would have been unthinkable in a royal portrait of the Augustan age. The painting also shows how serious a rival Pine was to Reynolds at this stage, although eventually he was to be increasingly outclassed by him, and to emigrate to the United States in 1784.

A small version of the painting is in the Royal Collection, and others are known.

Sir John Griffin (later Lord Howard de Walden) bought the portrait from the artist for 50 gns; the bill for the frame in October 1786 came to £13.15s.7½ (also in the Essex Record Office). This is a good example of the importance attached to framing in the eighteenth century and shows that owners were prepared to spend as much as a quarter of the price of an important modern picture on it.

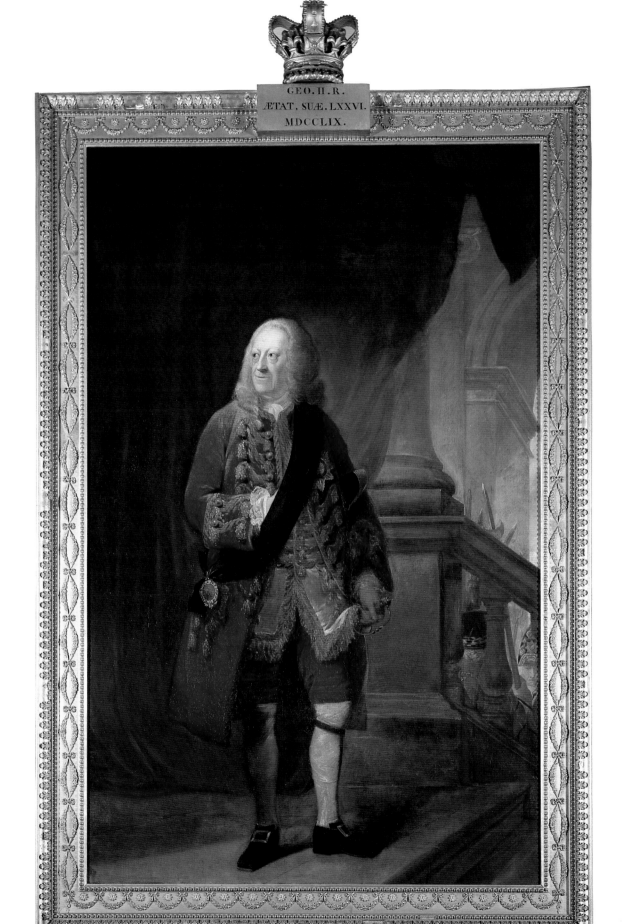

GEO. II. R.
ÆTAT. SUÆ. LXXVI.
MDCCLIX.

223

Biographical Index of Artists

COMPILED BY CAROLINE DA COSTA

BAKER, Joseph active 1742–died 1770

Cat.No.102 'View of Lincoln Cathedral'

Competent view painter known only from signed and engraved views of Lincoln and York, where he died in 1770. Recorded as director of the York Theatre.

BARDWELL, Thomas 1704–1767

Cat.No.106 'The Broke and Bowes Families'

Born in East Anglia, died in Norwich. First recorded in 1728 as a decorative painter, later as a painter of country house views, and as a portrait painter from 1741. Worked in London in 1740s and 50s, visited Yorkshire and Scotland in 1752–3 as itinerant portrait painter. Published *The Practice of Painting and Perspective Made Easy* in 1756, and settled in Norwich from 1759.

BRITISH SCHOOL *c.*1710

Cat.No.8 'Littlecote House'

BROOKING, Charles *c.*1723–1759

Cat.No.172 'Man-of-War Firing a Salute'

Best British marine painter of the mid-century. Brought up among shipyards of Deptford and encouraged in his career as painter by Taylor White, treasurer of the Foundling Hospital, for which he painted his largest picture in 1754. Promising career cut short by his death at the age of 35.

CANALETTO, Antonio 1697–1768

Cat.Nos.148 'Ranelagh Gardens'
149 'Vauxhall Gardens'
155 'Whitehall and the Privy Garden, from Richmond House'
156 'The Thames and the City from Richmond House'
176 'London Seen Through an Arch of Westminster Bridge'
178 'Old Walton Bridge'

Giovanni Antonio Canale, known as Canaletto, was born in Venice, where he became the leading view-painter of the eighteenth century and was extensively patronised by Britons doing the Grand Tour. Worked in London 1746–55 (with intermittent returns to Venice 1750/1 and 1753/4), and greatly influenced British view- and landscape painting.

CASTEELS, Peter 1684–1749

Cat.Nos.46 'Still-Life of Flowers'
47 'Fantastic Still-Life in a Classical Landscape'

A Fleming from Antwerp, settled in England 1708. Leading flower and exotic bird painter after Jakob Bogdany's death in 1724. Occasionally painted small histories in architectural settings. A founding member of Kneller's Academy in 1711. Returned briefly to Antwerp in 1713, but otherwise worked in London until 1735. Retired from painting and designed calico, living first in Tooting and then Richmond, where he died in May 1749.

DAHL, Michael ?1659–1743

Cat.No.18 'Henrietta, Countess Ashburnham'

Born Stockholm, died in London. Studied under Ehrenstrahl, becoming proficient in the international Baroque portrait style. Arrived in London 1682 and probably worked in Kneller's studio. Travelled to France and Italy 1685–8, returning to London via Frankfort. Settled permanently in London from 1689 and was immediately successful in securing important commissions, rivalling Kneller. Lost court patronage on the death of Queen Anne in 1714 but continued to paint members of the nobility, the law and the church, holding a respected position in the London art world until retiring in 1740.

DANDRIDGE, Bartholomew 1691–*c.*1755

Cat.Nos.39 'Captain Richard Gifford'
95 'The Ladies Noel'
108 'A Lady Reading *Belinda*'
150 'Edward Harley, 4th Earl of Oxford, and his Sister'

Born in London, and last recorded there in 1754. Successful portrait painter and important in the development of the Rococo conversation piece in Britain. He is known to have made small models to work out the precise arrangement of figures and chiaroscuro, a method adopted by Devis (*q.v.*) and Gainsborough (*q.v.*). Took over Kneller's old studio in 1731.

DEVIS, Arthur 1712–1787

Cat.Nos.187 'Gentleman and Lady in an Interior (The Duet)'
188 'Family Group on a Terrace in a Garden'
204 'Assheton Curzon and his Tutor'

Born Preston February 1712; died Brighton July 1787. Pupil of Tillemans (*q.v.*). Specialised in small-scale conversation pieces and single portraits. In good practice in Lancashire and probably London by 1745. Drew patrons from the middle classes who favoured small-scale portraiture. Exhibited intermittently at the Free Society of Artists 1761–80, and became its President in 1768.

DRAKE, Nathan *c.*1728–1778

Cat.No.183 'Newport Arch, Lincoln'

Painter of local topographical views and portraits. Born in Lincoln but settled and died in York, where initially he was apprenticed to his brother, a cabinet maker. Exhibited at the Society of Artists 1771–6.

GAINSBOROUGH, Thomas 1727–1788

Cat.Nos.152 '"Bumper": a Bull Terrier'
153 'The Gravenor Family'
163 'The Charterhouse'
180 'Extensive River Landscape'
189 'Unknown Couple in a Landscape'
217 'The Painter's Daughters Chasing a Butterfly'
218 'William Wollaston'

Landscape and portrait painter, and the creator of a new kind of poetical 'fancy picture'. Baptised Sudbury, Suffolk, May 1727; died London August 1788. Studied in London 1740–48 chiefly at the St Martin's Lane Academy under Gravelot (q.v.) and Hayman (q.v.). May have assisted Gravelot in some engraving projects.

Taught himself landscape painting by copying Dutch seventeenth-century works, and restored pictures for dealers. His reputation as a landscape artist was established when in 1748 he presented a view of Charterhouse (163) to the Foundling Hospital. Settled in Ipswich by 1748, earning a living by portrait painting in Suffolk while painting small landscapes for his own pleasure.

Worked in Bath 1759–1774, where he gained instant success as a fashionable portrait painter. Visited London annually from 1762, and exhibited regularly at the Society of Artists 1761–8.

Moved to London 1774 where he had the second largest portrait practice after Reynolds. Quarrelled with the Royal Academy and from 1784 ceased to exhibit there, using his own studio instead.

His own preference was for landscape but his reputation in his lifetime was based on portraiture. Although employed by the royal family in preference to Reynolds from 1776, he was otherwise considered second to Reynolds, perhaps because he never attempted History painting. His only pupil was, from 1772 onwards, his nephew Gainsborough Dupont. From 1781 began painting 'fancy pictures' on the scale of life, influenced by Murillo. Notable as the only leading portrait painter of his time not to use the services of specialist drapery painters.

GIBSON, Thomas c.1680–1751

Cat.No.30 'George Vertue'

Successful portrait painter in the style of Kneller. Active in London from 1711 (when made a Director of Kneller's Academy) to 1729, when moved to Oxford because of illness. Returned to London c.1732 and remained there until his death. Last recorded works are of the Princess of Wales and her children 1742.

GRAVELOT, Hubert François Bourguigon 1699–1773

Cat.No.110 'Le Lecteur'

Born Paris March 1699, died there in April 1773. French designer and illustrator, occasional figure painter. Pupil of Restout and Boucher. From late 1732 until 1746 worked in England, where he introduced the Rococo style, especially in engraved book illustrations. Highly influential as teacher at the St Martin's Lane Academy. Actively involved in the designs for the decorations at Vauxhall Gardens during 1740s.

GRIFFIER the Younger, John active 1738–1773

Cat.Nos.101 'The Thames during the Great Frost'
181 'Covent Garden from the South'

Member of a family of painters from Amsterdam who settled in England c.1705. Painter of topographical and ideal landscapes and noted as an excellent copyist of Claude. Known works date from 1738 and are among the earliest topographical paintings with a genuine feeling for real landscape produced in England.

HAMILTON, Gavin 1723–1798

Cat.No.194 'Elizabeth Gunning, Duchess of Hamilton'

Neo-classical history painter and portraitist. Born Lanark 1723, died in Rome 1798. Trained in Rome in the 1740s under Masucci. After practising portraiture in Britain in 1752–4, returned to Rome for the rest of his life and established his reputation as a dealer in antiquities. Aspired to the Grand Style of history painting with heroic classical subjects, and persuaded his clients to commission History paintings as part of their transactions.

HAMILTON, Gawen c.1697–1737

Cat.Nos.62 'The Porten Family'
63 'Thomas Wentworth, Earl of Strafford. and his Family'
64 'Edward Harley, 3rd Earl of Oxford, and his Family'
65 'A Conversation of Virtuosis'

Painter of small-scale portraits and conversation pieces. Born in the West of Scotland, near Hamilton, died in London. Studied under an obscure bird painter named Wilson. Set up in practice in London in 1730s, where he was considered by some a serious rival to Hogarth.

HAYMAN, Francis c.1708–1776

Cat.Nos.109 'The Wrestling Scene from *As You Like It*'
146 'The See-Saw'
147 'Jonathan Tyers with his Daughter Elizabeth and her Husband'
193 'The Artists Presenting a Plan for an Academy'
211 'Garrick as Richard III'

Painter of History, portraits and theatrical subjects and a prolific book illustrator. Born in Devon but moved to London (where he died) early in his career. Initially painted scenes for Drury Lane theatre. His portrait groups in landscape settings of the 1740s influenced Gainsborough (q.v.), who may have worked under him. Established a large practice in conversation pieces and small-scale portraits, though not so prolific in life-size portraits. Leading history painter after Thornhill's (q.v.) death in 1734, but little of this work survives. Active in forming the Society of Artists in 1760, and President of the Society from 1766 to 1768, until becoming a founder member of the R.A. in 1768. Best known for his designs for the decorations of Vauxhall Gardens in the 1740s.

HAYTLEY, Edward active 1740–1761

Cat.Nos.127 'Beachborough Manor: The Temple Pond Looking Towards the Rotunda'
128 'Beachborough Manor: The Temple Pond from the Rotunda'
164 'Chelsea Hospital'
165 'Greenwich Hospital'

Portrait and landscape painter. Perhaps born in Preston area. First recorded in 1740 as a flower painter, but better known for his small-scale portraits which are reminiscent of Devis. Exhibited at the Society of Artists 1760–61.

HEINS, John Theodore (Dietrich) 1697–1756

Cat.No.70 'A Musical Party at Melton Constable'

Portrait painter of German origin who settled in Norwich c.1720, and became the leading artist in what was then the second-largest town in Britain after London. Died there in 1756, his practice being continued by a son of the same name who specialised in miniatures.

HIGHMORE, Joseph 1692–1780

Cat.Nos.130 'Conversation Piece, probably of the Artist's Family'
131 'Unknown Man with a Musket'
132 'Portrait of a Lady with a Pug'
133 'Samuel Richardson'
134–145 'Twelve Scenes from Samuel Richardson's *Pamela*'
160 'Thomas Emerson'
161 'Hagar and Ishmael'

Leading and highly gifted portrait painter and occasional painter of Histories and themes from literature. Born London June 1692; died Canterbury March 1780. Originally studied law. Set up as a portrait painter in 1715 and studied for ten years in Kneller's Academy. Later influenced by Gravelot (q.v.). Retired from painting to Canterbury in 1761 to write on art.

In 1732 he travelled in the Low Countries to study Rubens and Van Dyck, and in 1734 visited Paris. His portraits are very varied in range and his conversation pieces were held in high esteem in his lifetime, although few of them can be identified now. As with Hogarth, his work is characterised by a new directness and warmth in the interpretation of character. Exhibited at the Society of Artists and the Free Society of Artists in 1760 and 1761.

HILL, Thomas 1661–1734

Cat.No.6 'Garton Orme at the Spinet'

Portrait painter of some refinement in the style of Dahl. Worked in London, but also recorded at Wells and Melbury c.1698 and 1720; died in Mitcham, Surrey. Taught drawing by Faithorne and painting by Dirk Freres. Several of his portraits were engraved. He gave up painting and sold the contents of his studio in 1725.

HOARE of Bath, William 1707–1792

Cat.No.219 'Richard Grenville, Earl Temple'

Portrait painter in oils and crayons. Born Eye, Suffolk; died in Bath. Studied under Grisoni (1699–1769, in England by c.1720), whom he accompanied on his return to Italy in 1728. Stayed abroad for nine years, mostly in Rome, returning to Bath in 1739, where he lived for 50 years, with one rather unsuccessful interval in London c.1751–2. He was the most fashionable portraitist in Bath until the arrival of Gainsborough (q.v.) in 1759. An altarpiece by him survives at St Michael's, Bath. Exhibited at the Society of Artists 1761–2; became a member of the R.A. 1769, and exhibited there 1770–9.

HOGARTH, William 1697–1764

Cat.Nos.53 'The Wedding of Stephen Beckingham and Mary Cox'
54 'Horace Walpole aged 10'
66 'The Jones Family'
67 'The Cholmondeley Family'
68 'The Indian Emperor or The Conquest of Mexico'
73 'Self-Portrait with Palette'
74–81 'The Rake's Progress'
82 'Falstaff Examining his Recruits'
83 'The Pool of Bethesda'
84 'Satan, Sin and Death'
91–94 'The Four Times of Day'
118 'William Jones'
119 'Mrs. Desaguliers'
120 'The Graham Children'
129 'The Dance'
157 'Captain Coram'
162 'Moses Brought before Pharaoh's Daughter'
173 'The March to Finchley'
191 'Hannah, daughter of John Ranby'
192 'George Osborne, later John Ranby'
196–199 'The Election'
210 'The Lady's Last Stake'

Painter of portraits, History, religious and 'modern moral' subjects and equally important as an engraver. Born London 10 November 1697; died there 26 October 1764. The most important British painter of the 1740s, and influential subsequently. Failed in his ambition to become the greatest History painter of the age in succession to his father-in-law Thornhill (q.v.), but was unsurpassed as a painter of contemporary genre.

Apprenticed to the silver engraver Ellis Gamble in 1713 and began his career as producer of satirical prints in 1720. Studied at Vanderbank's Academy. Began painting seriously in 1728–9 with scenes from 'The Beggar's Opera' and then specialised in small-scale conversation pieces and single portraits until the mid-1730s. His first series of modern moral subjects, 'The Harlot's Progress' of 1732, became very popular through engravings and was followed immediately by 'The Rake's Progress'. Secured the passing of the Copyright Act of 1735 to stop his prints from being pirated.

Inherited the equipment of Thornhill's Academy in 1734 and established new Academy in St Martin's Lane run on anti-academic lines. Visited Paris in May 1743 to recruit French engravers to work on 'The Marriage A-la-Mode'. Another visit to the Continent in 1748 resulted in 'Calais Gate'.

In 1746 encouraged his fellow-artists to present works to the Foundling Hospital in London, where for the first time a large collection of contemporary British paintings could be seen outside the artists' own studios.

Painted his most memorable portraits on the scale of life between 1740 and 1745. Published a treatise on aesthetics, *The Analysis of Beauty*, in 1753, which was not well received. His last and most important 'modern moral subject' was 'The Election' (196–199), completed in 1755, now in the Soane Museum.

HONE, Nathaniel 1718–1784

Cat.No.205 'Viscount Milsington'

Painter of portraits and occasional genre. Born Dublin, died London August 1784. Perhaps self-taught. Settled in London, where he had a fashionable practice as a miniaturist. Involved in setting up the Incorporated Society of Artists and became a Director in 1766. Exhibited at the Society of Artists 1760–68. Took up large-scale portrait painting in the 1750s. Became a founder member of the R.A. in 1768 and exhibited there 1769–84. Staged the first ever retrospective one-man show in 1775.

HUDSON, Thomas 1701–1779

Cat.Nos.158 'Theodore Jacobsen'
200 'Sir John Pole and his Wife'
208 'The Thistlethwayte Family'

Born in Devon, died Twickenham January 1779. Most popular portrait painter of the mid-eighteenth century. Pupil of Richardson (q.v.), whose daughter he married. His conservative style appealed to the older generation of sitters who resisted the realism of Hogarth. Devised a number of standardised poses and arrangements; his draperies were painted by Van Aken (q.v.). Reynolds (q.v.) was apprenticed to him in 1740–43, as was Joseph Wright of Derby later. Visited the Low Countries in 1748 and Italy 1752. Retired gradually from painting after about 1757.

HUGHES, Trajan active 1709–1712

Cat.No.7 'A Foxglove in a Landscape'

Still-life and animal painter, known only from two signed and dated paintings of some quality.

HYSING, Hans 1678–1753

Cat.No.72 'Sir Peter Halkett'

Portrait painter. Born Stockholm 1678, died London 1753. Settled in London 1700, where he studied under Dahl. Dated works range from 1721 to 1739. Important as the first teacher of Allan Ramsay (q.v.).

JERVAS, Charles c.1675–1739

Cat.No.19 'Martha and Theresa Blount'

Fashionable portrait painter under Queen Anne and George I. Born in Ireland, died in London, November 1739. Studied in London under Kneller (q.v.). Financed his travels to Italy through sales of copies of Raphael's cartoons. Recorded in Dublin 1698 and Paris 1699. Settled in Rome 1703, where he studied and copied the Old Masters. Returned to London 1709. Appointed Principal Painter to the King 1723.

KNAPTON, George 1698–1778

Cat.Nos.121 'Sir James Gray, KB'
122 'Charles Sackville, 2nd Duke of Dorset'
123 'Samuel Savage'
124 'Sir Bourchier Wrey'
125 'Frances Macartney'
195 'The FitzPatrick Children'

Portrait painter in oils and crayons. Born and died in London. Apprenticed to Richardson (q.v.) 1715–22. Travelled to Italy 1725–32. On his return to London, initially worked in crayon, helping to establish this as a fashionable medium. Founder member of and official painter to the Dilettanti Society from 1736. Seems to have given up painting about 1755, becoming Surveyor and Keeper of the King's Pictures in 1765.

KNELLER, Sir Godfrey 1646–1723

Cat.Nos.2 'The 3rd Earl of Burlington and his Sisters'
3 'The Triumph of Marlborough'
4 'Queen Anne Presenting Plans to Military Merit'
16 'John Erskine, 6th Earl of Mar, with his Son'
17 'Frances Pierrepont, Countess of Mar'
21 'Venus de' Medici'
22 'Giustiniani Apollo'
23 'Sir Samuel Garth'
24 'William Congreve'
25 'Francis Goldolphin, 2nd Earl of Godolphin'
26 'Lord Somers'
27 'The Duke of Newcastle and the Earl of Lincoln'
28 'Mehemet, Groom of the King's Chamber'

Chief Baroque portraitist of the late seventeenth and early eighteenth centuries, occasional History painter. Dominant artistic figure of his age in England. Born Lübeck August 1646, died London October 1723. Possibly studied under Rembrandt in 1660s. Travelled to Italy 1672–5; settled in England 1676. Appointed Principal Painter to William and Mary 1688 (jointly with Riley) and retained the post through successive reigns until his death. Governor of the first Academy 1711. Created a Baronet by George I in March 1715.

LAGUERRE, John active 1721, died 1748

Cat.Nos.49–52 'Four Scenes from *Hob in the Well*'

Son of Louis (q.v.). First recorded as a painter in 1722, but was chiefly a singer and scenery painter at Covent Garden 1735–1747. Regarded as a gifted painter by Vertue, but was too indolent to develop his gifts and died in want.

LAGUERRE, Louis 1663–1721

Cat.No.10 'A Feast of the Gods'

History painter and occasional painter of small easel pictures. Born Versailles 1663, died London April 1721. Trained under Charles Le Brun. Came to England 1683 and became the main rival of Thornhill (q.v.). A Director of Kneller's Academy in 1711 and influential in training the first generation of Georgian painters. Occasional portrait painter. Father of John (q.v.).

LAMBERT, George 1700–1765

Cat.Nos.85 'View of Westcombe House'
86 'Westcombe House from the Pond'
98 'Leybourne Castle, Kent'
171 'Landscape with Figures'
182 'Moorland Landscape with Rainstorm'
184 'The Great Falls of the Tees'

Painter of topographical and classical landscapes; also an eminent scenographer at the Covent Garden Theatre. Died in London January 1765. First mentioned in 1722 as an imitator of Gaspard Poussin and Wootton (q.v.). In 1732, collaborated with Scott (q.v.) on pictures of the East Indies Settlements and in 1736–7 painted

the landscapes in Hogarth's decorations for St Bartholomew's Hospital. His importance lies in his early ability to respond to the picturesque and to apply the rules of Dutch and classical landscape painting to English views from the 1730s onwards. First Chairman of the Society of Artists 1761 and elected its first President shortly before his death.

LAROON, Marcellus 1679–1772

Cat.No.61 'A Nobleman's Levée'

Painter of Rococo conversations, 'fancy' pictures, stage scenes and occasional portraits. Born Chiswick April 1679, died Oxford June 1772. His main career was in the army, from where he retired as a Captain in 1732, after extensive travels in the Low Countries and Venice. Drawings date from 1707 onwards and he worked in Kneller's Academy c. 1712. His most original work dates from the 1730s and consists mainly of small Rococo 'fancy' pictures, which show a strong French influence.

LILLY, Edmund active 1702–1716

Cat.No.1 'Queen Anne'

Portrait painter. Died Richmond May 1716. Enjoyed considerable court patronage under Queen Anne but examples of his work are rare. Worked in a style closely related to Kneller.

MERCIER, Philip ?1689–1760

Cat.Nos.40 'Conversation in a Park'
69 'The Music Party: Frederick, Prince of Wales, and his Sisters'

Painter of portraits and fancy pictures; also engraver. Born Berlin 1689 or 1691, died London July 1760. Familiar with the paintings of Watteau, whose works he engraved and may have forged. Came to England in about 1716, where his earliest conversation pieces date from the 1720s. Became Principal Portrait Painter to Frederick, Prince of Wales, in 1729. Painted his first 'fancy pictures' in 1737–9. Settled in York 1739–51, visited Portugal for a year in 1752, then settled in London, concentrating on fancy pictures as well as popular sentimental groups. Important for the introduction of French taste into England.

NEBOT, Balthazar active 1730–died after 1765

Cat.Nos.87–90 'Four Views of the Gardens at Hartwell House'
99 'Covent Garden Market'

Born in Spain, first recorded in London 1729/30. Painter of urban genre and topographical landscapes in London and elsewhere, especially Yorkshire where he is last recorded in the 1760s.

NICKOLLS, Joseph active 1726–1755

Cat.Nos.113 'The Fountain in the Middle Temple'
114 'St James's Park and the Mall'
115 'Charing Cross and Northumberland House'

Little-known but gifted painter of topographical London views, some engraved as early as 1738. First recorded as an illustrator. May have been scenery painter in the theatre; mentioned as decorative painter at Vauxhall Gardens.

NOLLEKENS, Joseph Francis 1702–1748

Cat.Nos.104 'Conversation Piece of Five Figures in a Garden'
105 'A Family in a Palladian Interior'
111 'Two Children of the Nollekens Family'
112 'Two Boys of the Nollekens Family Playing at Tops'

Painter of conversation pieces and genre. Born Antwerp June 1702, died London January 1748. Specialised in imitations of Watteau, especially genre scenes including children. Came to England in 1733 and worked with Tillemans (q.v.).

PENNY, Edward 1714–1791

Cat.No.151 (attr.) 'Margaret Cavendish Harley Duchess of Portland'

Painter of portraits, histories, and subject matter with a moral content. Born Knutsford, Cheshire, August 1714, died Chiswick November 1791. Studied with Hudson and later in Rome. On his return to England in 1743, specialised in small-scale full-length portraits. From 1762 exhibited at the Society of Artists. Became a founder member of the Royal Academy and its first Professor of Painting. Later specialised in sentimental moral histories.

PHILIPS, Charles 1708–1747

Cat.Nos.59 'Thomas Hill of Tern and his Family in a Landscape'
60 'Algernon, 7th Duke of Somerset, with his Family'

Fashionable portrait painter especially in small scale full lengths and conversations. Probably born and died in London and probably taught by his father. His works were popular with the aristocracy during the ascendancy of the conversation piece in the 1730s. Moved to full scale portraiture when the fashion for conversation pieces faded. Patronised by the Prince and Princess of Wales in the 1730s.

PINE, Robert Edge c.1720–1788

Cat.No.223 'King George II'

Portrait and history painter. Born London, probably in the 1720s, the son of an engraver, died Philadelphia November 1788. Listed as an 'eminent painter' in London in 1748. One of the first to paint actors in character parts. Exhibited at the Society of Artists 1760–71. Not appointed a founder member of the Royal Academy for political reasons but exhibited there 1772, 1780 and 1784. Lived in Bath 1772–9. In 1783 he emigrated to North America and developed a large portrait practice there.

RAMSAY, Allan 1713–1784

Cat.Nos.116 'The Hon. Rachel Hamilton and her Brother Charles'
117 'Thomas, 2nd Baron Mansel of Margam, with his Brothers and Sister'
154 'John Manners, Marquess of Granby'
159 'Dr Richard Mead'
215 'Lord John Murray'
216 'Mary Dalton, Lady John Murray'

Fashionable portrait painter. Born Edinburgh October 1713, died Dover August 1784. Received little formal training in Edinburgh and in 1734 studied with Hans Hysing (q.v.) in London. From 1736 to 1738 travelled in Italy where he studied in Rome and drew at the French Academy, a training which had considerable impact on his later style. On his return to London in 1738 he was patronised by Scottish nobility and maintained a studio in Edinburgh until 1755. At his best, his interpretation of character in terms of form, colour and tone paved the

way for Reynolds (q.v.). He acknowledged the new ideas in Reynolds's style and reacted by going again to Italy 1755–7 for fresh inspiration. Appointed the King's Painter 1761 and subsequently gave up private commissions, concentrating on production of royal portraits.

REYNOLDS, Sir Joshua 1723–1792

Cat.Nos.190 'The Reverend William Beele'
206 'Charles, 9th Lord Cathcart'
207 'Lady Cathcart and Daughter'
220 'The Children of Edward Holden Cruttenden'
221 'Charles, 3rd Duke of Richmond'
222 'Laurence Sterne'

Portrait and history painter. Dominant influence on the British artistic scene in the time of George III. Born Plympton, Devon, July 1723 died London February 1792. Apprenticed to Hudson (q.v.) 1740–43. Practised in Devon and London 1743–9 before going to Italy. In Rome 1750–52, where he studied the Old Masters intensely, not only for their technique but also for the intellectual ideas behind their art. Returned to London 1753 via Paris, and quickly became the leading portraitist of the day. Became in 1768 the first President of the Royal Academy and was knighted in 1769. Through the Academy he strove to pro-mote a British School of History painting to stand alongside those of Rome or Bologna, and his ideas were publicised in the *Discourses* which he published annually. His own attempts at History painting in the 1770s were less successful and his chief contribution lies in giving an intellectual dimension to British portraiture. Visited the Netherlands in 1781 and renewed his study of Rubens, resulting in simpler, more informal works.

RICCI, Marco 1676–1730

Cat.No.9 (attr.) 'The Mall from St James's Park'

Venetian landscape painter and stage decorator. Born in Belluno, died Venice January 1729/30. Nephew and pupil of Sebastiano Ricci (q.v.). Arrived in London 1708 and worked there intermittently until 1716. Patronised by the Earl of Burlington.

RICCI, Sebastiano 1659–1734

Cat.No.11 'The Baptism of Christ: Design for Bulstrode House'

Leading Venetian decorative painter. Born Belluno August 1659, died Venice May 1734. Brought to England by his nephew Marco Ricci (q.v.) in 1711/12 to work on the major decorative projects then being commissioned, but was largely thwarted in his ambitions by Thornhill (q.v.). Most important works in England are the decorations at Burlington House and Chelsea Hospital Chapel. Returned to Venice in 1716.

RICHARDSON, Jonathan, Snr c.1665–1745

Cat.Nos.20 'Alexander Pope with his Dog Bounce'
36 (attr.) 'Lady Mary Wortley Montagu'
71 'George Vertue'

Leading English portrait painter of first forty years of eighteenth century. Born and died in London, pupil of Riley 1688–91. Also writer on art and literary topics; published *The Theory of Painting* 1715. Helped to found the first Academy in 1711. Retired from painting 1740. Teacher and father-in-law of Thomas Hudson (q.v.).

ROMNEY, George 1734–1802

Cat.Nos.203 'Boy with Dog'
209 'Captain Robert Banks'

Fashionable portrait and History painter. Born Beckside, Cumberland, died Kendal. After apprenticeship with Christopher Steele (q.v.) 1755–7, practised in Kendal 1757–62 before going to London. Tendency towards the neo-classical reinforced by visit to Italy 1773–5. Returned to London 1776, and became the leading portrait painter alongside Reynolds (q.v.) and Gainsborough (q.v.). Never exhibited at the Royal Academy probably because of animosity from Reynolds, but this did not affect his thriving business.

SCOTT, Samuel c.1702–1772

Cat.Nos.96 'A Danish Timber Bark Getting Under Way'
97 'A Flagship Shortening Sail'
174 'Old London Bridge'
175 'Westminster Bridge'
177 'The Arch of Westminster Bridge'
214 'Covent Garden on a Market Day'

Best English painter of marines and Thames views. Born London c.1702, died Bath October 1772. Initially imitated Willem van de Velde, painting naval engagements and more tranquil views of shipping, but from the 1740s turned to painting views of London and the Thames in the wake of example set by Canaletto (q.v.).

SEEMAN, Enoch c.1690–1745

Cat.No.5 'The Bissett Family'

Portrait painter. Born Dantzig c.1690 and brought to England as a child by his father, also a painter. Died London March 1745. Had a good practice in London by 1717, when he painted George I. Retained good position in the second league of portrait painters until his death.

SMITH 'of Chichester', George 1714–1776

Cat.Nos.185 'Winter Landscape'
186 'Still-Life with Joint of Beef'

Prolific painter of rural scenes and some still-lifes. Born, died and worked in Chichester, but maintained studio in London. Often collaborated with his brothers, John and William. Their rustic and winter scenes were popular and much engraved, although ultimately rather monotonous.

STANNEY, John active 1730

Cat.No.48 'Vanitas'

Known only from one signed and dated work. Possibly an amateur who studied Dutch painting.

STEELE, Christopher 1733–1767

Cat.No.202 'Martha Rodes'

Portrait painter. Born Egremont, Cumberland, July 1733, died there September 1767. Studied for a year under Carle Van Loo in Paris before settling in

Kendal in 1750. Romney (q.v.), whom he greatly influenced, was apprenticed to him in 1755. Later worked as itinerant portrait painter, travelled to the West Indies 1762, but soon returned to Cumberland.

THORNHILL, Sir James 1675/6–1734

Cat.Nos.12 'Sir Isaac Newton'
13 'Design with the Story of Aeneas and Dido'
14–15 Two Designs for the Dome of St Paul's
31–35 Five Decorative Panels for the Ceiling of the New Council Chamber of the Guildhall

Leading British decorative history painter in the grand Baroque tradition and occasional portrait painter. Born in Dorset, and died Stalbridge, Dorset, July 1734. Apprenticed to Thomas Highmore, although he probably learned chiefly from studying Verrio and Laguerre (q.v.). Began painting scenery 1705; also studied architecture. Visited the Netherlands and Paris 1711 and in the same year became a Director of Kneller's Academy which he took over as Governor in 1716. His major works are the decorations at Greenwich Hospital and St Paul's. He was the only British painter able to compete successfully with the many foreigners then seeking work in England and was greatly helped by the then prevailing feeling of British patriotism. Father-in-law of William Hogarth (q.v.).

TILLEMANS, Peter c.1684–1734

Cat.Nos.29 'The Artist's Studio'
44 'The Thames from Richmond Hill'
45 'Edward and Mary Macro'

Topographical painter and draughtsman, occasional portrait painter. Born Antwerp c.1684, died Norton, Suffolk, November 1734. Trained by copying Teniers. Came to England 1708. Employed initially at Oxford and in Northamptonshire on topographical pictures. Developed a good practice specialising in views of country houses and sporting pictures, and became one of the founders of the sporting conversation piece. Respected in London art circles and taught Nollekens (q.v.) and Arthur Devis (q.v.).

VAN AKEN, Joseph c.1699–1749

Cat.Nos.41 'A Musical Party on a Terrace'
42 'A Sportsman and his Servant in the Grounds of a Country House'
43 'Covent Garden Market'

Painter of genre and portraits, and the top drapery painter of the age. Born probably Antwerp, died London July 1749. Member of a large family of painters from Antwerp, several of whom settled in England. Came to London 1720 and initially painted genre scenes and conversations. About 1735 he and his younger brother Alexander (d. 1757) took to specialising in painting draperies for Hudson, Ramsay, and many other London leading portrait painters.

VANDERBANK, John 1694–1739

Cat.Nos.55–58 'Four Scenes from *Don Quixote*'

History and portrait painter and book illustrator. Born and died in London, son of a tapestry weaver. Studied at Kneller's Academy in 1711. In 1720 founded his own Academy in St Martin's Lane with Chéron and from then on had an increasingly busy practice in portrait painting. Painted many small scenes from *Don Quixote* between 1730 and his death in impoverished circumstances in 1739, reputedly as payment for rent.

VAN LOO, Jean-Baptiste 1684–1745

Cat.No.103 'Augusta, Princess of Wales, with Members of her Family and Household'

Portrait painter. Born Aix-en-Provence 1684, died there September 1745. After working in the major centres of Europe, came to England 1737, and stayed until 1742, as an immensely successful fashionable portrait painter. His style brought a cosmopolitan elegance to British portrait painting.

VERELST, William active 1734–c.1756

Cat.No.107 'The Gough Family'

Painter of portraits and conversation pieces, best portraitist in a large family of Dutch painters, several members of which settled in England. Recorded in England c.1734/5–c.1756.

WALE, Samuel 1721–1786

Cat.Nos.166 'Christ's Hospital'
167 'St Thomas's Hospital'
168 'Greenwich Hospital'

Mainly a designer of book illustrations and bookplates, but an occasional painter of History and landscape. Probably born Yarmouth December 1721, died London February 1786. Apprenticed to a goldsmith 1735. Studied at the St Martin's Lane Academy under Hayman (q.v.) and Gravelot (q.v.). Became a foundation member of the R.A. 1768 and its first Professor of Perspective, also its Librarian in 1778.

WILSON, Benjamin 1721–1788

Cat.No.201 'Charles Ingram, later 9th Viscount Irwin'

Painter of portraits and theatre scenes, also etcher. Born in Leeds, died in London June 1788. Worked in Dublin 1748–50, then settled in London where became a leading portrait painter until about 1769; seen by many as a serious rival to Reynolds. After that, abandoned painting to concentrate on scientific interests. Exhibited at the Society of Artists 1760–1, and probably at the R.A. 1783.

WILSON, Richard 1713–1782

Cat.Nos.100 'The Inner Temple after the Fire of 4 January 1737'
126 'Westminster Bridge under Construction'
169 'St George's Hospital'
170 'The Foundling Hospital'
212 'Vale of Narni'
213 'Croome Court, Worcestershire'

First important British painter to work solely in landscape. Born Penegoes, Wales, August 1713, died at Colomendy, Wales, May 1782. Trained as a portrait painter and by 1744 had a successful practice. Painted some topographical landscapes before going to Venice in 1750. Stayed in Italy seven years, developing a classical landscape style. On his return in 1757 applied its rules to the English scene. Used landscape drawings made in Italy for the rest of his life as a basis of his 'poetic' and 'ideal' compositions, and elevated the country house portrait to a new art form. Important as teacher of later generation of

landscape painters. Extensively copied and imitated after his death. Exhibited at the Society of Artists 1760–8, and at the R.A. 1769–80.

WOOTTON, John ?1682–1764

Cat.Nos.37 'Equestrian Portrait of Lionel Sackville, 1st Duke of Dorset'
38 'Frederick, Prince of Wales, out Stag Hunting'
179 'Lady Mary Churchill at the Death of the Hare'

Painter of landscapes and horses. Born in Snitterfield, Warwickshire, died in London November 1764. Pupil of Jan Wyck (d. 1700). Developed a picturesque landscape style influenced by Claude. Recorded as sporting painter by 1714, and for fifty years chief horse painter to the aristocracy. Also painted battle pictures and portraits of country houses, and collaborated with Richardson (q.v.), Hogarth (q.v.) and probably others, who supplied the portraits in his equestrian and sporting groups. Retired from painting after 1761.

Lenders

PRIVATE COLLECTIONS

Her Majesty The Queen 28, 103, 114
Avvocato Franco Antico 7
Society of Antiquaries 30
Governor and Company of the Bank of England 174, 175,
 181
The Earl of Bathurst 21, 22
British Rail Pension Funds 105, 188
Ann Lady Boothby 66
Trustees of the Chatsworth Settlement 2
Trustees of the Chevening Estate 219
Chichester County Council 185, 186
The Marquess of Cholmondeley 67
The Viscount Cobham 20
Croome Estate Trustees 213
Society of Dilettanti 121, 122, 123, 124
J.J. Eyston 19
The Master of Forbes 5
Sir Brinsley Ford, C.B.E., F.S.A. 212
Trustees of the Goodwood Collection 155, 156, 221
Grimsthorpe and Drummond Castle Trustees 92, 93
The Earl of Haddington 116
Hamilton Collection 194
Harari and Johns, London 55, 56, 57, 58
Edward Harley 64
The Earl of Harrowby 36
Mrs Pamela Howell 125
The Earl of Mar and Kellie 16, 17
The Duke of Marlborough 1, 4
Honourable Society of the Middle Temple 113
National Theatre, London 211
National Westminster Bank, PLC 115
The Hon. R. Neville 154, 223
The Duke of Northumberland 40, 60, 176
The Earl of Pembroke 85, 86
Trustees of Sir John Carew Pole 200
Private Collections: 10, 13, 38, 54, 61, 63, 68, 70, 82, 106,
 107, 117, 119, 130, 150, 151, 152, 191, 192, 202, 203, 204,
 205, 208, 215, 216
Nathaniel Robertson Collection 42
Lord Sackville 37
Spink & Son Ltd 184
Worshipful Company of Stationers and Newspaper
 Makers 133
The Marquess of Tavistock and the Trustees of the
 Bedford Estate 195, 214
Trafalgar Galleries 46, 48
Lord Trevor 148, 149
Master and Fellows of Trinity College, Cambridge 12

PUBLIC COLLECTIONS

Audley End, English Heritage 154, 223
Aylesbury, Buckinghamshire County Museum 87, 88, 89,
 90
Bath, Holburne Museum 6
Birmingham, Barber Institute of Fine Arts 190
Buffalo, Albright-Knox Art Gallery 210
Cambridge, Fitzwilliam Museum 131, 135, 138, 139, 145
Eastbourne, Towner Art Gallery 41
Edinburgh, National Galleries of Scotland 72, 180
Exeter, Royal Albert Memorial Museum 193
Ipswich, Ipswich Museums and Galleries 218
Kendal, Abbot Hall Art Gallery 209
Leeds, City Art Galleries 47, 201
Lincoln, Usher Gallery 102, 183
Liverpool, Walker Art Gallery 18
London, Thomas Coram Foundation for Children 157,
 158, 159, 160, 161, 162, 163, 164, 165, 166, 167, 168, 169,
 170, 171, 173
London, Dulwich Picture Gallery 178, 189
London, Government Art Collection 43, 44, 98
London, Guildhall Art Gallery 31, 32, 33, 34, 35, 101
London, Marble Hill House (English Heritage) 110
London, National Army Museum 39
London, National Gallery 120, 217
London, National Maritime Museum 96, 97
London, National Portrait Gallery 3, 23, 24, 25, 26, 27, 65,
 71, 118, 222
London, National Trust 59, 69, 91, 94
London, Royal Armouries 8
London, St Paul's Cathedral Museum 14, 15
London, Sir John Soane's Museum 74, 75, 76, 77, 78, 79,
 80, 81, 196, 197, 198, 199
London, Tate Gallery 84, 99, 100, 109, 126, 129, 134, 140,
 142, 144, 146, 172, 177, 179, 182
London, Victoria and Albert Museum 187
Manchester, City Art Galleries 83, 95, 206, 207
Melbourne, National Gallery of Victoria 127, 128, 136,
 137, 141, 143
New Haven, Yale Center for British Art 49, 50, 51, 52, 73,
 104, 108, 111, 112, 147, 153
New York, Metropolitan Museum of Art 11, 53
Norwich, Norfolk Museums Service (Norwich Castle
 Museum) 29, 45
São Paulo, Museu de Arte de São Paulo 220
Sheffield, Graves Art Gallery 132
Springfield, Mass., Museum of Fine Arts 62
Washington, National Gallery of Art 9

Select Bibliography

All published in London unless stated otherwise.

Abbreviations for frequently cited sources

Allen 1987 B. Allen, *Francis Hayman*, New Haven & London 1987

Beckett 1949 R.B. Beckett, *Hogarth*, 1949

Constable 1953 W.G. Constable, *Richard Wilson*, 1953

Constable & Links 1976 W.G. Constable & J.G. Links, *Canaletto. Giovanni Antonio Canal 1697–1768*, 1976

Croft-Murray 1962 & 1970 E. Croft-Murray, *Decorative Painting in England 1537–1837*, I, 1962, II, 1970

D'Oench 1979 E.G. D'Oench, *Arthur Devis (1712–1787): Master of the Georgian Conversation Piece*, Yale University Ph.D. Thesis 1979, published on demand by University Microfilms International

Edwards 1954 R. Edwards, *Early Conversation Pictures*, 1954

Einberg & Egerton 1987 E. Einberg & J. Egerton, *The Age of Hogarth: British Painters born 1675–1709*, 1987

Harris 1979 J. Harris, *The Artist and the Country House*, 1979

Hayes 1982 J. Hayes, *The Landscape Paintings of Thomas Gainsborough*, 2 volumes, 1982

Kingzett 1982 R. Kingzett, 'A Catalogue of the Works of Samuel Scott', *Walpole Society*, XLVIII, 1982, pp.1–135

Kerslake 1977 J. Kerslake, *Early Georgian Portraits in the National Portrait Gallery*, 2 volumes, 1977

Lewis 1975 A.S. Lewis, *Joseph Highmore 1692–1780*, Harvard University Ph.D. Thesis 1975, published on demand by University Microfilms International

Millar 1963 O. Millar, *Pictures in the Royal Collection: Tudor, Stuart and Early Georgian*, 2 volumes, 1963

Nicolson & Kerslake 1972 B. Nicolson & J. Kerslake, *The Treasures of the Foundling Hospital*, 1982

Paulson 1971 R. Paulson, *Hogarth, His Life, Art & Times*, 2 volumes, New Haven & London 1971

Raines 1980 R. Raines, 'Peter Tillemans, Life and Work, with a List of Representative Paintings', *Walpole Society*, XLVII, 1980, pp.21–59

Ribeiro 1984 A.E. Ribeiro, *The Dress Worn at Masquerades in England 1730–1790 and its Relation to Fancy Dress in Portraiture*, New York 1984

Stewart 1983 J.D. Stewart, *Sir Godfrey Kneller and the English Baroque Portrait*, Oxford 1983

Vertue I–VI George Vertue's Notebooks, *Walpole Society*, 1930, XVIII (Notebooks I), 1932, XX (Notebooks II), 1934, XXII (Notebooks III), 1936, XXIV (Notebooks IV), 1938, XXVI (Notebooks V), 1942, XXIX (Index), 1950, XXX (Notebooks VI).

Waterhouse 1949 E.K. Waterhouse, *Reynolds*, 1949

Waterhouse 1973 E.K. Waterhouse, *Reynolds*, 1973

Waterhouse 1978 E.K. Waterhouse, *Painting in Britain 1530–1790*, (4th revised and integrated edition) 1978

Waterhouse 1981 E.K. Waterhouse, *Dictionary of British 18th Century Painters*, 1981

Webster 1979 M. Webster, *Hogarth*, 1979

Whitley 1928 W.T. Whitley, *Artists and their Friends in England 1700–1790*, 2 volumes, 1928

The catalogue relies largely (except where stated) on the following standard and recent works, which are recommended for further reading:

Hogarth

F. Antal, *Hogarth and His Place in European Art*, 1962

D. Bindman, *Hogarth*, 1981

J. Burke (ed.), *William Hogarth's 'The Analysis of Beauty'*, Oxford 1955

R.L.S. Cowley, *Marriage A-la-Mode: a re-view of Hogarth's narrative art*, Manchester 1983

D. Dabydeen, *Hogarth's Blacks*, 1985

D. Jarrett, *The Ingenious Mr Hogarth*, 1976

H. Omberg, *William Hogarth's Portrait of Captain Coram*, Uppsala 1974

R. Paulson, *Hogarth's Graphic Works*, 2 volumes, New Haven & London 1970

Eighteenth-century art-historical background

J. Burke, *English Art 1714–1800*, Oxford 1976

L. Herrmann, *British Landscape Painting in the Eighteenth Century*, 1973

E.D.H. Johnson, *Paintings of the British Social Scene from Hogarth to Sickert*, 1986

L. Lippincott, *Selling Art in Georgian London: The Rise of Arthur Pond*, New Haven & London, 1983

M. Whinney & O. Millar, *English Art 1625–1714*, 1957

M. Wilson, *William Kent: Architect, Designer, Painter, Gardener, 1685–1748*, 1984

Eighteenth-century historical and social background

B. Denvir, *The Eighteenth Century: Art, Design and Society 1689–1789*, 1983

M.D. George, *London Life in the Eighteenth Century*, 1925

M. Girouard, *Life in the English Country House*, 1979

J.E.C. Harrison, *The Common People*, 1984

R. Hatton, *George I*, 1979

D. Jarrett, *Britain 1688–1815*, 1965

H. Phillips, *Mid-Georgian London*, 1964

H. Phillips, *The Thames about 1750*, 1951

J.H. Plumb, *England in the Eighteenth Century*, 1950

J.H. Plumb, *The First Four Georges*, 1956

J.H. Plumb, 'The New World of Children in Eighteenth Century England', *Past and Present*, no.67, 1975, pp.65–95

R. Porter, *English Society in the Eighteenth Century*, 1982

A.F. Scott, *The Early Hanoverian Age 1714–1760*, 1980

A.S. Turberville, *English Men and Manners in the Eighteenth Century*, 1929 (reprinted 1964)

The Friends of the Tate Gallery

The Friends of the Tate Gallery is a society which aims to help buy works of art that will enrich the collections of the Tate Gallery. It also aims to stimulate interest in all aspects of art.

Although the Tate has an annual purchase grant from the Treasury, this is far short of what is required, so subscriptions and donations from Friends of the Tate are urgently needed to enable the Gallery to improve the National Collection of British painting and keep the Twentieth-Century Collection of painting and sculpture up to date. Since 1958 the Society has raised over £1 million towards the purchase of an impressive list of works of art, and has also received a number of important works from individual donors for presentation to the Gallery.

In 1982 the Patrons of New Art were set up within the Friends' organisation. This group, limited to 200 members, assists the acquisition of works by younger artists for the Tate's Twentieth-Century Collection. A similar group – Patrons of British Art – was formed in late 1986 to assist the acquisition of works for the Collection of British painting of the period up to 1914.

The Friends are governed by a council – an independent body – although the Director of the Gallery is automatically a member. The Society is incorporated as a company limited by guarantee and recognised as a charity.

Advantages of Membership include:

Special entry to the Gallery at times the public are not admitted. Free entry to, and invitations to private views of paying exhibitions at the Gallery. Opportunities to attend lectures, private views at other galleries, films, parties, and of making visits in the United Kingdom and abroad organised by the Society. A 10% discount on all stock in the Tate Gallery shop, apart from books and catalogues, and a 10% discount on current special exhibition catalogues. Use of the Members' Room in the Gallery.

MEMBERSHIP RATES (at August 1987)
Any Membership can include husband and wife

Benefactor Life Member £5,000 (single donation)
Patron of New Art £475 annually or £350 if a Deed of Covenant is signed
Patron of British Art £475 annually or £350 if a Deed of Covenant is signed
Corporate £250 annually or £200 if a Deed of Covenant is signed
Associate £65 annually or £50 if a Deed of Covenant is signed
Life Member £1,500 (single donation)
Member £15 annually or £12 if a Deed of Covenant is signed
Educational & Museum £12 annually or £10 if a Deed of Covenant is signed
Young Friends £10 annually.

for further information apply to:

The Friends of the Tate Gallery,
Tate Gallery, Millbank, London SW1P 4RG
Telephone 01-821 1313 or 01-834 2742.

Subscribing Corporate Bodies as at August 1987

*Agnew & Sons Ltd, Thomas
Alex, Reid & Lefevre Ltd
Allied Irish Banks Ltd
American Express Europe Ltd
Art Promotions Services Ltd
†Associated Television Ltd
Bain Clarkson Ltd
Balding + Mansell UK Ltd
†Bankers Trust Company
Barclays Bank International Plc
Baring Foundation, The
Beaufort Hotel
*Benson & Partners Ltd, F.R.
Bowring & Co. Ltd, C.T.
British Council, The
British Petroleum Co. Plc
Brocklehursts
Bryant Insurance Brokers Ltd, Derek
CCA Stationery Ltd
Cazenove & Co.
Charles Barker Group
*Chartered Consolidated Plc
*Christie, Manson & Woods Ltd
*Christopher Hull Gallery
Citicorp Investment Bank Ltd
Colnaghi & Co. Ltd, P & D
Commercial Union Assurance Plc
Coutts & Company
Crowley Ltd, S.J.
De La Rue Company Plc
Delta Group Plc
Deutsche Bank AG
*Editions Alecto Ltd
Electricity Council, The
Equity & Law Charitable Trust
Esso Petroleum Co. Plc
Farquharson Ltd, Judy

Fine Art Society Ltd
Fischer Fine Art Ltd
Fitton Trust, The
*Gimpel Fils Ltd
Greig Fester Ltd
Guardian Royal Exchange Assurance
 Group
Guinness Peat Group
Hill Samuel Group
IBM United Kingdom Ltd
*Imperial Chemical Industries Plc
Kiln & Co. Ltd
Kleinwort Benson Ltd
Knoedler Kasmin Ltd
*Leger Galleries Ltd
Lewis & Co. Ltd, John
*Lumley Cazalet Ltd
Madame Tussauds Ltd
†Manor Charitable Trustees
*Marks & Spencer Plc
Marlborough Fine Art Ltd
*Mayor Gallery, The
Minet & Co. Ltd, J.H.
Morgan Bank
Morgan, Grenfell & Co. Ltd
National Westminster Bank Plc
Norddeutsche Landesbank
Ocean Transport & Trading Ltd
*Ove Arup Partnership
Pateman Underwriting Agencies Ltd
Pearson Plc
Peter Moores Foundation
*Phillips Son & Neale
Piccadilly Gallery
Plessey Company Plc, The
Rayne Foundation, The
Redfern Gallery

†Rediffusion Television Ltd
Richard Green Gallery
Roberts & Hiscox Ltd
Roland, Browse & Delbanco
Rothschild & Sons Ltd, N.M.
Royal Bank of Scotland Plc
RTZ Services Ltd
Schroder Wagg & Co. Ltd, J. Henry
Schupf, Woltman & Co. Inc
Scott Mathieson Daines Ltd
Seascope Insurance Holdings
*Secretan & Co. Ltd, F.L.P.
Sedgwick Group Plc
*Sinclair Montrose Trust
Smith & Son Ltd, W.H.
Somerville & Simpson Ltd
Sotheby Parke Bernet & Co.
Spink & Son Ltd
Star Assurance Society
Stephenson Harwood
Stewart Wrightson Ltd
Sun Alliance & London Insurance
 Group
Swan Hellenic Art Treasure Tours
Swire & Sons Ltd, John
*Tate & Lyle Ltd
Thames & Hudson Ltd
†Tramman Trust
*Ultramar Plc
Vickers Ltd
*Waddington Galleries Ltd
Willis Faber Plc
Winsor & Newton Ltd

*By Deed of Covenant
†Life member

[253]

Photographic credits

A.C. Cooper
Bridgeman Art Library
John Freeman
Mancktelow Photography
Tate Gallery
John Webb F.R.P.S.
Woodmansterne Ltd